MW00755106

"An evocative and well-written account of All Things Che: chronicling the Argentine revolutionary's remarkable life and early death—followed by his subsequent beatification and spectacular reincarnation as a global brand. Casey's book is eagle-eyed on the merchandising of Che beginning with the cleverly cropped Korda photo of the beret-wearing Che. There are insightful interviews with Che's daughter Aleida and most especially with Che's illegitimate son, Omar Pérez López, a dissident and poet who finds himself picking tomatoes in a labor camp in Cuba that had been established by his father."
> —Ann Louise Bardach, author of *Cuba Confidential* and *Without Fidel*

"An interesting examination of the processes of mythmaking and commercialization working in tandem to guarantee immortality to a man who failed more often than he succeeded." —*Booklist*

"Part detective story, part travelogue, *Che's Afterlife* is the definitive account of the birth and dissemination of an iconic image. Michael Casey peers behind the photographs and posters of the guerrilla martyr Che Guevara, and finds a riveting tale of art and ambition, of rebellion and merchandising. It is illuminating and essential reading."
> —Héctor Tobar, author of *Translation Nation: Defining a New American Identity in the Spanish-Speaking United States*

"Che Guevara's death was a brilliant career move. His image circled the globe, giving hope to the hopeless and profit to its exploiters. Lively and informative, *Che's Afterlife* smartly chronicles the explosive Guevara growth industry in the marketplace of ideas and icons."

—Tom Miller, author of *Trading with the Enemy: A Yankee Travels Through Castro's Cuba*

"A tour de force of pop cultural entertainment and analysis. Whether the iterations of the picture appear in an advertising campaign for tennis shoes, on the T-shirt of a Berkeley fashionista, or at a Hezbollah rally, Casey has extensively documented and perceptively explained the remarkable transposability of one of the most famous photographs of the twentieth century (and beyond). Moreover, like the best students of humankind, he has shown us our own reflection in the icon—that is, how popular culture has come to dominate commerce, politics, even history. *Che's Afterlife* will inform historians and delight the public."

—David D. Perlmutter, Professor, University of Kansas and author of *Blog Wars*

"Michael Casey's notable history of how the Che Guevara brand was 'produced' by different creators has many readings. The most innovative may well be the one that explains how Fidel Castro and the Cuban Revolution used the myth and image of the Argentine revolutionary to disguise the conservative turn they took at almost the exact moment Guevara died. If Che had not existed, Casey suggests, Castro would have had to invent him."

—Jorge Castañeda, author of *Compañero: The Life and Death of Che Guevara*

Michael Casey

CHE'S

AFTERLIFE

MICHAEL CASEY is the Buenos Aires bureau chief for Dow Jones Newswires and a frequent correspondent for *The Wall Street Journal*. A native of Perth, Western Australia, he has worked in numerous other countries as a journalist, including Thailand, Indonesia, and the United States. He is a graduate of the University of Western Australia and has an MA from Cornell University. He is married with two children.

Dear Wilfredo, July 1, 2009
 NYC

I hope you enjoy

The book

All the best,

Michael Casey

CHE'S AFTERLIFE

The Legacy of an Image

MICHAEL CASEY

VINTAGE BOOKS

A Division of Random House, Inc.

New York

A VINTAGE BOOKS ORIGINAL, APRIL 2009

Copyright © 2009 by Michael Casey

All rights reserved. Published in the United States by Vintage Books,
a division of Random House, Inc., New York, and in Canada
by Random House of Canada Limited, Toronto.

Vintage and colophon are registered trademarks of Random House, Inc.

Illustration credits appear on pages 387–388.

Library of Congress Cataloging-in-Publication Data
Casey, Michael, 1967–
Che's afterlife : the legacy of an image / by Michael Casey.
p. cm.
Includes bibliographical references.
ISBN 978-0-307-27930-9
1. Korda, Alberto, 1928–2001. Che Guevara. 2. Guevara, Ernesto, 1928–1967—
Portraits. 3. Guevara, Ernesto, 1928–1967—Influence. I. Title.
F2849.22.G85C28128 2009
980.03'5092—dc22 2008032186

Author photograph © Josefina Tommasi
Book design by Jo Anne Metsch

www.vintagebooks.com

Printed in the United States of America
10 9 8 7 6 5 4 3 2 1

FOR ALICIA

CONTENTS

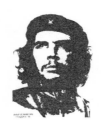

INTRODUCTION

The Eternal Tuk-Tuk Ride

Do I contradict myself? Very well, then, I contradict myself. I am large, I contain multitudes.
—Walt Whitman, *Song of Myself*

RAMBO, CHE, AND I were getting nowhere. Neither were the building worker and his elephant next to us. Like the other vehicles—rusty trucks laden with teak, buses jam-packed with schoolchildren, sleek BMWs whose tinted windows hid the city's shady nouveaux riches—my three-wheeled Tuk-Tuk taxi and the four-footed elephant were stuck in the gridlocked traffic of Din Daeng Road. My warrior companions glared at each other from the mud flaps attached to the chassis beneath me, while my English students twirled their pens and tapped their feet. Class would start late today, as would the job on a downtown construction site, which awaited the services of the great lumbering beast beside me.

Staying put meant enduring the incessant noise, the exhaust fumes, and the all-consuming humidity of the city's tropical air. But these were unavoidable mainstays of Bangkok in 1990. So too was the problem of running late. I was used to them. So I ignored the discomforts and took delight in my sharing a traffic jam with an elephant. Who back home would believe this?

I had come to Bangkok for a short visit, attracted by a passing interest in Thailand's unique culture. The six-week stay extended into a year, as I couldn't seem to get enough of its many oddly juxtaposed situations. I'd spot a saffron-robed monk wearing earphones or a traditional Thai "spirit house"—intended to keep the resident ghosts at bay—decked out as a mini-McDonald's. The bust of Rambo with the visage of Che Guevara on the back flap of a Tuk-Tuk, a vehicle so named for the sputtering sound of their two-stroke engines, was just another of these odd pairings. But it was an especially vexing one.

I could explain the burger joint for ghosts, the Walkman-wearing monk, the BMW idling by the elephant, all by-products of the clash between the old and the new in a rapidly changing city. As with the presence of two Western icons on the Tuk-Tuk, itself a long-lasting icon of Thailand, these were all signs that foreign modernity had come to coexist with Thai tradition. But what I, as a know-it-all twenty-two-year-old backpacker, failed to grasp was why Che, the most famous Marxist guerrilla of the Cold War, had ended up with Rambo, the Sylvester Stallone character whose vengeful victory over Vietnam's communists had thrilled American moviegoers. A hopeful declaration of peace, a wish for common ground between the United States and Cuba expressed 10,000 miles from Havana? Or was it a Taoist message, a yin and yang pairing of eternally interacting opposite forces?

Rambo's appearance was relatively easily explained: Both *Rambo: First Blood II* and *Rambo III* had recently been filmed on location in the country, and his picture generated a certain amount of national pride. But the long-dead Argentine revolutionary riding through Bangkok with him? That was a puzzle. Surely Che was turning in his grave, his image living out eternity on the back of a noisy vehicle full of bag-laden tourists in a fume-choked foreign city—all the while with his darkest enemy, an icon of anticommunism, just three feet away from him.

Here was one of history's most contested figures, now con-demned to a purgatorial existence. What a way to spend an after-life.

★

Through encounters with him in Europe, the United States, and Latin America, I would later realize that Ernesto Guevara, better known as Che, is living not just one surreal eternity, but thou-sands. With his beret askew, his wispy beard, and his piercing eyes staring intently into the distant horizon, Che is now every-where. In its common form as a two-tone abstraction of Alberto Korda's famous 1960 photograph, his image is simultaneously a potent symbol of resistance in the developing world, an anti-globalization banner, and a favored sales vehicle among globally engaged marketing executives. Korda's image has given Che what the Argentine-born revolutionary seemed to search for through-out his action-packed life: immortality. It gives true meaning to the popular slogan "Che Vive!" (Che Lives!)

Death—and how to cheat death—were constant themes dur-ing Guevara's flesh-and-blood life. For thirty-nine years, the leg-endary revolutionary and right-hand man to Fidel Castro defied his mortality countless times. As an infant in Argentina, Ernesto was brought to within an inch of his life by a severe bout of bronchial pneumonia; it left him chronically prone to a debilitat-ing form of asthma. He and travel partner Alberto Granado sur-vived hair-raising crashes on their motorcycle odyssey across South America, including a headlong run into a cow in Chile after their brakes snapped. In Guatemala, Che had to flee security forces intent on killing him. Later, after he left Mexico for Cuba with eighty-two of Castro's invaders on the overloaded *Granma* pleasure yacht, he was one of at most twenty-two survivors. (Offi-cially Cuban history puts the figure at twelve, a number filled with apostolic symbolism.) Over the course of the Cuban cam-

paign Che was shot three times—in the neck, in the foot, and across his chest—not to mention the time a medicine tin protected him from a bullet headed for his heart. And while he was participating in Cuba's defense against the Bay of Pigs invasion, Che's gun somehow discharged into his cheek.

On October 9, 1967, in a little Bolivian town called La Higuera, his luck finally ran out. There, the nervous, half-drunk Bolivian sergeant major who was sent to finish off the prisoner hesitated when he got face-to-face with his victim. "Shoot, coward, you are only going to kill a man," Che said, or so his assassin later claimed. Commander Guevara had ordered his own execution.

In the decade before then, news headlines frequently reported his death—erroneously, it turned out. These stories appeared during the Cuban civil war when the Batista government fed false information to foreign journalists. They resurfaced throughout the first four months of Che's clandestine Congo insurgency in 1965, when his sudden disappearance from Cuban public life gave rise to a colorful array of rumors. (The most common opinion was that Castro had him murdered for being pro-China.) And amid constant speculation over his whereabouts during his next failed campaign—this time in Bolivia—the Central Intelligence Agency prematurely pronounced Che's demise on at least one occasion.

Invariably, Che recovered from his mishaps to prove the reports of his death wrong, breeding an underground myth of immortality. Cuban *campesinos,* poor country folk, came to believe in him as their protector, a Christlike figure brought to deliver them to salvation. Like any good Marxist, Che disdained such religious superstitions. But that didn't stop people from wanting to believe he was blessed with godlike powers.

The myth of his divinity strengthened after his real death. Bolivian peasant women took locks from the hair of Che's corpse in the belief that these relics would protect them. One of count-

less pop art reproductions of the Korda print was the "Chesucristo," a rendering of Christ in Che's image, the Guerrillero Heroico with a crown of thorns or a halo. Even atheistic Marxists ascribed supernatural powers to his ghost when nearly all the Bolivian army officers involved in hunting him down died violent deaths in the years that followed. "Che is watching over us. He is our secular saint," wrote novelist Paco Ignacio Taibo II at the conclusion of his devotedly sympathetic biography of Guevara.

Che himself prophesied his own death and legacy in the final paragraphs of *The Motorcycle Diaries*, his 1953 account of the Latin American road trip he took the previous year as a twenty-three-year-old medical student. Ernesto ended the book with an "Afterthought," a passage in which a mysterious character appears to tell the young Guevara, "You will die with your fist clenched and your jaw tense, the perfect manifestation of hatred and struggle." Duly warned, Che concludes his story with a fiery pledge: "I brace my body, ready for combat, and prepare myself to be a sacred precinct within which the bestial howl of the victorious proletariat can resound with new vigor and new hope."

However, Ernesto could not have foreseen the kind of immortality he has today: an eternity determined by human, not divine, intervention. Political opportunism, the publishing industry, photography, silk-screening, pop art, graphic design, computers, the Internet, copyright laws, and consumer-marketing theories have all collaborated in the maintenance of Che's afterlife.

Of course Che is not the only famous person to live on in popular memory—society provides some form of posthumous earthly existence to anyone notable enough to be remembered. But Che's legacy is different from most celebrities'. His fame has not only been sustained by historians but has also constantly evolved on account of a single 1960 image that has taken on a kind of postmortem life of its own. Whereas the compelling events of his real life and the story of its violent end perpetuated his legacy, it took

the mass replication, reproduction, and marketing of the Korda photo to years later transform him into a pop superstar of immense iconic power.

To no small degree, Che's immortality reflects the versatility of the Korda image. The photo is at once an advertising tool for "tribal marketers" selling just about any consumer product imaginable and a lasting symbol of resistance to the capitalist system promoting such products. The image seems to resonate with this self-contained irony. *New York Times* columnist Thomas Friedman tells us that in order to prosper in the globalization era, people and institutions should act globally, be adaptable and durable, respond to decentralized decision-making, and above all, embrace change. That describes our twenty-first-century Che Guevara perfectly. Yet the contradictions contained in this posthumous engagement with global capitalism leave us with another question: Is there a core meaning at the heart of this image's lasting power, and if so, what is it?

Some seventeen years after leaving Bangkok, I found myself in a city where it is considerably harder to confuse Che with Rambo. The Korda image is all over Buenos Aires—for good historical reason: He was an Argentine and his country has a strong tradition of left-wing militancy. When Che appears in force here, the message is overtly political, no more so than during the annual March 24 rally in the Plaza de Mayo to commemorate Argentina's 1976 coup. At this event, Che dominates the landscape. And yet here, just as much as in Bangkok, his presence is intertwined with capitalist enterprise.

At the 2007 event, I watched a man with two bundles of polyester flags at the intersection of Avenida de Mayo and 9 de Julio, the center of the city's street grid, where participants gathered for the march to the plaza. He was doing a brisk trade. That year the

rally was blessed with a bright sunny day, which helped to boost the turnout—around 50,000, organizers said. For Fabian the flag salesman, it was a perfect day for business.

There were unemployed *piquetero* protesters, union leaders, and student activists, each affiliated with separate organizations identified by banners that stretched the width of Avenida de Mayo. There were *murga* dancers in shiny carnival costumes, fire breathers, clowns on stilts, and foam puppets of sinister-looking military men. As with every year, the center of the parade was reserved for its heroes, the now aging Mothers of the Plaza de Mayo, who were identifiable by their distinctive white head scarves. These were the women who thirty years earlier shamed the Dirty War generals with their weekly vigils in the city's central plaza. Everywhere, the faces of those and other mothers' lost children were visible on homemade T-shirts and posters, solemn memorials to the people who had "disappeared." In each case, the individual was now recognized—simply, poignantly—with a name and a date: "Hugo Miedan, 18-2-77," "Oscar Arturo Alfonso, 16-2-77," "Carlos Gustavo Cortinas, desaparecido 15 de abril de 1977."

It was a crowd of proud, angry faces, yet it was filled with a festive spirit. While a few with megaphones denounced *neoliberalismo* and *yanqui imperialistas*, their followers chanted militant songs with gusto, the lyrics and melodies melding into a confused mess. Accompanied by whistles, bugle blasts, and the incessant banging of drums, they produced an impressive cacophony, a chaotic but powerful show of defiance. And above it all, the flag salesman was somehow making himself heard: "Banderas! Banderas!" Flags! Flags!

Setting aside the stack of blue and white Argentine national flags at a customer's request, he reached into the better-selling Che banners, which displayed a basic stencil of the Korda image on a red square and the words "El Che Vive!" Another transac-

tion had been settled in the multimillion-dollar worldwide Che industry.

This industry, which now dictates Che's afterlife, reflects a world that's very different from the one Ernesto Guevara knew. Whereas Guevara placed himself firmly on one side of an ideological cold war and sought destruction of the capitalist system, Che's image is now a participant in that system. In some cases, Che sales are pushed by large multinationals, a practice that in recent years has prompted some high-level legal battles and fueled a wide-ranging struggle over the copyright to the Korda image. Yet most transactions occur at the street level, such as this one.

"How are sales?" I asked Fabian.

"Good. We do all the marches, and this one's very good. We'll sell at least a hundred flags today," he replied. The flag salesman explained that his family had been in this business for decades, supplying both political and sporting events.

"Are you a fan of Che personally?" I asked.

"Yes, he sells well."

"What does Che mean to you?"

"Well, the only representation we have of him comes from overseas. They've all taken him from us. But he was Argentine. We have El Che and El Maradona." He paused, and then he asked, "Are we done? Can you let me go and work?"

Fabian ran off. His customers needed him. The flags provided them with a means to participate, to express solidarity, to make a personal identity statement, or simply to celebrate. Similarly, Fabian needed them: He had money to make, food to put on the table. The market, in other words, was functioning: Supply was satisfying demand. This was a long way from socialism; no government was involved. In fact, it's unimaginable that the Argentine state—with a viewpoint on Che that has historically oscillated between ambivalence and paranoia—would be willing or able to

fill this need. Only free market capitalism could leave both parties satisfied.

The flag transaction was a microcosm of the global capitalist economy, a system that subsequently plunged into an identity crisis one and a half years later. The economic destruction wrought by the Wall Street debacle of 2008 blew a hole in what many assumed to be that system's defining tenet: that the market's self-correcting qualities—Adam Smith's idea of the invisible hand—will produce the optimal outcome for all. Paying dearly in the process, we've learned the limitations of a laissez-faire doctrine that was imbedded into U.S. economic policy amid the Reaganist triumphalism of the early post-Soviet era. For the first time since then, opponents of supply-side, free market economics can draw upon a powerful case study from inside capitalism's heartland. The recent crisis proved that markets in the real world do not always function as the idealized, self-correcting systems described in economic textbooks. It showed that prevailing inequalities—in wealth, in availability of credit, in education—are not merely moral concerns; they also facilitate monopolies over information and so breed dysfunctional markets and asset bubbles, which ultimately burst at great cost to all of us. Unless the government intervenes to address these imbalances, greed, fear, and folly—a trio with a long record of conspiring against the common interest—will always guide us into the kind of destructive, herdlike behavior seen before, during, and after the collapse of 2008.

But just as pure free market capitalism was always an unworkable idea, so too was pure communism. Sitting at either extreme of an ideological spectrum, each dogma occupies a fundamentalist position—more theology than science—attracting fanatics who treat it as an absolute truth. Both have hindered the development of an effective model, one that would encourage entrepreneurial innovation but within a regulatory framework that prevents self-interest from working against our common interest.

In denying such pragmatism, ideologues have constrained the space for constructive debate, making it harder to engender collective trust in our leaders and in the political system and its rules, without which no market—regulated or otherwise—can function properly. So, it would be a great pity if we were to let the pendulum swing too far back to the left and lose this once in a lifetime opportunity to establish some true middle ground.

The economic ideas of the far left are no less discredited now than they were when the Berlin Wall came down. Notwithstanding the differing degrees of state intervention in each country, market capitalism—imperfect, universally misunderstood, at once reviled and revered—is entrenched in our world, so much so that the term global *capitalist* economy is something of a tautology. To acknowledge the power of this system, we need only cite what happened in China and India, home to almost half the world's population, after they began dismantling the bureaucratic infrastructure of their planned-economy models: Income levels doubled in less than a decade, an achievement unheard of in human history. In fact, left-wing politics is so subordinate to the global capitalist system that it has itself become a tradable "product" within it. This is especially so with the symbols and imagery of the left—no more so than with the Che icon.

★

Capitalism has made Che what he is today: a brand, used for both commercial and political purposes. It has provided the means of production and the distribution channels for getting goods marked with the Korda image to consumers who identify with Che. It also provides the overarching context in which the image's political meaning is defined—positive for some, negative for others. The paradox is that to wield Che in an attack on that system, its critics must participate in it. They engage in the act of *consuming* Che.

This is not to deny the genuine intentions of those who strive to undo the inequities of the world in Che's name. Even before Wall Street imploded, the brief, violent history of the twenty-first century has made it painfully clear that the fundamental tensions underlying the Cold War were not resolved by having one ideology declare victory over the other. What has changed is that left and right are no longer arrayed against each other in defense of one of two alternative economic systems; they now compete within the framework of a single dominant one. Che-wearing activists might spout the language of Marxist revolution, but their actions—making Nike improve work conditions in its Indonesian sweatshops, inserting environmental protections into free trade agreements—are in effect a validation of that system. They seek a bigger chunk of its riches for the disadvantaged, not its destruction.

The way these post–Berlin Wall leftists achieve their goals is by marketing their ideas to the public. They compete with other interest groups trying to sell ideas into an information-loaded society. Whether social actors seek to convince TV viewers of the superior whitening power of a type of laundry detergent or lobby Congress for trade sanctions against Burma's military government, the success of their undertaking will largely depend on the resonance of their *brand*.

Political branding strategies need not be interpreted as a sell-out of principles. In fact, much as marketing strategists have observed with commercial brands, sustained success will only come to a political brand when there is a logical consistency between the underlying product and the advertising slogans, logos, and concepts attached to it. Barack Obama's critics tried to dismiss his 2008 electoral juggernaut as a marketing con job, but it is impossible to separate his policy proposals from his brand. Viewed as a product offering, Obama was a bundle of concrete ideas (on health care, taxes, foreign policy, and so forth) and

appealing values (symbolized in buzzwords like *hope* and *change*) mass-marketed via an unplanned alliance of grassroots activists and professional strategists—much as was Che, as we'll see. The "Change we can believe in" slogan, the youth-focused TV ads, Will.i.am's goose-bump-inducing "Yes we can" music video, and the Korda Che–inspired "Hope" and "Progress" posters of Shephard Fairey were not tricks for duping gullible voters; they were an integral part of a packaged whole, one that seamlessly merged concrete ideas and emotional appeal. Like any successful brand, Obama sold well because Americans—the entire world, in fact—wanted to consume every part of that package, not just its dry policy elements. His brand made people *feel* better and since that's the best antidote we have for the fear, cynicism, and apathy that lie at the heart of our current economic and physical insecurity, it's a policy objective in itself.

With the relentless advance of communications technology, consumers are increasingly bombarded with information. That fuels a ferocious competition for their money, attention spans, and information-processing capability. Images, more than anything—logos, slogans, symbols, pictures—become the most effective way to compete in this noisy, chaotic environment. They help the messenger stand out in the crowd and reduce a complex body of information into a simplified concept, an easily digested repository of values and meaning. Herein lies the post–Cold War function of the Che brand and logo, the Korda image: an attempt to be recognized, heard, and understood in an image-saturated world.

★

How this brand evolved and became embedded in global consciousness is what interested me from the start of this project. Since it is a political brand, I wanted to examine how the major events of the past half century have shaped this process. When I set out to investigate this, to determine how an image captured

in Cuba in 1960 had ridden the cult of a dead Argentine revolutionary to the far corners of the world, I anticipated a task like other journalistic endeavors I'd undertaken, only longer. I would research written and other archival material, travel and talk to people, and then, with the facts at hand, lay my findings down in a more or less conclusive document.

I had no idea what I was in for.

Everywhere I turned, it seemed, myths were presented as fact. This was the case whether my source revered Che or hated him. Clearly, the truth lay elsewhere. But the problem is that discovering that one part of the historical record doesn't jibe with another is no assurance that you will locate an objective truth in the middle.

At first the elusiveness of the truth in the Che myth was frustrating. Then it became clear that my goal should be to somehow capture this "truthlessness." I can now come out and say it: There is no single, final story of the Che icon. There are many, indeed millions of different stories. And together they define it. Popular icons are by definition social constructs, which means they assimilate a range of inevitably contradictory ideas. And since Che is one of the most contested and politicized of all popular icons, the range of ideas contained within it is very broad indeed.

I soon realized I would never have the time or resources to investigate and verify all these myths, versions of the truth, varying accounts, and competing narratives. But what, in any case, would be the point of doing so? The truth about the Che icon, wherever it lies, can exist only in such a way that it incorporates and reflects the great variety of these stories. This is not to say that self-serving lies haven't been told in the construction of it— there are plenty on either side of the Florida Strait. But to deny one version of Che in favor of the other would be to exclude part of the whole.

This book contains a mere sprinkling of these stories; it cannot

claim to be a definitive account of what the icon represents. But the characters behind them make for a colorful and varied cast. We will meet them as we travel from Cuba, where the icon or "brand" of Che is defined, manufactured, and refashioned over time, to other parts of the physical and cyberspace world, where it is consumed and reinterpreted. Along the way, the influence of some key players will become apparent. Two of the three leading personalities in the story, Che Guevara himself and Fidel Castro, loom large not only in the history of the icon but also in the history of the world over the past fifty years. The third, Alberto Korda, though not as well known, played a critical role in documenting that history. Alongside these characters, the narrative also counts on an ever-present foil figure, an "other" against which Che's image is contrasted. Sometimes this character, known formally as the United States of America, takes on human form, as it did with CIA agent Félix Rodríguez. (His souvenir snapshot in La Higuera before Che's death left a "U.S.A. Was Here" stamp on the photographic record.) Most often, it is faceless. It sponsors coups and covert operations; it blockades its enemies' economies and it runs the International Monetary Fund (IMF) and other institutions demonized by the left. Yet, at least not until the economic contraction at the end of 2008, it has also been the principle engine behind a global market economy in which a stream of daily transactions in Che-brand products sustains and defines the icon.

The second-tier characters—including, for example, French philosopher Jean-Paul Sartre and millionaire Italian publisher Giangiacomo Feltrinelli—play vital roles. They interpret and then translate the *idea* of Che, taking it out of its original Latin American revolutionary context and giving it a more universally appealing form. Cultural output from this surprisingly interconnected group of photographers, artists, graphic designers, writers,

musicians, and filmmakers helps fuel the icon's popularity and carries it into the world.

The lives of these central participants have an uncanny effect of weaving in and out of one another within the overarching narrative, almost leaving the impression that this phenomenon is solely the work of an elite cabal. But while evidence of political intent is clearly present in the development and the promotion of the Che icon, it is just one part of the story. Millions of ordinary souls have invested emotion and energy into it, people with little access to the levers of power or to the forces that drive popular culture.

Western commentators tend to place such people—certainly those on the pro-Che side—outside the mainstream. But that's precisely what makes them influential. The mainstream does not spearhead change. The revolutionaries behind all new technological, social, and cultural ideas—from entrepreneurs such as Apple's Steve Jobs to political actors such as Che—approach their subjects from the margins, the only place from which it's possible to see things differently. The often eccentric but mostly well-meaning people who have helped build the cult of Che come from the same place. They are among the select few charged with writing human history, our history.

★

So in the end this is not a book about Che Guevara; it is a book about us. It is about what we—society in general—have created as Che. The icon is a repository for the collective pool of dreams, fears, beliefs, doubts, and desires that makes up the human condition. The true mark of Che's durability throughout his tumultuous afterlife is that his icon has somehow been able to reconcile all these demands. Che functions as the *site* of a long-running bitter conflict, one that preceded his death and now succeeds it.

This conflict is sustained by either side's steadfast commitment to its own definitions of justice, liberty, equality, fairness, etc. It's a debate that societies, political systems, and religions have tried to resolve for centuries without success. And whereas the convictions we all hold on these matters might simply reflect the reality of our material or social circumstances, the stories we use to explain them are often imbued with the more romantic and profound language of morality. Many of us conceive of our politics in spiritual terms.

In fact, the idea of a "spirit" comes up a lot in the stories people tell of what Che means to them. Mostly this concept is addressed by his fans, but in remarkably varied ways. We've already met the Ghost of Che, the vengeful specter that haunted Bolivian military officers. Less known is the guardian angel Che that leftist guerrillas thought was protecting them during the Central American insurgencies of the 1980s. (Ironically, Guevara saw such superstitions as an impediment to revolution. He was dismayed by his co-combatants' claims in the Congo that *dawa* medicine made them impervious to bullets.)

But his spirit is not just found in combat. I learned this from Nelson Tupac Amaru Salgado Paredes, a Bolivian I met in La Higuera who told me that before I gulped down my glass of *chicha,* a cloudy yellow corn liquor, I should pour two drops into the dirt: one for the Pachamama, the Andean fertility goddess; the other for Che. Shortly afterward, Irma Rosado, the shop owner who'd plied us with the *chicha,* told me about San Ernesto, to whom she had been praying for four decades, ever since the prisoner in her town's mud-brick schoolhouse had mesmerized her with his "beautiful eyes." I later found Nelson's and Irma's spirits synthesized in the words of a Havana painter called Panchito, who told me he'd once done a piece showing Che with an open chest from which emerged "all the saints and angels of every

religion," a comment, he said, on the revolutionary's "ecumenical spirit."

Fertility gods, saints, and angels aren't part of the lexicon of Stuart Munckton, a student activist I met at a "Marxist Summer Camp" at Sydney University. Nonetheless, he speaks of Che's "spirit of rebellion," which he hopes will inspire Australian unionists to oppose employer-friendly wage reforms. Argentine composer Armando Krieger gets closer to his hero's own wording when he explains that his new opera, which is simply entitled *Che,* lauds the "revolutionary spirit" that sustains the left's eternal struggle for social justice. Alternatively, Ricardo Brizuela, who developed a tourism attraction at the Guevara family's first home in northern Argentina, says what his country most needs is to embrace Che's "entrepreneurial spirit." For the time being, an unemployed *piquetero* protester I met in Buenos Aires has more modest expectations. The face on the banner above his head, he told me, is the "spirit that makes me get up in the morning."

Spirit is a wonderfully malleable word. Christians believe in *the* Holy Spirit, but they also generalize about any religious or metaphysical experience as being "spiritual." Actors or sportsmen are said to put in "spirited" performances, just as someone who endures difficulty "has spirit." It's the je ne sais quoi of life, a force that drives human achievement, makes big things happen, and helps us overcome impossible odds. Spirit also exists in social settings and can be passed from one person to another. It seems to have been there at every moment of abrupt social change.

Sociologists, anthropologists, marketing strategists, investment analysts, theologians, poets, and journalists have all tried to explain what makes trends happen or ideas spread; this book will draw on their accumulated knowledge. Yet we still observe with wide-eyed wonder the speed with which some things take off, whether it's the simultaneous collapse of Eastern Europe's social-

ist regimes in 1989 or the sudden appearance of low-cut jeans on every teenager's hips. We understand the role played by the media and those who use it—advertisers, fashion editors, political commentators, and so forth—but this merely deals with the infrastructure that carries an idea, not with the force behind it. At such moments we grasp for language that's metaphorical but imprecise: We talk of the boiling *energy* in a rioting crowd or the joyous *mood* at a victory celebration. These words acknowledge that collective behavior is driven by an ill-defined common force, one that stems from within the individual but is shared by the group. Is this not *spirit*?

The word thus offers a useful tool for exploring the Che phenomenon. It helps us conceive of the social force spreading the Korda image around the world and converting it into a political and commercial brand. Using it in this context, I deliberately eschew moral connotations. After all, the same spirit concept can equally apply to Nazi Germany as to the global popularity of Bob Marley. Like the cult of Che, both owe their rapid expansion to charismatic figures whose core values appealed to their followers. And just like Korda's Che, the symbolic imagery was instrumental in each case: the swastika, the Rastafarian dreadlocks.

But it would be wrong to suggest that the frequent references to the "Spirit of Che" are not founded in strongly held moral beliefs, ideas that must also be examined if we are to grasp the power of the icon. Che's spirit is invoked so fervently by the left and attacked so virulently by the right because each side frames the conflict around a battle between good and evil, one with roots planted deeply in human history. This is why the various myths of Che have narrative structures common to tales of heroism throughout history. They are drawn from the same source that feeds the Greek epics, Shakespeare's plays, and the stories of the Bible.

This is perhaps the best way to understand the seemingly inex-

plicable pairing of Che and Rambo in Bangkok. Both mud-flap images trace their existence to these same universal myths and to the good-versus-evil battle contained within them. Rambo's vengeful return to Vietnam is a classic tale of American redemption. Yet at the end of the day, it follows the same essential script as the story of Che: A brave, noble warrior single-handedly takes on an evil force to strike a blow in the name of justice. Neither Rambo nor Che destroys his enemy, but they both claim the most important victory of all: the moral victory. Their juxtaposition in the exhaust-choked streets of the Thai capital was far more profound than I first thought.

PART I

BECOMING EL CHE

The Making of a Global Brand

HAVANA, MAY 5, 1960

A Frozen Millisecond

Sometimes I get to places just when God's ready to have somebody click the shutter.

—Ansel Adams, photographer

EARLY ON MARCH 4, 1960, two massive explosions ripped through the French freighter *La Coubre* while it was docked in Havana's harbor with a load of Belgian weapons in its cargo hold. At least seventy-six people died, and several hundred more were injured. Cuban leader Fidel Castro immediately accused the U.S. Central Intelligence Agency of sabotage. (The exact cause remains a mystery, but Cuba maintains to this day that it was an act of terrorism.) Parallels were drawn to an explosion decades earlier whose cause was never proven, one that also sunk a foreign ship berthed in Havana: the USS *Maine*. The events triggered by that 1898 blast led the United States to declare war on Cuba's Spanish rulers. Now, sixty-two years later, many feared the tragedy of *La Coubre* would have a similar catalytic effect.

Castro staged a state funeral the following day, an event that attracted a massive throng of mourners. There he tapped his countrymen's nationalist sentiments. "Patria o muerte! Vencere-

mos!" Castro bellowed. *My homeland or death! We will win!* This rousing call to arms would become one of the Cuban revolution's most enduring slogans. On March 5, 1960, it set the tone for an escalation in conflict with the United States.

The day of the funeral was unseasonably cold, even to the point of being chilly, and the sky was overcast. Yet for one group of Cubans whose presence mattered a lot to the image-conscious Castro, the conditions were fortuitous. The self-described "Epic Revolutionary" photographers, a recent addition to the leader's growing entourage, would find that the gray conditions lent the event an evocative, funereal light.

Among them was Alberto Díaz Gutiérrez, a Porsche-driving fashion photographer turned photojournalist. On contract to *Revolución,* the flagship newspaper of Castro's 26th of July Movement, he was the nearest thing his intellectual editors had to a paparazzo. Díaz Gutiérrez, known as Korda, was in position on the corner of 23rd and 12th streets among the multitude. His eyes were at the level of the platform set up on a flatbed truck in front of Havana's stately Colón cemetery. As the Cuban leader launched into his bombast, Korda snapped shots of the celebrities in attendance, his back to a massive crowd that was by now stretching down the two intersecting streets. He got a few of Castro midtirade, with a sampling of the Cuban leader's theatrical facial expressions and hand gestures, and a couple of a pensive-looking Antonio Núñez Jiménez, the geographer and soldier whose impressively long and thick beard lent him the aura of a Victorian-era professor. Most important, he was careful to get a whole series of two special foreign guests whose visit to revolutionary Cuba he'd been assigned to follow: the French philosophers Jean-Paul Sartre and Simone de Beauvoir. Days earlier, he'd taken shots of them locked in an animated discussion that went into the wee hours of the morning with Cuba's young, French-speaking central bank president: an Argentine who'd impressed

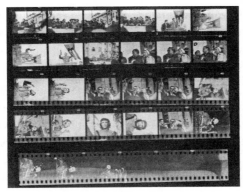

Korda's contact sheet, March 5, 1960.

them immensely with his intelligence and energy. Here, however, at a memorial to a tragedy in which the dead included six of their countrymen, Korda captured the pair of French intellectuals in an appropriately somber mood.

Then someone else appeared in his viewfinder. It was the central bank president, who was standing a little off to the side of Castro. Braced against the cold, the man was dressed in a leather bomber jacket zippered to the collar, and he wore his trademark beret on his head. Before sitting, he paused, an unsettled sky behind him, and looked out intently across the crowd. Little did he know, he was staring straight into the firing line of Korda's trusty Leica camera.

The photographer depressed the trigger. Light rays, dim as they were on that cloudy day, bounced off the features of his subject and then raced through the lens and the open shutter. When it landed on the Kodak Plus-X film on the other side, it caused a chemical reaction among the tiny silver halide crystals embedded in the celluloid. A millisecond of time in a tiny part of our ever-changing universe had been frozen for eternity. Korda then turned his camera on its side and captured a subtly different image. Then the man sat down. The moment passed.

The first frozen millisecond, manifest as a striking photograph of Ernesto "Che" Guevara de la Serna, would eventually take the world by storm. Some in Cuba would see it a year later, in a context greatly removed from the events from which it arose. But it was almost a full decade before most people knew of its existence. To some extent, this long delay between the taking of the photograph and the image's entry into public view is attributable to the appeal of the other celebrities in attendance that day. Thanks to Castro, whose provocative and history-making speech assured him of front-page press, and the two French intellectual tourists, who were superstars in the eyes of a young government eager for intellectual legitimacy, Che didn't appear in the next day's papers.

Ironically, this also-ran status ultimately worked in the photo's favor, at least in terms of its effect on the world. The delay meant that the image, years later dubbed "Guerrillero Heroico" (Heroic Guerrilla), enjoyed a perfectly timed global launch in late 1967. At that moment, a generation of strong-willed youth was rising up in rebellion across the industrialized West, while their contemporaries in the third world were taking up arms in the hope of replicating Cuba's revolution. With its sudden appearance on the world stage at that time, Korda's image became the defining icon of that generation.

Almost half a century since he captured it, Korda's frozen moment is etched into the consciousness of our global society. Some say that only the famous photograph of Marilyn Monroe, her skirt rising as she stands over a subway grate, has been more reproduced—and that may be so in terms of official reprints. But Marilyn hasn't traveled like Che has. With Korda's image as his vehicle, he has gone to the far corners of the earth. Anyone who's tried to track the multiple and varying representations of the

Korda image—the vast bulk of them done as unauthorized, sten-
ciled copies that escape the bounds of any official count—knows
that Che beats Marilyn hands down. That same captured milli-
second now travels the world's supply routes, stamped on myriad
consumer knickknacks. At TheCheStore.com, offerings include
T-shirts, pants, caps, bandannas, lighters, key chains, coffee mugs,
wallets, and backpacks, all bearing a reproduction of the Korda
classic. The image has been used to sell car air fresheners in Peru,
snowboards in Switzerland, beer in Korea, and wine in Italy. It has
appeared on advertisements for consumer brands such as Smir-
noff vodka and Converse sneakers and in a campaign by a British
church group equating Christ with revolution. Australian ice
cream maker Magnum used it on the wrapper of its Cherry Gue-
vara line, which described the eating experience in this way: "The
revolutionary struggle of the cherries was squashed as they were
trapped between two layers of chocolate. May their memory live
on in your mouth!" Sometimes it appears as a subtle nod to the
original, such as in the beret worn by a suave, wavy-haired young
man surrounded by bikini-clad girls in a Mexican billboard ad that
urges tipplers to "Chemix" their drinks with Torres brandy. But its
most common usage is in a generic two-tone format, the same one
found on mouse pads, doormats, beach towels, cigarette cases,
condoms, lip balm, hair combs . . . The list goes on and on and on.

 The image frequently makes the rounds of the fashion and
celebrity scenes. Taking the form of a pastel-colored Che bikini,
it has sashayed down a São Paulo catwalk on the curvaceous body
of supermodel Gisele Bündchen. It subtly appeared on a cover of
Rolling Stone, where Johnny Depp sported it on a necklace. It
was spotted on a T-shirt worn by actress Liz Hurley during a night
of club-hopping in London. (Hurley chose to accessorize her look
with a Louis Vuitton handbag, the *Miami New Times* reported.)
And it lives permanently in the form of a rough ink profile on the
tattooed torsos of such bad-boy sport stars as boxer Mike Tyson

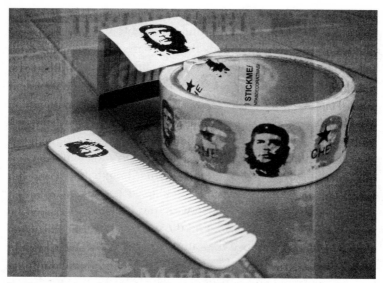

Products designed by Jimena Chague and Soledad Calvano of
Stickme.com.ar, Argentina.

and Argentine soccer legend Diego Maradona. Meanwhile, Al
Saadi Mootsam, the playboy son of Libyan leader Muammar al-
Gaddafi, is the owner of what is quite likely the most expensive
item bearing the Korda image: his ninety-foot luxury yacht, the
Che Guevara II, has the image on its bow.

It's impossible to overlook the irony: the commoditization
of an anticapitalist rebel who opposed all that his hyper-
commercialized image now represents. But despite the conver-
sion of Che into what political commentator Alvaro Vargas Llosa
describes as the "quintessential capitalist brand" and the fact that
most young Americans know him only as a T-shirt logo, for mil-
lions more around the world the Korda image remains a powerful
indicator of rebellion and resistance. The twenty-first-century,
media-friendly "Che"—a multipurpose banner flown by a wide
range of political causes—is a long way from the idealistic Che of

the 1960s, he who believed a Marxist utopia could be attained through self-sacrifice and guerrilla warfare. Yet everywhere, people living lives nothing like Che's are drawn to the Korda image. It is instantly recognizable, identifying the wearer as someone outside the conservative mainstream.

This is especially so in Che's old stomping ground. Amid a resurgence in populism and left-wing politics throughout Latin America, Korda's snapshot is again the symbol of choice wherever regional activists give the middle finger to the U.S.-backed free market system. In Latin America the symbolic battle between left and right now effectively boils down to Che versus Uncle Sam— or in the wider globalization debate, Che versus the golden arches of McDonald's. It is spray-painted onto walls across the continent, both as large, colorful murals and as rudimentary graffiti, and it is the model for folksy statues on university campuses. It is on a lectern used by Bolivia's new socialist president Evo Morales as he announces the nationalization of foreign oil companies' gas reserves. Draped from the second tier of an Argentine soccer stadium jammed with left-wing activists, it offers a striking prop for Venezuelan president Hugo Chávez as he lists the evils of free trade at a "People's Summit" in Mar del Plata. (The massive banner is a de facto snub to Chávez's nemesis, George W. Bush, who is attending an official Summit of the Americas a few miles away.) And when Colombian government soldiers infiltrate FARC-run camps to free Ingrid Betancourt from her leftist guerrilla captors, some of the undercover operatives don Che T-shirts. (The disguise works: No one doubts the rescuers' rebel bona fides.)

In fact, wherever young people rise up, Korda's Che is there, crossing religious, ethnic, and even political divides with abandon. Islamic Iranian students displayed it when they ousted the shah in 1979, and it has figured prominently in Palestinian intifadas. And yet young Israeli fans of Jerusalem-based soccer team Hapoel also embrace Che as a symbol, as do U.S.-backed Christian rebels

in Sudan who are fighting a Muslim regime. Che was prominent among socialist antimonarchists in Nepal and the Portuguese-backed guerrillas of East Timor, who modeled their struggle against Indonesian occupation on Castro and Che's Cuban campaign—right down to the beards. He continues to inspire those with both peaceful and violent agendas throughout the world: antiglobalization crusaders, antiwar protesters, gay rights activists, environmentalists, and indigenous and immigrants' rights groups—they all wear Che.

★

How did this frozen millisecond become so powerful? How was it filled with meaning and then repeatedly emptied and refilled again with new meanings? How was it transformed into a universally recognized and bitterly contested icon? What does its popularity say about the society that created it?

One simple answer is that it's a sexy photo of a sexy guy. It's true: Linking rebellion and sex has always sold well. Look at Elvis, the Beatles, or—most relevant to the Che comparison—James Dean, another "rebel" who died young and left a pretty poster. Che was the ultimate alpha male: good-looking, intelligent, and phenomenally tough. He is a model for anyone who dreams of striking back against a cruel and unjust world. He sells.

But the fact that Che looks or seems hip—however that's defined—is an inadequate answer. The Che phenomenon goes far deeper than commercialized sexiness. If it had been nothing more than the superficial packaging of chic rebellion, the mass marketing of the image would have milked it dry years ago, killing its appeal. Witness the demise of grunge or indie rock once the major record labels co-opted them under the contrived label of alternative music. And who these days believes tattoos or body piercing are proof of a rebellious spirit?

As Naomi Klein, the bestselling author of *No Logo,* notes, Che

is different. He is among a select set of counterculture symbols so deeply rooted in political struggle that they can survive appropriation by corporate marketers. The resilience of the Che cult and its dominant icon, the Korda image, lies in the political reality that gave it life in the first place, not in the stylistic interpretations advertisers later gave to it. To comprehend the phenomenon, we must examine the social, cultural, and political forces behind it.

<p style="text-align:center">★</p>

Amid the rampant commercialization of Che's image, it's tempting to downplay the significance of the man himself. But if Che's rich and fascinating life had not come to a violent end at an epochal moment, Korda's photo would be an eye-catching and memorable portrait of a bygone public figure, but not a ubiquitous global symbol. And yet it's also true that without the photo, Che would be recognized as a significant historical figure, a prominent inductee to the ideological left's pantheon of heroes, but he'd hardly have become *the* hero.

These two parts of Che's public image mutually reinforce each other, driving a process that separates Ernesto Guevara from his flesh-and-blood self. When Spanish speakers refer to him as *El* Che, it helps distinguish him from the Argentine slang word *ché*, from which his nickname is derived. But the definite article also has the effect of objectifying him, detaching the idol from the historical person. No longer a man, Che is now a subject of quasi-religious adoration for many.

A somewhat different process has occurred in the West, where the image is now more powerful than the story behind it. Korda's image has so infiltrated public consciousness that many know the face but not the man. (Asked to name him, many people often cite the guy on the T-shirt as a rock singer or a hippie artist from the 1960s.) In such cases, the Korda image itself is an icon in its

own right, quite separate from the concept "Che Guevara." In this way, Korda's photo has simultaneously given Che an afterlife and robbed him of it.

So the sexy photo *does* matter. But why this one? With his photogenic looks, his penchant for provocative gestures, and his high-profile international status, Guevara was a magnet for press photographers. Why did the icon emerge from this photo and not from one of the countless other Che moments captured by the world's media?

For starters, Korda's Guerrillero Heroico is not really a press photo. Technically, it's classified as photojournalism in that the picture comes from a random moment captured at a news event and was intended for mass media publication. But it is better defined as art. There is a timeless quality to the photo, especially so because Korda ruthlessly cropped it. He did away with a palm tree that was visible to the right of Che and the profile of a colleague standing to the left. Che's torso floats mystically in a windswept, cloudy sky, removed from the historical moment in which it had originally appeared.

Undoing Korda's cropping makes for some interesting discoveries. The man whose nose, brow, and eyes protrude into the left of the frame was only recently identified by Italian publisher and researcher Roberto Massari, who pinned him as the journalist and onetime guerrilla Jorge Masetti. Fittingly, that means that the two secondary images flanking Che on either side of the original photo link him to the two countries at the core of his identity. The palm tree, of course, gives us Cuba; Masetti, Argentina. The journalist had come to Cuba early in the civil war to interview his compatriot in the Sierra Maestra and from then on became an active participant in the Cuban revolution. He went on to found the Cuban news agency Prensa Latina but then gave up journalism to launch a guerrilla campaign in a remote part of northern Argentina in 1964. The operation, which Che directed from Cuba, was a com-

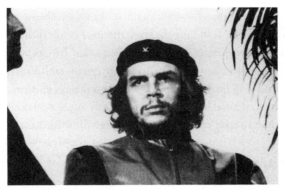

Ernesto "Che" Guevara (original version, uncropped),
Havana, March 5, 1960. Photo by Alberto Korda.

plete disaster. Most of the men died. Masetti's body disappeared
completely.

The story of the superfluous nose doesn't end there, either.
Masetti's son, also named Jorge, followed in his father's footsteps,
joining ill-fated guerrilla outfits in Argentina and other Latin
American countries in the 1970s and '80s and working as a spy for

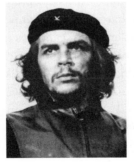

Guerrillero Heroico (cropped version),
Havana, March 5, 1960. Photo by Alberto
Korda.

Cuban intelligence. In 1989, however, the younger Masetti defected from Cuba in disgust after the execution of his father-in-law, Colonel Antonio de la Guardia, on what he and many independent observers say were trumped-up drug-trafficking charges aimed at purging dissidents from the armed forces. These days he lives in Paris, where he works closely with another exiled descendant of one of the two Argentine guerrillas in Korda's photo: Canek Sánchez Guevara, Che's grandson. Together they have put together a book describing the failure of the Cuban revolution and the exploitation of the Che myth.

All this juicy interconnected history can't be traced back to the publicly known, cropped version of the Guerrillero Heroico photo, the power of which has little to do with the historical moment itself. That makes it different from most other iconic news photos, the kind that win Pulitzer prizes, which are recognized for commemorating specific events at important moments: the GIs raising the Stars and Stripes at Iwo Jima, the naked Vietnamese girl fleeing a napalm bomb, the fireball atop the World Trade Center. By contrast, Korda's Che could be anywhere at any time. Very few people, even those who can name the face in the photo, know where Che was when it was taken. But the events described in the opening of this chapter are secondary to the photo; they are not what make it a compelling image. Much of Guerrillero Heroico's depth of meaning is contained in the image itself, in its artistic qualities.

The most captivating feature of Korda's photo is Che's eyes. Che's piercing gaze gives the image its power as a timeless work of art. Variously described as pensive, serene, determined, defiant, meditative, or implacable, his expression is—like the Mona Lisa's smile—difficult to put a finger on. It contains what French philosopher Roland Barthes, Sartre's contemporary and a fellow indulger in melancholia, once described as the *punctum* of a powerful photograph, its "sting, speck, cut, little hole . . . that acci-

dent which pricks me, . . . bruises me, is poignant to me." Che's eyes appear to be looking right through us, as if he is focused on some far-off horizon with its promise of a future utopia. In fact, this kind of distant gaze is a feature of many popular portraits of leader figures, says University of Kansas historian David Perlmutter, an expert in photographic icons. "Among the qualities of great leaders that historians tend to talk about is of their having a far vision, the idea that they see things on the horizon that we can't see," Perlmutter says. "So their images tend to be looking past us; they are looking at something beyond us that only they, because of their mystical sense, can see. That's something very primordial. It probably goes back to the caves, the idea that we should make Joe the caveman our leader because he just seems to know where the mammoths are."

Nonetheless, Che and his cult are real products of history. So it's useful to relocate the image, including that piercing look, to its historical moment. What do we find when we restore Jorge Masetti's nose and the forgotten palm tree into the picture? What happens if we imagine ourselves as Korda and take our eye away from the viewfinder to survey the scene: the crowd to our back, the bearded speaker with his jugular vein bulging? There, outside the frame of the lens, where the line between art and documentary is drawn, we grasp a different, objective reality, which was erased in the subjective act of pressing the trigger. In this case, what was lost was a moment of great significance, one that stirred the soul of a person who dreamed of world revolution.

The events leading to this fateful moment had been shocking. There'd been a massive loss of life: Hundreds of Cubans had hours earlier suffered the wrenching pain that comes with the waking mind's first conscious thought the morning after a loved one is taken. The blast in the harbor had abruptly suppressed the innocent joy of a nation that had believed the prior year's revolution marked an end to Cuba's relentless cycle of violence. And

Che, who'd rushed to the scene of the first explosion and had personally witnessed the destructive power of the second, could not have harbored doubts about who, or what, was to blame for it. Che would have subscribed to the conventional wisdom of the day. He would have felt certain that the explosion was the handiwork of the United States, the embodiment of imperialistic evil, his sworn enemy against which he would fight to the death. No wonder Korda described Che's look as "angry and grieved." It was the face of Ernesto Guevara mad as hell and eager to avenge bloodshed, yet also aware of the immense heartache associated with the struggle he'd chosen for his life.

We even have a scientific measure of Che's expression, courtesy of University of Amsterdam researcher Nicu Sebe, who recently applied an "affective computing" technique for reading people's emotions to portraits of famous figures. (Sebe claimed to have solved the Mona Lisa mystery: She was 93 percent happy and 7 percent disgusted.) When his computer analyzed Korda's first horizontal photo, its conclusions threw some cold water on the myth of the steely, defiant Che, but it did confirm he had a sensitive side. Sebe found that the Guerrillero Heroico was 52 percent sad, 41 percent neutral, and 5 percent surprised. Che registered neither happiness nor disgust, but he was a bit angry (1 percent) and even mildly fearful (1 percent).

Sebe also analyzed the second photo Korda took of Che just seconds after his first. This photo is almost identical to the first but was taken in a vertical frame and contains a subtle but perceptible shift in Che's look, which seems slightly more focused on the horizon and a little more resolute. The photographer actually preferred this second, less-known photo, according to his daughter Diana Díaz López, because it made Che's expression seem more intense. (The only reason it lost out to the other shot was because the perfectionist Korda couldn't accept the presence of an intruder: The back of a man's head was visible above Che's

right shoulder.) Sure enough, when Sebe ran this second version through his computer he found that the Guerrillero Heroico was in that case just shy of 50 percent disgusted and 45 percent angry. Perhaps this proves nothing more than the software doesn't work: After all, how can someone's mood change so dramatically in a matter of seconds without apparent provocation? On the other hand, perhaps Che's mood did change as he stood there contemplating the scene. Maybe Castro said something in the interim that touched a nerve. Maybe Che saw something in the crowd.

Computers are one thing, but we humans see all sorts of stuff in Korda's Che. Anger, defiance, sadness, hope, determination: They all seem present to us now. (And here, I'm referring to both versions. Few people are aware there are two or would recognize the difference.) In this way, Che's expression crystallizes the essence of a complicated person, one in whom a firm belief that human beings can together reform an unjust world shared space with a capacity for vengeance and violence. This is what makes Korda's photo one of the greatest ever taken. It documents the moment but, like many timeless pictures, also captures a deeper aspect of its subject and that subject's place in history.

Thanks partly to the dim light on that gloomy day and partly to the fact that Che wore a flat-edged beret, not a shadow-casting cap or a wide-brimmed hat, his face is neither overly exposed nor dark in spots. The result is a pattern of strongly contrasting dark and light tones that clearly delineate the contours of his face: the eyes and eyebrows, the left ridge of his nose, the nostrils, the mustache, and the closed mouth and strong chin. With these basic elements, the picture is both complete and instantly recognizable. (Argentine design firm NoBrand has even produced a catchy Che T-shirt that does away with the beret and hair altogether but that is made unmistakable by a floating star and a few basic lines for the eyes, eyebrows, nose, mouth, and mustache.) These two-tone contours from the original image create the tem-

NoBrand's Che

plate for the reproductions that flow from it, the outline for sten-
cils that are then used in silk screens or spray-painted graffiti. In
the digital terminology of our age, they are the binary code of
Che's universally recognized face.

UCLA art historian David Kunzle, one of the world's leading
authorities on the Korda image, has identified in it other features
that a less-trained eye might not notice. The photo contains
"aesthetic magnets," Kunzle points out—namely, the hair, the
beard, and the star on Che's beret. These steer the eyes' attention
but also provide reference points for derivative art, facilitating
the image's mass reproduction as a two-tone icon and a plethora

of abstract interpretations, works that transform "El Che" into "a Che."

Paintings and posters in the Cuban tradition of caricature art often exaggerate Che's hair and wispy beard, for example, accentuating their symbolic value. Here, "Che's beard becomes . . . a deep, resonant shadow below, while joining with the copious head of hair to fan out in decorative, electric wanton wisps: a map, a landscape, the contour of an amazing revolutionary itinerary," Kunzle says. In some works the facial hair is reconstructed from a collage of secondary images that's lifted out of different cultural contexts, an expression of the broader humanity in which, many say, the Spirit of Che resides.

Then there's the comandante's star affixed to the beret, the sole signifier of the Cuban rebel army's highest military rank. It is a beacon. One can imagine it flashing, which is precisely what some artists have made it do. There are paintings and posters— again, many of them Cuban—in which the star comes to life, emitting beams of light or floating heavenward away from Che's head. Today we see T-shirts that just show a star and Che's signature; even with such a minimalist abstraction, the link to the Korda image is clear. Che wore the star-adorned beret in countless other photos, but it is Korda's photo that established the symbolism of El Comandante's star. The same goes for the beret itself. While this form of headwear still means "Frenchman" on the head of a Parisian, or "crack commando" when it is green and worn by a member of the U.S. Army Special Forces, it now means "rebel" or "anti-imperialist" in other contexts. It becomes far less politically charged, however, when affixed to some fake black hair to become a party gag: a Che Guevara wig made in China, available in flea markets in Buenos Aires.

Susan Smith Nash of Excelsior University demonstrates the great versatility of Che's beret in its political and pop culture

Silk screen, Raúl Martínez. Collection of El Museo Nacional de Bella Artes, Havana.

La Boina del Che (Che's Beret), Rubén Alpízar and Reinerio Tamayo.

manifestations. This wandering piece of headwear, Nash notes, goes first from Che to Haydée Tamara Bunke, the mysterious East German–born agent known as Tania who died with him in Bolivia, and then quickly jumps to the head of Faye Dunaway, who plays a rebel bank robber in the 1967 film *Bonnie and Clyde*. Then in 1974, Patty Hearst, the real-life machine-gun-toting newspaper heiress who took the name Tania, dons the beret as she robs American banks in the name of her obscure Symbionese Liberation Army. Finally, in 2003, Madonna strips the beret of any vestiges of the original military meaning when she takes on the whole Tania-Che look for the cover of her *American Life* album. Its title song, Smith Nash observes, contains some apt

Packaging for Che Guevara wig sold in
Buenos Aires.

lyrics: "I'm just living out the American dream. And I just realized
that nothing is what it seems."

★

Like the hazy photograph itself, which was partly distorted by
some faint scratches on Korda's 90-millimeter lens, the facts
about the Guerrillero Heroico's incredible global journey into
iconhood have always been a bit cloudy. Korda contributed to
this with some contradictory memories, even of the main event,
the moment when the millisecond was captured. The photogra-

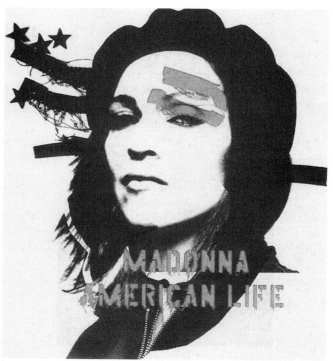

Madonna's *American Life* poster.

pher, who died in 2001 and had become sick of answering the same questions from journalists, sometimes described it as a fleeting, almost inconsequential moment. But on other occasions he added dramatic flourish to the story. For a few moments before depressing the trigger, Korda told one press interviewer, he stood there, "shaken, trembling, and moved by the expression in [Che's] eyes." Interviewed for a Cuban-Chilean documentary made about the image, he even demonstrated how he recoiled backward in shock, pulling his eye away with amazement from the viewfinder.

The sight of Che in his viewfinder undoubtedly caught Korda's attention. Why else would he have bothered to turn the camera on its side and take the second, vertical image? (He was thinking of a magazine cover, Korda once said.) But on that busy street corner, with cameras whirring in one ear and Castro bellowing in the other, with people teeming around him, he could hardly have imagined the portent of the image.

It wouldn't have been until later that day, when it first emerged in the chemical bath in his studio, that Korda recognized he'd taken a very special photograph. He had captured the unspoken essence of Che, the Che of the Cuban revolution. In early 1960, the enigmatic, handsome thirty-one-year-old was already a larger-than-life global celebrity. And while Cubans didn't always understand his prickly Argentine demeanor, to many he was an empowering symbol. The presence of Che, an internationalist figure who'd captured the world media's attention, made their revolution seem all the more important and encouraged them in the belief that they'd achieved something bigger than themselves. Many young middle-class Westerners, meanwhile, identified with this doctor who'd laid his life on the line to liberate another country. He let them vicariously participate in a global revolution. All of this was somehow present in the image that appeared in Korda's chemical solution that afternoon.

As we know, he actually saw two great images arise from the solution. But since he didn't have the tools to remove the second head from the one he preferred, he went for the other photo. From that one, he had only to remove a superfluous palm tree to the right and the intruding nose to the left to leave nothing but Che and the swirling, overcast sky. The original frame, complete with the discarded details, was not converted into a print until 1986, when Korda's longtime associate and close friend José Figueroa convinced him of its historical importance. That first

full print now hangs in Figueroa's Havana apartment, his own piece of twentieth-century history. Now, twenty years later, technology has advanced far enough that Korda's daughter can fulfill her deceased father's wishes. With Photoshop software, Díaz, the sole heir to the photographer's estate, recently put an aesthetically enhanced version of the second photo on the cover of *Cuba by Korda,* a book of her father's photos.

Imperfect as it might have been, Korda was immensely proud of his final print. He pinned it on the wall of his busy studio, where a steady stream of visitors over the years admired it, some of whom received a copy of it as a gift. These included many well-connected clients and friends, the people who would years later play messengers' roles in getting word out about the photo's existence. Yet on the day it was taken, Korda's editors at *Revolución* were not sufficiently impressed to select the photo for the next edition. So the photo's publication was delayed. When it belatedly entered public consciousness, the world had changed.

In choosing to illustrate their funeral coverage with a cover shot of Castro—one in which he was shown holding up two spent bomb casings as "proof" that the ship explosion was no accident—and another of Sartre and de Beauvoir inside, Korda's editors at *Revolución* made a fateful decision. In hindsight, it seems the biggest of missed opportunities. How did they feel years later as they watched the photo they'd pushed aside become the omnipresent emblem of an explosive worldwide cult? Did they even remember it passing across their desk? Carlos Franqui, the newspaper's editor and now an outspoken Cuban exile, maintains that this was a simple case of no-nonsense news judgment. He criticizes Korda for overemphasizing the rejection of the photo in his account of the image's history. "It was the day after the *La Coubre* explosion . . . and it was the first time that Fidel had ever

said 'Patria o muerte.' Obviously, he was the story, not Che," said Franqui. As for Sartre, he simply had a lot of celebrity power at that time, Franqui said.

Remarkably, Korda's photo recovered from this early snub. In the days before digital backups, rejected photos rarely got second chances. Typically, photos that failed to make the next-day edition ended up gathering dust in the newspaper's archive library; those that reemerged did so as cropped-down and easily forgotten head shots. The Korda image was different. When late in 1967, the world finally got to see the millisecond Korda had captured seven years earlier, it saw the vital face of a thirty-one-year-old, not the body of a war-ravaged man on the verge of forty. In this way, Korda's photo stands as a challenge to Barthes, who morbidly concluded that photographers are "agents of death." Images of lost loved ones, the photo connoisseur said, remind us of our mortality; they are artifacts of a bygone life in which we "observe with horror an anterior future of which death is the stake." Korda achieved the opposite: In freezing Ernesto Guevara at the prime of his life, the photographer resurrected him.

The Che of 1960 embodied youthful confidence and success. When he died in 1967, he'd just finished the second of two disastrous guerrilla campaigns, one in the Congo, the other in Bolivia, and his goal of leading a global revolution was looking far-fetched. (As is the case with most martyr figures, this failure would form part of Che's appeal.) In March 1960, by contrast, he was the second-most-prominent official of a revolutionary government that had the eyes of the world upon it. He had personally commanded some of the critical battles of a revolutionary war and had developed an already formidable aura of invincibility. A year had passed since the war and he was now in good health. Despite an early food-rationing campaign and an intense regimen of work, Che was living better than he had for years. He looked fit.

With their early deaths, we are told, celebrities such as Marilyn

Monroe, Jim Morrison, and James Dean left good-looking corpses, thus sustaining their legends and bolstering their pin-up appeal. This is not meant to be taken literally, of course—we rarely see how famous people look after death. The entire world, however, got to marvel at Guevara's corpse when it was ghoulishly displayed by a Bolivian military eager to show off its triumph and hide the ugly truth of how Che died. But this exercise, intended to diminish Che's appeal, backfired when Bolivian photographer Freddy Alborta captured a shot of the body that gave the dead Che a Christlike serenity. That incredible photograph made its own significant contribution to the cult of Che, to his deification. Still, there's no way that this image of a gaunt, bushy-bearded wild man could be described as good-looking. It could never have become a banner for student rebellion and an icon of cool. That's when the conveniently preserved Korda image stepped in.

Most important, in terms of his appeal for the hippies of the late sixties, Che's hair in March 1960 was long. This was merely a happy coincidence. In the early years of the revolution, the hairy, unkempt look of Castro's *barbudos* (bearded ones) was intended to differentiate them from the conservative dress of other militaries. It had nothing to do with fashion in the United States or Europe, where long hair and beards had not yet caught on. Shortly after the photo was taken, Che ditched his rebel soldier's locks for a closely cropped haircut and a more neatly trimmed beard. And in 1968, Castro banned long hair altogether, seeking to protect young Cuban men from a corrupting Western influence. Meanwhile, as the hair of Cuba's revolutionaries got shorter, Western hairstyles got longer. By the time of Che's death, long hair was the defining symbol of a rebellious generation: Hair stood for freedom of thought, peace, and sexual liberation. It symbolized a deliberate rejection of the conservative values of the older generation. This spirit was captured in the classic musical *Hair,* whose opening night Off-Broadway occurred on October 17, 1967, just eight days

after Che's death and right at the moment that the image of a long-haired Che entered the world's stage. The global release in 1967 of Korda's 1960 image distorted time and political reality—and thus enhanced the myth of Che. The image bound two distinctly different phases of history together, merging them into one simultaneous moment.

One real constant connects these two moments. They both depend on the outsize presence and influence of Fidel Castro. The Cuban leader made the birth of the icon possible—he staged and defined the mood of the event that brought a sad/angry/disgusted Che into Korda's viewfinder—and he played a catalytic role in its global promotion seven years later. Korda's Che is rooted in Cuban political history, a history dominated by Castro, a man with an extraordinary capacity for shaping public perceptions of reality and an acute understanding of the power of images. Castro would not be who he is if he had not carefully managed his own image. And to a significant degree he has done that with the photographic image of someone else.

★

Writing in 1973, Susan Sontag observed that photographs had become "material realities in their own right, richly informative deposits left in the wake of whatever [real person or object] emitted them, potent means for turning the tables on reality—for turning *it* into a shadow" (Sontag's emphasis). If any photograph has done this, it is Korda's Che. In fact, the image contains many competing realities, with competing stores of value for different people. To explore how this came about, how this one image took on a multiplicity of meanings in politics, commerce, fashion, and popular culture, one must first acknowledge that an iconic photo's power is not fixed at the moment of its taking. Nor is it solely responsible for generating that power. Rather, society creates it through an ongoing process of cultural construction. An

image's meaning is created—and then altered over time—via an ongoing noisy dialogue between competing and ever-changing political viewpoints, the voices of our modern society. We are not passive viewers of Korda's frozen moment, which for all its beauty is really just a static template. No, quite the opposite. As we have collectively filled the image with meaning—some as Che's fans, others as his sworn enemies—we have locked ourselves into an endless negotiation with it.

ODYSSEUS

Revolution is . . . the great poem of the masses that makes
possible the impossible, that conquers the unknown . . .
that supersedes the world of daily things.
> —Ramiro Barrenechea Zambrana,
> foreword to *El Che en la Poesía Boliviana,*
> an anthology of Che-dedicated Bolivian poems

CHE GUEVARA WAS, as much as anything, a storyteller. Che
"wrote" his own epic life story, and in so doing helped shape the
way people perceived the momentous events in which he was
involved. He converted the very idea of revolution into a romantic
vision for millions.

"Revolution requires the articulation of compelling stories that
enable, ennoble, and empower people who seek to change the
material and ideological conditions of their lives," says Eric Sel-
bin, a professor of political science at Southwestern University.
"Memories of oppression, sagas of occupation and struggle, tales
of opposition, myths of once and future glory, words of mystery
and symbolism are appropriated from the pantheon of history of
resistance and rebellion common to almost every culture."

No revolutionary figure has contributed more to this stock of
traveling stories than Che Guevara. His tales have fed their way

into the mythology of guerrilla and resistance movements as different and distant from each other as the Nepalese Maoists, the East Timorese independence fighters, the liberation theologists of Central America, the Irish Republican Army, the Palestinian intifada, and the Iranian revolution. The myth of Che, Selbin writes, "weaves in and out of history with incredible sinuosity, meandering and looping around not unlike old rivers, cutting through landscapes, leaving behind 'lost rivers,' bends which become lakes, or even areas which become high and dry."

Ernesto Guevara first began writing himself into this history with *The Motorcycle Diaries,* the then twenty-three-year-old medical student's account of his high jinks and travels through South America with Alberto Granado. The book was not published until 1992, when it became a bestseller and inspired Brazilian director Walter Salles to make his popular movie of the same name twelve years later. But it's possible to read *The Motorcycle Diaries* as the first chapter in the epic life of Che. Indeed, *Diaries* is not a diary at all, but rather a deliberately reconstructed memoir that the young Ernesto fashioned and embellished from his original source notes upon his return to Argentina in 1952. Throughout, the narrator seems driven by a sense of personal destiny. Having knowledge of his later life, we instinctively read it as a journey of awakening, stepping-stones in the path by which Ernesto becomes El Che.

In the book's final section, entitled "As an Afterthought," the line between nonfiction and fiction is not merely blurred but blatantly crossed. There, as the memoir segues mysteriously into a nighttime encounter with an unidentified European man, Ernesto hints that there will be more to his story—that a sequel is in the offing. First, we hear the stranger foretell his young interlocutor's fate: "You will die with your fist clenched and your jaw tense, the perfect manifestation of hatred and struggle, because you aren't a

symbol (some inanimate example), you are an authentic member of the society to be destroyed; the spirit of the beehive speaks through your mouth and moves through your actions." It is the prediction of an oracle and it comes as an epiphany for Ernesto. "I now knew that when the great guiding spirit cleaves humanity into two antagonistic halves, I will be with the people," the narrator declares. It was as if Ernesto Guevara were predicting his own afterlife. Fifteen years later, his violent death fulfilled the prophecy.

In 1962, Guevara, by then known as Che, once again converted his diary scribblings into a book. This one, *Episodes of the Cuban Revolutionary War,* a grand saga filled with acts of daring, twists of fate, and moments of comic relief, became Castroist Cuba's defining account of the liberation struggle and a key source of its folklore. Indeed, in stripping out facts, sanitizing, embellishing, or otherwise altering details for the official record, Che played a hands-on role in the construction of an apocryphal Cuban history. The book shows Che as both censor and poet, the Homer of Cuban mythology.

As Jon Lee Anderson discovered in his fabulously detailed biography of Guevara, the differences between the soldier's diary and the history in *Episodes* reveal much about Che's character. One example is the differing accounts of the death sentence meted out to Eutimio Guerra, the first traitor discovered among the rebels' ranks in the Sierra Maestra. In the published book, the tale reads like a Cecil B. DeMille script, with an ambiguous ending that leaves us wondering who pulled the trigger: "At that moment, a strong storm broke out and total darkness descended. In the middle of a colossal downpour, with the sky crisscrossed by lightning and thunder claps . . . the life of Eutimio Guerra just ended, without any one of the close comrades able to hear the noise of the gunshot." There is no ambiguity, however, in the

chillingly matter-of-fact account contained in Che's personal diary: "I ended the problem giving him a shot with a .32 [caliber] pistol in the right side of the brain, with exit orifice in the right temporal [lobe]. He gasped a little while and was dead."

Che's stories "are like little orchestral compositions. Not exactly fiction, they are more like faction," Anderson says. Then once they were embedded in myth, all the actors involved in the stories "became pretty much complicit" in them, he adds, while the truer versions became essentially state secrets.

Another contribution to the body of works giving Che a voice from the grave was a series of three essays published over the course of seven years and then combined into a single volume entitled *Guerrilla Warfare* after his death in 1967. It's fair to say that the book, which combines combat tips with radical revolutionary theory, would have disappeared into obscurity if it hadn't been for the author's life story. Che's own failures in the Congo and Bolivia demonstrated that the central argument of this volume—that small bands of guerrillas can spark revolutions and from this beginning bring about a final end to imperialism—is tragically flawed. His claim that a *foco* of guerrillas can single-handedly foment the "necessary conditions" for a society to undergo revolution is founded on a misreading of the Cuban war, most scholars now agree. Che seemed to overlook the vital role played by Castro's extensive urban support network before and during the rebels' struggle.

Che's military adventures outside of Cuba hint at a desperation to put his *Guerrilla Warfare* thesis into practice. This in turn was a product of an essential element of his character, one for which he is these days often admired: his determination not only to say something but also to act upon it. In writing down his ideas he pushed himself to do as he preached, lest he be found guilty of the same apathy and fear of which he accused Communist Party

leaders, whom he blamed for neglecting the rights of the poor to a liberation struggle.

Despite Che's and others' repeated and costly failures to prove its theory correct, *Guerrilla Warfare* lived on in the minds of radical leftists. As if to confirm the U.S. State Department's fears, the book became popular among the urban guerrilla movements that blossomed in the wake of Che's death across Latin America. However, its power lay not in its instructional contents but in its symbolic badge of Guevarism. For many Che-revering militants of the seventies, *Guerrilla Warfare* was more a holy book than a combat manual. Many took to heart the last words of the final essay, "Message to the Tricontinental," published while Che was incognito in Bolivia, where the revolutionary declares that he and his colleagues would welcome death if "another hand reaches out to take up our arms, and others come forward to join in our funeral dirge with the rattling of machine guns."

These days, *Guerrilla Warfare* still attracts readers among young leftists—not only in Latin America but also in the West, where it has gone through numerous printings. Does this mean Che fans still heed his call to arms?

In a few cases, yes—as with John Daly, the head of the Miami chapter of the Party for Liberation and Socialism (PLS), which places the Korda Che prominently on its website and promotional material. Daly told me that his newly formed party—whose presidential candidate, Gloria La Riva, won some 7,000 of the 120 million votes cast in the 2008 election—supported armed struggles "at the right moment." Ultimately, he said, "we do think it is going to take a revolution to attain the goals we are talking about: that is, in terms of health care and housing and rights to work and full employment and ending racism." In 2005, Daly demonstrated a feisty, Chelike willingness to run headlong into mainstream opinion when, as an English teacher at a New Jersey community col-

lege, he sent an angry e-mail to a Republican student who'd orga-
nized a campus visit by an Iraq War veteran. The e-mail's last line
earned him a reference on Fox News, attracted the scorn and
ridicule of conservative bloggers, and led to his losing his job at
the college: "Real freedom will come when soldiers in Iraq turn
their guns on their superiors and fight for just causes and for peo-
ple's needs."

But for the most part, Che's outdated combat manual seems an
inappropriate text for most of the current-day social movements
promoting his image. Even the broader ANSWER coalition, to
which Daly's PLS party belongs, seems to convey an antimilitary
message: Its acronym stands for "Act Now to Stop War and End
Racism." After all, what use to an antiglobalization activist is a set
of instructions on how to ambush a tank in a hole covered by
banana leaves? For many people, the appeal of reading Che's
words today lies beyond their literal content. It comes instead
from the sensation that they are hearing the pure, unfiltered voice
of an icon.

★

In 1964, Che directed the first test of his *foco* theory, organizing a
guerrilla campaign in his native Argentina to which he named as
leader his compatriot Jorge Masetti, the journalist cum revolu-
tionary whose nose had intruded into Korda's photo frame four
years earlier. The campaign was an unmitigated disaster, in both
military and political terms. Yet this failure appeared to impose no
restraint on Che or on his determination to change the world
through military means.

In November 1964 Che delivered a bellicose speech to the
United Nations, and then four months later followed it up with
another at a conference of third world liberation movements in
Algiers. In these, he talked energetically about the need for a
bloody global war on imperialism and slammed both the Ameri-

cans and the Soviets in equal doses. Then, after a whirlwind tour in which he seemed to be everywhere, he suddenly went silent. In April 1965, Che Guevara disappeared completely from the world stage, an unannounced departure that generated a great deal of speculation. Over the following weeks and months, fanciful stories of his whereabouts abounded. Different press accounts placed Che in six different Latin American countries, including in a psychiatric ward in Mexico City. An Italian journalist claimed to have interviewed him in Peru and a Miami newspaper reported his death in the Dominican Republic. On June 28, 1965, *Newsweek* summarized some of the rumors. Among them: Che was in Vietnam; he'd defected after selling Cuban secrets to the United States for $10 million; his body was in a Las Vegas basement. Meanwhile, a CIA memo speculated that he was in a Havana mental hospital at the same time that the agency was spreading the rumor that Fidel had done away with Che for his anti-Soviet stance. As biographer Paco Ignacio Taibo II put it, "Che's ghost was haunting the globe."

It wasn't until two years later, with the Bolivian military hot on Guevara's tail, that credible stories of his whereabouts emerged. Twelve months after that, with the posthumous publication of Che's Bolivian diary, the gap in the story was filled back to December 1, 1966, the date of the journal's first entry. But what's truly remarkable, especially from the perspective of our current twenty-four-hour news cycle, is that for another two decades the public remained ignorant of where Che had been before then. In official terms it remained a mystery. Cuba's incentive for keeping Che's Congo mission a state secret was likely tied to its ongoing relationships in Africa, where its soldiers fought for many years on the side of Angola's rebels. Still, one has to marvel at the watertight Cuban intelligence machine. Hundreds of people, including Guevara's colleagues, kept the story locked up in their heads.

The eventual, officially sanctioned leak of Che's Congo story in

1990 was well timed for sustaining his cult. As the world entered
a new post–Cold War era in which Che's relevance was being
questioned, suddenly he was interesting again. Che, we now
learned, had all along been battling evil in a land of jungles, goril-
las, and warrior tribes, deep inside Conrad's Heart of Darkness.

The first accounts of the Congo campaign came from Che's
former comrades. But a decade later, the buzz was revived again
when his personal diary—better termed a memoir—went public.
Now his fans had the adventure in their hero's own words, a pre-
quel with which to complete the saga. As a *Scotland on Sunday*
reviewer states in a blurb on an updated U.S. edition from Grove
Press, which bears the revamped title of *The African Dream,* the
diary is both a "missing historical jigsaw piece" and "a very per-
sonal insight into the thoughts and emotions of Che Guevara, the
twentieth century's great revolutionary martyr."

The key insight one would look for in *Diaries of the Revolution-
ary War in the Congo* would be a rationale for Che's taking the
next step, the one that led to his demise. As to why Che decided
to fight another war in Bolivia so soon after the ill-conceived
Congo campaign, we are left guessing. What we do sense from
the subtle fatalism in this otherwise analytical text is that, for Che
Guevara, there was by then no turning back. His destiny was set.

In April 1965, Che had formally renounced his citizenship in
what was supposed to have been a private letter to Castro, osten-
sibly to exonerate the government from responsibility for his
actions. But six months later, in a bid to quash the rumors of his
whereabouts, the Cuban leader publicly read the letter. It con-
tained no details of his location but made it clear he was fighting
a revolution somewhere. Partly because of Che's stubbornness
and partly because of the political sensitivity of the situation, this
act meant the Argentine could never return, or at least not pub-
licly. In this sense, whether it was premeditated or not, Castro
effectively condemned Guevara to death. Not only was Che now

compelled to live out his myth in secret and to take his campaign to its fatal end, but he had also acquired a kind of supranational everyman status. The renunciation of citizenship was effectively a declaration of statelessness: Che belonged nowhere, which also meant he belonged everywhere.

Still, this is a sad moment for Che, one conveyed with great power in the final lines of the Congo book, where he describes the pain of waving farewell to a boat taking his retreating Cuban colleagues across Tanganyika Lake. He was staying behind in Tanzania and, unlike his comrades, felt he could not return to see his family in Cuba. By his own choice, Che was now homeless. "Never have I found myself so alone again as I do today after all my travels," he writes.

This melancholy ending to the penultimate chapter in the epic adventure known as Che Guevara's life is followed—at least in the sequence in which they were written, if not published—by a tome that captures this fatalistic sense of destiny more than any other: the Bolivian diary. In the form in which it is most commonly read these days, the diary is delivered more or less as it was written, although the Cuban government must have censored it to some degree. (Thomas H. Lipscomb, a writer who in 1968 was granted access by the CIA to what he describes as "the unexpurgated diaries," claims that "Castro's version left out the good parts," including Che's complaints that the Cuban leader "had deserted him.") Still, there's little evidence the Cuban government significantly altered Che's prose. That means that unlike the other published memoirs, the content of the Bolivian diary is raw and unembellished. And yet as Rubén Mira, the author of a daring novel based on a science fiction rewriting of Che's Bolivian diaries in a 1980s setting, says, the diaries play a role in Latin American culture as part literature, part popular history. "I find it striking that while the greatest bestseller of magic realism, [Gabriel García Márquez's] *One Hundred Years of Solitude*, sold

more or less the same quantity of issues as Che Guevara's Bolivian diary did in its day, the latter has never been thought of as part of the corpus of Latin American literature," Mira says. "Che had this project of wanting to construct a new kind of history. . . . The idea was that a sum of many voices would constitute a popular history. What's striking is that he believed it had to be written. And from there we find the presence of his diaries and his narratives after the fact, as well as so many guerrillas writing diaries and narratives."

The appeal of Che's diary is also attributable to the reader's knowing that the end of the narrative involves Che's death. It's an implied tragic-heroic finale, which bolsters the power of the real-life story and sustains the passage of the author into martyrdom. For a man who had established himself as a role model of selfless action for the common good, this was the ultimate act of sacrifice, the concluding proof that his words would be his deeds. As with others slain in the pursuit of their social cause—Mahatma Gandhi or Martin Luther King Jr., for example—Che's murder makes it difficult to attack him, regardless of how hard his enemies try.

★

In dying, Che rounds out his myth. We are left with a life similar to that of the prophets of the mainstream religions: A man, a teacher, lays down a code of personal conduct from which to build a just society, a utopia, and then proceeds to live and die according to it. If there is a single work that functions as the creed of this "religion," it is Che's essay "Socialism and the New Man in Cuba," which was published by the Uruguayan weekly *Marcha* a month before his disappearance but was not read in Cuba until after the fact. Regarded by many as Che's farewell message, it prophesies a future society founded upon a "new individual," a New Man concerned not with material possessions but with

"inner wealth" and driven by a "love of humanity." The essay sets the author apart from Soviet leaders and most other communist policy makers, including Castro. They imagined a workers' paradise with the same toys as the Americans—the cars, the televisions, the intercontinental ballistic missiles—albeit produced by a benevolent wealth-redistributing state rather than by profiteering capitalists. Che, on the other hand, thought the path to socialism lay in forgoing all the earthly stuff entirely. For him, utopia lay in the denial of desire.

This is hardly a novel idea. Philosophers and preachers have been telling us to model ourselves on the New Man for centuries, to quit thinking about ourselves and focus on the needs of others. What makes it resonate with the Che icon is Che's life story. Che himself remains his followers' yardstick for measuring their own progress toward the ideal of the New Man: the military commander who refused to let asthma constrain him and who personally led battle charges; the government official who worked like a dog, spearheaded cane-cutting drives, rejected a ministerial salary, and turned down extra rations; the liberator who made the ultimate sacrifice in a foreign land.

Che's life story, along with other factors—including Freddy Alborta's spooky photo of the dead Che—helps explain a frequent pairing of Che with Christ, exemplified by the ubiquitous "Chesucristo" artwork in which Korda's Che is rendered with a halo, as it was on the cover of German magazine *Der Spiegel,* or depicted naked and crucified, as in a painting by Nicaraguan artist Raúl Arellano. In reality, this is a conflation of two completely incompatible figures. In a letter to his mother from a Mexican jail cell in 1956, Che wrote: "I am the very opposite of Christ . . . I will fight with all the arms within reach, instead of letting myself be nailed to a cross." For Che, turning the other cheek was tantamount to aiding and abetting imperialism.

Indeed, how could Christ's message of love for one's enemies

"Mythos Ché Guevara," *Der Spiegel,* no. 38,
September 16, 1996.

be confused with that of someone who openly advocates hatred
in the bloodthirsty lines of "Message to the Tricontinental"? In
that final, 1967 *Guerrilla Warfare* essay, the same author who'd
argued two years earlier in his "New Man" letter that "the true
revolutionary is guided by a great feeling of love" now urged revo-
lutionaries to fill themselves with an "intransigent hatred for the
enemy" and to become "effective, violent, selective, cold, killing
machines."

The answer is that both Che and Christ have been subjected
to the simplifying process through which religious icons are cre-
ated. An icon is concerned with ideals—purity of thought and

action, absolute truths—and less so with philosophical tenets. In this process, even Che's advocacy of extreme violence can be converted into idealism. His assertion in the "Message" essay that "we have no right to believe that freedom can be won without a fight" can be read to mean that an act of murder is morally superior to a restraint from such action. Against an unjust imperial system, killing is not merely permissible; it is noble. Suddenly, an inconsistency with the humanistic spirit of the New Man is bridged.

Thus Che, the model New Man, is transformed into a religious hero, where the inherent contradictions of his own philosophy— love versus hatred—are wiped away. All that's needed to complete the deification is a universal symbol. Enter the Korda image, the crucifix for the Church of Che. It's not for nothing that this image is described as an icon, a word derived from the Greek *eikōn,* which itself means "image" and was first used in the Greek Orthodox Bible in reference to God making man in his image. Religions, social movements, and commercial entities have been strengthened throughout history by iconography. To function in this way, however—as an all-encompassing symbol—the identity, ideas, and life history of the author or the organization must be distilled and simplified. Whether it is the Christian cross, the Islamic crescent, the Korda Che, or the Golden Arches of McDonald's, iconic images underline the purity of a central idea and dispense with the complexity and nuance of their underlying reality.

★

But if Che's image inspires religious devotion among some, it also generates visceral anger in others, especially among the anti-Castro and anti-Che right wing. Enraged by the proliferation of commercial products that trivialize Guevara's violent ways and by a stream of books, films, and songs paying tribute to him, this

group is on the attack. A Google search linking "Che" with either "murderer," "thug," "executioner," or "assassin" produces more than a million hits. Che hate is rife in cyberspace, almost to the extent that it overwhelms Che love.

The two sides will often engage in verbal warfare within the comments sections of online material dealing with Che-related issues. There, freed from the offline world's demand for civility, their battle often degenerates into vulgar abuse. Just two weeks after a video I produced for *The Wall Street Journal*'s website found its way onto YouTube, it had generated eighty-five responses. Not one of the commentators addressed the video itself; rather their remarks formed a set of scrolling claims and counterclaims about Che's values (or lack thereof) and of derogatory statements directed at one another. One expletive-rich exchange started out with an observation by "evilputa69" that "the cult of Che Guevara . . . STINKS!" This prompted "luisnavarrette" to respond, "You must of [sic] opened your legs, that's what your [sic] smelling . . ." Evil Puta then opened up a follow-up post by mocking Luis's English before closing it out with an offer: "Yes, my cunt stinks, but I only charge 5 bucks. C'mon let me fuck you!" To Luis, it was a deal: "I would love to fuck that foul smelling cunt, but five bucks only . . ." In the endless Che debate, where consensus is inherently impossible, perhaps an agreement like this one is the best that can be hoped for.

As for the more serious anti-Che iconoclasts, they often seem as evangelical as their enemies. They are on a mission to inform: If only the horrible truth were known, they believe, this vile icon would wither and die. The problem, however, may lie in too much, not too little, information. Historians, biographers, and journalists—and, as we've seen, Che himself—have compiled a vast, comprehensive written record of Guevara's actions and personality traits. With the exception of eleven million information-starved Cubans, we all have easy access to this archive. So this is

not a debate about the facts surrounding Che's life; rather, it's a question of whether society should idolize a man with such a record. And from there we enter into a quarrel as old as history.

We're dealing with a centuries-old dispute, one concerned with how history is written and how to define loaded words like *liberty, equality, justice,* and *power.* After fifty years of yelling at each other, Che lovers and Che haters are on either side of an unbridgeable gap, so soaked in ideology and politics that any claim of the other group is suspect.

This divide is starkly illustrated in the different versions of Che's eleven-month tenure at La Cabaña fort. Built originally by Spain's King Carlos III on a windswept cliff above Havana Bay in 1774, the massive Fortaleza de San Carlos de la Cabaña was designed to prevent the British from getting their hands on his Caribbean jewel. Over the years, however, La Cabaña became less associated with protecting Cuba from foreigners than with the brutal methods employed by its foreign-backed rulers to protect themselves from Cubans. In the late nineteenth century, Spanish firing squads executed hundreds of José Martí's independence fighters there, gunning them down against the fort's southeastern wall. And in Cuba's prerevolutionary twentieth-century period, U.S.-supported dictators Gerardo Machado and Fulgencio Batista used La Cabaña as a prison for suspected coup plotters. So when Castro took charge in January 1959, there was a symbolic message in the appointment of his toughest taskmaster, Che Guevara, to command the fort: A new order had begun in Cuba.

These days, tourists amble about the fort's grass-covered moats, peering into old cannons and snapping shots of the city below. It's a sleepy place, offering the same depoliticized take on Cuba's colonial past that comes from a stroll through the beautifully restored streets of Old Havana—almost as if the turmoil that came during and after it never occurred. Out of all the historical

figures associated with the fort, Che is the only one who gets any real showing at La Cabaña, courtesy of a small museum dedicated to his memory in the commander's cottage. Like so many "museums" in Latin America trying to create an opportunity for tourism out of the fact that El Che was once there, it offers few artifacts. It's all about the photos, the same photos of Che you see everywhere.

Still, two features stand out at La Cabaña's Che museum. One is the large, bold-colored pop art painting at the end of the photographic exhibit. It shows El Comandante with a gentle, almost smiling expression, his black hair flowing like a river into the distance and his bright green, star-adorned beret emitting joyful rays against a yellow background. The painters' signatures identify it as a collaboration of the Cuban artists Rubén Alpízar and Reinerio Tamayo, but there's no other explanation: no date, no context. The other key attraction is the office Che occupied during his eleven-month tenure as the fort's commander. Separate from the rest of the exhibits, the narrow room is presented in a way that suggests its contents haven't changed in fifty years. A rope at its entrance forces visitors to peer respectfully from afar at a simple wooden desk against the back wall, with an old black telephone on it. Again, there are no details about what he did in there.

Yet the actions Ernesto Guevara took here after he arrived in Havana are of great relevance to the status of his myth today. So it is not right that we leave La Cabaña with nothing more than the museum's simple message that "El Che was here." Thankfully, there are plenty of detailed accounts of what happened during his stay at the fort. Rolando Castaño tells one of them. Right there in that now-roped-off office, he says, Che Guevara put two bullets into the back of his father's head.

When his father, José Castaño Quevado, who'd been second in charge of the CIA-backed Bureau for the Repression of Communist Activities, was sentenced to death along with hundreds of

other ex-Batista officials in the early days of the revolution, officials at the U.S. embassy lobbied hard to have him spared. Castro, who was then still trying to cultivate a relationship with Washington, responded late on March 6 by sending someone to La Cabaña to look into the case. "But when he got there," the younger Castaño said, "Che Guevara told them it was too late and that my father had been killed that night . . . What we were told later was that Che Guevara personally killed my father." When the family was allowed to exhume the body years later, he says, they discovered big bullet holes in the back of the head—indicative of a point-blank shot.

The Castaño family is now an integral part of the large and politically influential community of anti-Castro Cuban exiles in Miami. Rolando's brother, José Jr., was the first to go. He made the crossing at age sixteen, immediately after his father's violent death. (In Miami, José joined the resistance. Two years later, he was captured during the ill-fated Bay of Pigs invasion and spent twenty months in a Cuban prison.) Rolando left Cuba the following year and then spent the next ten years working to get his mother and sister into the United States.

The retired consultant says he has put his family's painful past behind him. "It all happened a long time ago—almost fifty years. We're getting old," says Castaño. Yet he often feels compelled to speak up when he sees someone wearing a Che T-shirt. "Most of the people I talk to who wear Che, especially young kids, they don't know who Che Guevara really was. Quite often, if I have the chance to say something, I ask them, 'Do you know who this man was?' And then I tell them the story."

Castaño's story is not the only one out of La Cabaña to paint a disturbing picture of Che. A writer using the pseudonym of Pierre San Martin described in Miami's *El Nuevo Herald* how he and other cellmates watched in horror as the fort commander dragged a fourteen-year-old boy into the execution yard and personally

"put a bullet into the back of the boy's neck that almost decapitated him." In a report for the human rights group Cuba Archive, economist Armando Lago documented a total of 216 Cuban deaths under Che's orders, all but 35 of them during his eleven-month stint at La Cabaña. Journalist Luis Ortega, who knew Che from the early 1950s, claims the real number is 1,897.

The firing squads at La Cabaña were part of a wave of executions of Batista-era officials during the first months of the revolution. Castro has acknowledged that 550 "criminals" were sentenced to death in 1959 and 1960; exiles' estimates of total firing squad deaths typically range from the 5,775 figure recognized by the Cuban Archive project to more than 30,000. (Curiously, these differing figures are in both cases attributed to Armando Lago, whose long-awaited manuscript has yet to be published. Some anti-Castro writers even cite Lago as the source for a highly inflated figure of 110,000.)

The government vigorously defended the tribunals, describing them as Cuba's version of the Nuremberg trials and arguing that justice had to be swiftly brought to bear against a group that acted with impunity during the prior regime as it tortured and murdered thousands. But critics in the United States attack the lack of due process. The accused were tried in rapid succession via "revolutionary tribunals" with inexperienced, overworked judges. And to expedite the process, habeas corpus and other civil rights were suspended. Despite this, leading scholars of Cuban history have been cautiously sympathetic to Castro's actions at that time. They've noted the widespread support for the executions among Cubans, who were angered by an apparent double standard in the response from Washington, which had remained closemouthed over the actions of Batista's thugs. Some argue that the speedy trials were the only way to defuse mob rule and note that for all the death sentences no vengeful bloodbath took place on the streets. As for Che, his defenders point out that his role as a commander

in authorizing La Cabaña sentences was a ceremonial one and that he had no formal judicial power.

None of this is much comfort for the families of those killed, an inordinate number of whom live in the United States (and about whom we will read more later). Inevitably, Cuban-Americans characterize Che's role in the killings as a central one claiming that he bullied both judges and prosecutors into hurrying executions. José Vilasuso, a lawyer who worked on a prosecuting commission, recalls Guevara trying to "indoctrinate" him: "He said, 'Look, this is my court. It's very simple, all you do is the file examination . . . The investigating official is always right, he always tells the truth. We always have to accept what the report says. They're killers, criminals, they belonged to a dictatorship, they should die.' "

SEX, PHOTOS, REVOLUTION

Well-known performers danced or sang in the squares to swell the fund; pretty girls in their carnival fancy dresses, led by a band, went through the streets making collections. "It's the honeymoon of the revolution," Sartre said to me. No machinery, no bureaucracy, but a direct contact between leaders and people, and a mass of seething and slightly confused hopes. It wouldn't last forever, but it was a comforting sight. For the first time in our lives, we were witnessing happiness that had been attained by violence.

> —Simone de Beauvoir,
> reflecting on her and Jean-Paul Sartre's 1960 visit to Cuba

THE MYTH-MAKING and conflict-generating power of Ernesto Guevara's words represents just one of the antecedents to his posthumous cult of personality. Just as important are the events, characters, and vibrant arts and literary scene of early revolutionary Cuba. Alberto Korda's photo emerged out of this fertile, creative environment, a cultural milieu that helped define its status as the internationally recognized Che icon and brand.

The conventional tale is that the image first went through a seven-and-a-half-year hiatus after its birth in 1960 before exploding onto the world stage after Che's death in October 1967. This was the story that journalists and researchers heard years later,

after they realized the extent of the phenomenon and went looking for the man who started it all. As years passed and the aging Korda told the story dozens of times, inconsistencies emerged. But the basic plotline remained as follows: Korda's editors at *Revolución* reject the photo; he pins it up in his studio; seven years later, Giangiacomo Feltrinelli drops by and gets a print; Che dies shortly afterward and the Italian publisher sells a million copies of a poster based on the print. The rest, Korda would say, is history.

This is an appealing story because it turns the frozen 1960 millisecond into a prophecy of Che's later resurrection as a god/hero, and because it removes politics from the iconography. Instantaneously and independently, it says, the youth of Europe go crazy over the poster.

But it is not true.

Although it's fair to say Korda's photo was not widely recognized during the interim years before Che's death, we now know that this was not for want of publication. Recent research has uncovered numerous pre–October 1967 reproductions of the image inside and outside Cuba. And while its presence worldwide was indeed fueled by the raw energy of the masses, the evidence points to a political effort, especially by the Cuban government, to harness this energy.

Recognizing a myth is one thing; replacing it with irrefutable facts is another. It is still unclear exactly how the Korda Che made its transition into the world. Social phenomena like this do not lend themselves to archival research, nor has much of a paper trail been left in Cuba's ramshackle official records. Inevitably, some alternative yet equally baseless myths about the Korda image's origins have arisen.

Celebrated Cuban novelist and staunch Castro critic Guillermo Cabrera Infante once even claimed that Korda was not responsible for the photographic image as we know it. Writing in Spain's prestigious *El País* newspaper six months after the

photographer's death in 2001, Cabrera Infante declared that it
was Feltrinelli and an associate who first noted the striking
expression on Che's face inside a long shot that Korda had over-
looked. On its own, the story sounded credible. But as demon-
strated by the recent archival discoveries of various pre-Feltrinelli
publications of the image, Cabrera Infante's report of a scam is
itself a scam.

The air of mystery that was maintained around the image left
the door open to these fanciful alternatives to Korda's own, ques-
tionable story about its passage into the world. And that in turn
can be attributed in part to his failure to mention the early public
appearances of the image. But to be fair to the photographer, the
first displays of his photo drew close to no public attention. More-
over, Korda was stuck in a politically isolated island-state that
refused to recognize copyright. When he gave Guerrillero Hero-
ico prints to friends and associates in the 1960s, he relinquished
control over them, leaving him unable to monitor their passage
around the world. So later, with limited information, he did what
we all do when we talk about our lives: He fashioned his recollec-
tions of the image's history into a narrative.

★

Una cuenta cuentos. This term, meaning "a raconteur," was the
first one José Figueroa gave me during a chat in his art-lined
Havana apartment after I asked for a description of his former
boss and photographic collaborator. "Alberto always had so many
anecdotes. He was always able to establish a connection, a
communication. He was a unique person, someone who always
managed to land at the center of attention," Figueroa said. Sur-
rounded by black-and-white photos exploring the multiple repli-
cations of his friend's most famous image, Figueroa refilled our
glasses of Portuguese red and continued: "Alberto was a true
character. He had this deep, gravelly voice. He was always in

jeans, right to the end of his life. He was one of those personali-
ties always appearing in the media, charismatic, a lover of all
things beautiful, including of course women. He was a drinker—
as I am, too—and a lover of the tango. When he sang tangos and
played the guitar he would almost cry doing so."

Those who knew Alberto Korda almost always say such things
about him. He was a debonair bon vivant, the life of the party. A
noted celebrity within Havana's arts and entertainment scene,
the photographer was instantly recognizable by his close-cut
beard and by the tumbler of rum and cigarette close at hand. He
was also a legendary womanizer, with an ability to charm even the
most resistant of targets. In this sense, Korda was the antithesis
of the self-sacrificing New Man represented by Che. And yet his
hedonistic ways did not make him any less a product of Castro's
Cuba, where the pursuit of pleasure has always coexisted with
the regime's relentless call to discipline. To the Cuban revolution,
Korda was the yang to Che's yin.

Korda was born Alberto Díaz Gutiérrez in Havana on Septem-
ber 14, 1928—according to official records, exactly three months
after the birth of the man with whom, in the words of Korda's
daughter Diana Díaz, he would be "married forever." Early on,
photos fascinated the young Alberto. He was consumed by what
Cuban journalist Jaime Sarusky describes as "the immense
attraction of the image itself." As a teenager, he kept a scrapbook
of magazine advertisements simply because "his eye was caught
by things he found pretty," says Sarusky, who adds that his subject
started taking pictures not to publish them but because "he just
needed to capture that image."

In 1956, while Castro and Che were in Mexico making battle
plans, Díaz Gutiérrez founded a photography studio with his
friend, Luis Pierce, to specialize in fashion and publicity. For its
name, they took that of the recently deceased Hungarian film
director Alexander Korda, which also conveniently sounded a bit

like Kodak. The studio quickly developed a reputation as the best of its kind in Cuba, such that people began giving its name to the photographers themselves. From then on, they were known as Luis Korda and Alberto Korda.

The Korda studio became a magnet for artists, actors, musicians, and other celebrities, a meeting place for the beautiful people of Havana. But although the junior partner reveled in this star-studded world, he continued his habit of capturing random images of everyday street life. This solitary activity kept him in contact with a far less glamorous side of Batista's Cuba. His photo file includes one of a woman and her three small children sleeping in a doorway, with newspapers for blankets. Sights like these ate at the fashion photographer's conscience. So too did the photos of the legendary Raúl Corrales, four years his senior. While his own portfolio was full of fashion and publicity shoots, Corrales's work for the underground communist newspaper *Hoy* portrayed, in Korda's words, "the inequalities of the lives of *campesinos*."

It was perhaps inevitable then that when Castro's rebels entered Havana in 1959 and turned the city's society on its head, Korda plunged headlong into the hurly-burly of Cuba's political transformation. Fittingly, the master storyteller traces this decision to a treasured captured moment: a shot of a little girl embracing a piece of wood that she called "my doll." That photo, Korda later recalled, "convinced me that I should dedicate my work to a revolution that could transform these inequalities."

The epiphany did not diminish the photographer's love of the good life, however. His world was a veritable parade of beautiful women—and it continued to be so for many years after 1959. The dates and details of Korda's many loves and relationships during this hectic period tend to blend together. Among the many interviews Korda gave in his life, some while the photographer was

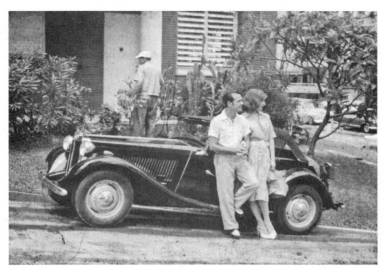

Alberto Korda with Natalia Méndez, c. 1958.

apparently drunk, he is quoted in at least one claiming to have
had six or seven wives. "I can't remember exactly," he told one vis-
itor in 1997. His first child, Diana, was born out of a short-lived
relationship with a woman called Julia López. But at around the
same time, he became infatuated with Natalia Méndez, a slender,
drop-dead-gorgeous woman who towered over him and to whom
he gave the nickname Norka. The best-known Cuban model of
her era, she became the subject of countless Korda photos. The
pair eventually married, becoming a prominent celebrity couple.

According to many accounts, marriage did not stop Korda's
adventures with other women. He'd cruise the Malecon in an
MG convertible, his signature accessory, with a guttural-sounding
engine that would signal his approach, regularly with a different
woman in the passenger seat. With Castro's rebels consolidating
their power, Korda upgraded that car to a Porsche, an ostenta-
tious choice for those revolutionary times. Not long after, Norka

took off for Paris to become a catwalk model for Christian Dior, leaving their two children in Alberto's custody—a son, Fidel Alberto, and a daughter, Norka, who bore her mother's nickname as a legal name. Eventually he moved in with the acclaimed Argentine-born actress Monica Guffanti, with whom he had the last two of his five children, Dante and Alejandra.

If Korda's extravagant lifestyle ran counter to the discipline of Che Guevara, it was in keeping with the mood of the early years of the revolution. Many in Havana's arts and cultural scene saw Castro's arrival as reason to celebrate. Most were delighted to see the end of the violent dictator Batista and saw no threat to liberty from the bearded rebels. After all, Castro had promised elections. And no matter what, the rum would keep flowing and the music and the dancing would go on. It always had.

"Yes, Korda was a womanizer and a drinker, but we all were then," said the late José Gómez Fresquet, a close friend of Korda's and one of Cuba's best-known poster makers. With his toothy grin and infectious laugh, Gómez Fresquet was himself a study in Cuba's contradictions. When I met him in November 2006, less than a year before he succumbed to cancer, Frémez—as he was commonly known—was president of the fine arts department at the National Union of Writers and Artists, an institution with an uncomfortable history of censorship. Yet he was also a daring painter whose vivid, politically charged art struck directly at the viewer's conscience. His life with Korda in the early days of the revolution, meanwhile, was not short of indulgences. "We would spend every night at the Hotel Capri in Vedado, and by the end of the night we'd be looking for a woman to spend the rest of it with," Frémez said, puffing on a fat Habano cigar. "Korda lived in front of the Hotel Capri. And whenever it was my turn, I'd never have any money, so I'd say to him, 'Hey, Alberto, lend me some money for the hotel, or at least lend me a room in your house.' This was the kind of thing that was going on around Korda. But

you know what, it was not incompatible with his humanism or his dedication to the revolution. The trouser fly has nothing to do with ideology."

Frémez's philosophical musings notwithstanding, the gap between Korda's professional and private life is not easily bridged. His commitment to Castro and to Cuba is not much in doubt. In fact the idea of exile appears to have been unthinkable to him, even after government security forces abruptly shut down his beloved studio and destroyed more than a decade's worth of his fashion photos. Even so, right until his death in 2001, the photographer seemed to live in two worlds, as if he had a foot on either side of the Florida Strait or in two eras, simultaneously belonging to pre- and post-1959 Cuba.

"Capitalism was Alberto's greatest foe, at least that's how he spoke. The world's problems were in part due to the ill effects of the capitalist countries trying to dominate and exploit the underclass. At the same time, Alberto came from the capitalist world, which he very much enjoyed," notes Darrel Couturier, a Los Angeles gallery owner who represented Korda and other Cuban photographers as an agent when the government changed course and began allowing them to sell their work overseas in the 1990s. "When he took that pivotal image of the little girl with the tear in her eye holding her wooden 'doll,' *La niña de la muñeca de palo,* he had arrived at her little house in a Porsche."

Couturier stresses, however, that his former client and friend was a humanist at the core, a genuinely warm person with a generous spirit who valued friends, family, and home above all. When he started traveling on promotional tours, the photographer would soon become homesick, Couturier says.

Indeed, the owner of the world's most reproduced photo appeared to make a deliberate choice to forgo riches in order to stay in the country where his soul belonged, which in turn left him ill prepared for the global market when, late in life, he sud-

denly had to deal with it. It's not that Korda was uninterested in making money—"he would badger me every two minutes wanting to know how many photos we sold," Couturier recalls—it was that he made little effort to grasp the realities of the market. For some time, Couturier says, at least until the penny dropped about how much more money he could make, Korda dismissed his agent's suggestions that he sell his signed prints of Guerrillero Heroico for more than the pitiful $300 price he had typically charged visitors in Cuba. And that seems to reflect in part Korda's greater interest in people than wealth. The travel writer Tom Miller described in a 1997 *Washington Post* article how Korda, unsolicited, dropped the price of a Guerrillero Heroico print he'd come to buy to $100 from his standard $300. Korda, recounted Miller, explained his reasoning on these grounds: "You are a friend of Jose's [Figueroa], and that shows you choose your friends well. Second, you have written about Cuba honorably without resorting to attacks on our character . . . And finally, you have married a Cubana, so you are one of us." The author concluded his article by noting that he had never in his life "negotiated a purchase in which friendship, literature and love played so significant a role."

Still, it was never easy being Alberto Korda in Castro's Cuba, where the flip side of the joviality described by Frémez is the mistrust it generates. Korda's flamboyance and the perception that he used his social ties to accumulate privileges did not endear him to many people. "I believe he had more enemies than friends," the photographer's daughter Norka said in a Mexican interview-documentary produced shortly after his death, a short homage to her father that is both heartfelt and melancholy. "Despite what people say, no one ever talks about how he was rejected by so many people. People looked at him as a kind of immoral or irresponsible person and an opportunist, and for all these reasons he had many enemies."

★

Opportunism can also be a virtue. Korda was quick to seize the opportunity posed by Fidel Castro's victory. Perhaps the most iconic image to emerge from the rebel leader's victorious arrival in Havana on January 8, 1959, came from what was widely recognized as one of Korda's best photos, a shot that launched his photojournalism career. Showing Castro and the rebel commander Camilo Cienfuegos atop a jeep, it so impressed Castro and his aides that the photographer was invited to join the Cuban leader's entourage in Venezuela for his first official overseas trip.

The truth is, Alberto Korda never took that photo. Luis Korda was behind the camera. Yet for more than forty years Alberto routinely took the credit, even signing prints of it. Luis's widow took up the issue after both men had died, and eventually the older photographer received formal recognition as the author of the Camilo-Fidel photo. Even so, it seems clear the younger man played a key role in turning the photo into an icon. According to a Cuban press interview published just after he died in May 2001—the only public record in which Alberto acknowledged his partner's creation of it—Luis was originally unimpressed by his own photo. Alberto claimed that he showed him how compelling the image would be if they cropped it to a narrower frame containing only the two rebel leaders.

This capacity to find "the image within the image" was one of Alberto Korda's great strengths as a photographer and an artist. In refining the composition of his photos to remove what seemed like peripheral subjects—as he did with his famous photo of Che—Korda enhanced the iconic power of these images. Yet he also did away with historical details and in so doing diminished the complex reality of the moment from which these images arose.

History has a habit, however, of leaving barely perceptible

traces in photos—like Jorge Masetti's nose in Guerrillero Heroico. In the Camilo-Fidel image, it left a gun barrel poking into the lower part of the frame. This was the weapon of Huber Matos, then a high-ranking member of the 26th of July Movement and later commander of Camagüey Province. Matos, whose face and body are visible in Luis's original, was arrested ten months after the photo was taken for criticizing the regime's communist tilt, a crime for which he was to spend the next twenty years in prison. Seven days after the arrest, Cienfuegos, who had been sent to Camagüey to carry it out, was lost at sea when his plane mysteriously disappeared en route back to Havana. Although no clear information about the accident has ever come to light, rumors have persisted that Castro did away with Cienfuegos because Matos had convinced the army chief to join him in challenging the Cuban leader.

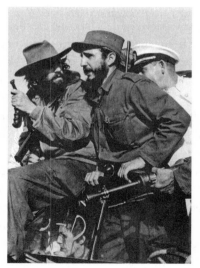

Camilo Cienfuegos and Fidel Castro, Havana, January 8, 1959 (published version, cropped). Photo by Luis Korda, cropped by Alberto Korda.

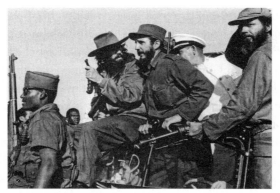

Cienfuegos and Castro, Havana, January 8, 1959
(original version, uncropped). The bearded Huber
Matos is visible at the right of the frame. Photo
by Luis Korda.

None of these ever stopped the revolution's propaganda machine
from converting the pair into a study in contrasts: one an idealized
martyr, the other a despicable traitor. In hindsight, it was a true
stroke of luck that the cropped photo that most famously memori-
alized the first contained no bigger trace of the second.

While Huber Matos and Luis Korda disappeared from Cuban
history, Alberto Korda received a ringside seat to it. Swapping
one celebrity lifestyle for another, he made a surprisingly smooth
transition from the world of glamorous models and film stars to
that of Castro's scrappy soldiers. This was not just a matter of
turning down shoots with models and instead focusing his lens
on Cuba's inequalities—in fact he continued to do both for a
number of years. It required political finesse and charm, Korda's
forte. Very early on, the photographer's gregarious personality
got him into Castro's good graces. After the Venezuela trip, he
got invitations to both official and unofficial social events and

eventually was given the ambiguous title of Castro's *fotógrafo acompañante*.

"Korda became very intimately involved with Fidel. He was the photographer of choice whenever Fidel wanted one around," says Lee Lockwood, a freelance photojournalist who knew both Korda and Castro well. "Castro couldn't take a lot of the newspeople who were working officially in Cuba. He couldn't take their officiousness. But he got along famously with Korda. It wasn't long before [Korda] got to become part of the inner circle in terms of being in demand and being expected to leave on a moment's notice to go on an overseas trip or to play baseball with him. He was like a buddy."

Over this time, Korda amassed a giant portfolio of more than 10,000 photos, many of them of unique candid moments. From these arose well-known images, such as the shots of Che and Fidel playing a screwball round of golf in their fatigues and the one of Castro staring up at the Lincoln Memorial in Washington, a piece Korda dubbed "David and Goliath." But the vast majority never saw publication. "I censored many of these myself because I understood that it was not the opportune time to publish," Korda once explained to an Argentine reporter. "Why? Because in fifty or a hundred years, there will be people writing about the Cuban revolution, and this [archive] is a historical fact."

Those Korda photos that the public did see were often of remarkably candid moments. Deliberately eschewing the gray aesthetics of socialist realism then common to Soviet propaganda, which presented Russian leaders as vainglorious strongmen, Korda sought to humanize powerful people. Other Cuban photographers shared this style, but no one had the chance to apply it as frequently as he did to the man at the center of the country's revolution. "I was never interested in photographing [Castro] as a hero or a leader of the masses," Korda said in 2001. "My best photos are of very conventional and natural moments."

This effect is highlighted in the collections that emerged from

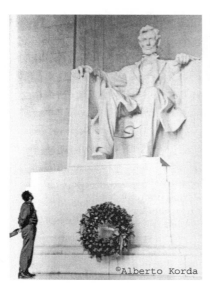

Castro visiting Lincoln Memorial, Washington, D.C., 1959, sometimes titled "David and Goliath." Photo by Alberto Korda.

©Alberto Korda

two Castro trips to the Soviet Union during Nikita Khrushchev's tenure, some of which are pure comedy. They include one of the two entourages engaged in a snowball fight in the Siberian woods and another, taken behind Castro, of the Cuban leader snapping a Polaroid of three generations of the Khrushchev family posing in front of a field at his Soviet counterpart's dacha. Whether consulting Khrushchev about a hunting rifle or awkwardly learning to cross-country ski, the Cuban leader appears as a familiar figure, almost like an oddball uncle. He elicits affection, not awe or fear. Such photos offer an appealing proximity to power, a voyeuristic peep into an exclusive world. It makes the lighthearted moments of such people's serious lives seem extraordinary.

Yet the gravitas of these shots also lies in their historical context. The snow-fight photo, for example, was taken just before the Cuban missile crisis. Once again, the events beyond the frame matter enormously. One Korda photo taken at Khrushchev's

Fidel Castro taking Polaroid photo of Nikita
Khrushchev's family, Khrushchev's dacha,
USSR, 1962. Photo by Alberto Korda.

dacha of a pair of cupped hands holding a mound of soil might
seem hardly significant. It comes alive when we learn that the
hands are Fidel's and the dirt is from Nikita's fields.

There's no documented evidence that Castro ever instructed
Korda or any other photographer to take such photos. But it
seems clear that the Cuban leader understood the value of show-

Polaroid of Khrushchev family in Castro's
hands, Khrushchev's dacha, USSR, 1962.
Photo by Alberto Korda.

ing himself in a natural, human light—at least before he threw his lot in completely with the Soviets in 1968, when the aesthetics of the Cuban revolution turned accordingly grayer. Shortly after his 1959 triumph, Castro held a live satellite television interview with Edward R. Murrow in his pajamas, during which he introduced the American audience to his son Fidelito, who entered carrying a puppy.

In fact, Castro was far cleverer than to rely solely on heavy-handed censorship in his propaganda efforts. Familiar with the teachings of Italian Marxist thinker Antonio Gramsci, who argued that control of popular culture was essential for winning the support of the masses, he sought to influence the entire cultural output of his country's artists, writers, photographers, musicians, and filmmakers. Incredibly, he had considerable success in doing so. He understood the power of photographic images. Some have described how Castro's posture would shift and his facial expressions and gestures would become more animated when a photographer entered the room.

The strategy in the early years was not so much to restrict the publication of negative images—which is not to deny that censorship was and still is very strict in Cuba—but to encourage positive ones. Fifty years later, many of the great photos of that era are deeply etched into public consciousness: Raúl Corrales's panoramic shot of a packed Plaza de la Revolución audience before a fired-up Castro, Korda's photo of the Cuban leader surveying the Sierra Maestra. They are part of the foundations upon which the Cuban revolution is imagined as an *idea*.

★

"The history of the revolution can be written by one writer or by a million, but it cannot be illustrated without turning to Korda, Corrales, and the group of photographers who took part in those moments," Corrales, the elder statesman of this pack, once said.

The group's members, who also included Liborio Noval and the father-and-son team of Osvaldo and Roberto Salas, were not neutral chroniclers of their age. Their photographs imbued the events of 1959 and afterward with historical importance, offering positive visions of sweeping social change. Forceful personalities in their own right, they resembled the clique of photographers who documented the Vietnam War a few years later, people such as Larry Burrows, Henri Huet, Tim Page, and Don McCullin. The Cubans, however, created a picture of hope, not despair.

The impact of this photographic enterprise owes much to the vibrant presence of *Revolución* and its first editor, Carlos Franqui. Antithetical to the conservatism of the Batista-era press, the paper promoted avant-garde art, ideas, trends, and concepts, as much in its content as in its layout and graphics. "The public identified *Revolución* with the revolution," wrote Franqui in a recent memoir. "The first page was a lampoon that sat somewhere between the posters of Cuban popular culture and the most modern typography: big ribbons, big and good photos, a red equilibrated with the black . . . not the olive green of Fidel and the rebel army."

This iconoclastic look was consistent with the way that many intellectuals and artists first saw the revolution itself. They believed that Castro's interventionist state, far from restricting private expression, would actively encourage the flow of information, ideas, and innovation, challenge U.S. cultural hegemony, and lay the foundation for an open, democratic society. "I embraced the revolution because it meant freedom," says Antonio (Tony) César Evora, who headed graphic design at *Lunes,* the paper's edgy weekly arts supplement. "I was filled with Dada and surrealism, and the new typography of Germany and Switzerland, so many different new ideas . . . I wanted to shake the royal Cuban palm tree. Everything was so gray and old visually in my country before then. And now I had this vehicle."

Later, as the regime drifted toward communism, the influence of the free-spirited founders of *Revolución* waned and many of them, including Franqui, Cabrera Infante, and Evora, became disillusioned with Castro and opted for exile. But in the first three years after 1959, the paper they created dominated the media. It benefited, of course, from its status as the official organ of the 26th of July Movement and from the new government's heavy-handed treatment of more critical media organizations, most of which were banned by the end of 1961. It was also rich in resources. After starting out as a clandestine pamphlet during the armed struggle, *Revolución* was suddenly endowed with all the assets it could want. In one fell swoop, Franqui's paper took over the printing presses, newsroom facilities, typewriters, and even the staff of the daily *Alerta*. (These had been left for the taking when Ramon Vasconcelos, the proprietor and a former Batista communications minister, made an early exit into exile.)

Photography enjoyed special prominence at *Revolución*. "Right from the beginning there was a lot of space in the newspaper . . . and day by day there was more space," recalls Roberto Salas, a Korda contemporary who still works in Havana. "They had full pages of this, full pages of that. Because of the political changes that were coming, a lot of the advertising had dropped out and there was a lot of empty space we had to fill. And there were a lot of illiterate and semi-illiterate people at that time—maybe 40 or 50 percent of the population . . . The paper started being distributed all over the country and the only way to tell the people what the hell was happening was through pictures." There can be no doubt that the group with which he is now associated was then at the cutting edge of photojournalism. "We came with a new mission, a completely different way of doing it: 35-millimeter cameras, natural light, high-speed film, no flash, and so forth," Salas said of *Revolución*'s adoption of a photo-essay format pioneered

by U.S. magazines such as *Life* and *Look* that had never really been tried in a daily newspaper.

By capturing a bright, distinctly American aesthetic, these photographers helped make the revolution accessible and appealing to the outside world, aiding Castro in his bid for moral support in his battle with Washington. (This later translated into financial benefits too: The Soviet Union saw a propaganda payoff in providing generous sugar subsidies to Havana to maintain an alliance with this internationally popular rebel state; Venezuela's Hugo Chávez has made the same calculation in recent years with oil subsidies.) The photos borrowed some of the sex appeal of pre-revolutionary Cuba and planted it in the framework of what many assumed would be a politically liberating new era. They turned Castro's revolution into a top-selling cultural "product," an international brand, and they laid the foundations for its ultimate expression: the Che T-shirt.

★

Korda's Guerrillero Heroico portrait was born amid this cultural renaissance. Korda would not have been where he was at the memorial for *La Coubre* if it weren't for the resources and encouragement of Franqui, Cabrera Infante, and other dynamic leaders of the early revolutionary media. In fact, as the myth about the photo's seven-and-a-half-year incubation has been exploded, the extent of the role played by *Revolución* in its early promotion has become ever more apparent. Korda was correct to state that his editors rejected his Che photo for the issue after the rally, but he never mentioned that they used it on at least three subsequent occasions over the following two years. Each of those low-key appearances now helps us reassert the historical roots of an image ingrained in global public consciousness.

In 2006, Trisha Ziff's world-traveling Revolution and Commerce art exhibition explored the Korda image's multiple and var-

ied appearances through time. It showed how two April 1961 editions of *Revolución,* fourteen days apart, used the image to illustrate an ad for a conference that listed Guevara as the keynote speaker. The first ad from April 14 was repeated because the very next day the invasion at the Bay of Pigs happened and the conference had to be postponed. Assuming Che turned up at the rescheduled event two weeks later, he wouldn't have looked as good as he did in the promotional material. During the rapidly suppressed invasion, Che's gun misfired, grazing his left cheek and temple, the bullet narrowly missing his brain. When a doctor treated him, the tetanus shot sent him into toxic shock. If, as the saying goes, the revolutionary saw his life pass before his eyes, it's fitting that he might also have then gotten an advance glimpse of what his afterlife was to look like. As Ziff noted, Guevara quite probably saw the ads in *Revolución* and so witnessed "the photo that would later contribute to his iconic status."

More recently, publisher Roberto Massari, who heads Italy's Che Guevara Foundation, reported that the first appearance of the Korda Che occurred at an even earlier date. In an archive he maintains in Italy, Massari found an ad similar to the later ones in *Revolución*'s August 18, 1960, edition. Separately, Tony Evora told me he once hand-drew an enlarged reproduction of the Korda image in black ink for the back page of the same paper sometime between September 1960 and December 1961. (He could not recall the exact date and said he never kept a copy. I was unable to find any record of this piece during a search of the paper's admittedly incomplete archives in Havana.)

Revolutionaries are supposed to frown upon idolizing the living in this way. But it was hard for these young artists, photographers, and editors to ignore Che. He was a striking-looking human being, supremely photogenic. "He was a guy who you took pictures of no matter where he was and you always had a good image," says Salas, who notes that in Che's five years as a Cuban

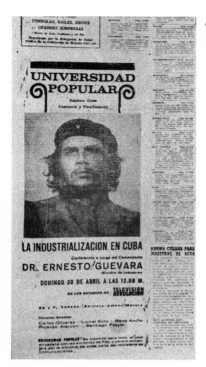

Revolución newspaper, April 14, 1961.

official around twenty-five "exceptional photographs" were taken of him, many more than of Castro in his fifty years of public life. Taking a dig at Castro's not-so-sexy-looking brother and recent successor, Cabrera Infante explained Che's idol-ready face in another way: "Imagine for a moment Raúl Castro occupying the same historical place, and you will know why [Che's] image is so popular."

BANISHED, CRUCIFIED, RESURRECTED

Unhappy the land that is in need of heroes.
—Bertolt Brecht

BY 1965, THE question of Cuba's independence from the Soviet Union had become a hot-button issue. For his part, Che had decided it was better to go it alone in the battle against *yanqui* imperialism and was blasting the Soviets for not supporting third world liberation. Castro wanted independence too, but he knew that cutting ties with the Kremlin was not easy. Sugar prices were low, and the domestic output of Cuba's primary export crop was falling behind that of its competitors. With the U.S. embargo in place, the regime's very survival depended on Soviet sugar subsidies. And while Moscow's foreign aid was an indication of how much it valued an alliance with Cuba, a valuable toe in the Americas, the subsidies were not set in stone. Now Castro's efforts to get them increased were being hindered by Che's anti-Soviet diatribes. Guevara's view was popular among idealistic revolutionaries, which put Fidel in an awkward position. To publicly rebuke his charismatic colleague just to keep the Kremlin happy would have carried a great political cost.

All of a sudden, a solution landed in Fidel's lap: Che gone forever. Although there is no clear evidence backing the oft-stated assertion that Castro engineered it, Guevara's disappearance from public life in April that year was undoubtedly convenient for the Cuban leader. He could now have it both ways. He could publicly show support for his old comrade in arms while Moscow could rest easy that the man who posed the biggest threat to political continuity in Cuba was physically incapable of exercising it. The fact that Che had renounced his citizenship offered an additional guarantee.

In the months and years that followed, Castro—ever the risk taker—upped his bet, increasingly speaking out in support of the absent guerrilla's internationalist vision and encouraging Marxist revolution in Latin America—a challenge to Soviet leadership of world socialist affairs. Yet much of it was pure Fidel theater. It was more of a symbolic distancing from his patrons than a real one, and he could easily take back the rhetoric when he needed to go back to them, cap in hand. To be sure, Cuba did provide material support to revolutionary movements—in addition to Che's Congo adventure, it trained guerrillas in Guatemala and Venezuela, for example. But the essence of Castro's policy shift was about creating an impression of change, not real substantive change: an *image* of Guevarism.

For this theater to have its desired effect, the Cuban leader needed an irreproachable image with which Cuba could be identified. Che fit the bill perfectly. So, beginning with the release of Guevara's farewell letter on October 3, 1965, Castro progressively converted the missing guerrilla into a kind of premartyr. Metaphorically speaking, Che was already dead—in the audience when the letter was read, the guerrilla's not yet widow, Aleida March, wore black. To many Cubans, it sounded like a will. One way or another, the message was that Che was not coming back.

At first the process of idolization was gradual. Che's writings

were given prominence and his memory was evoked to promote the internationalist cause. Then midway through 1967, the "Che, Sí" campaign—as French art critic and social commentator Alain Jouffroy called it—went into overdrive, with visuals added to the mix. Two years after Che's disappearance and a full six months before his death, the Korda image was launched into public consciousness in Cuba, where it was in effect employed as a logo, or brand, for Castro's PR campaign. The genius of this strategy lay in its appeal to thinkers and artists of the Western European left, many of whom had lost faith in the Soviet Union, at that point controlled by the hard-liner Leonid Brezhnev. It also sat well with young radical students in the United States and Europe, who were impatient for societal change and for whom the very word *revolution* was inspiring.

The convergence of interests between creative leaders of popular culture and Fidel Castro coalesced at the Salon de Mayo artists' festival of 1967. This gala event was a marketing coup for Castro and gave early international exposure to the Che icon as a Cuban brand. Ostensibly a private sector affair, the salon was the brainchild and work of a few Cuban intellectuals with contacts among Europe's artistic elite. They managed to persuade eighty painters, sculptors, and writers, most of whom were Paris-based, to transplant their annual Salon du Mai from the French capital to Havana. Truth be told, the artists didn't take much convincing. Many, particularly those of the pop-art-inspired Figuration Narrative school, were eager to make art more politically engaged. They saw their rightful place in the social conflicts of their era as participants, not as art-for-art's-sake observers.

Incongruously, the decor that accompanied this indulgent summer-long party exalted the tough business of liberation struggles—Castro's grand theme of the moment. Che's ideas and image were everywhere. One sign at the salon, paraphrasing Che, read: PAINTERS AND GUERRILLAS, THE DUTY OF THE REVOLUTIONARY

IS TO MAKE REVOLUTION. In the Casa de las Americas, an impressive display of rifles was arranged into a pyramid sculpture. And yet it is hard to imagine a contrast starker than that of the French artists during their Cuban holiday and Guevara's doomed band of bedraggled soldiers at that very same moment. Che's Bolivian diary entry for May 16 says it all: "Just as we started out, I came down with intense abdominal pain, with vomiting and diarrhea. I got it under control with Demerol, but lost consciousness and had to be carried in a hammock. When I awoke I felt much better, but I was covered in shit like a newborn baby. I borrowed a pair of pants, but without water, the stench could be smelled for a league away."

Meanwhile, the artists were enjoying the "incomparable hospitality of the Cubans" at the "most luxurious hotels in Havana," as one Frenchman put it. There were constant parties with rumba music, conga lines, Habano cigars, and bottles and bottles of rum. A ten-minute documentary by Cuban filmmaker Bernabé Hernández depicts the event as a classic late-sixties festival of sex and fun. With a mix of psychedelic sound effects and bossa nova music, close-ups of bare breasts, and shots of a girl frolicking on the beach while French sculptor César Baldaccini plays the clown on a cross-Cuba bus trip, the film turns the salon into a celebration of Cuba's insertion into the happening, liberal art and music scene of the West in the late sixties. It hardly looked like a forum for promoting guerrilla campaigns in the unforgiving jungles of Africa, Asia, and Latin America.

When this planeload of eccentric Frenchmen descended on Havana in May 1967, they were greeted by cultural affairs minister Raúl Roa, who assured them, "The revolution guarantees and exalts the right of artists and writers to freely express present and future reality." The trick, though not everyone recognized it, lay in

second-guessing the revolution's definition of reality, which was by then tautological: Reality, or truth, was defined as all that is revolutionary; anything counterrevolutionary was an untruth, a false reality.

The stunting of the revolution's earlier creative boom by this oppressive form of thought control was the hidden subtext to the Salon de Mayo, one that ran counter to the *esprit de liberté* promoted during the event. To be sure, dance and music were still encouraged in Cuba—as they are today—and continued to generate significant creative energy, while many painters and other artists remained committed to the revolution and its anti-imperialist principles. Leading Cuban writers, on the other hand, were rapidly losing their enthusiasm, as political commentary and journalism were by now rigorously suppressed. For one former Castro loyalist who was actively involved in the arts festival, the shift had been especially painful.

Carlos Franqui, the visionary founder of *Revolución,* claims to have been the mastermind of the 1967 Salon de Mayo. Others say the event was the work of Paris-based Cuban artist Wilfredo Lam and Haydee Santamaría, the energetic director of the Casa de las Americas cultural center. Regardless, Franqui's networking with the Paris art scene was central to the salon's success. Indeed, it's remarkable how much energy he put into an event that promoted the Castro regime, given what this regime had done to his journalism career in the preceding years. After the government closed his newspaper's daring *Lunes* arts supplement, life got difficult at *Revolución,* whose editorship he quit in 1963, opting for life as a correspondent in Italy. Then in October 1965, at the founding of the central committee of the Communist Party, the 26th of July Movement's paper was closed altogether as Cuba became a one-party state and banned all nonaffiliated media organizations. Two new official organs of the party were created: the morning daily paper, *Granma,* named after the famous yacht,

and the evening paper, *Juventud Rebelde,* deemed the voice of the party's youth wing. Franqui watched in despair as these colorless mouthpieces of government propaganda became entrenched, thereby ensuring that for forty years Cubans would have nothing but two drab sources of news in print. And yet with the Salon de Mayo, he enjoyed a spectacular last hurrah. (A year later, the man who'd once been Castro's favorite journalist would defect.)

The salon's artistic centerpiece, displayed at Havana's Pabellón, or arts pavilion, was a sweeping mural to which all the artists contributed, a brightly colored collage that spun out from a common center. The mural's most striking single image, according to a number of close observers, was Cuban artist Raúl Martínez's painting of Che. Martínez, whose work mixed pop art with Latin American folk art, was at that time producing a series of Che pieces—affectionate renderings that employed a Warholian repetition of images of a saintlike Che. Art historian David Kunzle says Martínez's paintings represent the moment in which Che was "first apotheosized in art." These were not facsimiles of the Korda image—for one, the face is less stern—and may have been modeled on another Che photo. (A picture of Che taken in 1960 by Osvaldo Salas is one candidate.) Yet it's hard now not to see Korda's photo as the inspiration for these early 1967 portraits. It is quite likely the first graphic reproduction of an image that would later spawn thousands more derivative works.

The best-known of these paintings replicates Che's face in nine panels across which are disjointedly displayed the words *Che America.* In his *Lápiz y nube* blog, art historian Ernesto Menéndez-Conde recently speculated that the letters might have contained a disguised nod to the sarcastic humor of underground gay culture. Noting that Martínez had put the second *E* in a different color from the other letters, Menéndez-Conde suggested that the painter had arranged the letters to hint at an alternative phrase: *"Chea Marica,"* which in Cuban slang means "cheap

queer." Martínez, who was persecuted for his homosexuality, pulled such a trick in another piece of iconic revolutionary art, his pop art mural *Isla 70*. (There, a keen eye will find erect phalluses disguised as cane stalks.) But to joke with Che like that would be audacious to say the least. When I asked the artist's partner of many years, the Cuban playwright Abelardo Estorino, he adamantly rejected the idea, arguing that Martínez would never have toyed around with "such an important Latin American figure." The Che Marica thesis was the result of after-the-fact overanalysis, he said.

Menéndez-Conde corrected his blog entry after I recounted to him my conversation with Estorino. Nonetheless, since we are dealing with an image that is the subject of so many competing myths, stories, and distortions, it remains tempting to imagine that one of its most important reproductions was designed to simultaneously poke fun at and venerate the Che icon. It would be classically Cuban, in keeping with the *doble cara* (two-faced) humor of the island's culture. After all, Cuban officialdom appears to have made its own reality-distorting amendments to this very piece. Although the painting, which is often referred to as Che America, was clearly finished by the time of the 1967 Salon de Mayo—five months before Che's death—it now hangs in Havana's fine arts museum under the title *Fénix* (Phoenix) and is dated 1968. It appears that a work of art made in honor of the living Che was retroactively altered so as to pay homage to the martyred Guerrillero Heroico. Whether the title was also changed is not clear. Although Phoenix hardly seems an appropriate label for a man who has not yet died, it would not have been the only instance during the summer of 1967 in Havana in which that term was used in reference to the missing Guevara. One French painter at the Salon de Mayo who was greatly impressed by Martínez's work produced a neon montage based on a Che theme and called it *Guevara the Phoenix*. Bernard Rancillac, founder of

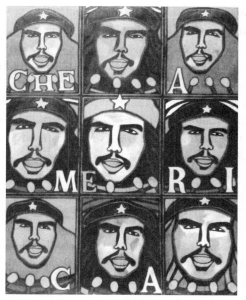

Fénix (*Che America*), Raúl Martínez.
Collection of El Museo Nacional de Bella
Artes, Havana.

the politically driven Figuration Narrative school, who still lives
and paints in Paris, does not know where this work is now.

The Martínez-Rancillac connection is significant for other rea-
sons, as it forms something of a nexus between the 1967 salon in
Havana and the May uprisings of Paris exactly twelve months
later, which are widely regarded as the events that gave the Korda
image its most important boost in Europe and the rest of the
world. Rancillac and other artists present in Havana became
directly involved in creating the aesthetic environment of the
May 1968 uprisings. They contributed to the vivid posters and
banners that caught the attention of the world's photographers.
Among the flags and posters displayed everywhere during those

events was a fiery black-on-red one based on the Korda image, accompanied by the slogan "Che Vive!"

★

Midway through 1967, the Cuban government metaphorically resurrected Che before he'd even died. And in so doing, it employed the Korda Che as one of its symbolic vehicles. Foreign magazines' pictorial coverage of the programmed events in Havana and Santiago de Cuba for both the Salon de Mayo and the inaugural conference of the Organization of Latin American Solidarity (OLAS) two months later include large billboard reproductions of the image coupled with Che's sayings. These leave no doubt that the Korda Che's debut as a political icon occurred under Castro's direction during the 1967 Havana summer, not, as the photographer always maintained, in Europe in the fall of 1967 at the moment of Che's death.

The OLAS event, which attracted thousands of socialist delegates from around Latin America, as well as honored guests from places such as North Vietnam and North Korea, clearly exhibits the political motivations behind this propaganda. This event also marked another awkward marriage of anti-imperialist, revolutionary rhetoric with Caribbean decadence and marketing gimmicks. Highlighting "fiestas in which white-coated waiters scurried up with icy daiquiris, Scotch, etc.," *Look*'s Laura Bergquist estimated that "OLAS couldn't have cost the Cubans less than a million bucks." She called it "the most garrulous, lavish, least clandestine guerrilla meeting in history" and observed that it came with a key change in the revolution's iconography: "Down had come the old posters of Mao, Lenin and Marx; Kosygin was noplaceville. Propaganda, commercials, celebrated heroic Latin guerrillas, Bolívar, guns, guns, guns and, towering above all, the myth-hero Che Guevara, sometimes in red beret—Cuba's answer to the U.S.

green beret. His sayings peppered the countryside: 'The duty of every revolutionary is to make revolution' or to 'create two, three . . . many Vietnams.' "

The presence of markers of Che at this event was deliberately provocative. It was targeted at delegates from the region's traditional communist parties, who, in line with Soviet interests, were resisting a call to arms. Castro's message was that, unlike him, these pacifists were too beholden to Soviet demands to risk lives in the interest of defeating capitalist imperialism. To prove that Cuba was different, he wielded the Guerrillero Heroico. Cuban officials, who acknowledged for the first time that Che was conducting guerrilla warfare "somewhere in Latin America," named him honorary chairman of the conference. And when Castro closed the event on August 10, a giant photomural of Che's face was used as the backdrop for his speech. The mural certainly impressed the American John Gerassi, a former *Newsweek* editor turned leftist writer, who reflected on its meaning: "Like a revolutionary phoenix, Che Guevara is rising from the ashes of his own, self-imposed obscurity."

★

Two months later, Che really did die, posing a tough test for the faithful who'd left the OLAS event inspired by the idea that the Cuban revolution and its leading guerrilla icon offered hope for a better world. Now it became clear that he was not invincible, and by extension, neither were they.

In spite of the theories blaming Castro for Guevara's death, he was close to Che and reportedly was saddened by his death. Nevertheless, the Cuban leader sought to turn loss into victory. Just nine days later, on the night of October 18, 1967, the biggest public gathering in Cuban history occurred in Havana's Plaza de la Revolución—many estimates put the crowd at one million. A somber yet grandiose ceremony began with Cuba's de facto poet

laureate Nicolás Guillén, who read an ode to his friend. The poem, simply entitled "Che Guevara," compared its subject to both Argentine South American liberator José San Martín and Cuba's José Martí and would become only the first of countless other Che-dedicated poems and folk songs over the years. The poem was followed up by a film projected onto a giant screen, one that cobbled together footage from the Sierra Maestra, Che's speeches, and newsreels about U.S.-Bolivian operations.

As Castro rose to the podium, "there was a silence never known before in the Plaza de la Revolución on days of marches," *Granma* observed. In a slow, deliberate speech filled with off-the-cuff oratory and many hand gestures, Castro took his people from a somber reflection on their nation's pain into an inspiring crescendo of hyperbole. Che was a "person of total integrity" with the "fullest expression of the virtues of a revolutionary," in whose "conduct not one stain can be found," Castro intoned. He was a man whose "ideas—as a man of action, as a man of thought, as a person of untarnished moral virtues, as a person of unexcelled human sensitivity, as a person of spotless conduct—have and will continue to have universal value." By contrast, Che's killers had shown "the weak side of the imperialist enemy," believing "that by eliminating a person physically they have eliminated his thinking."

Castro closed with a new motto for Cubans: "If we wish to express what we want our children to be, we must say from our very hearts as ardent revolutionaries: We want them to be like Che." Ever since, Cuban schoolchildren have chanted each morning: "Pioneers for communism! We will be like Che." Suddenly this very un-Cuban Argentine—who'd spent eight years in their country as a troop commander, government official, and bureaucrat—was reintroduced to Cubans as the ultimate standard-bearer of revolutionary virtue.

Throughout the ceremony, the audience's eyes were repeatedly directed to a massive version of Korda's Guerrillero Heroico photo

draped behind the stage. In a declassified memo, an unnamed CIA operative cited the use of "extreme close-ups, filling the outdoor screen, of Che Guevara's face" and "cameras [that] pan to huge photomurals of Guevara illuminated by floodlights." Later, the memo continued, "shots of half-masted Cuban flags [were] superimposed on the huge Guevara photomural," which was illuminated again during a twenty-one-gun salute and throughout the subsequent speech by the Cuban leader.

Meanwhile, on display in the crowd and on the streets of Havana was a Guerrillero Heroico poster that Frémez, Korda's old drinking buddy, had produced days earlier after he'd heard of Che's death. By running a simple screen print on basic red paper from an enlarged print of the photo he'd received years earlier from his photographer friend, the artist had turned Che's face into a haunting gray visage. "Red was the only color available," he explained to me, weaving a common Cuban tale of creativity born out of scarcity. Perhaps because Frémez's version was rather basic, the government later commissioned another Korda image poster by Antonio Pérez González (known as Ñiko), which multiplied more solidly contrasted two-tone images of Che's face across the page. For this reason, Frémez's work later earned the title as the first-ever private Korda Che poster, while Ñiko's was recognized as the first official such work. (In fact, it appears that neither deserves such honors: A photo in an August 1967 edition of *Paris Match* taken during the OLAS event shows a Cuban at a rally holding an unidentified black-and-white poster of the Korda image.)

Notably, both Frémez's and Ñiko's posters carried the words *Hasta la victoria siempre* (Ever onward to victory), which Castro used for the first time at the end of his eulogy, along with "Patria o muerte" (Homeland or death) and "Venceremos" (We will win), his standard closers. In its clever yet oxymoronic merging of the notion of an endless revolution with a confident prediction of its

successful conclusion, "Hasta la victoria siempre" has become for Che's followers an affirmation of their faith that their hero's eternal spirit will eventually lead them to the utopia they seek.

In this event, we witness what can be thought of as a brand launch. There, in the Plaza de la Revolución, the Cuban revolution's world headquarters, its leader converted the hitherto little-known Korda image into a powerful mnemonic, a lasting logo. Castro combined the Cuban revolution, Che's stellar qualities, and the Guerrillero Heroico image into a single attractive product. And he had a ready-made target market: the restless youth of the world. Just as urban sneaker-wearing teenagers seem susceptible these days to advertisers who encourage them to identify with brands such as Nike or Tommy Hilfiger, in late 1967 radicalized students across the Western world were ripe for the Che brand. Enrique Ávila González's well-known steel sculpture of the Korda image, which now looks down upon the Plaza de la Revolución from an adjacent wall of the ministry of the interior, is more than a memorial to Che. It is a monument to one of the Cuban revolution's greatest marketing accomplishments.

Castro declared 1968 the Year of the Guerrillero Heroico in Che's memory. More accurately, it might have been called the Year the Punch Bowl Runs Out. In Cuba in 1968, all private enterprise was prohibited, wage bonuses were dropped in favor of Che's "moral incentives" plan, the voluntary labor program was greatly expanded, and a raft of draconian restrictions on social behavior and personal expression was imposed. At the same time, with Cuba's finances in dire straits, Castro showed a much friendlier face to his financiers in Moscow, who eventually bought more sugar at inflated prices. This was vital. Cuba's production of its primary commodity had stagnated over the preceding decade, while total global output had risen 33 percent. In return, Castro

dropped his criticisms of the policies of the Soviet Union, got closer to the traditional nonbelligerent communist parties of Latin America, and most controversially, voiced his explicit support for "fraternal assistance" missions, such as the Soviet invasion of Czechoslovakia.

The deal was disastrous for Cuba over the long term: Dependency on Soviet largesse postponed the development of stand-alone competitive industries. But for Castro, it was a brilliant political maneuver. He'd given up real economic independence but maintained the illusion of political independence, partly with the help of the Che brand. "The process over those years between Che's departure and the new line in foreign policy that began to emerge in 1968 was contradictory," wrote Mike Gonzalez in *International Socialism,* the journal of the British Socialist Workers Party. "Its ideology was internationalism, a critical attitude towards the Soviet Union and the creation of an independent national economy. Its reality was an early recognition by Castro that this perspective was utopian; consequently he sought a rapprochement with the Soviet Union while conserving a degree of political space within Cuba that would ensure his continuing control over the state. In that sense, the portrait of Che was the mask that Castro wore."

The man who made this mask had a harsher 1968 than most. As a member of the now banned petit bourgeoisie—a group that included barbers, at-home garment makers, and hot dog sellers—Alberto Korda had to forfeit control of his beloved studio, the centerpoint of his vibrant social, cultural, and professional life. Although the same demand was made of other photographers, few suffered as much as Korda.

Figueroa remembers the day clearly: "It was the fourteenth of March. First, two officials from the police department's technical investigation division came looking for photographs of a pornographic type, of lesbianism or of nudes. And of course they found

stuff, because the problem was that like all police they couldn't distinguish between a beautiful artistic photo of a naked woman and pornography. For them, a tit was a tit."

The police ransacked the office and carried off the studio's entire collection of prints and negatives. A desperate Alberto called his friend Raúl Corrales, then head of the national photography archives, who in turn asked Celia Sánchez to intervene, apparently convincing her of the value of Korda's work to the national heritage. One box of negatives and prints from that decade labeled "archives of the revolution" had been kept separately, including the historic photos Alberto Korda took as Castro's companion photographer and his negatives from the March 5, 1960, roll with the two Guerrillero Heroico shots. This set, which also contained photos by Luis Korda, was the only one rescued under Sánchez's orders. Everything else from the studio's fashion and publicity work—between 85 and 90 percent of the collection, Figueroa estimates—was lost.

Security issues, argues photojournalist Lockwood, explain this raid. "When he kind of just became Fidel's personal photographer, [Korda] had no goal. He wasn't looking for coverage, he wasn't looking for great shots that would go down to his fame . . . but the problem was that Korda had all the pictures himself. He kept them. They didn't go anywhere . . . and at one point, it must have been in the sixties—it probably had something to do with the Soviets—they realized the risk. It was the fact that he had his hands on all these precious images and that they could be misused. No one had monitored what he was doing with his pictures. He just had them . . . and then came this moment in which someone said, 'Jesus Christ, we can't let this go on.'"

Once they were recovered, Korda officially "donated" the negatives from the revolutionary file to the national archives. But he retained copyright and exclusive access, rights that were later extended to his heir, Diana Díaz. Legally, and for practical

purposes, she has been able to treat those photographs as her property. But the fact of the state's physical control over the negatives raises concern about the uncertainty of the post-Castro period. How might a new government treat its assets?

While Korda had access to his revolutionary photos, the loss of his fashion shots was a big blow. "In essence, they took away his women, which is a big deal for any man, but especially for a man like Korda, who was in love with women," says Hector Sandoval, the director of *Kordavision,* a documentary about the photographer's life made shortly before he died. Korda's daughter Norka is more specific. The lost photos, she said, came from "a period as a photographer in which he put a great deal of humor into his work, the great bulk of which was done with my mother. Alberto was crying that day because he said they had lost all the work that they had done together. Yes, I believe it was a heavy burden, a very heavy burden to bear."

Some believe the politics of the security raid had to do with the risks posed to certain individuals in those increasingly prudish times by the potential existence of compromising photos. "There were a lot of photos of models and of women, half-naked women, and half of them were of people's wives and girlfriends and could have been used for blackmail," says Darrel Couturier, the Los Angeles gallery owner who acted as Korda's agent in the United States. "Korda never admitted to that. But you have to ask: Why didn't they return those along with the revolutionary photos?" Simple malice or revenge may also have been at play. "There was a lot of jealousy among many Cuban photographers that had naturally built up over the years over his access to Castro," says Lockwood of Korda. Meanwhile, the photographer's ostentatious ways made matters worse. "I heard him say that people would talk at the time about how he was driving a Porsche," notes Couturier. Korda got rid of the sports car after 1968, opting instead for a Volkswagen Passat. When he eventually traded in that vehicle

later for a Lada, the boxy East German car that's even more common on Havana's streets than 1950s Chevys, the photographer's personal automotive history had become a metaphor for Cuba's economic path over four decades of revolution.

★

The government's treatment of Korda shows how ideologically extreme Cuba's revolutionary offensive became after Che's death, a sweep that Castro biographer Tad Szulc described as Cuba's version of China's Cultural Revolution. The government nationalized a total of "58,012 businesses, ranging from auto mechanics, repair shops to small stores, cafés, and street vendors of sandwiches and ice cream," according to Szulc. Photography and other artistic works were now officially viewed by the communist bureaucracy in the same utilitarian terms as other forms of work, with absurd results. Figueroa recalls that the studio was simply handed over to a female hairdresser, who declared it "the Administrative Headquarters of the Barbers and Hairdressers of La Rampa Zone." Why was a photography business linked to hairdressing? "Because the Commercial Interior Ministry now classified the work of photographic studios as 'minor services,' which included barbers, hairdressers, photographers, shoe cleaners, and others," Figueroa said.

The government's 1968 shift in policy killed the last vestiges of early 1960s liberalism. In September of that year, Castro launched a tirade against young Cubans who lived in "an extravagant manner," those listening to rock music and displaying long hair and fancy clothes. A decimated press, by now incapable of thinking for itself, jumped on the bandwagon. One commentator denounced guitars, marijuana, and those who "danced madly to epileptic music" and formed "bands of schizophrenics." There were forced shavings of long-haired men, labor camp assignments for miniskirt-wearing women, and a fresh crackdown on

homosexuality. It was truly ironic that in Western cities long-haired students who listened to rock music and professed sexual liberation brandished images of a similarly long-haired Che Guevara in the belief that Cuba was a model to follow. For them, Che was a symbol of rebellion. In Cuba, by contrast, where there were reports of authorities detaining youths accused of desecrating his image, Che was already a symbol of authoritarian rule.

In 1967, Castro proposed that writers and artists reject the principle of copyright. The country had already dropped out of the international Berne Convention on artistic and literary copyright standards. Now its leader was goading writers into denying ownership of their creative output. Incredibly, the Cuban Writers Union unanimously accepted the idea. Sounding a bit like Che, the young writer Jaime Sarusky argued that "nonpayment enabled the author to realize himself as a human being." Thirty years later, once Cuban copyright was restored, Sarusky would write forewords for books of Alberto's photos that were sold for profit by the Korda estate. But in the interim, the owner of potentially the most lucrative photo in the world could do nothing but watch as it was propagated freely around the world.

Meanwhile, Korda shifted his line of work. After a brief stint at *Granma,* where he couldn't deal with the socialist realism it favored, the photographer ended up in the oceanographic department, assigned to photograph Cuba's coral reefs. He'd gone from models to revolutionaries and finally to water. Korda loved scuba diving—friends say he introduced Castro, a longtime diving enthusiast, to the sport—but he still suffered for the loss of his upscale lifestyle and studio. And yet, according to Diana Díaz, he quietly accepted the government's excesses. "My father was a very revolutionary man," she said. "Although he had lost something that was a part of him, something he had built with his own money and efforts, he believed right up to the last minute of his life in the revolution." Lockwood says it was even more personal

than that. His friend never left Cuba, despite what happened, "mostly because he believed in Fidel," the U.S. photojournalist says. "I think it was a personal commitment, not at all ideological or political. It was an emotional response. I think Korda had a great ability to idealize people who were serious and committed. Once he got close to Fidel, he saw something there that was admirable in terms that he couldn't deny. He became a true believer."

By the end of the decade, Korda was free to join his former photographic assistant in private photography and publicity work as Cuba moved away from Che's extremism. This was possible, Figueroa explained, because by then "there was no oceanographic work to do . . . he could not get out to sea because there were no boats leaving, there was no fuel, no equipment, no cameras." Still, it would not be until midway through the 1990s that Alberto Korda would again have the right to own and control his own work, including his world-famous classic.

MILAN, PARIS, BERKELEY

Art, Fashion, War, and Peace

Martyrs, my friend, have to choose between being forgotten, mocked, or used. As for being understood: never.

—Albert Camus

MANY CONFLICTING CLAIMS exist over how and when the Korda image first left Cuba and who first published it overseas. There's Korda's account of Italian publisher Giangiacomo Feltrinelli paying him a visit sometime in 1967 and then taking his photo back to Italy to turn it into a poster just after Che's death. There is Irish pop artist Jim Fitzpatrick's tale that he received a print around the same time from people connected with Jean-Paul Sartre. And there's the Korda Che on the cover of the October 1967 edition of Paris-based *Opus International,* a graphic that went public when the magazine hit the newsstands just after Guevara died but that was most certainly conceived and produced before then. (Intriguingly, this minimalist work by Polish artist Roman Cieslewicz seems to assume public familiarity with the image.)

But after curator Trisha Ziff cited the August 19, 1967, edition of *Paris Match* in her exhibition, the debate has more or less been

Cieslewicz's *Che Sí* poster, also used as the cover for
Opus International, October 1967.

closed. (At least until stronger evidence supporting some reputed
mid-sixties sightings in Vietnam and Brazil comes to light.) In that
issue of the French society magazine, the photo was displayed
in a full-page reproduction alongside other shots of Che-related
scenes in Havana (including a rally in which a poster of the Korda
image is held aloft) and an accompanying article about the missing
Guevara by French war correspondent and novelist Jean Lartéguy.
Hinting at the image's status as a propaganda tool even before
Che's death, Lartéguy describes it as the "official photo" of Che.

But establishing who was first and on what date does not

"Les Guérilleros" article by Jean Lartéguy, *Paris Match*, August 17, 1967.

explain the image's move into global prominence. A full account-
ing of how that happened would require the input of thousands of
people for whom Che signifies something important—an impos-
sible task, which is why this book offers just a sampling of their
stories. At this point we'll start with a smaller group of movers and
shakers who play key roles in the early days. Exploring these tales
of the image's early incarnations, we find a striking interconnect-
edness. The intersecting stories confirm the observations of Mal-
colm Gladwell, author of *The Tipping Point,* who describes the
presence of small groups of people with key personality types at
the heart of any cultural epidemic, such as fashion fads and other
changes in mass behavior. Gladwell talks of *inventors,* who create
the idea; *mavens,* who process information about it; and social
networkers, whom he calls *connectors,* those who disseminate the
information. His model would have Che as the inventor of an
idea called, let's say, revolutionary fervor and would see him ably
assisted by two mavens who communicate information about his

idea: Korda, with photographic information; and Castro, with propaganda and rhetoric. Later, Korda reappears as a connector. Aided by his gregarious personality and his ties to well-connected people, the photographer forges relationships with international, influential people, to whom he passes copies of his print as gifts. These gifts become starting points for the image's spread throughout the world.

<center>★</center>

Feltrinelli's story is as good a place as any to start. Even if it was beaten to the punch by *Paris Match,* his three-foot-by-two-foot black-and-white poster still stands as an important historical marker in the icon's European launch. And that's because it was timed perfectly, if accidentally, with Che's death. Korda gave a free copy of Guerrillero Heroico to Feltrinelli when the millionaire visited Havana in April 1967. But it wasn't until six months later that he did anything with it. Carlo Feltrinelli, who today runs his father's publishing house, told me of footage showing his father unveiling the poster at the 1967 Frankfurt Book Fair. But then the timing is off: The Frankfurt fair's opening was on October 12. This suggests the poster was made before Che was pronounced dead, consistent with the younger Feltrinelli's claim that it was intended not to commemorate his death, but to prevent it. Regardless, its appearance just happened to synchronize with Che's new status as a martyr. Back in Milan, the posters flew out of Feltrinelli bookstores as young Italians took to the streets in anger over Che's death.

Cuban officials had assured Korda the Italian was a good revolutionary, so the photographer was justifiably annoyed when the poster bore the words "Copyright Libreria de Feltrinelli." Yet Korda's claim that Feltrinelli printed a million posters and that the Italian reaped an enormous profit is far-fetched. Forty years

later, copies of the original poster are nearly impossible to locate, says art historian and collector David Kunzle. As for profits, Carlo Feltrinelli, who used his publishing house's archives and resources to investigate, write, and publish his father's biography, maintains that the poster was purely promotional and was given away to support the cause of revolution.

Giangiacomo Feltrinelli's rise to fame took an unorthodox path. As the heir to one of Italy's powerful family business empires—an elite group that includes the Agnellis, the Pirellis, and the Mottas—he inherited a fortune. But rather than follow his father, Carlo Sr., into high finance, Giangiacomo came out of World War II, during which he had fought in the antifascist underground, determined to use his wealth for socialist purposes. After joining the Communist Party, he hit upon the idea of founding a progressive publishing house.

Feltrinelli's first and biggest publishing coup was ironically an attack against the left-wing establishment and, unintentionally, a blow in favor of U.S. capitalism. In a daring maneuver, he smuggled Boris Pasternak's explosive anti-Soviet manuscript for the novel *Dr. Zhivago* out of Russia. Soviet records show that the Kremlin desperately tried to get Feltrinelli's communist associates in Italy to stop him from publishing the book. It has also come to light that the CIA covertly financed the publication of a pirated Russian-language copy of Pasternak's novel to help him win the Nobel Prize in 1958, all with the goal of embarrassing the Soviets.

Neither agent in the Cold War had any real claim to Feltrinelli's loyalties, however, which moved increasingly toward a progressive revolutionary form of socialism. This shift occurred under the influence of Fidel Castro—they met in 1964 in what was originally conceived as a business venture, a failed attempt to buy the Cuban leader's memoirs. According to his biographer son Carlo,

Feltrinelli was at first skeptical of Castro, put off by his verbosity, his lack of punctuality, his ego, and his bigoted views on homosexuality. And yet, like many other influential media personalities who count themselves as Friends of Fidel—a group that includes Ted Turner, Oliver Stone, Gabriel García Márquez, and many others—Feltrinelli eventually warmed to the charismatic Cuban. Fidel changed his life.

"In 1964, when I became Castro's friend, I no longer believed in anything. No type of commitment, either ideological or political . . . But finding yourself talking about world politics face-to-face with a head of state, and being in direct contact with a concrete environment like the Cuban one, can change something in your life," Feltrinelli explained to an Italian magazine in 1967. "We are living in times in which we do not know how to give a content, a perspective to our anxieties. We talk of politics and we talk of it in an abstract way . . . But not Cuba. Cuba is there, and politics is constructed day by day with immediate effects."

To Feltrinelli, Castro was "an intellectual of action—not a philosopher or thinker," who helped a man of words and books understand the value of putting politics into practice. The Cuban converted the millionaire into a militant. Naturally, Feltrinelli also came to admire Che Guevara, the ultimate example of words made manifest as action. So, kissing good-bye to a $25,000 advance he'd handed to Franqui in 1965 for Castro's never-finished memoirs, he focused on a book about Che and revolution. This is what brought him to Korda's photo. Thinking publicity for both the book and the cause—by now they were one and the same to him—Feltrinelli sought out the best image available of Che during his 1967 Havana visit and was directed to Korda.

Initially at least, Feltrinelli was not a man of guns; he was a publisher with a knack for symbolic gestures. This is what motivated him to go to Bolivia in August that year to personally inter-

vene in the trial of one of his publishing house's authors, Régis Debray, a young Che-admiring philosopher whose arrest there on subversion charges had converted him into a French cause célèbre. Feltrinelli had become convinced, like many others, that Che, the man whose story he badly wanted, was in Bolivia too. Even here, though, the guiding hand of the Cuban government is visible. According to Carlo Feltrinelli, the idea of attending Debray's trial in Camiri, Bolivia, was hatched by Cuba's legendary head of espionage, Manuel "Red Beard" Piñeiro, who dispatched the first secretary of the Cuban embassy in Rome to meet his father in early July of that year. It took the senior Feltrinelli five minutes to make up his mind, his son wrote.

In the bustling, mostly indigenous Indian city of La Paz, the tall, mustachioed Italian stood out like a sore thumb. A week later Feltrinelli was arrested—according to former interior minister Antonio Arguedas (who later earned fame and notoriety for smuggling Che's diary and severed hands to Castro in Cuba), the Bolivian government was tipped off about Feltrinelli's presence by the CIA. Feltrinelli was detained for a few days, becoming a media sensation but also harming another of his objectives: keeping Che alive. The Bolivians were reminded of the world attention that Che's trial would attract.

As military activity against the guerrillas intensified, Feltrinelli apparently became desperate to save Che's life. Believing that more, not less, publicity was the answer, he sought to raise Che's profile. That's why he dusted off the photo he'd gotten from Korda six months earlier and printed the now-famous poster. But by the time the poster hit his bookstores it was too late.

Che's death made Feltrinelli's poster a big pop-culture hit; it also radicalized the publisher and sent him toward his own demise. A year after working with the Cuban government in 1968 to rush out the first foreign-language edition of Che's diaries, with

a publisher's note promising that the proceeds would "be donated to the revolutionary movements of Latin America," he was named as a suspect in a 1969 Milan bombing that left sixteen dead. He fled to a secret hideout, disappearing from public view, à la Che, for three years. In 1971, after the death in Hamburg of Roberto Quintanilla, a former army colonel involved in the campaign against Che, police discovered that the pistol that killed him, fired by a German-born Bolivian woman, was registered to the missing publisher. You could say that Feltrinelli's involvement in this incident, one of the many untimely deaths and accidents to befall Bolivian leaders of the 1967 military campaign, implicates him as an agent of the famous "Ghost of Che."

On March 14, 1972, Feltrinelli was found dead at the base of an electricity tower on the outskirts of Milan. He was the victim of a premature explosion of fifteen sticks of dynamite strapped to the structure's foundations. Some at first suspected Feltrinelli had been murdered. Others found a romantic appeal in the "terrorist" label that the Italian press now pinned on him. "A Revolutionary Has Fallen" was the headline in the Italian Workers Power Party magazine. Feltrinelli's legend was fortified by his lonely death at age forty-five and by its association with another act of failure. In dying in this way—also à la Che—the millionaire publisher further made a connection with the man whose icon he helped create.

★

Shortly before he disappeared, Giangiacomo Feltrinelli was wandering the world, not unlike Che's globe-trotting in the months before April 1965. One of his travels brought him to New York, where his half sister Benedetta Barzini had landed in the avant-garde world of Andy Warhol's Factory in Greenwich Village. Feltrinelli never met Warhol, but he did make a connection with

the artist's main collaborator, the poet Gerard Malanga. Malanga became quite close to Feltrinelli and even made a short film about him, while Barzini became the poet's muse. In late 1967, Malanga went to Italy, in part to convince her father (Feltrinelli's stepfather), Luigi Barzini Jr., to permit him to publish poetry about his daughter. When that permission was not forthcoming and as he struggled to raise money for a film he planned to make, the cash-strapped Malanga decided to forge some paintings of Che in Warhol's name in a bid to make some quick money. As Malanga puts it, Che was to him and other artists of the sixties generation "our first martyr." It was perhaps with this in mind that in December that year, he produced two large Warholian Che works on canvas and at least twenty smaller pieces on paper. He had no trouble lining up a big-name exhibitor, winning the support of Plinio de Martis, the owner of Rome's Galleria de la Tartaruga.

Just before the opening of the exhibition in February 1968, Malanga figured he should let his famous collaborator in New York know about what was going on. "I assume everything's OK with you about me selling an 'Andy Warhol' painting," he wrote Warhol. He assumed wrongly. The pop artist's New York dealer told de Martis that his client had never made the Che paintings, prompting the furious Italian collector to threaten forgery charges against Malanga. In a series of increasingly desperate letters, the poet pleaded with Warhol to formally assert authorship of the paintings to save him from prison. Warhol eventually relented, declaring in a telegram that the paintings were the "authentic works of Andy Warhol" while noting as an aside that Malanga was unauthorized to sell them and that payment should be wired to him. De Martis knew the verification of authenticity was false but was apparently more concerned about his reputation as Italy's best-known collector of contemporary art than about knowingly purchasing a forgery. So he dropped the threats

against Malanga. Warhol had done well: He'd saved a former associate from prison and a prominent collector from public embarrassment. In the meantime he'd pocketed a check for paintings that weren't his to sell.

After David Bourdon recounted this bizarre story in a biography of Warhol, it was widely assumed to explain the origin of an especially ubiquitous pop-art-style reproduction of Korda's Che image. That painting, in which the Korda Che is replicated nine times in contrasting pastel colors in a crude imitation of Warhol's silk screens of Marilyn Monroe and other famous figures, appears on an endless variety of kitsch offerings and has inspired all sorts of ironic knockoffs, including a Warhol Che club shirt. But Matt Wrbican, an archivist at the Warhol Museum in Pittsburgh, discovered in 2004 that the fake Warhols that Malanga displayed at the short Rome exhibition were not based on Korda's 1960 photo. Rather, they were derived from Freddy Alborta's photo of the dead Guevara.

Wrbican, who later curated an exhibition displaying the correspondence between Malanga and Warhol, has cleared up one matter, but he left unanswered a multimillion-dollar question: Who did make the Korda Che painting, the one still widely attributed to Warhol? No one seems to know where to start—not Wrbican, the archivist; not the lawyer for the Warhol Authentication Board, Ronald Spencer; and not any of the subscribers to a Warhol-themed chat room.

The mystery may never be solved. Many legitimate Warhol paintings were conceived and commissioned by the artist but were physically painted by his Factory "assistants." It is thought that some of these acolytes later turned mastery of their leader's style into a fraudulent source of profit. The Factory's ambiguous stance on authorship left the door open for generous interpretations of what constitutes a Warhol, including works by Malanga, whose business manager Asako Kitarori offered me the following

response to an e-mail inquiry about the Rome incident: "When is an Andy Warhol an Andy Warhol? When Andy Warhol says it's so." According to this logic, it didn't matter that Andy never had a hand in Malanga's Che paintings in Rome. They were Warhols simply because he claimed ownership of them.

As for the ubiquitous fake Korda Che work, whoever actually painted it has never realized anywhere near its true value. The Internet has made the "Warhol Che" more widely available than ever before, on any number of consumer items—everything from posters to coffee mugs, and from stickers to T-shirts in which the image is outlined with Swarovski crystals. Inaccurate references to Warhol's work on the Korda image are found in articles written by art historians and social commentators.

★

The web becomes even more tangled. In the nine mechanically reproduced images of the "Warhol Che," a slightly lopsided letter *F* is detectable in the artwork that defines the subject's left shoulder. This *F* stands for Fitzpatrick, Jim Fitzpatrick, the Irish folk artist who in a few brief years after Che's death put out some ten different posters based on separate hand-traced reproductions of the Korda image. Many of these, including a black-on-red poster in which the artist gave Che a slightly more defiant and horizon-focused gaze, have since become the template for countless subsequent works.

The "Warhol Che" is one such product. Clearly lifted from Fitzpatrick's image, which is in turn a copy of Korda's, it is a knockoff of a knockoff. This never bothered Fitzpatrick, who said he made his posters copyright free because in his outrage over Che's death, he wanted the image "to breed like rabbits." These days he is critical of the way Korda's daughter Diana Díaz exercises copyright over her father's image, especially when it pertains to reproductions that are as much derived from Fitzpatrick's work

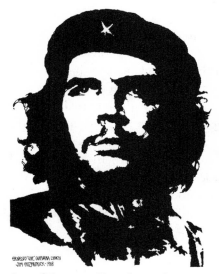

ERNESTO 'CHE' GUEVARA LYNCH
—JIM FITZPATRICK—1968

One of Fitzpatrick's early graphics
in which the identifying *F* can be
discerned within the lines of Che's
left shoulder.

as from the photographer's—for example, her 2004 lawsuit
against Paris-based Reporters Without Frontiers, which used
Che's head in a poster protesting the imprisonment of journalists
in Cuba. Now, in an act of what he describes as "a bit of anarchic
mischief," Fitzpatrick says, "I am republishing the so-called
Warhol Che as a fine art print signed by me with the royalties
going directly to the Children's Hospital in Havana." And why
not? If the real "Warhol Che" creator won't stand up, Fitzpatrick
has as much claim to it as anyone.

Fitzpatrick says he felt a strong affinity with Che when he read
a statement by Ernesto Guevara Lynch declaring that he'd "died
like an Irish revolutionary." The artist reflected on this in a phone
interview: "If you know the history of Irish revolutionaries, they
were always lost causes. To me this was the same sort of thing,

that terrible Irish thing, totally fatalistic, the idea that you can go forward knowing you are going to lose and at the same time know that if you make the supreme sacrifice you'll triumph in the end." But he says his interest in Che dates back earlier, to 1961, when he claims to have met Guevara in a bar in Kilkee, western Ireland. No official record puts Che there at that time, but an encounter remains possible, given that the revolutionary did pass through those parts on at least two occasions en route to and from his many visits to Europe and northern Africa in the first half of the 1960s. Fitzpatrick's tale is now immortalized in celluloid: It was Irish filmmaker Anthony Byrne's inspiration for a bar scene in the surrealist short film *Meeting Che Guevara and the Man from Maybury Hill.*

Another story Fitzpatrick has told researchers has also proven impossible to verify. He says his early paintings were taken from a print of Korda's photo that he received from a group of activists and performance artists known as the Provos, who'd in turn received it before Che's death from Jean-Paul Sartre, who had been present at the March 5, 1960, funeral for *La Coubre* victims in Havana. It's tempting to believe this story, one that sets up the French philosopher as a vital conduit, a traveler carrying the frozen moment from 1960 to the man who would turn it into a powerful graphic seven and a half years later. It's somewhat plausible: Sartre spent much time with Korda during his visit to Cuba, and it is thought that the two men exchanged gifts. Might not Korda have thought his visitor would like a copy of the fabulous photo he'd just taken of the man Sartre so openly admired? But every effort I made to confirm the story ran into dead ends. Roel Van Duijn, founder of the Provos movement and editor of its magazine, could provide no further illumination. The same was true for retired Irish cartoonist Jacques Teljeur, who in a strangely disjointed telephone conversation responded with a

hesitant "I hope so" to my question on whether he was, as Fitz-
patrick claimed, the Provo artist who handed him the print.

★

Regardless of the veracity of Fitzpatrick's Che tales, there can be
no doubt about the importance of his work, not only for its popu-
larity but for the shifts in meaning that were produced in his and
subsequent pop art representations of Che. Pop's rejection of
complexity, its deliberate focus on lowbrow subjects replicated in
a mechanical fashion—Andy Warhol's Campbell soup cans, Roy
Lichtenstein's comic books—altered the way people viewed their
consumer society and its commercial, political, and celebrity
icons. Eventually, pop's ironic commentary on consumerism
became a consumable item in its own right. The media became
the message, the signifier the signified.

Some believe pop art has a natural affinity with Che and the
class struggle he symbolized. In challenging and rejecting the
snobbish values of fine art, they say, pop artists mocked class dis-
tinctions and showed their disdain for the false values of bour-
geois society—even though Warhol himself was overtly apolitical.
Either way, the pop artists who reproduced Che's image to make
political statements helped—unwittingly, perhaps—to strip it of
its historical and political roots, including Che's Marxist ideology.
These new versions of Che made him mainstream, accessible to
all, but in doing so reduced the subject to something far narrower.
"Pop's depersonalization and standardization simplified Che's
image and helped align him with the masses, at the same time cer-
tifying his image as everyman," says Jonathan Green, a curator
for the California Museum of Photography at the University
of California, Riverside. "Traditional art relished ambiguity,
chance, introspection, and the logic of uncertainty. Pop's aesthetic
pushed toward absolutely unambiguous and uninflected mean-

ing, repeatability and uniformity. This reduction of the real world provides the perfect vehicle for distancing the image from the complexities and ambiguities of actual life and the reduction of the political into stereotype. Che lives in these images as an ideal abstraction."

The pop art revolution was aided by changes in artists' techniques and technology. In the 1960s, Warhol and others took to silk screening, which had been used in World War I as an industrial printing technique, and turned it into a popular artistic medium. Along with it came technologies that aided the transfer of photographic images into art—for example, bleach-out techniques, which reduced the gray areas in a photo and highlighted the contrasts. Some artists used so-called photomechanical transfer, or PMT, cameras to reduce the tonal differences in an original photograph. On other occasions, as when Jim Fitzpatrick worked on his early Che posters, a machine called a Grant projector was used to make it easier to hand-trace the photo's line definitions. In equipment-starved Cuba, the prolific pop artists who assisted the propaganda efforts of the Havana-based Organization of Solidarity with the Peoples of Africa, Asia, and Latin America (OSPAAAL), had to improvise with whatever materials they could find. This didn't prevent them from pumping out countless highly influential Che-themed posters as inserts for OSPAAAL's internationally distributed *Tricontinental* magazine.

These various techniques, used for the bulk of the Che posters and T-shirt images made in late 1967 and afterward, gave photo images what Rutgers University graphic design historian Jerry Beegan describes as "flatness." In effect, they stripped the photographs of their three-dimensionality. With these techniques, the source image lost its complexity, its varied tones, and its subtle shadings and background, reducing it to a simplified and sharply focused foreground image that was "either off or on, either there

or not there," Beegan says. The trend contributed significantly to the transformation of the Korda image into an everyman icon. "The most important thing about the image of Che as it is seen in mass reproduction is that it is *not* a photograph," says Beegan, challenging the oft-cited claim that Korda's photograph is the most reproduced in history. "Its incredible longevity, power, and malleability as an image rests on its rejection of photography."

The flat, two-dimensional reproduction of a once-photographic image thus becomes a deliberate, powerful statement. It remains connected to the original photo in some way so as to retain a reference to the real world from which it arose, but it also blatantly distances itself from any claim to convey that reality. "It is saying this is ink on paper; it is an idea," says Beegan. "It is not a representation of the world. It is not trying to fool you. There is an element of honesty to it."

This is postmodern honesty. The historical Ernesto Guevara was irrelevant. Che had become an *idea*. Or an *ideal*.

★

Most deaths mark an end. Yet to many young people of that era, Che's was a beginning. "In a way, 1968 began in 1967 with the murder of Che," social commentator Christopher Hitchens once noted. Truth be said, the abrupt end to Che's little Bolivian insurgency was of no great political significance to the Western world. As a symbol, though, Che's death had far-reaching political and social import. It was a signal for the start of a year-long sequence of world-changing occurrences: a watershed battle in Vietnam; the U.S. race riots; the peace marches; the uprisings in Paris, Prague, and Mexico; the assassinations and other violence during a chaotic U.S. electoral campaign. Che's death gave the more radical participants in these events a kind of spiritual purpose. Some believed they were actually avenging Che.

For the Korda Che, the headline event in 1968 was in May, in Paris. There, red-on-black Che posters based on Fitzpatrick's model became symbols of the resistance movement. Even in a setting flooded with avant-garde political art, audacious street performers, and witty graffitists, the Korda image stood out. A key connection was drawn with Cuba here too. Quite a few of the French artists and intellectuals who had participated in the Salon de Mayo a year earlier became involved in the Paris student movement. Bernard Rancillac and the Paris-based Icelandic pop artist Erro, both proponents of the Figuration Narrative school of politicized pop art, were among those from the Havana group who participated in the Atelier Populare, a student artist work-shop that cranked out posters for the uprising. There's no record of Che posters being made in the workshop. In fact it's not clear who produced the Che posters of Paris. Even so, the essence of Che's new afterlife was captured in the workshop's striking out-put, which reflected the same nexus of art and politics, the merg-ing of pop and revolution presented as the dominant theme at the Havana salon.

A prominent figure in Paris at this time was Jean-Paul Sartre. He regularly turned up at the occupied Odeon Theater to inspire students; around this time he also made his now-famous pro-nouncement that Che was "the most complete man of our age." Years later those words would appear engraved on the back of pirated copies of Swatch's Revolución line of Che watches. The art critic, poet, and sometime artist Alain Jouffroy, who spear-headed the Salon de Mayo along with Carlos Franqui and Wil-fredo Lam, was also there. As the founder of *Opus International* and with his ties to André Breton and Marcel Duchamp, Jouffroy had weight within the French intelligentsia, though he was not necessarily well liked by all. Strongly influenced by the surrealism of Breton and a great supporter of pop art's anti-bourgeois cur-rents, Jouffroy took a polemical role in the uprisings. While the

students held Che aloft and attacked the political establishment, Jouffroy stirred up the leaders of the art world, attacking their aloofness from the people and promoting the role of the artist as activist.

Régis Debray, who in addition to Che had connections to Feltrinelli and to Jouffroy (the French art critic and poet paid the imprisoned young intellectual homage in a poem before the Paris uprisings), was not present for these events in person. He was still in his Bolivian jail cell, where he would stay until 1970 and where, reflecting on Che's failure to bridge cultural difference in Bolivia, he would start to lose faith in the possibility of outsiders bringing Marxist revolution into such places.

Oblivious to this change of heart, many young Parisian students viewed the imprisoned French Marxist as a direct cultural connection to the Che legend. As much as Ernesto Guevara Lynch, whose ancestors were from Galway, helped make Che an Irishman for Fitzpatrick, Debray, the Guevara protégé, somehow turned Che into a Frenchman for many students in the Left Bank barricades. Not only was Debray an intellectual turned man of action in the Guevarista mold, but his writings also played a key role in transplanting Che's *foco* theories on peasant-led third world revolution into an urban European milieu. This came about primarily through his popular *Revolution in the Revolution,* which became a companion handbook to Guevara's *Guerrilla Warfare.*

The image-driven "revolution" of May 1968 was worlds away from the nasty third world struggle in which Debray became embroiled, but at least the French students hurled Molotov cocktails and spouted the language of proletarian revolution in a manner somewhat consistent with their martyred hero. It was the Korda Che's leap into the United States shortly after the Paris uprisings that more forcefully severed the image's ties to Ernesto Guevara, Marxist revolutionary. Quite removed from the confrontational revolutionary socialism and anarchism of the Left

Bank, the culture and politics of the '68 youth movement in the
United States were dominated by the antiwar, pro-peace hippies.
Again, it was art that facilitated the insertion of Che into this con-
tradictory setting. And while in the end the pop art Che would
prevail, one of the first steps in softening the warrior rebel's image
was taken by an artist who applied a wholesome Christian aes-
thetic to Korda's photo.

In February of 1968, the left-wing arts and politics journal
Evergreen gave the Korda image its first widespread appearance in
the United States when it put a painting by Paul Davis on its
cover. "I was trying to make an image of Che as a martyr," says
Davis, the son of a Methodist minister. His painting, which was
later used for the dust jacket of Jon Lee Anderson's biography of
Che, has been described as a synthesis of early Italian Renais-
sance art and socialist realism. But it also seems influenced by
American Christian folk art. It is reminiscent of Chicago artist
Warner Sallman's wildly popular *Head of Christ* from 1941. It also
evokes a painting by another American artist popular in the post–
Vatican II Catholic churches preferred by my parents in Australia.
This portrait by Richard Hook from 1964 shows a suntanned,
healthy-looking Christ with warm, sensitive eyes. Vital, yet devoid
of arrogance or aloofness, this Christ had an open, accepting
face—much more man than God. Subtly, this Christ looked like
an Aussie, or at least the popular idea of a sun-kissed Australian,
for it was taken from Hook's second version of his painting, which
he'd touched up by bronzing the skin. White European painters
through the ages have made a dark-featured Nazarene Christ in
their own likeness. Davis's Che worked in the same way. He made
Guevara the warrior fit the hippie stereotype of beauty—strong
and handsome, but sensitive and loving at the same time.

Yet Davis and others could never fully strip Che of the conflict
within him. The offices of the magazine were firebombed and

poster ads based on the painting, which carried the slogan "The Spirit of Che lives in the new Evergreen!" were systematically vandalized. In that case, right-wing Cuban émigrés were named as the culprits. But it was not all love fests and pacifism on the left that year, either. Especially after the death of Martin Luther King on April 4, 1968, civil rights leaders such as Stokely Carmichael, Eldrige Cleaver, and Malcolm X became vocal advocates of a more militant struggle for black Americans. And nothing, certainly not the peaceniks' softening of Che, was going to stop their followers from embracing the Korda icon too. From the barricades in the Left Bank to the summer of love in California to the Black Power movement in the poor neighborhoods of America's racially divided cities, Che was already available in 1968 in a wide variety of political brands.

In its May 17, 1968, edition, *Time* observed that the Che legend, in giving "rise to a cult of almost religious hero worship among radical intellectuals, workers and students," had also produced widespread fads across the Western world. In addition to the ubiquitous "Che Vive!" posters at anti–Vietnam War protests in the United States and student riots in Europe, there were "Guevara-style beards" and berets in Italy and "handkerchiefs, sweatshirts and blouses decorated with his shaggy countenance" in "half a dozen countries." The article described how "French schoolgirls hang his photo in their boudoirs alongside those of movie idols" and how "students at the London School of Economics now greet each other with the salutation 'Che.' " Meanwhile, the phenomenon had created "not only a cult but a new source of profits for composers, poster makers and book publishers." Rayner Unwin of the London publishing house Allen & Unwin is quoted as saying, "Everybody is jumping on the Guevara

bandwagon." And in addition to four Italian publishers making Che books, *Time* said, at least half a dozen moviemakers were "scrambling to get on-screen first with a Guevara biography."

Time could have recycled much of that article forty years later, right down to the movie reference. (Steven Soderbergh's much-delayed biopic on Che, starring Benicio Del Toro in the lead role, was one of the most talked about films in Hollywood until it premiered in what some critics thought was an unfinished state at the Cannes Film Festival in June 2008.) Indeed, while the sociopolitical context is significantly different now, it's worth remembering that the line between politics and business was just as blurry for the Che icon in 1968. No matter who wears or displays him, Che has always been *consumed* in one way or another. Our capitalist society insists it be that way.

In his iconoclastic study of the sixties *The Conquest of Cool*, Thomas Frank discusses how the advertising industry played an active role in the construction and spread of the counterculture in the second half of the decade. Frank's point is not that an entire generation's antiauthoritarian rebellion was the product of cynical businessmen—anarchists and hippies were for the most part thinking for themselves. Rather it is to remind us that it is impossible to separate "authentic" counterculture from the mainstream and the capitalist machine that drives it. How else did the look of the day—the tie-dye, the long hair, the beads and granny glasses—become so popular so quickly if not via the market? "From its very beginnings down to the present, business dogged the counterculture with a fake counterculture, a commercial replica that seemed to ape its every move for the titillation of the TV-watching millions and the nation's corporate sponsors," Frank writes. "Every rock band with a substantial following was immediately honored with a host of imitators; the 1967 'summer of love' was as much a product of lascivious television specials and *Life* magazine stories as it was an expression of youthful disaffection;

Hearst launched a psychedelic magazine in 1968; and even hostility to co-optation had a desperately 'authentic' shadow, documented by a famous 1968 print ad for Columbia Records titled 'But The Man Can't Bust Our Music.' "

On both sides of the political divide today, many bemoan the commercialization of Che and the separation of the icon from its roots. They tend to see it as a contemporary phenomenon, a function of the ignorance of twenty-first-century youth. Meanwhile, aging hippies sneer at the supposed hypocrisy of their successors' flouting mobile phones provided by Verizon, AT&T, and other titans of information age capitalism in their activities—the subtext being that their own rebellion four decades earlier was more authentic. But the same process was at work in 1968. Honed throughout the postwar boom, U.S. capitalism provided both the channels and, in many cases, the inspiration for the spread of the sixties subculture. The trendsetters who first imagined a different world and put Che on their T-shirts may well have been true radicals, those who hated their capitalist society. But their worldview was transferred to the mainstream by less radical elements, those who constituted the bulk of their generation. They were encouraged to do so by the marketing whizzes of Madison Avenue, who didn't hesitate to expropriate the conveniently multipurpose aesthetic of a group of nominally anticapitalist artists.

The Marxist-inclined artists who stripped the Korda Che of its bourgeois "photo-ness" in order to turn it into a radical political idea unintentionally facilitated this process. By simplifying the image into a more basic, *flat* graphic, they freed it from the confines of photographic realism, but they also made it free for just about anyone to use, including advertisers. This now universally recognized two-tone image took on the same status in public consciousness as many similarly simplified corporate logos. Thus Che's image can comfortably sit in a retail outlet alongside Nike's Swoosh.

★

The fervor for change in 1968 dissipated almost as quickly as it began. In Paris the May uprisings fell way short of becoming the May revolution. By June the students were in class again, French workers were back on the job, and de Gaulle had returned to the presidential palace. Conservatives will say, with some justification, that the revolution failed because the middle-class students wouldn't forgo their material comforts. (They just couldn't "be like Che.") But the failure also relates to the impotence of their weapons. Posters, graffiti, and performance art have nothing on a machine gun for overturning a political system.

In the years that followed, a more cynical politics emerged in the West. Whereas the pre-1968 years were an era of political consensus forged around a common faith in authority, an age when slogans like "my country, wrong or right" were not laughed at, political expediency dominated the post-1968 years. Richard Nixon took control in the United States, allowing realists like Henry Kissinger to radically realign what was previously thought to be a rigid Cold War divide. China, a communist country, became an ally of the capitalist West. Where now did the ideological line lie? It was the age of Watergate and of horse-trading with special interests on everything from human rights to inflation controls. Wedged between these two eras, 1968 seems like a bizarre foray into spirited, if naive, idealism.

And yet the events that year mattered. The rebelling youth who rejected the old order set the parameters for a new political bargain between the generations. Perhaps it was a quasi-revolution. Regardless of its co-optation by commercial forces, and in some cases because of it, the imagery and iconography of protest were transformed in 1968 into an expression of power for a baby-boomer generation that had suddenly acquired phenomenal political and economic clout. This group alerted businessmen and

politicians to changes in tastes and social values in everything from clothes to race relations, all of which had to be attended to.

Once this new generation's influence was established, capitalism could figure out how to accommodate their demands—whether for religious freedom, sexual liberation, free education, liberal dress codes, long hair, or whatever. Where these demands clashed with the values of the older generation, which more or less still owned the economic capital, a pragmatic solution was found: The market would now make room for competing values. It was a postmodern capitalist solution, one that disregarded the quaint notion of a social order in which truth is defined in clear black-and-white terms and left it open to different interpretations, including those of advertisers.

This is how the Korda Che icon—born in 1968 as a poster boy for idealists who believed they could channel his power and wipe away the lies of the ruling class—ended up in a more ambiguous position. Che became the quintessential postmodern icon—anything to anyone and everything to everyone.

PART II

MIMICKING

A MARTYR

San Ernesto

of Latin America

ARGENTINA

The Prodigal Son

If you don't cry you don't get fed, and if you
don't steal you're stupid.
 —Enrique Santos Discepolo
 (Argentine tango composer), *Cambalache*

IN AN ESSAY entitled "The Day I Failed to Be Che Guevara," the writer Ariel Dorfman describes how he lost control of his senses in Santiago, Chile, during a street protest in the lead-up to the presidential elections of 1970. He was hurling insults at the headquarters of the leading right-wing candidate when a group of armed thugs appeared. "Instead of running for cover, I . . . insanely continued to rant at them," Dorfman wrote. "I can still see myself, my fist raised in the air as if I were Che Guevara himself."

Dorfman's performance earned him a shotgun blast in the legs. He soon recovered from his wounds and joined the government of Salvador Allende following Allende's landmark victory later that year. But the new president was not so lucky. Allende died defending the palace against Augusto Pinochet's coup on September 11, 1973. For leftists of the 1968 generation who'd come

to believe in the prospects of a bloodless democratic revolution, the ouster of Allende—who had provided a model for this vision—was a painful blow. And in Latin America, it prompted many to change course. Dorfman fled to the United States, where he'd grown up. But many others from his generation chose a more radical response. For them, Pinochet's coup, which had been foreshadowed three months earlier when a right-wing terrorist group blew up a Che monument in Santiago, justified the message of the Argentine revolutionary: Hatred and violence were a critical part of the struggle. Thousands more young men and women were to die in Uruguay, Argentina, Chile, and virtually every country on the continent.

The Latin American insurgencies of the late 1960s and '70s were a product more of idealism than of clearheaded strategy. After Che's death and the rise of Soviet influence, Cuba scaled back its support for regional revolutionary movements, which put a brake on the guerrilla movements then active in Venezuela and Guatemala. The new revolutionary forces that arose in the cities of Latin America were generally more independent of Havana— although Castro's revolution remained the model to emulate. Dominated by university students, these urban guerrilla "armies" were departures from Che's now-discredited *foco* model of rural warfare. To them, Che's combat advice in *Guerrilla Warfare* was less relevant than his status as the role model for a heroic revolutionary. With writers like the Argentine poet Juan Gelman glorifying him in literary tributes, many young Latin American radicals internalized the Spirit of Che.

Even more than activists in Paris in 1968, these young Latin American idealists saw Che as one of their own—young, educated, middle class, yet unable to accept social injustice. Fed up with quasi-feudal hierarchies and gaping disparities in wealth, many found their conscience tested by the question "If Che could do it, why not I?" Guevara "represents the heroism and

nobility of myriad middle-class Latin Americans who rose up in the best way they could find, against a status quo they eventually discovered to be unlivable," writes Jorge Castañeda. "If ever there was an illustration of the anguish evoked in sensitive and reasonable, but far from exceptional, individuals at being affluent and comfortable islands in a sea of destitution, it was Guevara. He will endure as a symbol, not of revolution or guerrilla warfare, but of the extreme difficulty, if not the impossibility, of indifference."

But these young insurgents were warriors of the heart, not the head; their plans lacked coherence. In 1969–70, the National Liberation Army of Brazil tried to translate Castro's tactics for warfare from the jungles of the Sierra Maestra to the streets of São Paulo, where it was all but wiped out after a year of street battles with the military dictatorship. The Tupamoros of Uruguay were better organized and managed to control parts of Montevideo in the early 1970s before the country's president dissolved parliament and invited the military to launch a coup to restore order on June 27, 1973. Across the river in Argentina, meanwhile, things went completely haywire, as exemplified by events in Buenos Aires seven days before the Uruguayan coup. On that day, as three million gathered for Juan Domingo Perón's return from twenty-two years of exile, the Peronist movement exposed its violent internal divisions. At Ezeiza airport, right-wingers among Perón's bodyguards got into a firefight with the Montoneros, the Peronist youth movement's revolutionary wing. Officially, 13 people died, although the number is thought to be much higher, and 365 were injured. For Perón's opponents, especially those of the older generation, it was all deeply disturbing. Argentina had sixty years earlier been the seventh-richest nation in the world. Now it seemed to be collapsing into a collective psychosis.

When Perón died at age seventy-eight a year later and the presidency fell to his ill-prepared wife, Isabel Martínez de Perón, real power went to her Rasputin-like fascist mentor, José López Rega.

He set up the Argentine Anti-Communist Alliance (AAA) death squads charged with liquidating armed leftist groups. The People's Revolutionary Army (ERP), whose iconography drew heavily from Che imagery, fled to Tucumán province to pursue a traditional rural guerrilla strategy. But the Montoneros stuck it out in the cities, where they attracted an impressive active membership of 7,000, mostly university students. Whereas Perón and Evita figured heavily in the icons and ideology of the Montoneros, the romantic ideal of Che was clearly important in their recruitment drive. Finding members was one thing; waging revolution in an urban area, however, was another. In the end, the Montoneros resorted to quasi-military tactics: bomb attacks, assassinations of senior military officers, and kidnappings of businessmen. As these escalated while the AAA ramped up its equally violent "cleansing" campaign, Argentine society began to lose its bearings. Seizing this pretext, a core of military officers took power in a bloodless coup on March 24, 1976, and declared the beginning of the Process of National Reorganization, later known as El Proceso. From then on, Che was totally off-limits.

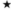

Beyond Hitler and Pol Pot, it's hard to imagine a more easily caricatured bunch of bad guys than Latin America's dictators from late in the Cold War era—men such as Chile's Pinochet and Paraguay's Stroessner. These militarists made the Guevaristas look like saints and their violence seem forgivable, even justifiable. Throughout the late 1970s, more and more horror stories emerged. None were more so than those of the military junta's activities in Che's homeland, with its accounts of electric shock and psychological tortures and its expanding tally of *desaparecidos,* estimates of whose numbers during the seven-year "Dirty War" run as high as 30,000. Perhaps sickest of them all: the practice of giving condemned prisoners' newborn babies to military families.

If it weren't for sociopolitical changes in Europe and the United States, the world might have stayed ignorant of all this. Under Richard Nixon, realpolitik trumped ideology, which allowed a new left to emerge from the rubble of 1968, one disinclined to take sides in the Cold War and instead focused on the nominally apolitical goal of protecting human rights. Amnesty International, founded in 1961, saw its membership explode in the 1970s, as did other such groups. The members of these groups were children of the information age. Their weapons were not guns or rocks, but press releases, letter-writing drives, and publicity campaigns. They worked on the assumption that the public's increasing access to information and demand for accountability would make it more and more difficult for dictators and their foreign supporters to hide their crimes. The pacific, democratic human rights movement was in this sense the antithesis of the armed Guevarista socialists.

Remarkably, Che's image worked its way into human rights movements as well. The icon had by then been so brutally suppressed, especially in Argentina, that the act of displaying the Korda Che became a symbolic assertion of the fundamental right to free expression. Suddenly a new Che emerged: a pacified, pro-democracy, human rights Che. From there, a decade or two later, it wasn't much of a leap to the Che of antiglobalization efforts, gay rights activists, and many other special interest groups.

One could argue that Argentina's Mothers of the Plaza de Mayo paved the way for this new, pro-human-rights Che. With their weekly vigils on behalf of their disappeared children, staged under the sinister, watchful eye of the junta, these women showed astounding courage. But the genius of their method, which entailed quietly circling the plaza's central monument, lay in its aesthetics. Each participant wore a white head scarf, thus creating an image of honesty, that of a mother in search of her child. The simple ritual was free of political overtones and cut

across ideological and national boundaries to strike a chord with all. In Argentina, it brought unbearable shame on the military leaders, exacerbated by the fact that they resorted to subterfuge and murder to try to suppress the Mothers. Eventually, these courageous women were able to reclaim the Plaza de Mayo, the country's most important political space, as theirs, and thus, by extension, for the people.

In truth, many of the Mothers were aligned with armed militants. Even thirty years later, the original group is bitterly split between doves and hawks. A moderate faction calling itself the Grandmothers of the Plaza de Mayo works mostly on reuniting children who were stolen from their disappeared parents with their biological extended families. By contrast, those who still call themselves the Mothers follow the leadership of Hebe Bonafini, an extremist who wields her head scarf as an instrument of power.

Néstor Kirchner, Argentina's president between 2003 and

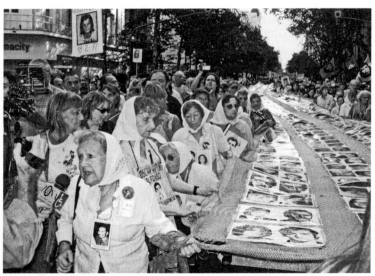

Mothers of the Plaza de Mayo, Buenos Aires, March 24, 2007.

2007, brought Bonafini into his political machine. Kirchner's government positioned itself as an ostensibly left-wing alternative to the "neoliberal" free market policies of the nineties, at that moment in disrepute for their role in bringing about Argentina's devastating financial crisis of 2001–2002. After she took over from him in 2007, Kirchner's wife, President Cristina Fernández de Kirchner, maintained the relationship with the outspoken leader of the Mothers, who has also cultivated ties to Venezuela's Chávez and Iran's Mahmoud Ahmadinejad.

Yet even as she plays politics, Bonafini attacks the democratic institutions she and her colleagues helped restore in 1983. After the September 11 attacks she spoke of empathizing with those "who were happy and felt that the blood of so many in that moment was avenged." And when Pope John Paul II died, she predicted he would "rot in hell." Bonafini's rants have done little to sully the international reputation of the Mothers of the Plaza de Mayo as a peaceful, apolitical group. In 1999, she won the UNESCO Peace Education prize. Clearly, image has trumped reality. By positioning motherhood against evil, the Mothers established a durable brand early on, one that fits easily into the narrative of the left. An appealing image associated with desirable values like stoicism and honor—the ingredients in this mix are not unlike those that transformed Che's face into an even more powerful brand of the left.

★

As with the image of the Mothers, this revived Che of the late Cold War strayed far from the historical Ernesto Guevara. It's hard to see Che "as a warrior for human rights, human rights that he himself did not observe," says Ariel Dorfman. But the writer adds, "If we think in terms of the purity of Che, we see that he was forgoing the protection that we have from our states and our nations. And in a way he was breaking down the barriers and say-

ing that what matters is humanity. In a sense, this was a funda-mental right, the right to be free."

This is an anarchist's vision of freedom. And it was on full dis-play on March 24, 2006, in Buenos Aires when groups that tradi-tionally identify themselves as the Argentine left held their annual rally to celebrate the end of the dictatorship. The 2006 event was one of the biggest gatherings ever. President Kirchner had made the thirtieth anniversary a one-off public holiday. An estimated crowd of 150,000 filled the Plaza de Mayo and stretched up Cinco de Mayo Avenue, with banners identifying different organi-zations as socialist, Leninist, Peronist, Trotskyist, or Guevarist, an alphabet soup of acronyms: MTD, FTV, CEPA, UJS. (While each group would readily describe itself as of the left, the great variety of ideologies underscores how this term has as much to do with image and symbols as with substance.) Yet there was one con-stant. Everywhere, on handheld red flags, on huge banners, on

Piquetero banner, May 25, 2006, Buenos Aires.

bass drums, posters, flyers, and countless T-shirts, Korda's image of Che was proudly on display.

It appeared to be a gathering of competing tribes, with Che perhaps the only commonality among them all—a scene of unity and disunity at the same time. The drums and chants blended into a cacophonic mélange. Murga dance troupes performed acrobatic leaps to African polyrhythms while the aging Mothers of the Plaza de Mayo silently carried a long white sheet bearing their lost children's names down the center of the avenue. Meanwhile, a hoarse-voiced fortysomething man yelled the lyrics of an old Montoneros song into a megaphone: "Volveremos, volveremos, con soldados de Perón" (We will return, we will return, with the soldiers of Perón). All of it culminated in a scuffle on the stage at the center of the plaza, where one faction of the organizing committee reacted indignantly to Hebe Bonafini's decision to remove criticisms of Kirchner from the closing declaration.

Here was a display of one of the defining constants of Argentine political life: the victory of chaos. All political shifts in the country are in some way an attempt to impose order on chaos, but chaos always wins out in the end. Sometimes it appears as hyperinflation, undermining left-leaning and populist governments that boost incomes with generous public spending. Other times it explodes as social unrest and strikes, frustrating conservatives' and liberal market reformers' attempts to restrain labor's power. Every Argentine has a theory on how to fix the system, but in the end most refuse to be governed (and to pay their taxes). For many, even those who yearn for the rule of law, chaos is preferable to the order imposed by a perennially corrupt state. This uncontrollable force may even be what keeps Argentina going, fueling a vitality that allows it to overcome the cycle of crises and to continue producing world-class sportsmen, musicians, writers, and doctors.

Perhaps this is the real reason for Che's rehabilitation in his homeland. Even if a huge sector disapproves of his presence, Che

is at home in this chaotic society. The historical Che of Cuba would not fit in here: Che's disdain for individualism and his disciplinarian instincts would clash with Argentina's laissez-faire ways. But Dorfman's Che, who breaks down state control in the name of human freedom, does belong. That Che, with his dream of a borderless, unified Latin America, belongs in an anarchic Argentina that has been forced to confront its place in the region, one that its people for too long declined to recognize.

The myth of European sophistication was dispelled in Argentina during its financial crisis at the start of the twenty-first century. By the end of 2002, a year in which the economy shrank by 11 percent and the Argentine peso lost 70 percent of its value, Argentina had a per capita income in dollar terms on par with Guatemala's—a far cry from its status at the beginning of the twentieth century, when it was the envy of the world. A quarter of the country's population was out of work and half of it lived below the poverty line. Beggars and scavengers became a common sight on the streets of Buenos Aires, horrifying "refined" *porteños*. For the city's predominantly white middle class it was a long-delayed moment of reckoning that seemed to prove their country's true Latin American quality.

But if they can appreciate this, they can also welcome home a rebellious son from the city of Rosario. It helps too that his image has played a valuable role in a booming industry that enabled the country to get back on its feet after the crisis: tourism.

★

A 2006 survey of Europeans found that Che Guevara and Eva Perón are, respectively, the first- and second-best-known Argentine-born historical figures among Europeans. Although many could not actually place Che as an Argentine, the tourism secretariat took this as a signal. It began to float the idea among travel professionals of associating Che with Argentina's tourism

brand and launched a Footprints of Che project to promote places the revolutionary once lived in or visited.

The poster town for this project is Alta Gracia, where the Guevara family lived between 1932 and 1943. The welcome signs in this pleasant settlement in the Córdoba Sierras—chosen by the Guevaras because the mountain air was less taxing on little Ernesto's asthmatic lungs—now show Che's photo alongside its other big attraction: a 1588 Jesuit mission. Crucifixes and other Christian memorabilia share space in the town's souvenir shops with maté gourds, plaques, flags, T-shirts, ponchos, and other paraphernalia bearing the Korda Che and the words "Alta Gracia, Argentina." This juxtaposition of Che and the Jesuits isn't as incongruous as it sounds. The Jesuits of Argentina were rebels too. During the Spanish colonial period, the Jesuit missions developed into complex, independent societies that challenged the legitimacy of the corrupt colonial government.

Modern-day Alta Gracia sponsors an annual "Che Week" festival, which draws dozens of people wearing Che T-shirts into its backpacker hostels to celebrate their hero's birthday. After visiting the Che museum in the old family home, these visitors can head to the Che Cave bar, where they can "take a picture playing chess with El Che in the Sierra Maestra cave and at a machine gun nest with guerrillas." Or they can play a round of blackjack at the recently reopened Hotel Sierras Casino, which sits atop a gorgeous hilltop estate. The Roggio Group, one of Argentina's biggest conglomerates, spent $8.5 million refurbishing the 1908 hotel.

The town got a huge publicity bump on July 23, 2006, when Fidel Castro and Hugo Chávez visited the Che museum together. Hundreds of townsfolk greeted the pair's motorcade, which was flanked by columns of Cuban security guards jogging alongside their leader's armored black Mercedes. The museum registered 9,710 visitors that same month, almost double the figure from July 2005, most of whom turned up in the week after the Fidel-

and-Hugo show. Locals are sanguine about Castro's visit, which occurred just days before he fell ill. "People now know of a town called Alta Gracia and will come here to look at everything," said souvenir seller Olga Saieg, beaming. Then she added, laughing, "I just hope they don't think we poisoned Fidel."

Castro's visit was a big deal for eighty-year-old Ariel Vidoz, seventy-eight-year-old Alfredo Moreschi, and seventy-five-year-old Enrique Martín, three of Guevara's childhood buddies who accompanied the then seventy-nine-year-old Cuban leader during his museum tour. "I still find it impossible when I think back on all my school friends and think of him, with the illness that he had, to imagine how he, of all of them, ended up with this destiny," said Moreschi. "How did he do what he did?"

Unlike other Argentine towns on the Footprints of Che route, which can do little more than state the fact of Guevara's past presence, Alta Gracia is blessed with a house to show off to visitors—a genuine Che relic. But that's about all it has for physical memorabilia. Every single exhibit inside the museum is an example of something related to Che, not an actual artifact. There is a chess table because, well, Che played chess. And there's a Norton motorcycle of the same model as Poderosa II, the bike Guevara and Granado rode—again, not the real thing. There's a bed like the one Ernesto used, and so on. The rest of the museum is filled with photos, the most prominent of which is the Korda image, which takes up an entire wall in the foyer and on whose right-hand lower corner is superimposed the nine-year-old Guevara's face. Even here, El Che, the mythical figure, overshadows Ernesto the boy.

Some tourism officials blame the lack of physical memorabilia at Alta Gracia and other sites on the fact that for many years Che was taboo. The dictatorship banned materials associated with him: books, photos, posters. People were not even allowed to resemble Che: Unkempt beards, berets, and long hair were out. It

was especially difficult for members of the large Guevara Lynch clan in Argentina. Although they were descendants of a landowning family—many of them by then middle-class city dwellers—and often didn't share Che's politics, the Guevara name proved a burden for many and a curse for some. This was especially so for Ernesto's immediate family: Both his mother and his younger brother Martín, who also spent time in Cuba, were jailed by military governments. (Adopting the same low-profile strategy as Ernesto's other siblings, Martín now runs a wine bar in the upmarket Belgrano neighborhood of Bueno Aires. He has one tie to his revolutionary past, however: He holds the exclusive license to import Habano cigars into Argentina.)

Even many socialists who favored an electoral solution were wary of Guevarista extremism in the early 1970s. Only later did Che become a broadly accepted symbol of the Argentine left—something for which the generals can also take credit: By banishing Che from young people's lives they turned him into a martyr all over again. That it took so long for Che to be more widely accepted, however, is an indication of how much he was once associated with death. Like Peter denying Christ, Argentines were too fearful to admit their relationship with him.

Che was seen as the antithesis of peace, says Blanca Peralta, a consultant hired by the tourism office of the city of Córdoba to dig up data about Che's past there for the Footprints project. "This is why we don't have much information about him. It wasn't until later that foreigners made an external reality apparent to us . . . That is why we have to accumulate information on Che Guevara. Tourism is demanding it."

More than half a century since Che left Argentina, places such as Córdoba and Alta Gracia have finally decided to promote their ties to an Argentine who influenced world history more than any other. The reasons for the delay are many, but in essence it reflects a nation's struggle with its demons. After an unprece-

dented two decades without military rule and with the threats and opportunities of globalization looming large, Argentines are finally unlinking Che from the terrifying 1970s.

Che was always associated with the Cold War and political instability, says Aldo Marinozzi, a tourism consultant in Rosario, another city with strong claims to Che's past presence. But now "we can talk about a museum project in this city in terms of his being an historical figure, not the symbol of a particular party or a faction, a perception that had impeded us from letting Che become part of the heritage of our society." Marinozzi attributes this trend to a generation of youth who grew up with democracy and for whom Guevara is an icon of popular culture. "You could say he has been rehabilitated by rock music," he says.

Che's long-delayed homecoming still meets resistance, however. When viewers participating in a recent television poll chose Che as the twentieth-century figure most representative of the "Argentine gene," both conservative and liberal commentators were aghast. (The first group saw the violent guerrilla's belated assimilation into *argentinidad* as another blow to their vision of a sophisticated, developed, worldly society, while the latter dismissed the notion of leisure-loving Argentines having anything in common with Guevara's disciplined New Man.) Later, an official was booed when he informed a travel seminar in Buenos Aires that the national tourism secretariat planned to incorporate Che into its "national brand." By the same logic, said local travel agent Michael Poots when he took the microphone, "Germany should engage in Hitler tourism." According to Poots, Guevara's principal contribution to Argentine history is that "he motivated a lot of idiots like [Montonero leaders] Enrique Gorrierán Merlo and Mario Firmenich to go about killing people either because they had money or a uniform." Even members of Guevara's family are uncomfortable embracing their long-ignored relative. In an article entitled "My Cousin El Che," Alberto Benegas Lynch resorted to

the same Nazi metaphor. Wearing a Che T-shirt, he wrote, "is like flaunting the gloomy image of the swastika as a peace symbol."

But these voices appear to be fighting a losing battle against popular culture and economic reality. Che is increasingly being reimagined as an Argentine icon. With Walter Salles's 2004 film, *The Motorcycle Diaries,* helping install a stronger connection between Che and his home country, Buenos Aires bookstores began selling "Che Route" maps of Ernesto and Alberto Granado's travel route. One stop on that route that was highlighted in the film, the Patagonian town of San Martin de los Andes, inaugurated a new museum to Che in June 2008. Displays of photos and texts of the revolutionary's words were set up in the same tried-and-tested format as the Alta Gracia museum and others like it, but like them it could show visitors no artifacts from the two travelers' brief stay. It's tempting to view the site more as a monument to Salles's film and the tourism potential it has generated than as a memorial to the real Ernesto Guevara's fleeting presence in those parts.

Meanwhile, kiosks on the city's Florida Street placed Che posters among their tango postcards, gaucho knives, and other Argentine mementos. At the root of this trend was the simple fact that the country became a cheap travel destination after the 2002 financial crisis, which left the peso at a third of its previous value in dollar terms and a mere quarter of its value in euros. This meant that backpackers from Europe, who show far more interest in Che than their American counterparts, could affordably fly to Argentina, where they could imagine themselves as modern-day Ernesto Guevaras replicating his traveling adventures. (As this book was going to print, the tourism industry in Argentina appeared destined for a much tougher period, this time because the currency market was working against it. Fearing inflation and an outflow of deposits, the government had to keep the peso steady against the dollar while the rest of the world's currencies

plummeted amid the 2008 global crisis. Overnight, Argentina became a less affordable country to visit.)

<div align="center">★</div>

Rosario City's experience with a flood of visitors looking for Che's birthplace tells much about the role tourism has played in Argentina's evolving relationship with a man it once tried to forget. In actual fact, the future revolutionary stayed only briefly in this port city. Celia de la Serna, Che's mother, had gone there seeking a more amenable place to give birth to her first child than the yerba maté plantation that she and Ernesto Sr. were then struggling to establish in the mosquito-infested jungles of northern Argentina. The dates of young Ernesto's stay are also unclear. He was born on either May 14 or June 14, depending on whether one believes Jon Lee Anderson's account that the birth certificate was post-dated to disguise the scandal of a premarital pregnancy. Yet this brief connection is so well known that Che is apparently a major motive for foreign tourists to visit the city. One tourism information officer told me that 90 percent of the foreigners who came to his office asked for the whereabouts of Che's home. All he could tell them at that time was to go to the corner of Urquiza and Entre Ríos streets and look at an old six-story building with an insurance office on the ground floor. He couldn't even tell them which window to look at—no one knows in which apartment the Guevara family stayed. Until recently this was all there was to see in Rosario for Che pilgrims. Many left disappointed.

The building in question has been the site of a long-running conflict, a battle that came to a head in April 2006 when a socialist councilwoman sponsored a bill requiring the city to comply with an outstanding 1992 decree to place a commemorative plaque on the building's facade. Property manager Héctor Adolfo Delgado wrote a letter to the mayor citing "an explosive element

of considerable power that did serious damage to the property and made victims out of its residents" the last time this was tried. He warned that the building's consortium of owners would hold the city responsible for damages. The city government, run by socialists throughout the preceding fourteen years, found a solution. On June 12, 2006, Che's official birthday, a thin red sign was installed in the sidewalk. Bearing the Korda image—the symbol for Che tourism—it reads: 'CHE' GUEVARA BIRTHPLACE HOME. The compromise left the privately owned building untouched, but it was a victory for the Che camp nonetheless. For the first time since it issued a birth certificate in 1928, Rosario had officially recognized Guevara's presence in the city.

This conflict is played out along ideological grounds, but its roots lie in economic factors. One cause can be seen from the bus that brings Che-hunting backpackers to Rosario. Either side of the highway from Buenos Aires is surrounded by flat green fields as far as the eye can see. At first glance this seems like a classic rural landscape, but if travelers start looking for gauchos on horseback, or even cows, they will be disappointed. These fields are not the fabled pastures of the Argentine pampas, and their produce is not destined for butcher shops in Buenos Aires; it's going to factories and chicken farms in China. The green stuff is soy, the wonder crop that was—along with tourism—hugely responsible for Argentina's recovery from its crisis. In 2007, soy and its derivatives represented 25 percent of all Argentine exports, bringing in $13.5 billion, quadruple the amount in 2000. (After world prices collapsed in late 2008, soy's contribution to the Argentine economy fell.)

The largest portion of Argentina's soy shipments leave from Rosario's port. And yet, apart from the brokers at the city's commodity exchange, most of the money bypasses its residents to end up in the surrounding countryside. There it enriches Argentina's

rural aristocracy (a group of families to which the names Serna and Guevara Lynch belong) and big multinational agribusinesses such as Cargill and Archer Daniels Midland.

But there are also victims of this boom. With growers paying top price to lease additional land on which to plant this genetically modified, high-yielding wonder crop, rural landowners have been expelling their existing tenants to make way for the deep-pocketed newcomers. The low-income tenant farmers, who'd formerly grown vegetables and other smaller crops on these plots, are then forced into the shantytowns, known as *villas de miseria* (villages of misery), that encircle the country's biggest cities. Rosario-bound backpackers will see their presence as the bus crosses a bridge, under which makeshift shelters can be seen, and when it crosses a railway line that's surrounded by the same. Meanwhile, in baby Che's upper-middle-class neighborhood, they'll find their anger spray-painted onto the buildings. "*Soja desaloja*" (Soy evicts), declares one common graffito. Others simply say *soja,* but replace the O with a skull, use a dollar sign for the S, or make the word drip blood.

As the soy refugees move into Rosario or Buenos Aires, they bring mouths to feed and a single modest currency: their votes. Politicians and activists immediately target them, promising both antipoverty policies and handouts delivered through an institutionalized patronage system. The new arrivals are also bombarded with images. Among them is one favored by the more grassroots-focused elements of the Argentine left, which recruits heavily in the *villas:* the Korda Che brand.

In 2008, with water shortages and a U.S.-endorsed biofuel initiative leaving a deficit of arable land in a world whose demand for food was growing at a faster pace than ever, a surge in international prices offered Argentina a golden opportunity. But as soy

prices pushed ever higher—before the bursting of the financial bubble in the second half of the year sent them tumbling—a trend that should have been a boon to the economy instead became the basis for a titanic power battle and yet another Argentine economic and political crisis. And in this one, both the city of Rosario and the icon of Che again played symbolic roles.

In March of that year, after the government announced a fifth increase in the tax rate it charges on soybean exports—a move, it argued, aimed at siphoning off some of the rural community's windfall and diverting it to needier Argentines—the influential farmers went into all-out revolt. Accusing a corrupt government of expropriating their hard-earned income, they launched a nationwide strike, boycotting grain sales and blockading food shipments around the country, bringing the country into a state of economic and political paralysis. The government refused to yield, and as both sides blustered and postured, the ghosts of the Argentine past were stirred up.

When in late March President Fernández de Kirchner compared the rural establishment's actions to those taken by conservative supporters of the last dictatorship, Kirchner ally Luis D'Elia, the militant leader of a leftist *piquetero* group that places the Che icon prominently on its banners, took it as a de facto call to arms. Provoking fears of class conflict, he called on members of his Housing and Land Federation—most of them from working-class or unemployed backgrounds—to mobilize against the "coup plotters." Then, amid an ensuing clash with middle-class government opponents in the Plaza de Mayo, D'Elia, who briefly held the title of land secretary in Kirchner's government, punched a heckler in the face. (He was never charged for this assault, an act that he later described as justifiable and immaterial compared with the "violence" of the farmers' strike.)

Two months later, on May 25, national Independence Day, the farmers staged a giant antigovernment rally at Rosario's national

flag monument, an imposing art deco edifice commemorating the foundation of the Argentine republic. For this provocative rally, they had the full support of the city's socialist mayor, Miguel Lifschitz, who—despite being a man of the left—is no fan of Kirchner's Peronist Party. And then three weeks after that, not far from where the farmers staged their rally, another conflict-provoking ceremony was held in Rosario, this time to unveil a new national monument—to Ernesto "Che" Guevara—on what would have been his eightieth birthday. In attendance: pro-Kirchner Che fans like D'Elia and anti-Kirchner Che fans like Lifschitz.

The second Rosario event was the culmination of a project launched in August 2006 by Andres Zerneri who, besides being a talented artist, is also blessed with a very Argentine gift for grand theatrical gestures. Announcing plans for a Monumento del Che, Zerneri sculpted a thirteen-foot plaster statue of Che Guevara and then called for donations of bronze to collect the three and a half tons needed for casting—the equivalent of 75,000 door keys. In this way the artist avoided the necessity for public funding and, in doing so, simultaneously got around the threat of political opposition and made an eloquent statement on the nature of power and collective action. Zerneri argues that this monument, made from personal donations of fire pokers, doorknobs, medals, kettles, grave plaques, and keys from thousands of people, better represents the wishes of *el pueblo* (the people) than any of the memorials to dead generals dedicated by politicians over the past two centuries.

Without any paid publicity, Zerneri's pitch received an overwhelming response. He met his targeted six and a half tons of bronze in mid-2007, one year ahead of schedule, with donations from some 14,000 people at twenty-three collection centers around the country and from as far away as Canada, France, and the United States. Each donor got to vote on the location for the statue. Overwhelmingly, they chose Rosario, to which the statue

was shipped in a barge from Buenos Aires three weeks before the unveiling.

Zerneri says his project recognizes Ernesto Guevara "as a symbol to follow, chosen by the people and not dictated by power." The idea, he says, is "to set a precedent of constructive solidarity that would generate and inspire other kinds of communal political projects, artistic or otherwise." This is a political manifesto more than an art project, one that speaks to Argentina's biggest weakness: a lack of faith in government.

Zerneri's Che does not carry a gun—"I prefer to see the hand as the weapon, much as an artist sees his hand as a weapon," he explains—but there is nonetheless a painful legacy of violence melded right into its core. A portion of the bronze is from keys once owned by *desaparecidos*. Like the shoes of Holocaust victims, these common items from an interrupted daily existence speak poignantly to the idea of a life stopped in its tracks. For the families who donate them, Che offers a powerful way to affirm the value of those lost lives. As with the word "Presente!" chanted at rallies in honor of the victims and in defiance of the military regime's evasiveness about their fate, the statue of Che makes their donation both a personal prayer and a declaration of solidarity with the movement to which the victims belonged.

But while the generals' crimes cannot be topped for their horror, it's true that some of the victims contributed to the cycle of bloodshed, for which Che's legacy can also be apportioned blame. Most of those "disappeared" or imprisoned by the junta were innocent, peaceful participants in the conflict—unionists, artists, journalists, aid workers, even nuns—but others, among them thousands of Latin American students who were inspired by Che's example, deliberately opted for armed struggle. They believed it was the only solution to the injustice and inequality of their societies, but it's hard not to conclude that the armed struggle only made things worse. Once the would-be guerrillas unleashed their

violence against the establishment, they set in motion a vicious counterresponse from the right, thus perpetuating a tragic cycle of death and retribution with which the entire continent—but especially Argentina—is still coming to terms.

★

This legacy of conflict takes a different form in the northern, subtropical Argentine province of Misiones, where Guevara spent the first two and a half years of his life. There it revolves around the polemical figure of Ricardo Brizuela, founder of the Solar del Che tourist trail at the site where the Guevara family established a yerba maté plantation. An unlikely character to be running a Che Guevara museum in a tropical forest, Brizuela has a thick mustache, a round face framed by graying sideburns, and the portly figure of a man who enjoys good food. As Brizuela trudges along a muddy track in polished brown leather shoes and a Solar del Che park officer's uniform, his differences with the stereotypical undernourished lefty become even more apparent. While recounting the Guaraní legends behind the flora and fauna and expounding on his quasi-scientific theory of how this jungle setting on the banks of the Paraná River nurtured the infant Ernestito's personality, the tourism consultant from the Argentine-Brazilian-Paraguayan "triple frontier" town of Puerto de Iguazú makes his case that Che's example holds the key to business success.

Brizuela doesn't care for those who use Che as a left-wing political banner, especially his former masters from the government of Misiones province in northern Argentina. He doesn't like the tree they dedicated to the *desaparecidos,* nor the nearby stone tablet with a black-on-red Korda image bearing the words "Seremos Como El Che," a nod to the Cuban schoolyard slogan "We Will Be Like Che!" "I want to recover the entrepreneurial and risk-taking spirit of Ernesto Guevara de la Serna, that which

existed before he became El Che," he says. "Before then, he'd already put a little motor on a bicycle and covered 4,900 kilometers in twelve provinces of Argentina when paved highways didn't exist, [and] he'd studied photography on his own, without ever attending school. He had special motivational strengths that helped him overcome his asthma; he was determined to overcome everything." This can-do spirit was cultivated in Argentina alone, Brizuela argues. "Cuba was an accident, a circumstance," he says. "Che Guevara would have been Che Guevara in whatever part of the world."

When Brizuela first learned in 2003 of the neglected property on the outskirts of a tiny town called Caraguatay, where the Guevara family lived until 1931, he saw an opportunity for an inspiring new project after various business ventures had soured. The provincial government had acquired the fifty-five-acre property on the edge of a yerba maté plantation in 1998 but had done little to develop it. It was consumed by overgrowth and was more or less in the same state in which it had been for seventy years. So Brizuela convinced the provincial government to let him develop a tourist circuit in the park. What he came up with earned him enemies. But he pressed on and now wants the Solar del Che to inspire young Argentines. If they embrace the risk-taking spirit of Che, Brizuela argues, his country can realize its vast potential.

"I have been a businessman seven times in Argentina, and seven times our country has suffered [financial crises]—they've taken twenty-one zeros from the currency," he says. "But I believe that the spirit of the businessman, even when it is destroyed, must be summoned to face another challenge, because economically there is always another challenge. Getting to know the identity of Che Guevara has generated for me in a spectacular way this new spirit . . . I want to deliver a message, and that is that we, the human beings of the world, we must all recover this entrepreneurial spirit."

Brizuela is not alone in imagining Che as a moneymaker's mentor. In the online pitch for his self-help book on how to harness "your Da Vinci-like personality," Garrett Loporto claims Guevara shared this risk-taking personality with Steve Jobs, P. Diddy, Elvis, Michael Jordan, John F. Kennedy, and Leonardo da Vinci, among others. Carlos Heller, the head of an Argentine banking cooperative, campaigned for deputy mayor in Buenos Aires city elections as a "Guevarista banker."

While such cases still fit uncomfortably with the mainstream view of Guevara's politics, most Che fans would probably get a kick out of the hour-long guided walking tour offered by the impassioned businessman at the Solar del Che. In a well-rehearsed script filled with long pauses, Brizuela delivers his thesis that this tropical setting holds the clues to how Ernesto Guevara became El Che. Visitors are told to shut their eyes, to listen to the insects and imagine the noise of screeching birds before logging wiped out their habitat, sounds that would have surrounded the young Ernesto. They are shown plants with natural healing remedies and told that antibodies acquired here helped Ernesto survive the asthma he later contracted. They are urged to marvel at the boy's father, Ernesto Guevara Lynch, who wrenched his new, pregnant wife from comfortable digs in Buenos Aires to clear a plantation in this untamed place. They hear of how Celia de la Serna, deprived of contact with the outside world, read books on philosophy, history, politics, and science to her young son. All this, the guide explains, went into the mix that created the legend. At the conclusion of the tour, Brizuela hands visitors a copy of his book with a photomontage on the cover synthesizing the tour's central theme. It shows a road leading through the forest of Caraguatay, upon which is superimposed a black-and-white photo of baby Ernesto learning to walk, and up above, floating amid the treetops, the ghostly face of Korda's Che.

The gems in Brizuela's tour are his "curiosities," phenomena that link Caraguatay to Che's adult life, as if proving its genesis role in the creation of El Che. The retaining walls on a small dam built by Ernesto Guevara Lynch form the shape of a star; the creek feeding into it bears the name Salamanca, a word that in Andean spiritualism refers to a mystical cave similar to the one eight miles from where Che died; and a settlement thirty miles downriver is called Nacahuazú, the same name as the Bolivian valley in which Che fought his last campaign. These coincidences are probably explained by the common topography, climate, and Guaraní Indian history of northern Argentina and southern Bolivia. Nonetheless, they richly contribute to the Che myth's patchwork of stories, in this case offering a bridge between the places of his birth and of his death. This is most so in the appearance of an oddly contorted tree at the end of the trail.

The tree is labeled *higuera,* the same name as the town in which Che was executed. The word also means "fig tree" in Spanish, and in this case it identifies a strangler fig, a species named for its habit of twisting its roots and trunk around external elements of its environment. At the ruins of the seventeenth-century Jesuit mission in San Ignacio, an hour from Caraguatay, one strangler fig, dubbed "the tree with a heart of stone," has totally enveloped an old stone pillar; another is perched atop a wall and has spread its roots through the brickwork. The *higuera* in Caraguatay is equally domineering. It is wrapped around the dead trunk of an *árbol paraíso,* a paradise tree.

For an optimistic Guevara fan such as Brizuela, the *higuera's* strangulation of the paradise tree is an awkward metaphor. In one of the more confusing parables of the New Testament, Christ condemns a fig tree to wither and die for not bearing fruit. The word *paradise tree,* by contrast, is an allegory for the Kingdom of God. In biblical terms, the tangle of trees at Caraguatay seems to

represent a vengeful attack on heaven by a cursed outcast. And in the context of the Che story, it gives us La Higuera: a place of death, destroying the hopes of a place associated with new life.

Thankfully, biblical scholars have found a way out of this dark reading, rescuing the hapless fig tree from eternal damnation. Faced with the vexing question of why Christ would treat the poor tree so harshly—it wasn't even fig season, apparently—some conclude that the fruitless tree in Mark's and Matthew's gospels is a metaphor for Israel's empty relationship with God. The tree's lush leaves represent the false, showy glitter of the merchants' wares in the temple, they say, while the absence of fruit denotes the spiritual emptiness within.

This is not far off the reinterpretation of Che's life by *his* disciples, those who downplay his literal violence to expose a core message. To many, Che's essential lesson is that individuals should honestly strive to produce their utmost for the good of all. They should bear fruit and not hide behind a leafy facade, in other words. It's relevant to Cuba's Che, the New Man. But it's also applicable to Ricardo Brizuela's entrepreneurial Che.

★

Early on, Brizuela's unorthodox treatment of his subject put him in conflict with Julia Perié, the province's director of museums and cultural heritage. "She is my number-one enemy," Brizuela warned as I bid him farewell and headed south to the provincial capital of Posadas. "She wants to politicize Che. She wants to create the Che of Cuba. If it had been up to her, there wouldn't be a Solar del Che."

The differences between Brizuela's and his number-one enemy's perspective on Che became clear when I met her. Perié's view was forged out of painful memories of Argentina's dictatorship, arguably the most important event for the icon's post-1967 evolution in Latin America. "Militant resistance was always present

in my family," Perié said. "So Che was always a part of our lives." Within a year after the 1976 coup, three of her brothers were in prison, leading her terrified mother to take her daughter into exile. "Thankfully, we are all still alive," Perié said. "It could have been worse."

This history continues to shape Perié's politics and view of Che, which are defined by her unwavering admiration for the Cuban revolution. She is friendly with the Cuban ambassador to Argentina and with Che's son, Camilo Guevara. She has visited the island numerous times, she told me, where she discovered that "Cubans are more like us, like Argentines, than anyone."

On this point, millions of Argentines would vehemently disagree. So would most Cubans. It is said of Che that his acerbic tongue and his seriousness were very Argentine—meant as a contrast with easy-going Cubans. Some Miami exiles even make the not-unreasonable claim that interethnic malice explains Guevara's nickname, which Castro's men gave Guevara in 1956 for his habit of using the Argentine slang word *ché*. As used in Buenos Aires, this word—a marriage of *hey!* and something akin to *buddy* or the Australian *mate*—has egalitarian qualities. A monosyllabic interjection, it levels the ground between speaker and listener, which may explain why Guevara, with his talent for tactical irreverence, proudly embraced the moniker. Yet to many Latin Americans who feel excluded from and envious of this historically wealthier, largely white European nation, the word *ché* reinforces a negative stereotype of Argentines as arrogant and uncouth.

Nonetheless, many Argentine leftists continue to regard Cuba as a model society. Many of them assumed senior positions in national and provincial bureaucracies when Néstor Kirchner came to power and began allying himself with radicals from the seventies generation to which he and his wife, Cristina Fernández, proudly claim to belong. In this way, this group is reasserting

its view of history, including that of Che. Julia Perié is one of
them. When she took over the directorship of museum and cul-
tural affairs in the province, and one of her brothers was charged
with environmental protection at the Solar del Che while another
occupied a post at the tourism ministry, they brought this view of
history to the Caraguatay park and sought to undo Brizuela's dis-
torted idea of a Cuba-less Che. "It's not right to assert that El Che
was someone who lived for two years in Caraguatay and leave it at
that," Perié said. "My impression is that Ricardo sees this merely
in terms of tourism potential. He wants to present a romantic
image of Che that he can sell to the tourists. But you can't and
shouldn't negate the whole story, and that includes that he was a
man who fought for revolution in Cuba and in Bolivia."

Perié set up a museum next to Brizuela's nature circuit; it dis-
plays the requisite photos of Guevara from more well-known peri-
ods of his life along with famous quotations by or about him. She
also moved to get rid of Brizuela. The tour guide's contract was
"transitory," Perié told me in Posadas. When we met again months
later at a Misiones press event in Buenos Aires to relaunch the
Che Park, the deed had been done. "I want to let you know,
Brizuela is out," she told me. "He doesn't represent this project
anymore."

But by then Brizuela was already anticipating the next swing
in Argentina's political pendulum. "This government's days are
numbered," he responded when I phoned him in early 2007, pre-
dicting a coming political crisis. He was buoyed by the Kirchner-
allied provincial governor's loss that year in a referendum that
would have ended term limits. "The birth of the Solar del Che
was important for the region. So I will continue my work, because
the people are asking for it. And they are not asking for El Che of
the machine gun. They are asking for El Che who is a global ref-
erence." Sure enough, when I returned to Caraguatay the follow-
ing year with a documentary film crew, the same Ricardo Brizuela

was there in the same Solar del Che uniform, making the same impassioned pitch for the entrepreneurial Che.

★

In Argentina, it's not just tourist sites in which Che is seen. A keen eye will spot him everywhere—in the jam-packed *sección popular* (people's section) behind the goals at soccer matches, for example, a place where utter anarchy reigns in a kind of throwback to barbarism. Bodies get crushed, urine and saliva flow, and so-called *barra brava* hooligans, the club's internal mafia, itch for a fight with the opposing team's *hinchas* (fans). Somehow, though, from the relative safety of the side stands, the *hinchadas* at either end are mesmerizing, even beautiful. The jumping, singing, and chanting fans, all waving their arms in unison to the nonstop rhythm of drums, unite to form a single heaving mass of humanity, a living organism. And if you look closely enough, Che is there, deep inside it. Views of his face periodically flash from thousands of colored flags fluttering in the stands, or it stares out from bare chests and shoulders, where his image is tattooed alongside team crests. The *hinchas* of Rosario Central, supposedly Guevara's team, claim Che belongs to them. But the truth is, he lives inside the anarchic heart of every football tribe.

There's also a connection between Che and Diego Maradona, Argentina's greatest and most beloved football legend—and that's not just because of the Che tattoo he wears on his right bicep. The cult of Diego is difficult for foreigners to comprehend. By most measures his life is a complete mess. His infamous "hand of God" goal in the 1986 World Cup forever labeled him as an admitted cheat; he owes $30 million in unpaid taxes to the Italian government; he gets arrested for brawling; and he seems unable to break a drug and alcohol addiction that has almost killed him on three occasions since 2000. How could this man ever be a national role model? The answer is partly explained by his magi-

cal on-field skills and partly by his wit. But it also reflects an
Argentine appreciation for refusing to conform and for living
life to the utmost. Maradona is a countercultural hero, and that
links him to Che. (One popular T-shirt puts their visages side
by side above the phrase "Futbol Revolución.") As incongruous as
it seems to pair this decadent soccer player with the austere
New Man, much about him—even his apparent death wish—
embodies the spirit of the Argentine rebel Che.

Che also has an unlikely affinity with Eva Perón, the other
mega-icon of the Argentine masses. Guevara never met Evita,
who died the day he and Granado ended their South American
tour on July 26, 1952. In fact, he distrusted her populism and the
fascist tendencies of her husband. But that hasn't stopped their
icons from sharing space at the left's rallies, where an "Evita-
Guevara Movement" banner is often visible. The leftists of the
Peronist Party have played a hand; seeking to leverage both
brands, they rewrite history, circulating accounts of Juan Domingo
Perón's admiration for Che. So too has popular culture. The movie
version of Andrew Lloyd Webber's *Evita* gave the narrator the
physical presence of Ernesto Guevara, played by Antonio Ban-
deras. He even got to dance with the lead character. (The influ-
ence of this history-bending film was brought home to me at the
Casa Rosada presidential palace, when the president's press sec-
retary showed journalists the view from his balcony to the Plaza
de Mayo. "Madonna stood right there," he told us. He didn't men-
tion that the woman she played also did so, surely a more impor-
tant historical fact.)

More than this, the Che-Evita link is also explained by our
"chaos theory." The former first lady's adoring *descamisados* (shirt-
less ones), who packed the city's plazas and avenues, scared the
hell out of the Buenos Aires establishment. It saw no place for
these destitute outsiders in its imagined idea of a sophisticated,
orderly European nation. For all Eva Perón's flaws—the extrava-

gant spending, the hollow populism—her greatest contribution to the cause of Argentina's poor was to force its elites to confront the very fact of their existence. Since then, the establishment's efforts to shut out this chaotic presence have repeatedly failed. With each failure, Evita and Che get stronger.

★

Another forum in which Che has come to take on a profile in Argentine life is the local rock scene. With the end of the *proceso,* during which many bands were forced underground, the revival of rock in the 1980s and '90s represented a noisy, proud reassertion of the once-oppressed spirit of Argentine chaos. Many of the bands embraced Che in their iconography, adopting him as a visual reminder of their difference from the junta that had constrained them in the preceding years.

This association with rock has continued ever since. In the minds of many fans, in fact, the Che icon's link to certain bands now seems stronger than its link to Ernesto Guevara himself. When I asked Fernando Luna, who was carrying a backpack with a handmade design pairing the words *La Renga* and the Korda image, what had brought him to the 2006 coup anniversary in Buenos Aires, he replied, "I'm here to support La Renga, they're playing here tonight." Luna still cared about the cause that had prompted La Renga, a heavy metal band that espouses a clear left-wing ideology, to perform. But more than politics, the icon that he and thousands of other Argentine teenagers associate with seems linked with the feelings of rebelliousness and belonging shared universally by teenage rock fans everywhere.

Even so, the antiauthority political essence of Che, his spirit, survives in this setting. According to satirist and social commentator Rubén Mira, for many young rock fans, Che functions as their *aguante,* a word that generally means perseverance in Spanish but in Argentina conveys a sense of dignity and inner strength in the

face of hardship. Noting an association between the Che icon, rock fans, and the Buenos Aires riots of December 2001—when a decade of free market policies ended with a violent crisis—Mira sees the *aguante* Che as a visceral, empowering force. "The sectors that were marginalized in the 1990s, above all the young, see in Che Guevara a symbol of resistance," he says, "not one that is rationalized, politically developed, or aimed at driving a revolution, but which is simply resistance in the face of power, the power of the police and the state."

The link between Che, chaos, and noise is also found in neighborhood dancing troupes known as *murgas*. In the seventies, the generals suspended the annual Carnival public holiday, the dancers' main festival, and ordered them to register with the government, virtually shutting them down. Accordingly, the annual coup anniversary these days involves a big turnout for the *murgas,* who bang their drums and cymbals as if the principal purpose of the restoration of democracy was the freedom to make noise. They wear colorful silky outfits with patches that place popular images into an incongruous context—Betty Boop or the Rolling Stones tongue. And typically, at least one dancer in the troupe will sport a Korda image patch.

At the 2007 coup anniversary march, I found Gustavo Alonso, a *murga* leader, carrying a bass drum with Che's face on it and a well-known Guevara aphorism written around its rim: "Trembling with indignation at any injustice." The words expressed the intent behind his drum's vibrations, explained Alonso, who wore a yellow-and-purple suit, a jester's hat, and a T-shirt demanding that Julio López "appear alive now!" This was a reference to a man who had gone missing months earlier before he was to testify at a human rights trial stemming from events thirty years earlier. "We regret that we now have 30,001 *desaparecidos*," said the jester with the bass drum.

The López case was a sad reminder that Argentina is still fight-

Murga drummer Gustavo Alonso, March 24,
2007.

ing its Dirty War and an indication as to why Che remains a highly
charged figure. If a consensual political model were to form
around, say, a moderate, social democratic political system, the
cycle of chaos would subside and his icon would become less rel-
evant politically. Democracy, as well as the influence of global
capitalism, is allowing this to happen at the margins, breeding
phenomena such as Che tourism and allowing a more sanitized
figure to arise in parallel. (Stickme.com.ar has even produced a
line of ironic Che-themed knickknacks for Argentine hipsters.
These include Che packing tape and a hotel amenities kit con-
taining a Che comb, a pack of Che matches, and a Che DO NOT
DISTURB sign. One T-shirt seen around Buenos Aires bears the

Korda image and the words "I don't know who this is but he's trendy.") But until the ghosts of Argentina's violent past are laid to rest, the hard-core icon of rebellion will survive as well. Different generations of the Argentine left will continue to tell a narrative of struggle that incorporates the martyrdom of a young rebel from Córdoba. As long as the cycle of violence continues, they will hold his icon aloft and assert what they see as their right—idealistically, perhaps—to dream of a different life, one they can set on their own terms and not on those of some external, malevolent force, be it Wall Street, the military, the IMF, neoliberalism, or a despised U.S. president.

"The past forty years of political life in Argentina were marked by violence," says Mira. "We have paid very high costs. We've lost friends, family members. Its presence is there, always. When you go to certify your car to sell it, you go to a concentration camp where thousands of people died and which is today a police depot. So for me it is a very painful problem, admitting any discussion about violence in Argentina, even though it seems to me that it is related to the essence of what Che means . . . Che represents this very violent reality, but he also makes us question the kind of life we are talking about when we say that political practices should not violate the sanctity of life. What life are we defending when we say that? A life devoid of adventure, of dreams, of importance? Is that a life worth defending?"

★

Some Argentine Che fans still believe violence is the only solution. Quite often I heard this from people I would not expect to hear it from, people like the Argentine composer Armando Krieger, author of a recent opera entitled *Che* in which he seeks to evoke the revolutionary spirit of his hero. The balding Krieger wears a close-cut gray beard, loose-fitting caftans of untreated

cotton, and sandals. He has conducted orchestras in numerous countries and was recently the musical director of the Melbourne City Opera. This gentle, soft-spoken man is not the kind one imagines planting a bomb in someone's car or kidnapping someone's father. Yet in supporting the Montoneros, Krieger implicitly condoned such actions before he fled into exile in Italy in 1976. The sixty-seven-year-old has no regrets. And he still believes it is the only way to achieve social justice. "There is no revolution without arms," he told me at Buenos Aires's Richmond Café, where bow-tie-wearing waiters served us espressos. "I would say that all democratic revolutions fail."

Younger Argentine leftists, on the other hand, seem content to pick up symbolic, rather than real, weapons. And judging by its omnipresence, the preferred of these is the Korda Che. I discovered how its power works during an afternoon with activists from the Jóvenes de Pie (Youth on Foot), the student-led youth wing of a 60,000-strong nationwide movement called the Barrios de Pie (Neighborhoods on Foot), one of many *piquetero* activist organizations that sprang up before and after the 2002 crisis to organize protests and community welfare projects among poor, marginalized groups.

The Jóvenes are worthy descendants of the Montoneros and other militant seventies groups. They respond to a similar call to militant action among educated middle-class youth, and when they talk about it they also refer to the example of Che. Romina Otrera told me that she takes the following message from Che's life into her work with slum dwellers: "If you think of something, say it and do it. Don't just stay with the thought in your head." Still, the current situation calls not for combat but for symbolic warfare. It demands that they act as part preachers, part marketing managers. As far as I know, the Jóvenes have no weapon stashes. Instead, both in the confrontations they stage with

authorities and in the attempts to convert their impoverished clients to their militant cause, they arm themselves with hundreds of images of their hero.

In a *villa* alongside a putrid drainage canal in the Florencia Varela area of greater Buenos Aires, I listened to Orlando Cisterna, the articulate coordinator of the Jóvenes' activities for southern Buenos Aires, address a group of women in the dusty yard of a house made of cast-off wood and rusted corrugated iron. "Che shows us that we have the power within us," he was saying, a red Che banner to his side. "We can and will work toward a process of change." The Jóvenes often accompany such sermons with a showing of *The Motorcycle Diaries,* Cisterna told me, making the story familiar, making it Argentine. They also emphasize the Korda icon over and over again.

"Whenever we have a rally to assert the rights of our citizens, we go to the barrio beforehand, we bring a flag, and we get the kids of the barrio together," he explained. "We lay the flag down, put a magazine with the photo of Che next to it, and get them to draw it, first with a pencil and then with paint. Often it doesn't come out looking exactly the same, but it always represents what El Che Guevara means to the person who painted it. And that's what's important. After that we go to the streets . . . with one of Che's phrases painted beneath the image—something like 'Hasta la victoria siempre' or some other. We do this for each mobilization, in each barrio, always adding new flags and banners. Before the 24th of March [anniversary of the coup], we were up until 3 A.M. doing this. We have an enormous collection of Che flags and we are always adding new ones."

Cisterna seemed to be describing a sacred rite, where the act of replicating the icon invokes the Spirit of Che, much as a repeated Zen mantra, a rosary reading, or the five-times-daily Muslim *salaat* builds spiritual strength. If this is a religion, though, it is no opiate of the masses. A few weeks before my visit,

Jóvenes de Pie activists, Villa Arrojo de Pierda.

Cisterna and his team held a Che-painting ritual with residents of the same barrio with conflict in mind. The next morning they were to rise early, take their banners to the nearby highway, and stage an angry demonstration. During a storm days earlier, the dirty water in the trash-blocked canal had surged into the *villa* with horrific results. A seven-year-old boy drowned when he couldn't open the door of the bathroom, the residents told me, and a forty-year-old man whose wheelchair got stuck in the mud died as the water rose above his head. Enraged, they halted traffic on the road for three days. Eventually the authorities came and promised to do something about the blocked drain.

The way Jóvenes activist Analia Barrionuevo tells it, Che had a hand in the result. "Che is the force in our marches, our actions. He accompanied us at the 24th of March rally and he accompanied us when we got the people to rise up here at the highway," she said. "We called on him then. He is the one inside of us." The Spirit of Che, the *aguante* Che, the Che brand, even the entre-

preneurial Che who strives to better himself—they were all present in this forsaken place. It seemed to me a sign of progress, of Che's evolution away from the days when he inspired his compatriots into suicidal armed struggles and condemned them to the same fate as his. One could argue that the Jóvenes, by embracing life in a place of death, achieve success, whereas Che himself died—necessarily, for the sake of his martyrdom—as a failure.

BOLIVIA

Second Coming

Look at that! Brilliant! You kill the leader and you nip
the whole movement in the bud!
—Caption on a cartoon by Michael Leunig showing two
Roman soldiers speaking in front of the crucified Christ

IF ARGENTINES ARE conflicted by the fact of Che's having
been born in their country, spare a thought for Bolivia, which has
lived with having hosted his death. It wasn't inevitable that Gue-
vara would meet a violent end in this Andean country; his passing
was the work of human hands, not God's. And yet, with hindsight,
it is obvious that in late July 1967, two and a half months before
the dramatic end of his Bolivian project, Che's number was
already well and truly up.

By then, his disguise was blown. His Bolivian combatants
knew who they were chasing and had already decided he would
not escape alive from the trap they'd set in the foothills of Santa
Cruz province. Che was without the medicine he needed to deal
with his increasingly debilitating asthma. Morale among his men
was dropping. They had failed to recruit a single person from the
Guaraní-speaking Indian communities of the region—a major

shortcoming by Che's own *Guerrilla Warfare* standards, one that he now attributed to a cultural barrier he had not sufficiently foreseen. In fact, the guerrillas suspected that locals were informing on them. To make matters worse, for four months they had not made contact with their colleagues from the rear guard led by Juan Acuña Núñez, alias Joaquín, who like Che's vanguard group were going around in circles and had no radio capability. (In August, Joaquín and his men were massacred in a military ambush, a tragedy the others had to learn about through Bolivian radio bulletins.)

The events described in Che's July 31 diary entry, if not the ever-confident tone of its author, illustrate the helplessness of the situation. That day, the same one on which Che was named honorary chairman of the inaugural OLAS conference in Havana and feted as a symbol of progress and revolutionary hope, he and his men were wandering up and down the Ñacahuazú River—first in one direction, as they fled the scene of a costly clash with government forces, then back the other way to cover the tracks they later discovered they'd left. Only after they cut off into the jungle in the evening could Che review the outcome of the prior day's battle: two dead, two wounded, and eleven backpacks lost into enemy hands, the contents of which included medicines, binoculars, notes, and two books—one by Régis Debray, the other by Trotsky—as well as a vitally important tape recorder for decoding messages from Havana. The twenty-two remaining members of the National Liberation Army of Bolivia were now completely cut off from the world. Their isolation was complete.

From then on, the diary assumes the tone of a Greek tragedy, one in which the unsuspecting hero marches dutifully to his doom. Unlike his three other published "diaries," Che never got to tweak this one. So although it retains his distinctive voice—his subtle sarcasm and his short, dry observations—much of it is methodical and factual. Yet strangely, the reader remains glued to

the page as the narrator recounts the daily comings and goings of the campaign. This is not really a function of prose, plot structure, or character development, but rather because the reader knows what is happening outside those pages. The book rushes relentlessly to a dramatic finale, not just the end of the tale of an eleven-month trek through the Bolivian foothills, but the end of a fifteen-year epic for this narrator-cum-hero.

The Bolivian diary is the final chapter in the odyssey that Che began writing with his Latin American motorcycle escapades in 1952. Even the most rational reader will sense that he is finally acting out the "sacred precinct" destiny he set for himself in *The Motorcycle Diaries*. Here Che is simultaneously writing and acting out that destiny; the formative moment of his myth is waiting just beyond his final diary entry on October 7, 1967. There, trapped in a ravine near La Higuera and convinced that Bolivian radio broadcasts are spinning the military's lies, his banal jottings reveal him as hopelessly ignorant that the jig is up: "The army issued an odd report about the presence of 250 men in Serrano to block the escape of 37 [guerrillas] that are said to be surrounded. Our refuge is supposedly between the Acero and Oro rivers. The report seems to be diversionary. Altitude = 2,000 meters." The power of these words does not lie in what they say. It is in the deathly silence that follows them.

Two days after those lonely last words were left hanging for eternity in an unfinished diary, a body was laid across a wash trough in the dingy laundry room of Vallegrande's hospital. Two and a half years of speculation, rumors, and story-spinning had been put to rest. Che Guevara—legendary warrior, mythical traveler—was dead.

As irrefutable as this fact was, the Bolivian military worried that the Cuban government would still call them liars and deny

them their victory dance. But in their eagerness to avoid the spectacle of a public burial, the generals had already decided to secretly dispose of the body. They had no choice but to briefly display it to the international press in a way that left no doubt as to the identity of the fallen soldier. This posed another dilemma: Giving away too much information risked exposing the lie that the revolutionary had died from his combat wounds a day earlier and not in a more recent point-blank execution. As they tried to walk this delicate line between fact and fiction, Che Guevara's killers unwittingly laid the foundation for the icon that would survive him.

The first snag came with the arrival ahead of schedule of dozens of journalists. Tipped off about Che's capture the day before, many were there at Vallegrande's airstrip to witness the bizarre sight of a helicopter arriving from La Higuera with a body strapped to its right landing skid. They watched the soldiers hustle the stretcher-bound corpse to a waiting jeep and then speed off up the hill. In hot pursuit, they followed it to the hospital. A few of them also picked up on the presence of a suspiciously American-sounding soldier, one that a few reporters correctly identified by his CIA operative name as Agent Ramos. This man, whose real name was Félix Rodríguez, would many years later officially blow his own cover and convert himself into a central character in the left's narrative of U.S. culpability in Che's death.

The media's premature presence also meant that when a team of doctors and soldiers—aided by an "affable nun," according to Reuters journalist Christopher Roper's detailed report of the events—got to work on making the slain Guevara fit for presentation, their activity was documented. Journalists and photographers had climbed trees in the yard outside the laundry room to peer into the open room and witnessed them clean the corpse and remove the evidence of a short-range blast from a semiauto-

matic. They saw a doctor slit the throat and inject the body with formaldehyde. They watched others trim the knotty shoulder-length hair and overgrown beard to reveal a world-famous face.

When the journalists were called in to view the results, they were confronted with a startling sight: the body of a man who looked strikingly alive, lying in a state of tranquility and repose. Che's eyes—those easily recognizable eyes—were wide open and, it seemed, at peace. "His clear gaze remains fresh in my memory," Roper later recalled. "There was no fear in those eyes. What, I wondered, had he seen in the situation that I couldn't see?"

Unintentionally the generals had given the corpse a Christlike visage. The final effect was not lost on the local residents they'd hoped to impress. As hundreds of them later filed past the body, some of the women surreptitiously clipped locks of hair from Che's head, saving themselves a future talisman. Until that moment, most of them had little idea who Che Guevara was. Yet many have since built an identity around the fact that they saw him that day, repeatedly telling their story to visitors. Some now claim that upon seeing him they were instantly converted into devotees of Che and his cause.

"I was one of the first here," recalled Lijia Morón of Valle-grande, who was eighteen at the time Che's body arrived from La Higuera. "There he was with his green jacket, his blue T-shirt and gray pants. What most amazed me was his expression, with his eyes open for eternity . . . The whole experience affected me deeply. I was seeing a man who wanted good things for the world, who wanted justice, who dreamed of a better Latin America, of equality between men and women. And here they'd killed him." Morón was telling me her memories while she stood in the place from which they arose, outside the little building that is now a shrine to the man who'd lain there.

The concrete laundry room with its terra-cotta roof has all the

hallmarks of a tomb, minus the body. Little more than a lean-to set aside from the main hospital, the building opens out onto a scraggly yard. Its centerpiece is the concrete trough in which Che was laid, a sarcophagus fit for a Marxist. Often, fresh flowers can be found in it, left there by local women who come regularly to clean the site.

The walls are covered floor to ceiling with graffiti. In some sections, the words merge into a massive, unreadable jumble. Among the more legible are those addressing contemporary politics: "Viva Che! Viva Chávez!" is common; so too are messages from far-flung Cuba solidarity organizations. Most, however, express timeless sentiments: "Che, you opened my eyes"; "Che, let your glory illuminate us"; "Che, may we find the courage to carry on the fight."

As with Christ's, Che's body would disappear from his tomb two days later. But before it was buried in an undisclosed location, it was subjected to one last humiliation. The hands were amputated and preserved in formaldehyde, another precautionary act aimed at maintaining the evidence. But this too would backfire on the Bolivians. Three years later, Castro somehow obtained Che's hands, and he exploited their sudden appearance as evidence of his enemies' moral depravity. (It could have been worse: General Ovando Candía had wanted to decapitate him and preserve his head but was persuaded that this would seem barbaric.)

Che's material possessions have also popped up in unlikely places: watches, pieces of clothing, a Parker pen, his marriage ring, a pipe, and books of poems, which fell into the hands of Bolivian soldiers, who traded them as collector's items. With the true location of his grave a mystery for decades, these items took on a status akin to religious relics as they forged a trail around the world. Of all these traces of his physical existence, two had an especially profound impact on his myth: a final, moving photograph and a diary that became a bestseller.

★

The first arose out of the barrage of photographers' snapshots that were taken of Che's body as it lay on the laundry slab. Of all of them, the photograph taken by Bolivian photographer Freddy Alborta was the one that would last as an iconic image. He captured an incongruous, clinical scene, one that offers a biting commentary on politics practiced at its most visceral level but that also contributed to the idea of Che as Christ or as a saint.

The photo juxtaposes the supine Che, his face looking placidly at the camera, and two mustachioed Bolivian officers who are pointing at his "battle" wounds and explaining them—a barefaced, clumsy lie frozen forever in celluloid. Between them are three civilians—local officials or Bolivian journalists, perhaps—the mortals in the middle, trapped in an oppressive, ridiculous world. They wear serious, distracted expressions, evoking uncertainty and confusion, while two innocent-looking soldiers watch from the wings, one of them toting a rifle, reminding us of the harsh realities of power.

Against this bizarre scene, the serene, half-naked man in the center seems to be offering an alternative, a path to nirvana free of the trappings of our material existence. Stripped of his clothes and belongings, Che exudes the wisdom of the dead. He looks at us with neither condemnation nor pity. This is "the gaze of the dead Guevara," wrote biographer Jorge Castañeda, "looking at his tormenters and pardoning them because they know not what they are doing, and [looking] at the world, assuring it that one does not suffer when one dies for one's ideas."

Yet if we look closely enough at Alborta's photo, we also find a warning about the dangers of heeding this dead man's message. It comes in the form of a barely perceptible clue: part of a forearm that's visible on the concrete floor in front of a soldier's feet. It's a

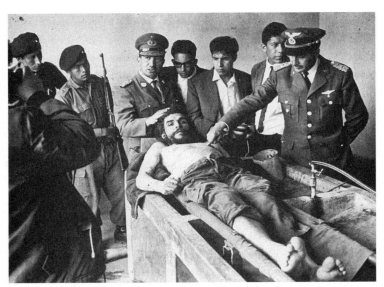

Alborta's photo of Che's body, Vallegrande hospital, October 9, 1967.

fragment from the world outside the frame, one that has invaded the otherwise flawlessly staged scene. Whereas Korda was able to remove the outside world entirely from his Guerrillero Heroico portrait, Freddy Alborta could do nothing about the forearm.

Whose arm is it? It most certainly belongs to one of two guerrillas whose bodies were dumped next to Che's in the Vallegrande laundry room. Most news accounts of the scene, if they mentioned the other bodies at all, gave no names. In his reporting, French journalist Jean Larteguy identifies them as "a Bolivian known as El Moro, and a Peruvian known as El Chino." The Chino citation is likely correct since it refers to the near-blind Peruvian Juan Pablo "Chino" Chang who was killed with Che in La Higuera. But the El Moro reference is wrong. The guerrilla who went by that nom de guerre, Octavio de la Concepción de la Pedraja, was Cuban and died four days later. Most likely the other body was that of a Bolivian, Simón "Willy" de Cuba, who was

also executed in La Higuera. But it could also have been one of three Cubans killed in the final battle in the Quebrada de Yuro ravine—Alberto "Pacho" Montes de Oca, René "Arturo" Tamayo, or Orlando "Antonio" Pantoja—or the only Bolivian to die there, Aniceto Reinaga. The bottom line is, we cannot name the owner of the forearm, precisely because it was irrelevant, indeed superfluous to the story the photographer wanted to tell. Che is at this moment finding the destiny he sought. But Willy—or Chino or Pacho or Aniceto—is already forgotten.

Surely this forearm delivers a message as strong as any other from Alborta's photo. A symbol of the human price paid whenever revolution is pursued, this is the arm of the Unknown Soldier, that frequent subject of national war monuments. Here, though, having found his way into the tomb of a well-known hero, he leaves a more realistic, less glorifying memorial. His arm speaks of neglect and betrayal. That it goes unnoticed by most who view the photo demonstrates the power that iconic images wield over us. Uncomfortable truths like this have no place within their idealized representations of reality.

Two weeks after Alborta's photo was taken, prominent English art critic and novelist John Berger pointed out that it seemed derivative of two famous paintings: Rembrandt's *Anatomy Lesson of Dr. Tulp* and Andrea Mantegna's *Lamentation over the Dead Christ*. Life was imitating art, or at least borrowing from its iconography.

Berger's essay proved influential. It was an endorsement of the photo's transcendental quality and thus an invitation to artists. In a series of four paintings done between 1972 and 1975, Canadian-born Mexican artist Arnold Belkin morphed separate elements from the photo and the Rembrandt painting into a sequential commentary on the nature of evil and truth in a dehumanizing, science-dominated society. Later, Venezuela-based Italian Paolo Gasparini played with the Christ comparison in Alborta's

Rembrandt's *Anatomy Lesson of Dr. Tulp,* 1632.

Mantegna's *Lamentation over the Dead Christ,* c. 1506.

photo by placing it into a montage he called *The Body of Che,* part of a trilogy entitled *The Sacrificed Passion.* In it, he juxtaposed its image of Che's lifeless body and photos of daily life among the poor of Latin America. The theme was revived again by Cuban artist José Angel Toirac in an icon- and myth-contorting exhibition in Austin, Texas, in 2003 to which he gave the title "Sacrifice." One of his works mimicked the Shroud of Turin with red wine stains outlining the face of Che as it had appeared in the Alborta photo.

The Bolivian government had its own, far less appealing photos of the haggard Che immediately before and after death available— those of CIA agent Rodríguez as well as photos in the possession of intelligence chief Federico Arana Serrudo that were released in 2005. As Jorge Castañeda has argued, Rodríguez's photo—which shows Che as a snarling, bushy-bearded madman—might have detracted from his myth had it been released instead of Alborta's graceful photo of the dead Che in October 1967. Trapped by their

Rodríguez with the prisoner Che in La Higuera, Bolivia, October 9, 1967.

own lies and by the need to protect the U.S. agent's identity, however, neither the Bolivian military nor the CIA could reveal these photos. Instead, the general public, which had not seen a single photograph of Che since his mysterious disappearance in April 1965, was now suddenly shown an image begging for a myth to be built around it. Unwittingly, the Bolivian military delivered the world a lasting and sympathetic picture of the man they'd hunted down. They gave it a crucified Che.

A few months later, a man from their own ranks was to do even more to aid the Che myth and benefit its biggest promoter. Antonio Arguedas Mendieta, the Bolivian interior minister who'd been frequently quoted attacking Che's "foreign invaders," organized a secret courier to send a copy of Che's much sought-after diaries to Fidel Castro in Cuba. In an explanation for his actions years later, Arguedas, who had been on the payroll of the CIA—allowing him custody of one of the three copies of the journal obtained by agent Rodríguez—said he was "just bored." Whatever the real motivation, this act immediately prompted him to seek asylum in Chile after the incident. But the Bolivian government coaxed him back, apparently fearful of what he might do with another important guerrilla relic that was inexplicably in his possession: Che's severed hands. Their concerns were justified. Three years later, Arguedas smuggled these to Castro too.

It was always hard to pin down Arguedas politically. He seemed to be a double or even a triple agent. Before his government and CIA jobs, he'd been a Communist Party member, and while his shift to Castro's camp implied a return to his former loyalties, doubts persisted over the true nature of his allegiances as his life progressed. After spending time in Cuba in the 1970s, Arguedas moved to London, then to New York, and later to Lima. He finally

returned to La Paz in the 1980s, where he was periodically the target of shootings, once had his house bombed, and spent time in jail for kidnapping a salesman. In February 2000, his body was found after an explosion in a residential La Paz neighborhood house. Police say they found bomb-making equipment at his home and literature from an underground kidnapping and terrorist outfit known as the Commandos Against Corruption, Cocaine and Castro-ism. If this reflects where his true sympathies lay, some people see his death as another notch for the vengeful ghost of Che.

Arguedas's politics weren't likely to stop Castro from exploiting his gesture in early 1968, however. The arrival of the diaries offered the prospect of a major publicity coup for the Cuban leader, who immediately enlisted staff at the Cuban Book Institute in a rushed effort to publish them before the CIA did.

"We worked for a whole week, like in a prison," recalls Tony Evora, the former graphic designer at *Revolución* who at that time was head of graphics at the institute. "People were calling to us from out in the street; 'Hey, what are you doing in there? Are you printing money?' There were all sorts of rumors. We had to stay until the book was finished and totally bound."

Separately, Castro had also sent for Giangiacomo Feltrinelli, who was by then fully engaged in Cuba's international PR campaign. According to the Italian publisher's son Carlo, he holed himself up in an apartment in the Vedado neighborhood of Havana and in a matter of days had produced an Italian translation. Meanwhile, translators got secretly to work on three other versions. Finally, on June 30, 1968, a million copies of the first Spanish-language edition were printed in Cuba. Days later, publishers in Italy, Chile, Mexico, France, Germany, and the United States all launched it, making it an instant bestseller. And of course each edition bore the Korda image on its cover.

★

The publicity generated by the diary and the compelling story behind Che's Bolivia campaign gave it a significance for Cuba and the international left that far outweighed its relevance as a military event. President Barrientos's depiction of the operation as a "Cuban invasion"—an effort to dissuade impressionable young Bolivians from buying Cuba's portrayal of it as a liberation struggle—was hardly an accurate description of the ragtag band who had wandered for months through an unimportant part of Santa Cruz, most of them to die pointless deaths.

Fast-forward to October 8, 2006: La Higuera, memorial for the thirty-ninth anniversary of the last day of Ernesto Guevara's life. Four decades later, the invasion foreseen by Barrientos is finally in full swing. And this time the Cubans are doing it right—with their culture, not with guns. Ably assisted by their Caribbean cousins from Venezuela, they have taken over this remote outpost of civilization with gaudy colors and loud music.

We arrived in a convoy—the official dignitaries in SUVs, the hangers-on like me in taxis, minivans, or trucks—raising clouds of dust as we descended upon this little town of mud-brick and thatched-straw houses at the dead end of a hundred-mile trek from Vallegrande. There it seemed that the only features maintained or upgraded since October 1967 were the town's proliferating Che murals and statues. Many of these sported fresh paint jobs for this year's ceremony. After all, the date did not merely signify that thirty-nine years had passed since Che's execution; it was the beginning of twelve months of preparation for an international gathering planned to mark the even more important fortieth anniversary. What's more, this was the first time the memorial had been held during the administration of Evo Morales, a socialist president who hangs a Korda Che made from coca leaves in his office.

Just fifty meters away from the place where Guevara was executed, the organizers of the event had set up two banks of speakers alongside a stage draped with Cuban and Bolivian flags and more pictures of the Guerrillero Heroico. A tape of Che-themed folk songs, including the ever-popular "Hasta siempre comandante," was blaring out into the valley below while the little plaza rapidly filled with visitors. Each was handed a paper Bolivian, Venezuelan, or Cuban flag. The biggest contingent, a group of Bolivia-based Cuban doctors, was settling into the folding chairs in front of the stage.

As members of their country's 30,000-strong foreign medical corps, these doctors are part of a Cuban aid program administering free health care in sixty-eight countries. They are the vanguard of Havana's new developing-world solidarity strategy. They deliver much-needed services, for which in return Cuba gets much-needed goods—subsidized Venezuelan oil, for one. As the face of their country's humanism, they are also pivotal to what economist Archibald Ritter describes as its bid to rebrand itself: "Cuba is trying to reduce the emphasis on tourism . . . and become recognized as a source of medicine and education services worldwide."

The marketing pitch behind this new brand centers on differentiating Cuba's free universal health care system from the dysfunctional, expensive American one. But it is also clearly hitched to the old Che brand. A disproportionately large mission of Cuban doctors works out of the Dr. Ernesto Guevara Clinic at Vallegrande's hospital, for example, the same one whose laundry room once housed its namesake's lifeless body. At the anniversary ceremonies in La Higuera, the two brands were synthesized into a single image: Each of the 240 or so doctors in attendance wore a white lab coat unbuttoned to reveal a red or blue Che T-shirt.

By 11:30 A.M., the doctors and hundreds of others who'd arrived in La Higuera were getting edgy. Jeeps carrying digni-

taries from Vallegrande were already an hour late. Without them, the memorial ceremonies could not begin. I used the time to visit the museum housed inside a small building on the site of the old schoolhouse in which Che was detained and shot. There I found a man introducing himself to visitors. He was Eusebio Tapia Aruni, and as he verified by pointing to his name on a list of victims and survivors, he had fought with Che. "It wasn't true, it was a mistake," I overheard him telling a Cuban doctor, who looked at him warily. I later found Tapia Aruni selling his autobiography and other printed material from a ragged blanket on the ground near the town's main Che statue. It wasn't until I read his book that I was able to put his presence there into its rightful context.

In March 1967, with rivalry and conflict brewing among his men, Che wrote in his diary that he had placed Tapia Aruni in a reject group before demoting him to the rear guard. It was a purge of what he called "the dregs," and later, "the quitters." Three months afterward, Tapia Aruni and another Bolivian, Hugo Choque, were captured. (The official Cuban version is that they deserted.) In response to army radio broadcasts about their surrender, Che wrote that he had no doubt they talked. But after reading Tapia Aruni's own account—how he was a victim of a struggle inside the guerrilla group, how he valiantly endured torture by his captors, how he believed in the revolutionary cause to the end—I'm not sure Che had it right. Either way, I could feel nothing but pity for the diminutive Bolivian: He'd been dubbed a traitor by none other than El Che, a man he'd nonetheless continued to idolize. A founder of Bolivia's Che Guevara Foundation and the author of more than ten books—on his life, on Che, on the revolutionary struggle, and on the injustices of neoliberalism—Tapia Aruni has spent his entire adult life trying to clear his name.

★

The sound of tires skidding to a halt on dusty pavement signaled the arrival of the anniversary organizer, Osvaldo (Chato) Peredo. With him came an entourage of Bolivian, Cuban, Venezuelan, and Argentine officials, including the guest of honor for the anniversary, Aleida Guevara. It was the first time Che's daughter had visited the place in which her father had died. After a tearful tour of the museum, she was led back to the plaza to address the crowd. "I never thought I'd be able to come to La Higuera," she said before a sea of waving paper Bolivian, Cuban, and Venezuelan flags. "But in fact I have a great sense of peace right now." Dr. Aleida Guevara said she was emboldened by the support of her medical colleagues, those "who've come again from our Cuban island in the Caribbean to bring health and education, and all the love possible to the men and women of this land." They'd followed in the footsteps of her father's men in 1967, she said, who'd similarly "left their families for a deep and beautiful ideal: to bring liberty and sovereignty to other peoples."

From then on, the program moved quickly. A lineup of speakers took to the podium, their speeches interspersed with audience chants prompted by an announcer: "Fidel!" "Viva!" "Chávez!" "Viva!" "Evo!" "Viva!" The wife of one of the Miami Five held on espionage charges in the United States, "the most terrorist nation on earth," called tearfully for their release. In a demonstration of diplomacy Cuban-style, the country's ambassador to Bolivia, an imposingly tall man with a mustache, railed against "the genocide facilitated by a servile opposition to the interests of the Bush government." And the Argentine representative, *piquetero* leader Luis D'Elia, who would later play a pivotal role in his country's political crisis of 2008, declared that a newly socialist Latin America, in "saying no to Bush, no to the Free Trade Area of the

Americas, and no to free trade treaties," was proving that "Che is not dead."

The sound of a military helicopter drowned out the Argentine's voice, however. Bearing both a Bolivian flag and the letters FAV (Venezuelan air force), the presidential chopper landed in a nearby field, kicking up dust and leaves that drifted over the plaza before descending onto the throng like gritty rain. There was a great sense of anticipation as we waited for the blades to stop. But the door opened and no Evo Morales was to be seen. A spokesman conveyed the president's apologies: He was delivering provisions in flood-affected areas.

As we returned to our seats, a guitarist played a few more melancholy Che ballads before Chato Peredo took the microphone. Such events are emotional affairs for this man, the brother of Coco and Inti Peredo, both of whom fought with Guevara and died in the struggle. In 1970, Chato led his own doomed attack on a U.S.-financed gold mine at Teoponte, north of La Paz, in which all but nine of the sixty-seven young guerrillas died. Today, however, he was acting as the most senior representative of Morales's Movement Toward Socialism (MAS) alliance, the new power in Bolivian politics. And in this capacity he had found himself in a slightly sticky situation as he explained why the official delegation had been held up earlier. The people of nearby Pucará, he told the crowd, had used this occasion to enforce a fifteen-year outstanding demand on the government. When Peredo's entourage had reached their little town, the townsfolk had stood in his way, refusing to budge until he signed a document promising them electricity.

After Peredo's remarks, the people of La Higuera made a ceremonial presentation to Aleida Guevara. Once this was concluded, the Cuban ambassador hustled the guest of honor into a waiting SUV while attendants took charge of her gift. Standing behind the jeep, I watched three men lift a solid two-foot-high replica of La

Higuera's main monument, a bust of Aleida Guevara's father, into the back of her car. As it sped off up the hill in another cloud of dust, Che's eyes stared at me through the rear windshield.

★

Aleida's departure triggered a mass exodus. Just as quickly as it had arrived, the invading army retreated up the same track. Within an hour, the Bolivian officials, the Cuban doctors, a delegation of Venezuelan teachers, three different state TV crews, and a variety of banner-waving student groups had all disappeared. Save for a few stragglers, La Higuera was quiet again. It returned to being a town in the middle of nowhere.

I caught a ride with an Italian chef and his Swedish girlfriend, who offered to share their taxi to Vallegrande. Fausto Borelli and Angela Fjordmarke had been making their living for the past ten years in the now booming city of Dublin, which explained their odd-sounding Irish-Italian and Irish-Swedish accents. They were now taking their hard-earned euros on a whirlwind bus trip through Bolivia. Fausto told me it had always been his dream to visit La Higuera. He'd been to Cuba three times and had traced Che's steps from the arrival point of the *Granma* yacht through the Sierra Maestra to Santa Clara and then to Havana. On this trip, he'd been in Rosario, Che's Argentine birthplace, and he had now finally made it to La Higuera, the climax point for Che's story. "It's amazing. I have goose bumps. I tell you, I might cry later," he said. Fausto insisted his interest in Che had nothing to do with politics or religion and was simply because "this guy did so many good things and helped poor people wherever he went." In fact, Fausto didn't even like those who use Che's image "for protests and things like that, because he wouldn't have wanted to be used as an idol."

The chef was nursing a hangover from the night before, but he was still keen to restock his beer supply for the journey back to

Vallegrande. So we stopped in Pucará, which sat at the halfway point in the two-hour journey. While Fausto stepped into a kiosk, I dashed off into the town square, where I hoped to find the mayor who'd organized the blockade at the start of the day. Chato Peredo, the ex-guerrilla and current representative of the Bolivian government who'd led the delegation of officials at the ceremony in La Higuera, had earlier told me he sympathized with the town's situation. "I come by here four or more times a year. It gives me great pain to see that in this era of human history there is still a town that doesn't have electricity," Peredo said. He'd insisted, however, that the solution was not confrontation, but rather dialogue. I figured the mayor would disagree.

He wasn't hard to find. "Over there, the one who's dancing in the yellow top," said a local, pointing out one of the town leaders, in a little group of revelers. Mayor Fernando Rengel seemed to be expecting me. "Imagine, we here, a municipality of 2,500 inhabitants and nineteen communities, we are the only municipality in all of the Department of Santa Cruz that doesn't have electricity. It's a truly incredible thing. What century are we in? We are in the twenty-first century," Rengel said, stopping occasionally to spit flecks of coca leaf from his teeth. For the next twelve months of events related to the fortieth anniversary of Che's death, his people were going to block the road repeatedly, the mayor vowed. "We are not going to let anyone past until we resolve this problem," he declared, adding that there'd been a $130,000 plan in place for twelve years to install electric cables and signaling equipment, but the prefecture and the government had failed to agree on how to implement it. "Well, no more agreements. They mean nothing! We are not going to let anyone continue on to La Higuera until we see the installations begin . . . How are we supposed to have appropriate conditions for all the tourists who are coming here without energy? We don't even have a hotel or a hostel. Why not? Because we don't have energy!"

I thanked my interviewee and returned to the car, where Fausto handed me a beer. After I'd recounted Rengel's words, the Italian looked at me earnestly and said, "I tell you, Che would have been proud of him."

★

Maybe it's the lack of electricity, the dusty unsealed roads, or the various other shortcomings in the infrastructure that hint at an inhospitable terrain's refusal to be tamed; or maybe it's the insularity of the people who inhabit it and the way they cling to a subsistence lifestyle. In any case, this part of Bolivia seems to be cut off from the outside world. Even after forty years of foreigners traipsing through it, it feels trapped in time. This is despite the fact that the area around La Higuera is both highly politicized and part of a giant multinational culture. It is the contradiction between this vast global identity and a small-world local reality that is so striking about the lack of development here, not the limited amenities per se or even the persistence of pre-Columbian traditions and languages.

The taxi that delivered my European traveling partners and me to Vallegrande seemed to symbolize this dogged resistance to the outside world's influence. Known as a *transformado,* our vehicle was once a right-hand-drive car designed for some left-side-of-the-road foreign country. It had ended up in Bolivia's used-car market, and to comply with local road rules, an auto shop had shifted the steering shaft to the left-hand side. And yet the instrument display remained on the right. Once again, the foreign had failed to merge with the local.

As I watched the speedometer tick before me in the front passenger seat, I became acutely aware of the gulf between our lives and that of the fourth occupant of the car, the driver. We three travelers had a connection forged out of a new era of global interconnectedness. I was an Australian-born employee of a U.S.

multinational living in Buenos Aires; they were from Italy and Sweden and had met as fellow immigrant workers in Ireland, the land my ancestors had fled in starvation now transformed into a high-tech powerhouse with an insatiable demand for foreign labor. We were hardly alike, but as we shared thoughts about a dead, Spanish-speaking white guy in a common international language, our differences began to look superficial. By contrast, when I glanced at the driver, I sensed an unfathomable cultural divide. Unable to make sense of our chatter, he dipped constantly into the plastic bag of coca leaves between us and chewed on its contents voraciously. He did not say a single word throughout the three-hour journey.

There is something tragic about this persistent cultural and economic gap, especially as it pertains to the outsiders who arrive here every year to rededicate themselves to the struggle for the poor and honor a man who did the same. For all the attention paid to La Higuera, they have delivered close to no material advancement to its impoverished residents. The pre-Columbian, animistic traditions of this place do not mesh with the ideas and sensibilities of the industrialized West. It's the same clash of cultures that stymied Che's attempts to introduce a progressive strain of that Western thought, as if those who follow in his footsteps are condemned to repeat his mistakes. Consider the scene each October—hordes of foreign dignitaries, political leaders, social activists, alternative lifestyle advocates, and romantic dreamers spend three hours in a remote, dusty village of decrepit mud-brick huts to hear bombastic speeches and plaintive ballads through giant speakers. Surely this is what Marx meant when he said that history repeats itself, first as tragedy, second as farce.

Che did leave a mark on this region. But it seems likely that the avowed atheist would not be fully comfortable with the form his posthumous influence has taken in the local culture. Many residents of the area around La Higuera and Vallegrande now see

Che as a saint, complete with the power to perform miracles. Rather than becoming the fired-up revolutionaries he had hoped to create, they've addressed their problems by seeking his spiritual intervention in them, quite often by praying to his likeness. (Here the Korda image quite literally lives up to the religious derivations of the word *icon*.)

These days it's not hard to find followers of "San Ernesto." Lijia Morón, the woman I met at the hospital morgue site in Vallegrande, is one. She showed me where she lights candles and incense beneath a painting based on a 1961 photo of Che in her living room. I also met Irma Rosado, a shopkeeper in La Higuera who charges visitors two dollars to hear the story of how she took coffee to a prisoner in the schoolhouse forty years ago, a man, she said, whose "exquisite expression" moved her soul. Ever since, she has been lighting candles daily beneath a Che statue in the town. "He has always helped me when I've needed him," she insisted.

In recent years, these and other believers have been quoted in various news articles. In 2006 a Cuban film, *San Ernesto, Born in Vallegrande,* documented their practices. Yet for decades the phenomenon was hidden underground—partly because, as in the case of Argentina, the topic was taboo in a country controlled by conservative military leaders who wanted to expunge Che's memory from its history.

"They used to come into town screaming at us," said Rosado of the periodic visits La Higuera would get from soldiers after Che's death, when fear of reprisals led dozens of people to leave the town for good. (From a population of eighty families in 1967, La Higuera has now been reduced to twenty.) Twice she watched soldiers storm into her little town and take away a statue some students had put there. Undeterred, the sculptors came back a third time. The fruit of their struggle—a crude, rough likeness of the revolutionary in stone—still stands in a fenced-off area at the

entrance to La Higuera, where it has in recent years been over-shadowed by the far bigger bust of Che and, since early 2007, by a realist-style twelve-foot full-body statue of Che in bronze that stands right in front of the students' noble little gray-painted sculpture.

As some tell it, the story of how the image went from being banned in this country to being an ever-present symbol, one now used frequently in La Paz and other parts of the altiplano by Evo Morales's Movement Toward Socialism (MAS) party, reads like a biblical tale of redemption, an allegory similar to that of the early Christians' passage from persecution to power in Rome. It gives us the Che T-shirt reconceived as the crucifix or as the Christian fish symbol.

Antonio Peredo—a MAS senator, author, former Morales running mate, and elder brother of Inti, Coco, and Chato—traces the symbol's liberation to 1997, the thirtieth anniversary, a year in which a Cuban forensic team announced the discovery of Che's previously hidden body. At that moment, the elder Peredo says, the extent of the San Ernesto cult became startlingly apparent in the Vallegrande area. At a meeting he held to plan the anniversary events, devotees started sharing their stories of persecution while the women took him to their houses to see their portraits of Che and to show how they venerated him. When the bones—whose authenticity is now disputed—were disinterred and sent to Cuba, the women made a vow, he said: "This year, El Che has come out from his clandestine existence. He will now determine the destiny of his enemies." This, Peredo explained to me, is why Hugo Banzer Suárez, who'd ruled Bolivia as dictator for most of the 1970s and had returned to power in August 1997 as an elected president, could not stage that year's October 8 commemoration of the military's victory in Vallegrande. The people of the town would no longer accept it.

From there, the narrative extends into the rest of Bolivia and

the rise of Morales, as the indigenous masses stand up against the "neoliberal" privatization policies of previous governments. Many old Bolivian revolutionaries now link this emancipation of El Che to the protests that rocked Cochabamba in 2000, for example, when the Bechtel Corporation was forced to abandon the city water utility it took over in 1997. Or they associate it with the "gas war" of 2003, when poor youths took control of the sprawling streets of El Alto and forced the resignation of President Gonzalo Sánchez de Lozada. After centuries of control by foreign interests, these events are seen on the left as a moment of enlightenment, one in which members of Bolivia's downtrodden Amerindian majority finally took control of their country's abundant natural resources and, by extension, their destiny. It is as if Che's spirit, now arisen from its hidden grave, was finally able to spark Bolivian revolutionary consciousness, a force frustratingly dormant during his campaign forty years earlier.

"I was a vice presidential candidate with Evo Morales in the year 2002, and I thought that in an electoral campaign there was no reason to link myself with El Che," Peredo told me. "But one day in which we made a tour through [the coca-growing area of] Chapare, I saw that El Che was everywhere. So I began to speak of El Che, and it was the speech that most captivated the people, the speech people felt most strongly about, because Che was not just a nice image, not the image of an actor, but the image of concrete things, things that had been undervalued by neoliberalism, things like honesty, things that are very clear to people . . . El Che is the very thought of revolution, the thought of social transformation, and this thought is what is present in this moment."

★

Senator Peredo's explication of El Che's broad, universal meaning was intended to indicate that Che's message shouldn't be narrowly interpreted as a military concept. This viewpoint is typical

of many in Latin America whose political antecedents lie in the armed movements that arose in imitation of Che. They are now converting their painful, bloody past into a present in which power is pursued peacefully through the ballot box, with symbols and a media presence used in place of guns. One man who has experienced this transformation personally is the politician who replaced Antonio Peredo as Morales's running mate in his successful 2005 bid for the presidency. Alvaro García Linera, the current vice president, spent five years in prison on terrorism and insurgency charges in the 1990s for his involvement with the Tupac Katarí guerrillas. Like Feltrinelli, his group was big on blowing up electricity towers. Today he is the face of a pragmatic alliance between Bolivia's white middle-class left and Morales's indigenous supporters, a coalition that led to their unprecedented electoral victory and a paradigm shift in Bolivian politics.

García Linera is tall and young, and—like virtually every presidential leader before Morales—has a white face with no trace of indigenous blood. Alongside the dark-skinned president, he is a striking embodiment of the idea that the advancement of the Bolivian left required middle-class socialists and indigenous leaders to bridge the racial and cultural divide that had frustrated reform efforts since Che's time.

I met García Linera by chance. I happened to see him stride out of his office with some aides as I was trudging up a hill in La Paz toward the presidential palace, where I had spent considerable time other days waiting fruitlessly for a promised interview with Morales. Recognizing the chance at a compromise, I dashed up the hill to greet the vice president.

I quickly realized my mistake. Unaccustomed to La Paz's 4,000-meter altitude, I ran out of breath. By the time I'd caught up to García Linera and tried to introduce myself, I could hardly speak. "Señor . . . (gasp) . . . Vice . . . (gasp) . . . Presidente . . . (gasp) . . . soy . . . (gasp) . . . Michael . . . (gasp) . . . Casey . . ." A pitying look

came my way, along with an outstretched hand and some advice that I should think twice before running up hills in La Paz. The vice president also gave me the number of a secretary who would set up an interview. A day later, in a thirty-minute, wide-ranging conversation, the articulate García Linera came across as a worthy representative of a Latin American left that has adjusted to the demands of the twenty-first century. My interviewee talked of overturning "five hundred years of apartheid" and of preventing the wealthy white oligarchs in Bolivia's low-lying southeast from controlling too much of the country's wealth, a precursor to a serious constitutional crisis that would erupt a year later as the anti-Morales provinces in that resource-rich region threatened to secede before unilaterally declaring autonomy. But he also promised profitability for foreign investors, with whom he vowed to negotiate in a bid to insert his country into the world economic system. It was a case of militant Guevarista meeting global economy realist.

Despite García Linera's peace offerings, he and Morales have managed to create many enemies in the foreign business and political community, including the U.S. government. Partly that's because of the fiery rhetoric coexisting with their softer messages, as well as the confrontationist political symbols, including Che's image, that they thrust in their foes' faces. It's also partly due to their bold policies. Morales nationalized his country's vast natural gas resources and quadrupled the state royalty that multinational oil companies must pay to exploit them. And in a contemptuous dismissal of America's war on drugs, he has permitted greater coca production—solely to supply traditional, non-narcotic markets, he insists. He has also forged alliances with U.S. enemies such as Hugo Chávez, Fidel Castro, and Iranian president Mahmoud Ahmadinejad. Morales has accused the United States of conspiring to assassinate him and has dug up intelligence that, while failing to confirm this death threat, leaves

the impression that U.S. policy makers do indeed continue to manage relations with unfriendly foreign governments via clumsy, Cold War–like tactics. In 2008, a Fulbright scholar studying in Bolivia revealed that an official at the U.S. embassy in La Paz had asked him to provide the names of any Cuban and Venezuelan aid workers he encountered in the field. Morales immediately accused U.S. ambassador Philip Goldberg of a conspiracy against his government.

The United States has sanctioned Bolivia in various ways. Notably, constraints have been placed on the U.S. Agency for International Development's $120 million budget for the country, downgrading an aid presence that dates back to middle of the last century. But the gap has simply been filled by Venezuelan aid, now thought to surpass U.S. assistance as Bolivia edges further into the Chávez camp. The change of benefactors means a change in, but not an end to, conditions attached to aid. No longer so dependent on U.S. money, Bolivia is less bound by the politically unpopular coca eradication goals linked to much USAID largesse; this no doubt suits Morales, a former coca grower representative. But Chávez's money is not without strings attached. Many Bolivians fear that their country is becoming a client state of the Venezuelan leader. What's more, tighter controls on U.S. aid disbursements make it harder to funnel such money into various market-driven development projects that exist outside of the antidrug program, projects that can successfully arm Bolivia's poor with the tools to participate in the global economy.

★

One aid program that suffered collateral damage from the battle between Morales and Bush is a bold new tourism project in the area in which Che's guerrillas fought. In 2004, aid agency CARE International launched its "Che's Route" plan with much fanfare and $600,000 in seed money from the U.K. government. But

after Morales came to power and railed against Western governments' support for the neoliberal policies of his predecessors, CARE was unable to raise money for the next phase. Foreign donor governments no longer favored Bolivian projects, especially one associated with a historical figure now revived as a political symbol by a confrontational populist government. The infrastructure upgrades needed to advance the project were at a standstill, which in turn meant that tourists continued to avoid underdeveloped places such as La Higuera or limited their stays to brief, fleeting visits.

A few travel agents now offer hiking and jeep tours under the "Che's Route" concept. But despite the renewed attention paid to Guevara and a clever logo—a trail map formed from the contours of the Korda image—the project has had a slow start. The problem, Santa Cruz–based agent Walter Guzman says, is a self-perpetuating one: a lack of investment in infrastructure. Unlike Caraguatay, which has the world-famous Iguazú Falls; Alta Gracia, with its Jesuit mission; or even Cuba, with its beach resorts, Bolivia's Che zone has no existing foundation of tourism upon which to develop its offerings. It is stuck in the same cycle of poverty that Che's National Liberation Army encountered forty years ago.

The setbacks encountered by CARE have not, however, stopped grassroots development activists from placing their hopes in Che-related tourism. One case is the Mambo Tango Cultural Center, formerly known as the Che Guevara Cultural Center. Founded in 2005 by Nadine Crausaz, a Che-admiring Swiss sports journalist, and her friend Manuela Prax-Meyer Tusco, the center offers supplemental education and recreational activities to local children in Samaipata, two hours from Santa Cruz. Here, ten teachers and the occasional foreign volunteer give lessons in health education, nutrition, art, music, football, tennis, horticulture, and Brazilian capoeira dance.

The Mambo Tango Center ties its philosophical outlook to Che but tends more to the "New Man" essay than to the "Message to the Tricontinental." There is a large mural in the foyer based not on the Korda image but on a Raúl Corrales photo of Guevara laughing. "I wanted another vision of Che, not the serious one with the beret, but one with more charisma," said Miguel Talamas, the center's painting teacher.

With many of the local families unable to pay the ten-boliviano ($1) monthly charge for attendance and outside donations hard to come by, the center is pursuing a range of novel funding ideas. Crausaz is hoping to one day organize a fund-raising match involving current and former soccer stars bearing Che tattoos. She has lined up financial backing for the event, but organizing the game and the players—especially erratic types like Diego Maradona—has proven difficult. So in addition to that bold bid, the center is also betting on tourism. It has built a little Che Guevara museum on the premises to siphon off some of the dollars that pass through the town. "Samaipata has a nice climate and it's a pleasant town, so people come here," said Prax-Meyer Tusco, the director. "The idea was that there needed to be a center here based on Che. So the people could first arrive here and then go on to Vallegrande." Visitors who drop in are offered Mambo Tango souvenirs: colorful wristbands and other items hand-woven by the children, as well as a sampling of Che gear, including hats and T-shirts based on Talamas's rendition of the smiling Corrales image and little bobblehead Che Guevara dolls.

Nestled in a low-lying valley, Samaipata is a quiet, pleasant place that draws a steady inflow of foreign backpackers, some of whom stay to study Spanish. It is not exactly a mecca for Che fans, but the town did feature briefly in the guerrilla saga. In August 1967, some of Che's men seized a small garrison stationed here. Their actions had no military purpose: Rather, to the amazement of the locals, who were more accustomed to soldiers steal-

ing from them, the guerrillas simply held down the fort a short while so that a few of them could go to the local pharmacy to buy asthma medication for their ailing commander. Unable to find what they needed, they released their prisoners and left.

Partly because of this history, the cultural center initially ran into problems with the mayor of Samaipata, Adolfo Pérez Saldias. An ex-military man, Saldias forbade any association with the revolutionary, which prompted the organizers to put Talamas's mural in the foyer rather than outside the building and to adopt a cleverly subtle name. (Mambo Tango is the name Alberto Granado gave to a raft he built with Guevara in Peru during the *Motorcycle Diaries* trip, a friendly dig at his travel partner's poor dancing skills. Ernesto, Granado discovered, couldn't tell the difference between a mambo and a tango.)

Still, attracting Che tourism is difficult without mentioning the main attraction. So it was a great relief to Crausaz when, a year later, the mayor did an about-face. When I met her in La Higuera during the fortieth anniversary celebrations, she told me that Saldias was now actively promoting the center's connection to Che. It was not that he had joined the cult of San Ernesto; rather, the mayor had found the religion of Che tourism.

There has also been a modicum of progress toward modernity in La Higuera. Fittingly, perhaps, the first step was taken at the home of the old telegraph operator, the official who, on October 9, 1967, received the message containing the encoded order that Guevara be executed. For many years, the abandoned home was a symbol not merely of a lack of progress, but of the town's regression. In 1967, when the telegraph was in place, it represented a link to the outside world. Forty years later, La Higuera was connected to neither the national grid nor the telephone network. But in 2005, a Frenchman, Juan Rebras, converted the station into a hostel, even installing the town's first hot water heater there. This accommodation has had an effect on the town. Now,

says shopkeeper and San Ernesto devotee Irma Rosado, at least a few people stay for a day and buy provisions from her, rather than bringing them from Vallegrande.

Even so, the old woman's run-down little store, with its dirt floor, its moldy walls, and its out-of-date, faded calendars of blond-haired models, is a reminder of how small the gains have been. She does not expect her or her neighbors' lives to improve through tourism. Some, like Rebras, see such attitudes as a reflection of the townsfolk's inherent desire to keep things as they are. But it might just as well be a reaction to the Bolivian political system's track record of placing stumbling blocks in the way of progress. During my first visit to the town in 2006, I asked Rosado, who had watched thousands of visitors pass through over the previous thirty-nine years, why, as she put it, "we've made no progress." Shrugging, she replied, "I don't know. People come, they walk around, and then they go. Other than aid workers, no one stays." Until the government seals the road or puts in electricity or makes other improvements, she doesn't expect big changes. "Politicians always say they're going to fix roads," Rosado said, "but they never do it."

★

A year later, I was back in La Higuera for the fortieth anniversary memorial of Che's death. This time the organizing committee of what was billed as the Second International Che Guevara Congress (the first was in October 1997) had arranged for participants to do a five-mile walk from Pucará to La Higuera on the night of October 7. The goal was to arrive in town around midnight for a vigil in the early hours of October 8. My traveling partner, the Argentine satirist and author Rubén Mira, and I took an easier option: We got a lift into town first so we could witness the pilgrims arriving.

Bit by bit, some two hundred marchers straggled in, carrying

flags and banners, most of them looking exhausted, especially those who'd arrived in Vallegrande only the night before after a three-day bus journey from Buenos Aires. Many perked up in La Higuera, however, with the aid of a variety of intoxicants. Rum, *chicha* corn liquor, beer, and joints passed through the crowd, which gradually grew to about six hundred and began to take on the feel of a circus. Along with the requisite Bolivian, Cuban, and Venezuelan officials, La Higuera was being overrun again by dreadlock-wearing hippies, Argentine students, ex-Cuban guerrillas and current Cuban doctors, indigenous activists, European Che fanatics, curious tourists, and dozens of journalists.

Within this mob, I spotted some of the most convincing Che look-alikes I have so far seen. These were not performers in search of money. Rather, they simply seemed to express their dedication by copying their hero's look, a new interpretation of the motto "Be like Che." As with the Elvis impersonators who descend on Memphis in homage to their hero, they helped La Higuera do a pretty good impression of Graceland.

Whatever Ernesto Guevara was trying to do there forty years earlier seemed irrelevant in this theater of the absurd. We watched as new arrivals stood beside the newly installed bronze sculpture and gave the thumbs-up to their photo-snapping friends. The gesture was in keeping with the statue—this Che sported no guns, wore a smile, and with a hand that held a cigar between its fingers, waved cheerily at his visitors.

Later, a woman excitedly ushered me into the pavilion near the town's plaza, a building that, like all the others, had no electric lighting. My guide showed me a mark on a wall that others were highlighting with flashlights. The shadowy image refused to go away, she told me, no matter how much the townsfolk repainted the wall. "And look, it's the image of Che." Sure enough, the contours of this stubborn grease stain roughly resembled the Korda image. (The following day, at a ceremony in Vallegrande attended

by Evo Morales, a similar "miracle" occurred. The announcer told the audience to look to the sky and behold the Spirit of Che, which in this case had taken the form of a circular rainbow that completely ringed the midday sun.)

The crowd in the La Higuera plaza was getting steadily drunker, such that when the delayed official ceremonies finally began after midnight, disorder prevailed. As a representative of Bolivia's unions and cooperatives took to the podium, a late-arriving folkloric group behind the stage that seemed unaware of its bad timing started setting off firecrackers and launched into a rousing rendition of a traditional *siku* (pan flute) song. (Only after a loud *shh* from the crowd did the instruments abruptly stop.) The Cuban ambassador then delivered his standard rant about America's sins, before Bolivian vice tourism minister Ricardo Cox stood up to praise the powers of "revolutionary tourism." Losing the thread on this incoherent idea, he then offered music as an alternative way to make his point. The mustachioed official picked up a guitar and, with a sequence of thrashy, open-chord strums and a bellowing voice that made his jugular bulge, regaled us with a ten-minute song he'd written about Che.

Meanwhile, seated with the other VIPs were town leaders from Pucará. It seemed Mayor Rengel's confrontational strategy had paid off. Not only was the township invited for the first time to have representation among the delegations, but the promise of electricity was also tantalizingly close to being fulfilled. Lying beside the stage were long poles that were supposed to have carried power into the town by the time of the festivities, but that would nonetheless eventually achieve that goal.

Later I discovered, however, that Peredo and Morales's arch-enemies in the provincial government of Santa Cruz were claiming responsibility for the power project, which was to be founded on a small hydroelectric plant. By the time of Che's fortieth anniversary, Pucará, La Higuera, and Vallegrande—all key names in

Che lore—had become pawns in a raging feud between the central government in La Paz and that of Santa Cruz and its neighboring provinces.

On paper, the dispute that was by then threatening to tear Bolivia in two was about constitutional reform. But in essence it tapped into the most divisive issues of Bolivia's painful colonial and postcolonial history: race, wealth, and power. While La Higuera is poor, a significant part of Santa Cruz does quite well for itself, courtesy of some large agribusiness activities near the subtropical city of the same name, Bolivia's second biggest after La Paz. And most of its voters tend to be a lot whiter than the indigenous Aymara and Quechua people that inhabit the high-altitude altiplano in which the capital is located. As a part of his effort to break down the power of the white elite in Santa Cruz and other low-lying regions of the southeast, as well as to improve the well-being of Bolivia's long-suffering Amerindian majority, Morales's government introduced a new constitution that strengthened indigenous rights, giving them greater participation in a planned redistribution of private and state lands. It scared the wits out of Cruceños—as the province's inhabitants are known. Their representatives boycotted the constituent assembly and instead insisted that their long-standing and referendum-approved demand for more autonomy be fulfilled. (Six months later, with Morales refusing to accede to this demand, the province and four others went ahead anyway, setting up local assemblies that were intended to take some key powers away from La Paz.) As Morales threatened to block this challenge to his power with force, some locals countered with a call for outright secession. Suddenly Santa Cruz was awash with one ominous graffiti slogan: "Take up arms, Cruceños!" This tense climate, one in which talk of civil war was rising, was the one in which Morales's supporters launched the Second International Che Guevara Congress.

In December that year, a small explosion occurred at the Santa Cruz home of Chato Peredo, the anniversary organizer, during a bout of anti-MAS reprisals. But during the October events, Peredo's biggest problem was the mayor of Vallegrande, who belonged to the pro-autonomy, anti-Morales opposition. Some even accused the mayor's supporters of sabotage, blaming them for the low turnout—numbers were well short of the projected 10,000 foreign visitors; there were fewer than at the thirty-ninth anniversary—and for various logistical hiccups. Many believe the citywide power outage that occurred on the night of a concert that was to be held in Che's name was no accident. And, according to one common account, the reason it was so hard to get a bus from Santa Cruz to Vallegrande was that local officials had deliberately chosen this time to raid bus companies and suspend drivers accused of drunk driving.

Despite—or perhaps because of—this tension, one of the reliably controversial mainstays of Che culture was thriving in Vallegrande: commerce in his image. The stalls set up in the official public plaza near the Che museum tended to be run by true believers in Che. There, the Mambo Tango Center could again be found selling its wares to raise money for its Guevara-themed cultural center. There also, a man was selling red and white balloons with Che's face stamped on them to recover the cost of bringing his family to Vallegrande to honor his hero's memory. Incredibly, he had hand-carved the stamp onto a tiny one square centimeter of rubber with such precision that when the balloons were inflated, the Korda image appeared in perfect proportion. In compensation for this impressive craftsmanship, he was asking one boliviano (12 cents) for each balloon.

In a smaller but far busier plaza a few blocks away, a different set of Che merchants hawked their wares in a more irreverent way, as if deliberately mocking the solemnity with which Latin American leftists regard the town. In the bustling street market at Valle-

grande's *plaza popular,* where vendors sold fruit and *chicharón* pork stew from precariously assembled food stalls while a dentist performed open-air molar extractions and a megaphone-wielding skin cream salesman endlessly listed the ailments that his wonder product promised to cure, Che was on offer in some tremendously incongruous forms. For a dollar, I picked up a baseball cap that combined an embroidered Korda image, the words "Che Vive," and a fabric patterned with Major League Baseball logos. A store-front that opened onto the plaza displayed two mannequins decked out in a combination of camouflage-chic gear and Che T-shirts. And on lampposts, posters for the later-canceled concert juxtaposed Che's face with the familiar red-and-white corporate logo of a famous American soft drink.

Had they seen these posters, I'm quite sure that anti-Castro bloggers in Miami would have gone nuts over Coca-Cola's spon-sorship of a Che memorial event. But it would probably pale in comparison to the indignation that Che fans expressed over another commercial venture in the smaller plaza. From a truck parked alongside the square, bottles of Cuba El Che, a new Santa Cruz brand of premixed rum and cola with a logo comprised solely of the Korda image, were selling like hotcakes. On either side of the vehicle's cargo container was a giant photo of a raven-haired beauty in a red bikini standing on a beach, her legs parted suggestively, a two-liter bottle of the same product resting on one knee. Above her head was a slogan: "Cuba El Che—El Unico." The scene encapsulated every breach of the integrity of Che as defined by members of both the Korda and Guevara families: sex and alcohol, combined in a shameless commercial exploitation of the Cuban revolution's beloved hero. Of all places, it was dis-played here, in the city in which his lifeless body was laid and secretly hidden for decades—and on the fortieth anniversary of those events, no less.

The owner of the operation, Fernando Porras, gave us a frank

Baseball cap, Vallegrande, October 7, 2007.

description of how his idea was conceived: "We noted that those who drink this kind of product are typically between the ages of sixteen and twenty at the same time that those who are admirers of Che are often between the ages of fifteen and twenty, so that's why we entered the marketing of Che," he said. (Porras said he supports Santa Cruz's bid for autonomy, but he thinks it is stupid that many of his fellow Cruceños who used to embrace the Che

symbol—such as university students and unions—have since dropped it to avoid an association with the president.)

It is with some trepidation that I disclose that this truck was my lift back to Santa Cruz. There were limited buses running at the time—something, we were told, to do with the ongoing political battle—so when the opportunity came up to take this vehicle back to the city, we jumped at it. Regardless, as the truck, displaying its oversize images of Che, the bikini girl, and a bottle of rum and cola slowly carried us through the forested hills in which Che Guevara and his band had fought their last, lonely battle, I felt a tad guilty. This feeling was heightened when, perched upon bottle crates, I saw through the open back doors of the truck a jeep with one of those very same men in its passenger seat. It was Leonardo Tamayo, better known by his nom de guerre of Urbano, one of the few survivors of Che's campaign.

It will hardly prompt forgiveness from the old Cuban guerrilla, but it needs to be said that Urbano's presence in those parts was also connected with a marketing exercise. Earlier he'd been a guest speaker, along with Evo Morales, at a rally near the pavilion that now guards the Vallegrande grave site where Cuban officials claimed to find Che's bones. There, while the Bolivian president talked of a new revolution, a sea of Korda Che flags flapped in the wind before him. Porras might have been exploiting Che to sell rum and cola, but Morales and his supporters were using him to sell ideas.

What we find is the same symbol representing contradictory brands, each employed as a weapon against the other in Bolivia's high-stakes constitutional battle. As Morales pitched his message—a strong central state, justice for his country's underclass—and placed it in direct competition with Santa Cruz's "autonomy" brand, whose buzzwords are *market democracy* and *individual rights,* the differing versions of Che seemed to can-

cel each other out. As they brandished the Korda image in pride, Morales's followers reasserted the Spirit of Che's values of self-sacrifice—resistance, struggle, social justice. In contrast, Porras's commercialized Che, one of booze, sex, and self-gratification, was a dismissal of such high-minded claims. It was not clear who was winning: Morales and his coca leaf Che occupied the presidential office, but the empty crates in the back of the truck were proof that the Santa Cruz businessman's Che was also selling well.

VENEZUELA

The Chavistas' Crusade

The mother of revolution and crime is poverty.
—Aristotle

THE MAN WHO has done more than any other to associate the Che image with the revival of the Latin American left at the start of the twenty-first century is Venezuelan president Hugo Chávez. After a decade of free market reforms swept the developing world amid the Western triumphalism that followed the Berlin Wall's collapse, Chávez's arrival onto the world stage in 1999 rejuvenated the hopes of the left—and not only in the impoverished parts of his continent.

To Australian student Stuart Munckton, with whom I spoke on the sidelines of what was billed as a "Marxist summer school" on Sydney University's plush, stately campus, Chávez's self-described Bolivarian revolution stood for the prospect of change through peaceful means. Yet he and others attending that event, where Che T-shirts were the norm, saw no contradiction in associating Venezuela's experience with the face of a man who prescribed armed struggle as the means of attaining socialism. In fact, the activist group to which Munckton belongs—an organiza-

tion that is simply called Resistance—places the Korda Che prominently on its website and promotional material.

"I think the Spirit of Che is absolutely relevant in Venezuela," said the ponytailed student, arguing that "there's not really a qualitative difference" between Chávez's ideas of ballot-box revolution and Guevara's, the only real difference being that the latter conceived of his "form of struggle" in an era of dictatorships "in which there wasn't a political space." What matters, Munckton contended, is that in Chávez's attack on Venezuela's old bourgeois elite—in nationalizing businesses, diluting property rights, funneling national oil wealth into welfare programs, and limiting the power of private media—"you are seeing the essence of what Che wrote."

A few months later I found myself amid another group of students eager to confront an elite group with its hands on the levers of power. I was in Caracas, but the target of the protest was not *yanqui* capitalism and its allies within the Venezuelan business community; it was Hugo Chávez and his domestic cronies. A week earlier, the Venezuelan president had refused to renew the license of one of the country's biggest TV broadcasters—the openly anti-Chávez Rádio Caracas Television, or RCTV—on the grounds that it had backed a failed coup against him in 2002. Chávez's supporters among his country's poor welcomed it as a long-overdue blow against Venezuela's dominant private media groups, but to the middle class, RCTV's removal was an attack on democracy, a step toward dictatorship, and a gift to a growing Chavista elite.

For the students who'd convened this rowdy rally, it was also something personal. RCTV, they told me, had been *their* TV station, known as much for its popular entertainment, including its

schmaltzy soap operas, as for its news content. "It is our chan-
nel. It was born with us," said Astrid Rivas, twenty-one. "We just
want peace, but the government is promoting conflict and vio-
lence." Banners shared these sentiments: "Freedom of Expres-
sion"; "We are with RCTV"; "Chávez, the Face of a Coward"; "No
to Cubanization."

As they marched down Francisco de Miranda Avenue through
the neighborhood of Chacao, the middle-class heartland of
the anti-Chávez opposition, people emerged from the Hewlett-
Packard and American Airlines buildings to cheer on the stu-
dents, men in business shirts and ties, women in skirts and
blouses. Some on higher floors had recycled their paperwork—
draft legal contracts, interoffice memos—as confetti, and it
rained down on the protesters below. Everywhere amid this fes-
tive mood, young men and women were making the middle-class
salute of our era: Their mobile phones, held a foot away from
their faces, digitally froze memorable moments from a memo-
rable day.

As these educated young people marched, they chanted slo-
gans that affirmed their collective power, often adopting a protest
standard that's also part of the Latin American left's repertoire:
"La gente unida jamás será vencida!" (The people, united, will
never be defeated!) They even resembled the Jóvenes de Pie
activists of Buenos Aires, with similar hairstyles, body piercings,
and tattoos on their arms and napes of their necks. Their back-
packs honored the same rock bands; their clothing displayed the
same brands. Yet there was one key difference. Although I spotted
Rastafarian hats, peace signs, Jim Morrison, Kurt Cobain, and a
few other global youth icons, I saw no Che. For once, this rebel
was unwelcome. Why? Because Che belonged to the enemy, now
on the side of authority, whose foot soldiers had that same day
gathered two subway stops away.

★

The nearby pro-Chávez rally, staged in a zone marked by pro-
government or anti-opposition and anti-U.S. graffiti—"RCTBush"
was a common slogan, in some cases coupled with an equals sign
and a swastika—was Venezuela's version of a leftist show of force.
It was another noisy gathering, yet it had none of the primal,
chaotic power of the Argentine equivalents I'd seen and certainly
none of the spirited energy of the free speech protest I'd just
come from. A series of trucks placed at fifty-meter intervals, each
stacked with banks of loudspeakers and followed by a few hun-
dred marchers, was creeping along. A woman representing the
government-funded universities screamed into a microphone in
condemnation of the anti-Chávez students from the private,
autonomous universities. "We want classes! No to vandalism! No
to the manipulation of the students! We won't accept dictator-
ships at the autonomous universities! We want a democracy!"
And then, after a pause: "Socialism or death!" Speakers on the
next truck were broadcasting a plaintive-sounding ballad about
then paratroop commander Chávez's failed coup attempt in Feb-
ruary 1992; the lyrics described it as "a struggle for the humble
ones" launched by a "patriot without measure." Further back,
another truck was surrounded by people in T-shirts with the logo
of TVes, the public broadcaster now in control of RCTV's confis-
cated signal. They were bellowing a familiar chant: "La gente
unida jamás será vencida!"

Everywhere, there was a sea of red. And here, dotting regula-
tion Chavista-colored baseball caps and T-shirts, the Korda image
lived. One woman's T-shirt had Che's face alongside those of
Bolívar, Chávez, and Castro, who were described as the "Fantas-
tic Four of the Revolution." On the stand she'd set up alongside
the march, a woman named Marie Gutiérrez showed off gar-
ments, pins, and other revolutionary paraphernalia. Her stall was

full of Chávez and Che trinkets and garments, with quite a few pairing the icons together, such as on a camouflage hat that placed them on either side of El Comandante's star. "The revolution is good for little people like me," explained Gutiérrez. She'd always sold revolutionary-themed materials, she said, but the police used to stop her from selling her wares and, because she had to pay for things like health care and food back then, she'd put in twelve hours to make ends meet instead of the eight that she works now. "Every day I'd cry because I couldn't see my children," she said. "Not now. Thank you, President Chávez."

This merchant of Chávez-Che hats seemed genuinely behind her president, not a propagandist. And I got the same sense from

Participant in pro-Chávez rally in Caracas, May 29, 2007.

José Javier Serrano, whose T-shirt gave Che's face the title of Major League Revolutionary. Yet he also unambiguously stood for the exercise of raw political power. After telling me that Che would have supported the RCTV suspension as "a step toward the revolution, a step for the people," Serrano identified himself as a member of the army's Seventh Reserve Corps—a volunteer corps, like reservists everywhere, which from time to time answers a call to national duty. "We are the ones that the president of the republic has called upon, and we are here in defense of the revolution," he stated proudly. After years of standing up to military dictatorships across Latin America, here was Che on the streets of Venezuela, back in his old guise as a government-paid soldier.

★

Chávez does not actively promote Che in the manner of Morales or Castro. His official iconography is dominated by the long-dead Simón Bolívar, the Venezuelan liberator, while Che is relegated to an eclectic grab bag of second-tier contributors to his "twenty-first-century socialism": Marx, Mao, Lenin, Rosa Luxemburg, Castro, and Christ. Unofficially, however, Che is of great importance to the Venezuelan president's political project, mostly because his support base is heavily into him. Che is worn by many of the young, red-shirted zealots who do the president's promotional work through a network of Chavista organizations known as the Bolivarian Circles. (Bolivarian militias, critics call them.) The Korda Che icon is also the most prevalent symbol among the leftist social movements of the region that have joined Chávez's pan–Latin American Bolivarian Congress of Peoples.

The popularity of Che may even pose a challenge to Chávez. As a call to higher standards and idealist values, Che is a force the Venezuelan must manage with delicacy. At the rallies Chávez periodically holds in Buenos Aires, those Che flags he faces in the audience—the hand-painted banners of the Jóvenes de Pie, for

example—belong to the Argentine Che of antiauthoritarianism, anarchy, and disorder. In such cases it's easy to imagine that the piercing eyes of the Guerrillero Heroico are staring judgmentally at this Bolívar-adoring ex-paratrooper, an embodiment of state-funded, militarized power.

Up until now, the relationship has been mutually beneficial. Chávez gives his audience something to believe in, a more acceptable manifestation of power than the free market system of the 1990s. He also pays for the buses that ship people into these events, the hire of the venue, the security, the latrines, and so on. In return, the crowd generates a raucous, theatrical show of power, an important indicator of Latin American populist success. Still, although he has a rapport with people and cultivates the image of a down-to-earth rebel unafraid to say provocative things, Chávez is no Castro. He never seems to be in total command of the Che-waving masses.

And in Venezuela, where class conflict is now a defining feature of the society—defying the president's efforts to centralize political discourse in the way that Castro did—Che has become an even more divisive figure. For half the country—the Chavista half—the Korda image is an inspirational icon; for the other half it is a target of disdain, facilitating iconoclastic statements of symbolic resistance. Twice in 2007, separate government-backed sculptures honoring Che were destroyed just hours after they were erected. The accounts of the vandalism were proudly covered on anti-Chávez and anti-Che blogs, complete with before and after pics: top, government officials unveiling the sculpture; bottom, headless bust discovered the next day. Che, reconceived in this Latin American country as an instrument of militarist state power, is now a catalyst for its divisions. Here, the clash of interpretations that has always persisted around this symbol has been made manifest in the real, political struggles of the day.

One example of how Che's divisiveness feeds into the real

political conflict was on display when I came to visit my Dow
Jones colleagues at the offices of El Universal, one of Venezuela's
biggest daily newspapers. Some of the paper's staff, enraged like
many journalists at the RCTV shutdown, had gathered on the
sidewalk to chant slogans in support of freedom of the press. Sud-
denly a motorcycle gang pulled up. In a tense moment, as engines
revved while the protesters raised their voices and directed
chants of "Libertad!" at their intimidators, I spied the Korda
image. Che looked out at me from the black T-shirt of a young
man on a Honda bike. Minutes later, he was gone. To the cheers
of the protesters, who'd stood their ground, the Guerrillero
Heroico's biker gang disappeared down the street.

Che's presence on that street corner marked him as a partici-
pant in a violent power struggle; a conflict pitting the wealthy
owners of the country's media organizations and the traditional
business establishment against Chávez and a growing clique of
cronies profiting from their ties to Venezuela's cash-rich state oil
company, PdVSA. Sometimes the tactics on both sides have
involved sending out the thugs, as with this incident. Mostly,
though, they have fought a propaganda war with the symbolic
weapons of news and popular culture. The Chavistas were right
to complain to me of the blatant bias in the news coverage of
RCTV, Globovision, and other opposition-backed private news
organizations. But they seemed blind to the government's monop-
olizing of information in other forums: the expansion of politically
compliant state-owned and "cooperative" media, as well as the
widespread use of public advertising, which dominates the bill-
boards of Caracas and many of the country's newspapers. The
threat of withdrawing this lucrative source of ad revenue func-
tions as a subtle but powerful way to get nominally independent
publications to censor themselves.

In Venezuela—unlike in Argentina, where an apathetic major-
ity opts out of the minority political class's slugfest—this fissure

reaches down to the street level. There too the battle among common people plays out with symbols. The student protesters' symbolic weapons included marker pens, with which they wrote slogans on placards and defaced government posters. Their own bodies were also part of the weaponry. As protesters from all parts of the political spectrum know, images of students facing off against water cannons and tear gas canisters can win international support—and this was so in the RCTV case. Meanwhile, hundreds of thousands of Chávez-supporting Venezuelans retort with their own symbolic statements in the clothes they wear and the accessories they carry. For most, Che is the preferred choice.

When I saw Che on a Ministry of Energy poster pinned to the side of a tent near the Esquina Caliente (Hot Corner) plaza, I immediately assumed that whatever was inside was part of some government-funded campaign. The ministry was "extracting oil," its ridiculous slogan declared, "to sow the seeds of consciousness needed to form the New Man." Inside the tent, however, there were no mustachioed bureaucrats, but rather three smiling women from the Esquina Caliente chapter of the United Revolutionary Socialist Front and a rack of literature. They were not part of the government and had voluntarily set themselves up here, Frances Peña assured me, to spread the word about socialism. They'd chosen the ministry's poster, she said, to associate their ideas with Che's values. Her colleague, Arleni Rengel, explained why these were relevant to the RCTV shutdown: "El Che thought it was necessary to create the new individual now so that future generations will benefit," she said. "We are not in this struggle for ourselves. We know the revolution will be enjoyed by others, by our grandchildren and by their grandchildren. It is for them that we seek to change the paradigm. We must create better media organizations that influence the young people of today so that we can form the individuals we need to lead the country in the future."

I didn't share her faith in achieving utopia by ditching a privately owned news organization in favor of one that backs an authoritarian regime. Still, it was refreshing to hear the Spirit of Che so idealistically invoked. It seemed to confirm its imperviousness to the abuse of power, even in a place like Venezuela, where power and money have always forged an unholy alliance.

★

Any discussion of the Chávez phenomenon and the factors behind the new Latin left must start with the region's social indicators. Throughout a decade of aggressive market reforms in the 1990s, Latin America's poor made less progress than those of Asia, which pursued a more gradual shift to the new post–Cold War paradigm. Latin American poverty rates stagnated or, in some countries' cases, rose. Meanwhile, the region's shameful income and wealth distribution worsened. According to the World Bank, the richest 10 percent in Latin America and the Caribbean controlled 48 percent of the wealth in 2003, while the poorest 10 percent controlled a measly 1.6 percent, a more unequal spread than anywhere else in the world. Whether this should be blamed on capitalism per se, on the corrupt or weak regulatory institutions installed at the time, or on the haste with which the reforms were introduced is open to debate. In fact, there's plenty to be said for the argument that the preexisting inefficiencies of the region's overprotected, state-dominated economies are the real culprits, since they made it more costly and politically difficult to implement change. But semantics are irrelevant to those who believe, with religious certainty, that socialism is the only solution— among them many young people who identify with the Spirit of Che. For them, Latin America's inequalities simply boost the Korda image's currency as a political brand and strengthen the appeal of leaders like Chávez who exploit it.

The country that best exemplifies the injustice of Latin Amer-

ica's wealth gap is oil-rich Venezuela. Halfway through the twentieth century, Venezuela was a well-to-do country with a respectably large middle class. By the end of it, after oil had been discovered and exploited, it had displayed all the classic signs of inequality of wealth that are seen across the continent, with the top 20 percent of the population controlling more than half the country's total income and the bottom 20 percent just 4 percent. The contrast is not merely statistical: Caracas's slums climb precariously up the mountains that ring the city, looking down condemningly on the middle-class residents of suburbs like Chacao in a striking juxtaposition of wealth and poverty.

In 1999, real per capita GDP in Venezuela was at its lowest level in history, a mere three quarters of what it was in 1978. Half the population was defined as poor, with 20 percent deemed "extremely poor." It could be argued that bad luck was partly to blame: While Venezuela's population doubled over that period, there was a steep plunge in the price of oil, its principle source of revenue. Nonetheless, in demographic terms, this shift meant that a marginalized sector of society reached a critical mass. Is it really that surprising that this large block of voters put their weight that year behind a bombastic figure like Chávez? He came to power in 1999 with a message for the poor: Their plight stemmed from the greed of foreign oil companies and Venezuela's political and economic establishment; *they* had stolen the country's wealth, the *people's* wealth.

Whether Chávez has made lasting structural changes to Venezuelans' lives or has set them up for a future of deprivation is an important question. Certainly, by 2008 mounting food shortages and surging inflation were clearly eating into whatever earlier victories he'd had against poverty. But his critique of past Venezuelan governments has strong merits. The simple fact that a country so wealthy has failed so dismally to beat poverty is a damning indictment of its past policies. In fact, its record of economic and

social development has not helped the case of wealthy business-
men everywhere, those who argue that low-tax, pro-business poli-
cies are in the interests of all because they provide incentives
for economic growth. In Venezuela, where access to oil "rents"
should in theory lower the cost of helping out the poor, the busi-
ness sector's promises of trickle-down benefits never material-
ized. "Resource-rich countries' failures to use their resources for
redistributive purposes give rise to Chávez-like people," says the
Columbia University professor and persistent IMF gadfly Joseph
Stiglitz. "These countries give us a test case of how economic sys-
tems work, and it reinforces the view that the reason we don't
have redistributive taxes is not incentives; it's theft."

It's a lot easier to redistribute oil wealth, however, when oil is
fetching eleven times more cash. The single most important fac-
tor behind Chávez's power, as he entered the tenth year of his
presidency, was the fact that a barrel of West Texas Intermediate
was by then selling for an unprecedented $135. When Chávez
assumed office in February 1999, the same industry benchmark
was at $12, its lowest level since July 1986 in absolute terms and
the lowest ever when adjusted for inflation.

By December 2008, oil prices had plunged to $45 a barrel, mark-
ing a dramatic reversal in Venezuela's fortunes and in Chávez's
capacity to exercise political power. The exponential price increase
in prior years had not only multiplied the value of Venezuela's oil
sales in straight mathematical terms, it had enticingly raised the
possibility of a massive expansion in output volumes. In theory,
the wider profit margin made it worthwhile for oil producers to
tap parts of the country's crude reserves that were previously too
difficult and of too low quality to extract. As a function of this,
the Venezuelan government estimated its *potential* oil reserves in
early 2008 to be as high as 235 billion barrels. But these highly
debatable figures—which would make Venezuela the second most
important producer in the world after Saudi Arabia's equally

contested numbers—which only existed in theory. Oil industry analysts contend that mismanagement of PdVSA during Chávez's tenure has so depleted the company of technological capacity that in practice very little of its harder-to-get reserves should be counted. Despite the global oil boom, Venezuelan production actually fell between 1999 and 2008.

Still, in the realm of politics, theory can be as valuable as practice. The mere prospect of having so much oil at a time of such high prices afforded great power to Chávez. With world demand soaring on the back of China's and India's race to industrialize, and with mature oil fields in the Middle East operating near capacity, Hugo Chávez positioned himself as the supplier of the critical *nth* + *1* barrel, the one everyone wants. Latin America's new revolutionary standard-bearer was blessed with something that its previous one, Fidel Castro, never had: bucketloads of money.

When this book went to print Chávez still pumped these petro-dollars into the country's low-income barrios, where zealous Chavistas in trademark red shirts delivered free education and computer classes, health services, and family food programs. He also used his deep pockets to project power outside of Venezuela's borders. His government purchased bonds from countries such as Argentina and Ecuador, allowing them to finance themselves while snubbing Wall Street demands for changes in economic policy. Venezuela quickly replaced the United States as Bolivia's main source of aid and played an even more vital role in Cuba, where one University of Miami report valued its 2008 oil subsidy at a staggering $4 billion. Both governments would say Havana pays for its oil with medical services, but with stipends of $3,000 per year, more than a million Cuban medics would have to be in Venezuela to cover the cost. The reality is that Venezuela became Cuba's new Soviet Union, easing some of the pressure on Raúl Castro for political and economic reforms that would otherwise

be needed to attract foreign investors. In return—much as the Kremlin did—Chávez got to hitch his brand to Cuba's in his pitch to left-wing idealists around the world. But it would be naive to imagine that this aid money was granted without other strings attached: Chávez demands support for his international ambitions, and if politics were to change in these client states, the money flow would dry up. For many years, Latin America's left-wing intellectuals subscribed to dependency theory, which held that the region was locked into a destructive economic relationship with the United States. Suddenly those countries that were feeding off the trough of Chávez's petrodollars found themselves in a similar relationship with Venezuela. What the shrinkage in the treasure chest will mean for this relationship remains to be seen.

The use of financial largesse marks a fundamental strategic difference between the Venezuelan leader and his mentor, Castro, who was forced to build his regional influence via propaganda and image management—an approach, as we've seen, that drew heavily on the brand of Che. It's hard to see how Chávez could ever do the same. He does not share the Cuban's oratory skills, even if his marathon speaking sessions and his weekly, four-hour *Alo Presidente* radio show seem founded on Castro's rule: By constantly talking, you deny your opponents a chance to attack. And yet Chávez *is* more than oil. He too has tapped deeply into the left's stock of symbols, stories, and myths to burnish his revolutionary cachet. Most important, he has stuck to a long-standing narrative thread that presents the history of the continent as a battle between an evil, powerful North and a poor, exploited South.

This story of imperialist subjugation is an old tale. Embellished by talented writers such as Uruguayan journalist Eduardo Galeano, whose bestseller *The Open Veins of Latin America* became the region's template for understanding the nature of foreign power, the basic story line runs: "*We* have the wealth; *they* steal it." The tale begins with the pillaging conquistadors, but it's

mostly dominated by the misdeeds of thieving *yanquis*: the Mexican-American War of 1846; the 1901 Platt Amendment permitting U.S. intervention in Cuba; CIA-backed coups and other foreign policy actions designed to help companies like Standard Oil and United Fruit; Henry Kissinger's tacit support for the South American dictators' Operation Condor crackdown; the Iran-contra scandal; the 1983 Operation Urgent Fury invasion of Grenada. Sadly, this us-versus-them narrative is backed up by a vast, damning archive of declassified U.S. documents, which only makes it harder for conservatives and others outside of the Latin American left to convince those inside it that the continent would be better off taking responsibility for its failings than blaming its rich neighbor.

After 1989, this North-South antagonism seemed briefly to subside. American-trained economists were allowed control of economy ministries across Latin America and were encouraged to remodel their economies, implementing the prescriptions of the World Bank and the IMF. Now, however, this brief cooperation appears to have made things worse—certainly in terms of Washington's relationship with the more confrontational parts of the continent. After a series of crises in Brazil, Argentina, Ecuador, and Bolivia, the experience of the 1990s—and its phraseology—has been integrated into the same old anti-*yanqui* narrative. Chávez and others contemptuously use the jargon of the previous era as if it refers to crimes against humanity. There's the word *neoliberalism*, which now sounds a bit like *murder,* and the sinister-sounding phrase *the Washington consensus.* Even in their heyday, these phrases were nothing more than clumsy stand-ins for a highly complex set of policies. If we follow *Foreign Policy* editor Moises Naim's advice, they are best understood as marketing tools: Previously wielded by those who promoted economic reform, these words are now turned against them by their opponents. After the Argentine financial meltdown in 2001, Naim

wrote that *the Washington consensus,* a buzz phrase in the 1990s, had become a "damaged brand." At the same time, for his various regional initiatives Chávez employs language that separates Latin America both ideologically and geographically from *the North:* a Bank of the South to compete with the Washington-based IMF and Inter-American Development Bank; the Telesur (TV of the South) cable channel, pitched as an alternative to CNN; and his Bolivarian Alternative for the Americas, a vague plan for intra–Latin American trade and aid whose Spanish-language acronym, ALBA, mocks that of the U.S.-backed Free Trade of the Americas, ALCA.

The emergence of Chávez and the new regional left, as well as the revival of their favorite icon, Che, was also helped by developments outside of Latin America. The Asian currency crisis of 1997–98 suddenly put into doubt the financial deregulation that had previously swept the globe, enriching Wall Street while leaving poorer countries vulnerable to sudden shifts in the global capital market. This gave rise to the antiglobalization movement in the West, with its ferocious attack on the IMF and the World Bank right at the moment that Che was being resurrected, courtesy of the thirtieth anniversary of his death and of the renewed media attention prompted by the Cuban government's announcement that they'd discovered Guevara's bones in Bolivia.

Then, after 2000, regional leaders like Chávez and Castro were given another gift: the arrival of George W. Bush, who would quickly become deeply unpopular overseas, especially in Latin America. Across the continent, I've heard *Bush* used pejoratively as a verb—as in "to be Bushed"—and I've seen countless graffiti showing his face with a Hitler mustache. Rightly or wrongly, the forty-third president of the United States was to many Latin Americans the very image of northern imperialist greed, both arrogant and ignorant. In the left's ongoing narrative, he conveniently personified the evil North, against which the good South

struggled. At the same time, he functioned as the perfect foil to Che, who represents the opposite values: selflessness, independence, and "the struggle."

In the symbolic warfare that shapes Latin American politics, Che gained significant ground during the disastrous eight years of the Bush administration. Much like a commercial brand that bolsters its appeal by differentiating itself from a big, but inferior competitor, the Che image's share of the political or ideological marketplace is enhanced whenever strong negative feelings are directed at the United States. But Barack Obama's inspirational victory in November 2008 makes the Latin American left's north-versus-south narrative and the caricature it encourages of white, conservative *yanqui* imperialism vulnerable to its inherent inconsistencies. It's not yet clear what this means for Che's political potency. Certainly, we can expect Chávez—and other anti-American populists who use the icon to burnish their often questionable socialist credentials—to focus on the more negative images emanating from the north, such as the utter failure of the U.S. financial system. Still, if Obama can give Brand USA the lift it desperately needs, Che may lose some of his appeal. He won't disappear—the icon draws deeply on some eternal ideas whose relevance extends far beyond this continent's divisions—but he might slink into the wings for the while.

As for Chávez, if his grip on power weakens in the months or years ahead, commentators will likely link it to the sharp fall in oil prices that occurred in late 2008. They might also highlight the domestic political conflict, which further intensified in the months after the RCTV takeover as the Venezuelan president drafted a new socialist constitution with expanded executive powers and then, undeterred by the rejection this received in a referendum, launched a series of hostile expropriations of privately owned industrial firms. But any examination of Chávez's political fortunes would be incomplete if it neglected to look at the issue

of the Venezuelan leader's brand and how it has in turn been shaped by changing public perceptions of America's brand.

Too often, mainstream political analysis ignores a vital aesthetic element to the construction of power. In portraying himself as the counterimage to an unfavorable caricature of the United States, Hugo Chávez bolstered his appeal among a key constituency on the left, as well as the appeal of the icons and symbols in which he wrapped himself. But now, with some minor easing in policy and a few conciliatory gestures, Barack Obama is in a position to undercut the common impression of America as a hostile military and economic power and instead accumulate what political scientist Joseph Nye calls "soft power." The irony is that Chávez, the regional leader who has invested more political capital than any other in attacking the hard-line Republican agenda behind this negative U.S. image, now has the most to lose from a moderation in U.S. foreign policy.

His won't be the only left-wing Latin American regime to face a marketing challenge in the era of a black, Democratic U.S. president, either. Castro's Cuban revolution and its Che-heavy brand may also be tested by an Obama administration that will be far less indebted to Havana's die-hard enemies on the other side of the Florida Strait than its predecessors.

MIAMI

The Heretics

If there be no enemy, there's no fight. If no fight,
no victory, and if no victory, there is no crown.

—Thomas Carlyle

IN FEBRUARY 2008, as Barack Obama's lead over Hillary Clinton in the campaign for the Democratic nomination began to widen, a "scandal" suddenly arose to energize his opponents. An observant viewer of a Houston-based Fox News affiliate had noticed something in the offices of a local Obama campaign volunteer group during an interview about their preparation for the forthcoming Texas primary: a Cuban flag bearing the face of none other than Che Guevara. Conservative bloggers went nuts: Obama had refused to wear a U.S. flag pin, his attackers noted, but apparently he had no problem with a flag honoring a man they variously described as "a psychotic Marxist thug," "Communist mass murderer," and "one of the most profoundly evil characters in modern history."

Fox's national network ran a story after it recognized the "scoop" its Houston affiliate had missed, but the mainstream

media—MSM, in blogspeak—treated the Che flag hype with the same lack of interest that the local Fox reporters did in the first place. After all, this was a *volunteer's* office. The story was quickly consumed by everything else and the bloggers directed their hysteria elsewhere. Nonetheless, conservatives could notch it up as a blow against Obama's appealing "hope" brand, seeking to associate it with another unappealing brand for middle America, that of Che the murderer.

If there was one interest group that wasn't going to let this one slip away it was the anti-Castro leaders of the Cuban-American community of Miami, a group with a famously outsize influence on American electoral outcomes. In the brutal tiebreaker that took place in their state in two previous elections, Florida's Cuban exiles forcefully demonstrated their awesome political clout when the Miami-Dade County canvassing board abandoned a planned recount of ballots upon hearing that a thousand-strong mob of angry Cuban-American Republicans was descending on their offices. It was to be a turning point in the battle to decide the election, which eventually ended up in the Supreme Court. Now, eight years later, with Florida again looming as a key battleground, with Obama talking about ending the exiles' prized embargo on Cuba, with Castro fading away, and with the aging original exiles' political solidarity threatened by a more moderate younger generation, the Che flag incident came as a fresh shot of adrenaline. As was evident in the flurry of postings by Miami's prolific bloggers when the Houston flag issue arose—the writers at babalublog .com, killcastro.com, and the Review of Cuban-American Blogs, for example—Che continued to be a great mobilizer of passion in Miami's political battles. Aside from Castro, there is no figure that's guaranteed to fire up the emotions of this tight-knit community more than "el asesino" Che Guevara.

★

For everything that the Cuban-American lobby has extracted from Washington—a trade ban lasting five decades despite its complete failure to achieve the stated political objective, billions in federal funds for everything from covert operations to public broadcasting facilities, and the uncanny ability of its own terrorists to escape justice—it's easy to forget that this is a relatively small, isolated interest group. Like the Armenians expelled from Turkey or the Israelites in Egypt, the Cuban-Americans of Miami form a close-knit tribe surrounded by hostile forces. Many instinctively perceive an alliance against them between the Cuban government 225 miles to the south and mainstream American liberals to the north, those who would deny their pursuit of freedom in a longed-for homeland.

As can be gleaned from Ann Louise Bardach's extensive reporting on the Cuban-exile community, its extremism—on full display during the Elián González affair in the summer of 1999–2000, for example—is best viewed as the defensive instincts of a tribe under threat. It is sustained by the idea that the group's identity, defined by adherence to a single cause, is permanently at risk of disappearing. And as with other isolated, put-upon communities—the heavily armed Jewish settlers in the West Bank, for example—the leaders of Little Havana in Miami have for many years practiced a raw, Machiavellian, and often violent form of politics.

Yet for the issues they care about—telling the "true" story of Che's La Cabaña tenure, for example—this legacy of corruption and bloodshed has been prejudicial to the broader community's interests. It has hindered the families of Che's victims in their effort to convey their suffering and change the behavior of others. Far from convincing young wearers of Che T-shirts to stop revering a murderer, their association with a community perceived as tainted by unseemly politics may have had the reverse effect. As with any collective group, the Che cult's own sense of belonging is strengthened by the presence of an enemy "other," an outsider

that functions as an ever-present villain. (The same principle exists in marketing: Big producers of household products like Procter & Gamble or Colgate-Palmolive have long understood the value of brand differentiation, which is why they sell several lines of laundry detergent under various, competing labels.) For the brand of Che, it's all about not being a *gusano,* a Cuban exile in Miami.

The Che icon's power is sustained by the competing narratives of these two groups, a cycle that perpetually feeds on itself. Eventually the stories and myths on each side start to sound the same. Stripped of details, the tales that form the foundation of the Che phenomenon, with its undying battle cry of "Hasta la victoria siempre," resemble the Miami Cuban community's backstory. It too encapsulates an unwavering struggle in the pursuit of a noble goal—in this case, the return to a homeland—one that is perpetually and unfairly frustrated by outsiders. And as in the Che cult, where the central story involves the hero's death at the hands of *yanqui* imperialists, Miami Cuban lore is rich in heroism, sacrifice, and betrayal. This exile community forged around a shared longing for home even has its own La Higuera moment: the Bay of Pigs invasion. It's another story of heroic failure, one that lays blame on John F. Kennedy's reluctance to provide the invaders with comprehensive air and ground support.

One street south of Little Havana's 8th Street main drag, on a quiet block renamed Brigada 2506 Street in memory of the brigade that led the Bay of Pigs assault, the aging veterans of the operation maintain their organization's headquarters, along with a small museum, which contains a library and rows of glass cases filled with tattered flags, uniforms, photographs, news clippings, and other deteriorating memorabilia from the invasion. The most striking feature, however, is found on the back wall, which is dominated by two displays of old photographs, one showing the faces of 106 "martyrs" of the invasion, the other, 360 "heroes."

Heroes and martyrs—a mirror image of the sentiments conveyed in the Che memorials of Argentina, Bolivia, and Cuba.

Brigada 2506's connection to Che is more concrete than this, however. It is personified in the figure of Félix Rodríguez, the current president of the veterans group, who is better known for his past role as the CIA agent present at Che's execution in La Higuera. While Rodríguez is a hero to his people in Miami, he represents the exact opposite to Che supporters. As an agent of American capitalism's opposition to their cause and the man who facilitated their hero's end, he is *the* quintessential villain in the Che narrative. From their perspective, Rodríguez's own epic story, in which he spends his life traveling the world to fight the evils of communism, would only affirm their preconceptions.

One year after Rodríguez revealed his once secret identity during the 1988 Iran-contra hearings in Congress, he published a tell-all book about his remarkable life, including the photo he'd taken in La Higuera on October 9, 1967. For Rodríguez, it was a souvenir shot, a memento of his place in history. But for devotees of Che it meant something else. Long aware of the CIA's involvement in their hero's death, they now had a face to go with the story. The agent's presence in La Higuera made manifest Che's prophecy that he would die fighting *yanqui* imperialism.

Since going public with his story, the ex-agent has sought to leave a positive impression of his role at La Higuera. In his version, he emerges as the good guy—a man of principle amid brutes. Recounting his final moments with Che, Rodríguez weaves a narrative of redemption and honor in which two warriors reach a point of mutual respect, doing for the executed Che what Guevara did for Eutimio Guerra in the Sierra Maestra.

According to Rodríguez's autobiography, *Shadow Warrior,* the undercover operative entered the town's mud-brick schoolhouse shortly after midday on October 9, 1967. There he informed the prisoner inside that his repeated efforts to convince the Bolivians

to spare his life had failed and that he would be shot minutes later. At that moment, he says, the pair embraced. "It was a tremendously emotional moment for me. I no longer hated him," Rodríguez wrote. "His moment of truth had come, and he was conducting himself like a man. He was facing death with courage and grace."

Rodríguez says he lobbied to save Che because those were his orders from Washington. It seems that neither humanitarian concerns nor the Geneva Convention had anything to do with it. Nor does there appear to have been any prescient concern about converting Guevara into a martyr. Rather, Rodríguez maintains that he was ordered to keep the prisoner "alive at all costs" because his superiors hoped Che would spill the beans on the Cuban government. "It was mostly for intelligence purposes. They knew he had a falling-out with Castro because of his pro-Chinese inclinations."

Although he paints himself as a moderate eager to save Che, the ex-spy also puts himself in the middle of the chain of command that led to the revolutionary's death, further embroiling the United States in events. In both his autobiography and in a recently declassified CIA briefing, Rodríguez said that he, not a Bolivian officer, received and relayed the codified radio message "500;600," which signified that Guevara was to be executed. What's more, knowing that the Bolivians were going to lie and claim that Che had died of his combat wounds, he instructed the soldiers to shoot below the head to disguise the means of death. These days, the retired agent and die-hard anticommunist occupies an unlikely middle ground, caught between Che's fans and his enemies, each of whom accuse him of distorting the truth. "Look at what people write: The far right say that he was crying, which wasn't true. And then on the other hand, you have the far left saying that I tried to slap him in the face and that he spat on me, which is also not true," Rodríguez told me. "Both sides will write whatever they feel like for their own agenda. I just wrote it

as it happened. And the man conducted himself with respect to the very end. No matter what, everybody has to respect that."

It's hard to imagine his opponents believing that Rodríguez embraced Che. The ingrained prejudices on either side of the Che divide leave no room for the left to attribute human qualities to a Miami Cuban rogue. It doesn't help the ex-CIA agent's image, either, that the details of his clandestine life outside of the Bolivian episode fit perfectly into the left's worldview on the evils of *yanqui* imperialism.

Rodríguez's globe-trotting life encapsulates the far-reaching contribution that the Miami Cuban community has made to world affairs over the past fifty years, a polemical role that has extended far beyond its influence over America's Cuba policy. In return for financial and political support for their anti-Castro struggle, many exiles have done the dirty work of their allies of the moment, be they in Washington or elsewhere. Members of the community's revered "freedom fighters" were directly involved in the Watergate break-in, a string of terrorist attacks against Latin American leftists, and the Iran-contra scandal, for example. Tales of Batista-era mafia connections abound, while conspiracy theories tying Cuban exiles to John F. Kennedy's assassination have long been in circulation. For his part, Félix Rodríguez has never been charged with a crime and he has not been directly connected to these events. Still, his is a life that constantly skirted the shadier moments of U.S. history. Before the Bolivia assignment in 1967, Rodríguez was an active participant in the Cuban exiles' covert activities against the Castro regime. He was a reconnaissance scout for the Bay of Pigs invasion; he ran an arms-smuggling operation out of the CIA's Miami station; he was part of a Nicaragua-based outfit that coordinated attacks against Cuba's infrastructure and military installations; and he personally made three attempts to assassinate the Cuban leader. After his La Higuera experience, however, the anticommunist's career went global. Over the course

of the next six years, Rodríguez conducted counterinsurgency training in Ecuador and Peru, ran intelligence operations in Vietnam, worked in Buenos Aires as an adviser to an Argentine general, and went to Lebanon to infiltrate Yasser Arafat's Palestinian Liberation Organization.

After a quiet period during the Jimmy Carter years, he jumped back into the Cold War with both feet in the 1980s under the Reagan administration. After devising his own counterinsurgency project in El Salvador, Rodríguez got involved in the effort to bring down the Castro-backed Sandinista regime in Nicaragua. There he gave a U.S. payroll job to Luis Posada-Carriles, an old Cuban pal from his resistance work in Miami and now a figure infamous in Castro's Cuba. Posada-Carriles had just escaped from prison in Venezuela, where he was charged with masterminding the October 1976 bombing of a Cuban airliner.

When his Central American operation was exposed, along with the interrelated Iran-contra arms smuggling scam, Rodríguez was summoned to Washington in 1987. There, his testimony during the congressional hearings cleared his name and that of an important contact he had made during the operation: Vice President George H. W. Bush. His cover blown, the spy retired and wrote his book. But the experience left him bitter, so much so that in 2004 he headed the Miami chapter of the Vietnam Veterans for the Truth propaganda campaign against presidential candidate John Kerry, the senator who had grilled him relentlessly during the 1987 investigation.

Sitting in his office at the Brigada 2506's headquarters, a small room adorned with the Stars and Stripes, the flag of Cuba, the American eagle, and the brigade's own banner, I asked the ex-CIA agent to reflect on how the event for which he is most famous affected all his later experiences. He paused and then he replied: "Capturing Che has definitely been an important part of my life. It did help when people were told that you were the one who par-

ticipated in the capture of Che Guevara. That did open a lot of doors. They see you as somebody with a lot of experience . . . It won respect from the people you were advising." It wasn't the response I'd expected. I'd imagined the philosophical musings of an old warrior. These were the words of a public servant for whom the Cold War was a career.

★

Rodríguez is one of many Miami Cuban leaders who've figured out how to use their community's voting clout and the debts owed by powerful people to win favors in Washington. With all the dirty work they've done for Uncle Sam along the way, you'd think they'd be secretive. But take a trip to Little Havana's Versailles Restaurant and Bakery and there's a good chance you'll run into some of them. Given the far-reaching influence this group has wielded over U.S. foreign policy, one could almost argue that the seat of world power—rather than residing at 1600 Pennsylvania Avenue, Washington, D.C., or perhaps 11 Wall Street, New York—sits in this noisy 8th Street diner serving home-style Cuban food.

When I agreed to meet Enrique Encinosa over Sunday lunch at Versailles, I figured his description of the venue as the "center of it all" was a reference to the eatery's geographic location in the middle of Miami's Little Havana district. In fact, he was speaking in political terms. As a morning radio host at Radio Mambi, one of the city's most influential Spanish-language stations, Encinosa wields great influence. Here, amid the bustling restaurant's baroque-kitsch decor of Formica tables, mirrors, and chandeliers, he was in his element.

A large man with a neatly trimmed beard, Encinosa is an intense person. He has written three books on Cuba, including one that Miami locals say is the definitive work on their resistance movement, as well as another on the tradition of boxing in his homeland. When we met he was working on a novel based on

Che. He was a perfect person to give the "official" Miami Cuban community perspective on the Che phenomenon.

After our waitress had laid our paper place mats and served up a truly delicious meal of *fufu de plátano* (mashed plantains and pork), Encinosa began on his theory of why Che is a failure. He explained how Guevara's incomprehensible actions in the Congo and Bolivia hinted at a "delusional" character who'd misinterpreted his own successes in the Cuban revolution as a sign that he could take on and defeat a force as powerful as the United States. Che was an incompetent and highly overrated military strategist, Encinosa argued. What's more, Encinosa contended that *Guerrilla Warfare,* Che's famous manual for would-be revolutionaries, appears to be a collaborative effort, as its style differs from classic Che prose. Much of the material, he said, seemed drawn from CIA and other U.S. documents.

My host found it hard to complete the discussion because he had to constantly interrupt himself. Well-wishers kept dropping by, including various legends of the struggle who'd turned up for lunch. "Oh, you must meet this guy," Encinosa said, introducing me to a man with an ING Financial Partners business card that read "Osiel Gonzalez, Registered Representative." (Two days later, this affable sixty-nine-year-old told me how, when fighting with the rebels against Batista's forces, a falling-out with Che had helped change his mind about the revolution and encouraged him to escape to Miami. There, Gonzalez helped found a paramilitary commando unit with the appropriately militaristic name Alpha 66. He and a number of other aging anti-Castro militants still attend training sessions at the unit's camp in the Everglades.)

After we'd eaten, chatted, and greeted a stream of middle-aged-to-elderly men, Encinosa went outside for a cigarette. He explained why he had launched a radio campaign on behalf of a "fellow patriot" and "freedom fighter," Luis Posada-Carriles. (At that time, the notorious fugitive was in custody on immigration

charges in Texas. A few months later, Posada-Carriles, a man whose extensive FBI dossier and press statements includes his own admissions to a spate of 1997 bombings in Havana, was released and allowed asylum in Miami. Naturally, the Cuban government was incensed and immediately saw a conspiracy. Up went a billboard outside the office of the U.S. Interests Section in Havana with three faces and a mathematical equation: George W. Bush + Luis Posada-Carriles = Adolf Hitler.)

As Encinosa elaborated while drawing deeply on his cigarette, a man came bounding over. After a hearty exchange of backslaps, my host introduced me.

"I want you to meet Virgilio Paz Romero," Encinosa said. "He's just gotten out of prison. He did ten years for the Letelier case. You know it?"

"Yes," I said, stunned. The grinning, well-tanned man in a baseball cap before me was one of the five Cuban-Americans hired in

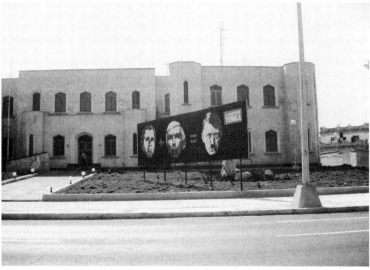

Billboard near the Office of U.S. Interests, Havana, November 2006.

September 1976 to assassinate the former Chilean ambassador Orlando Letelier in Washington, D.C. The car-bomb attack they orchestrated on behalf of the Chile's secret police immediately killed Letelier, then a leading figure in the overseas anti-Pinochet resistance, and his American assistant. Until September 11, 2001, it was the only act of state-sponsored terrorism in the U.S. capital.

"Michael's doing a book about Che Guevara," Encinosa explained to his friend.

"That bloodthirsty arsehole. Well, this guy will set you straight," Paz Romero said, nodding toward my host.

"So, are you happy to be free?" I asked. It was a stupid question, but its recipient obliged me with an answer. "You bet. We were in there for too long."

In fact, Paz Romero had escaped capture for fifteen years before he was arrested in 1991, during which time he hid out with friends and worked in various parts of Florida under aliases. Paz Romero never confessed to the crime during his trial. Unlike Posada-Carriles, however, he was convicted fair and square on the testimony of former CIA agent Michael Townley, who owned up to hiring the Cubans on behalf of his clients in Chilean secret police. Paz Romero was then sentenced to twelve years in prison before he was released on probation in 1997. But he was then moved to an Immigration and Naturalization Service detention center, because as a foreign convicted criminal he was eligible under U.S. law for deportation. Since Havana and the United States have no diplomatic relations, this was not possible, so he was left locked up indefinitely. Eventually an intensive effort by lawyers for the powerful Cuban American National Foundation and lobbying by Cuban-American Florida legislators Lincoln Díaz-Balart and Ileana Ros-Lehtinen paid off. After the Supreme Court ruled that indefinite detention of nondeportable criminals is unconstitutional, Paz Romero and fellow Letelier bomber José

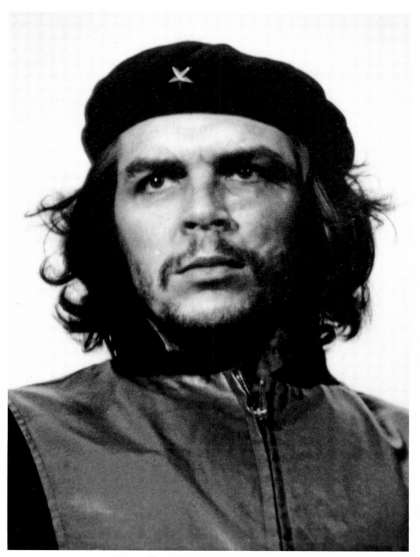

Guerrillero Heroico, March 5, 1960.
Photo by Alberto Korda.

Rally, fortieth anniversary of Che's death,
October 8, 2007, Vallegrande, Bolivia.

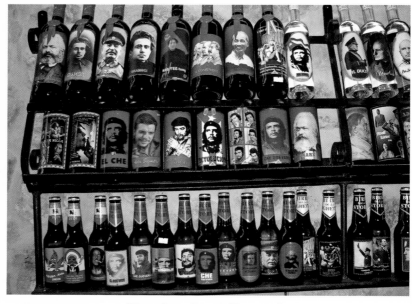

Wine shop, Cinque Terre, Italy.

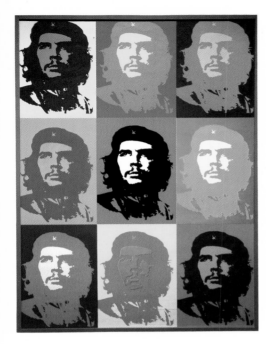

The Warhol Che (page 119).
Artist, date unknown.

Jim Fitzpatrick's most widely
reproduced Che poster
(page 120).

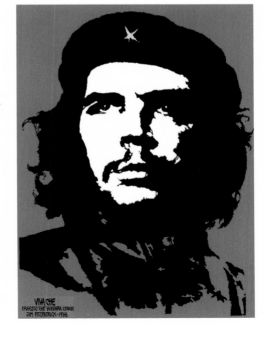

Paul Davis's poster used to promote February 1968 issue of the journal, *Evergreen* (page 128).

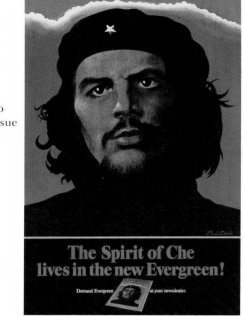

Souvenir store, Alta Gracia, Argentina (page 147).

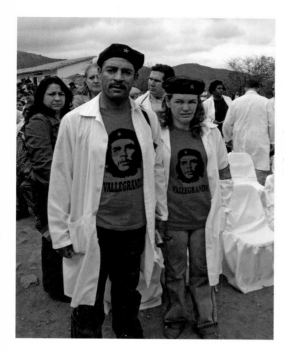

Cuban doctors in La
Higuera, Bolivia,
October 8, 2006
(page 189).

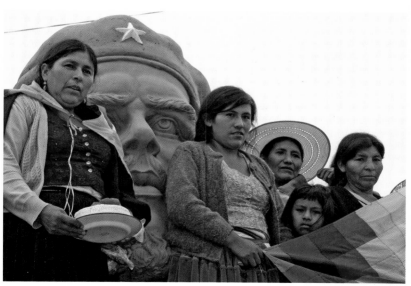

Bolivian women with Che bust, La Higuera,
October 8, 2007 (page 198).

Che look-alike in La
Higuera, Bolivia,
October 7, 2007
(page 207).

Flyer promoting musical
concert, Vallegrande,
Bolivia, October 7, 2007
(page 211).

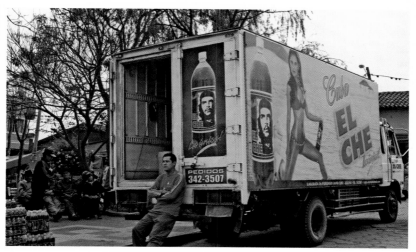

Truck advertising Che soft drink in Vallegrande, Bolivia,
October 7, 2007 (page 211).

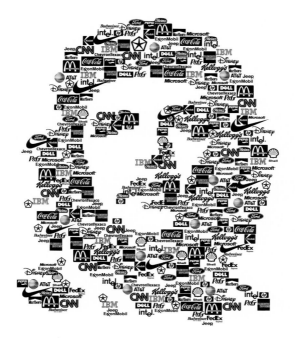

Patrick Thomas's *American Investments in Cuba* (page 266).

Boy with Jóvenes de Pie banner, Villa Arrojo de Pierda, Argentina, March 28, 2007 (page 171).

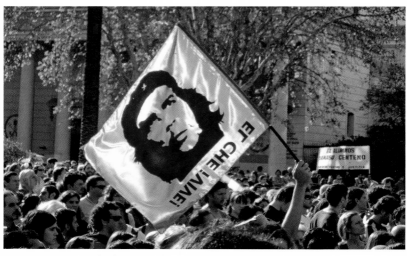

El Che Vive! Buenos Aires, March 24, 2007.

Dionisio "Bloodbath" Suárez were allowed to walk free on August 11, 2001.

Inevitably, the timing of their release provided fodder for more conspiracy theories about the ties between the Bush family and the Miami Cuban community. It was noted that Paz Romero's and Suárez's release occurred with the implicit backing of Governor Jeb Bush. This was just eight months after his brother had been helped into the White House following the 2000 Florida election crisis by both Cuban activists and the same Supreme Court. Legal technicalities are just as likely to have been at play in the court's decision, of course. Even so, the convenient fact that deportation is impossible for Cubans encourages talk of a double standard. The appearance of such disparities was accentuated further when, exactly one month after the Letelier terrorists were released, the U.S. mainland was attacked like never before, prompting President Bush to get tough on terror.

According to Paz Romero, his only regret about the Letelier bombing was that he had trusted his Chilean clients. "We really thought they would stick with us. We were naive," he told me.

Militant Cuban exiles often insist they are at war, a claim that sounds like the one the Che-admiring Irish Republican Army made throughout its U.K. bombing campaigns. Paz Romero's regret had nothing to do with killing two innocent people on American soil. It was simply that his patron hadn't stuck up for him. Like Encinosa, he believes such actions and the deaths of innocents associated with them are justified by the objective sought—in Paz Romero's case, winning the support of the Pinochet regime for their own struggle. It's in part a legal argument. Rules change in wartime: Combatants are given more liberties; civilians lose some of theirs. More important, though, invoking the notion of a war raises the act of violence to a higher plane, distinguishing political violence from hooliganism, adventurism, or wanton bloodletting. War carried out in the pursuit of

freedom is a noble act, we are led to believe. Ironically, Miami's Cuban freedom fighters aren't the only ones who have felt this way over the past fifty years. So too did Che Guevara and tens of thousands of guerrillas who followed in his footsteps.

After my new acquaintance had cruised off in a shiny silver Volkswagen GTI convertible—"It's fast, man," Paz Romero proudly told us—Encinosa offered me a final thought on a point I'd raised earlier. I'd suggested there were similarities between Miami "freedom fighters" and the guerrillas led by Che. I felt that both drew upon idealistic, romantic visions of their cause, which, along with a sense of adventure and fearless risk taking, were necessary ingredients for each side to move into battle. I hadn't mentioned that a cold capacity for violence was also necessary, but having just met an unrepentant convicted killer, I now wanted to add this to the mix. Encinosa seemed to read my mind: "You know, I was thinking about what you said, and yes, I think I can say that Che Guevara would get as much pleasure from putting a bullet in my head as I would in his."

★

To be sure, Encinosa's view does not represent that of all Cuban-Americans. Most hope for a peaceful transition in their homeland. Yet nearly every one of them has a tale of loss, injustice, or family separation. And in recalling that painful past, they play their own part in the struggle for change in Cuba. In so doing, many aim their attacks on what they see as an injustice invading the present: Che worship. New Jersey–based economist Maria Werlau's Cuba Archive project, for example, whose accounting of the Castro regime's human rights record stands as a dignified call to respect the lives that were lost, includes a list of Cubans said to have died at Guevara's orders. Miami-based journalist Pedro Corzo, who has dedicated much of his recent life to documenting

Che's wrongdoings, is another who earnestly wages this war with words instead of bullets.

Corzo insists that his Che project is unassociated with his employer, the U.S.-government-funded Radio Martí, which broadcasts "independent" news into Cuba out of Miami and whose ties to Cuban exile leaders have embroiled it in a string of ethics scandals. The documentary he produced in 2005 was driven by his own desire to reveal the true story, he says. Now, after the extensive research that went into it, Corzo says he has nailed down Che's psychological profile: Guevara was "an irreverent and cruel individual who felt a deep disregard for his fellow human beings . . . a man of undeniable discipline but of deniable personal values. He was very persistent, but at the same time very contemptuous of other people. He didn't accept or respect any ideas that weren't those that he sustained or defended."

Much of the historical record supports Corzo's characterization. Yet he and his fellow Cuban-American crusaders against Che make few dents in Che's popularity among young liberals. It can't all be blamed on the ignorance of fashion-conscious rebels; Corzo and company are also hindered by a connection to Miami Cuban politics. It arises in the opening interview of Corzo's documentary, *Guevara: Anatomy of a Myth,* where "historian and researcher" Enrique Ros delivers a series of subjective generalizations. (Before Guevara met Fidel Castro, we hear, he was "an adventurer who cared only about soccer and the photos he took.") What we don't learn is that the speaker, described as the author of "one of the most complete investigations about the life of the Argentine guerrilla," is also a Miami businessman, a Radio Martí announcer, and most important, the father of Ileana Ros-Lehtinen, congresswoman for Florida's eighteenth district and linchpin of the Cuban-American Washington lobby.

Along with her Florida Cuban colleague in Congress, Lincoln

Díaz-Balart—the nephew of Castro's former and now very much estranged wife Mirta Díaz-Balart—Ros-Lehtinen played a pivotal role in shepherding the notorious Helms-Burton Act into law in 1996. This act added foreign companies to those sanctioned for dealing with Cuba and promised U.S. money to a future Cuban government so long as it excluded Fidel and Raúl Castro and compensated U.S. citizens for property confiscated since 1959; it has been criticized around the world as an encroachment on other countries' sovereignty. Along with Bush administration initiatives such as the U.S. Commission for Assistance to a Free Cuba, which has a budget of $59 million, this overreaching U.S. policy plays right into the Castro brothers' hands. They can use it to turn islanders' attention away from their own dismal government record. Such legislation is portrayed in Cuba, with some justification, as a vehicle for the violent and greedy *gusanos* of Miami to invade the island and take everything that Cubans have. A common Havana billboard in 2007 dubbed the U.S. policy "anexationista." Another showed two smiling Cuban kids in front of the silhouettes of their parents and declared, "The Bush plan will take away forever the morning kiss, the hug, the return from school and that cheeky look."

In the 2008 elections, both Ros-Lehtinen and Díaz-Balart retained their seats in tightly fought contests, as did Díaz-Balart's brother, Mario, who joined them in the House in 2003. Nonetheless, President Obama's mandate, which included the prize of Florida's twenty-five Electoral College votes, now offers him a unique opportunity to neutralize much of the Helms-Burton Act and other elements of the United States' flawed Cuban policy. That's good news for anyone seeking progress on both sides. And it might make Che and his history a less explosive issue.

As of the time of writing, however, no steps had been taken to break the vicious cycle in which this conflict is entrenched. The Castro regime's criticism of the Miami community's control of

U.S. Cuba policy creates a vicious cycle of recriminations. This in turn stymies reasonable debate over contentious issues, including Che's violent legacy, as it strengthens resolve and breeds bitterness on both sides. Che's fans will provocatively don a T-shirt, further stirring up their critics, who eventually resort to expressions of frustration and incredulity.

New Orleans–based Humberto Fontova, whose book *Exposing Che Guevara and the Useful Idiots Who Idolize Him* tells you all you need to know in its title, has made an art form out of mixing frustration with ridicule. Fontova lost family members in the conflict with Castro, which understandably would contribute to his bitterness, but that past doesn't make his style any more effective. With a prose that marries Ann Coulter with Hunter S. Thompson, he basically yells at his readers, mixing a sarcastic wit with a touch of self-deprecation until it is overwhelmed by disdain for his opponents. Writing for the online conservative zine *Capitalism Magazine* of his visceral reaction to a T-shirt worn by his teenage son's friend, Fontova lathers himself into a rage over the "hideous visage of Che Guevara," an "assassin, sadist, bumbler, fool, and whimpering, sniveling, blubbering coward" who is "revered by millions of imbeciles."

The most unlikely word in this blast of hyperbole to reconcile with the facts is the one that Che could be forgiven for being: a coward. It does not stand up to the record of an asthma sufferer who pushed his tired lungs to the limit, of the commanding officer always on the front line, or of the international orator who cared nothing for the well-armed enemies he cultivated. Whether he was a violent, deluded ideologue is open to debate. But in a way that few people ever have been in history, Che was utterly fearless of death.

Fontova and others stake such claims on the words of a Bolivian soldier, who reportedly heard a man with his hands in the air say, "Don't shoot. I am Che Guevara. I am worth more to you alive

Flyer advertising a talk by Humberto Fontova at the University of Michigan, Ann Arbor.

than dead." The line comes from an October 10, 1967, press conference in Vallegrande, Bolivia, where Bolivian officers showed off Che's dead body and then lied that he'd died from combat wounds shortly after an ignominious surrender. Later, when the truth of Che's execution was exposed, the officers' credibility was destroyed. Then, to make matters worse, another of their men undermined their efforts to deflate Che's myth. Sergeant Mario Terán, the soldier who drunkenly filled Guevara's belly with a machine gun round, provided him with a theatrical last line befitting of a warrior hero's exit. His story went that as he hesitated to pull the trigger, Che calmly said, "Shoot, coward, you are only going to kill a man."

These competing phrases are now cut and pasted without attribution into an ever-expanding database of dubious secondary sources on the Internet, where the contradictory Che myths are

perpetuated ad infinitum. In effect, we are asked to make an emotional decision, not an assessment of the facts, and it boils down to a binary choice: It's either "Don't shoot" or "Shoot."

Much is at stake in these battling phrases. They relate to the climactic transitional moment in our character's story, when the flesh-and-blood man takes on an iconic afterlife. Those who revere Che need a story that gives that moment dramatic weight. Those who hate him feel compelled to reduce it to nothingness. Neither side can give an inch, as if the slightest doubt would bring down the whole enterprise. If Che is murderous and fool-hardy, he can't also be brave. If Che is a saint, he can have no flaws.

★

The expansive breach between these competing positions, and the heated passions so easily stirred on either side, make it hard to write or speak about Che Guevara in a public setting while maintaining the impression of neutrality. Any statement that does not jibe with one side's narrative tends to bring forth accusations of bias in favor of the other. It's not for nothing that mainstream filmmakers have struggled to bring to the screen the most polemical part of Che's life—the part of it that happened after *The Motorcycle Diaries*. Even in 1969, for the filming of *Che!*—in which Omar Sharif's Guevara emerges as a violent psychopath who manipulates a buffoonlike Fidel Castro (Jack Palance)—there were so many late, studio-directed changes to the script that director Richard Fleischer's plans for an "honest" portrayal of Che collapsed into a widely panned farce. The actors' restrained performances, observed one *Hollywood Reporter* critic, suggested that none of them "wished to be nailed with pro- or anti-sympathies."

It is unlikely that Steven Soderbergh was subject to the same politically motivated demands from financiers that Twentieth Century Fox imposed on Fleischer, but the pressure forty years

later on the director of *The Argentine* and his lead actor, Benicio Del Toro, must have been enormous. In a matter of weeks in 2006 after Soderbergh's Che Guevara biopic was first cited as an upcoming film on the industry website IMDb, the listing's members-only comments section attracted hundreds of postings, most of them either attacking or supporting Che. This hinted at a seriously difficult marketplace for the film: Audiences with strongly held preconceived ideas are hard to make happy. This particular Che project proved so challenging that it went through various producers, directors, and guises after Del Toro, the original driving force behind the idea, started seeking out backers in 1997. Soderbergh first got involved in 2002, but he soon ceded the directing job to screenwriter Terrence Malick. After Malick's slow pace caused friction with producers, Soderbergh returned to the role of director in 2006 and, after an on-again-off-again shooting and production schedule, was finally able to show something to the public in May 2008. But even then he seemed unable to achieve his stated goal of delivering two separate films and instead premiered all four and a half hours of compiled footage under one name. "It's back to the drawing board for Che," wrote a reviewer in *Variety* of the film's Cannes premiere to whom the absence of closing credits indicated a work in progress.

The epic, unconventional film—later split into two parts—was not without admirers. The director won plaudits for refusing to yield to popular taste and Del Toro won the Cannes best actor award. But it is a difficult, understated film and this as much as anything reflects the great complexity of its subject matter—in terms of the man himself and the way he is perceived by society at large. In January 2006, as filming was about to start, Soderbergh admitted in an interview that laying down the script had been time-consuming because Che made for a "really complicated" subject.

It is as if all the conflicting myths about Che have rendered it impossible to publicly represent him as anything that can pass for

objective reality. Che is okay material for Chávez fans or Miami's Castro haters with clear agendas, but it may well be impossible for a serious Hollywood filmmaker to deliver the "real Che" to a mainstream audience. We have invested so many competing ideas and meanings into the concept "Che Guevara" that we can't collectively conceive of what it actually represents with anything near homogeneity.

It is not as if liberal or rationalist critics who attack both the dogmatic Latin American left and the conservative line of U.S. foreign policy are in any better position to critique the public myth of Che. A case in point is found in Paul Berman's scathing *Slate* review of the 2004 film *The Motorcycle Diaries*. Berman calls the cult of Che and its cultural output "an episode in the moral callousness of our time." It obscures Che's totalitarian record, he says, and the "dreadful reality" of his role in inspiring "tens of thousands of middle-class Latin Americans to exit the universities and organize guerrilla insurgencies" only to "bring about the death of hundreds of thousands, and to set back the cause of Latin American democracy." Salles's film makes matters worse, Berman contends. It "exudes a Christological cult of martyrdom, a cult of adoration for the spiritually superior person who is veering toward death—precisely the kind of adoration that Latin America's Catholic Church promoted for several centuries, with miserable consequences."

This is impressive stuff. Unfortunately, as one reader with the online moniker Shrieking Violet observed in a comment posted on *Slate*'s site, it misses the point. "Berman completely fails to understand the role of iconography in art, particularly in Catholic cultures," Shrieking Violet asserts. "Religious art rarely emphasizes the true humanity of its subjects . . . But none of this ever shows up in iconography, nor does it matter one whit to the faith of a believer. The humans underlying the icons are just stand-ins for the values they emphasize. Che has come to symbolize the

values of resisting injustice and rejecting worldly excess. He's St. Francis in the secular host of angels. It mattered a great deal to his victims that he was really no such thing in life. But you aren't going to deflate that myth merely by pointing out that it doesn't match the man. If the film glorified the real Che Guevara, that would be highly offensive. But it's glorifying a person with decent values who never existed."

Liberals uncomfortable with Che's past face different challenges from those of conservatives. When Che T-shirts enjoyed a brief fad in gay nightclubs, some in the gay community were aghast. Che was a homophobe, they declared. The proof behind such charges is flimsy, often centering on reports that he spitefully expelled beat poet Allen Ginsburg from Cuba for describing him as cute. Such stories are augmented with a review of Cuba's gay rights record, whose low point was the Mariel Bay exodus of April 1980, when homosexuals and convicted criminals were crammed onto rusty ships to transport 100,000 "undesirables" to the United States. Cuba has become far more tolerant now—witness the success of the 1994 Cuban film *Strawberry and Chocolate*—although it's still not an easy place to be gay. (There is only one openly gay nightclub, I was told, and it's in Che's city, Santa Clara.)

But is any of this relevant to the Che polemic? Gays were of no consequence to Ernesto Guevara and the Cuban revolution, neither to be protected nor abused. Gay rights were tangential to anti-imperialist and class struggles. Only in affluent Western societies where capitalism has supposedly won the Cold War dispute, do matters of social liberalism define the left-right divide. The "Gay Che" debate is not about *that* Che Guevara, the Cuban revolutionary; it's a debate over *our* Che, the twenty-first-century icon. Why can't this Che be gay? He has been everything from Christ to Hitler, from antiglobalization activist to vodka salesman. Surely he can dance in a gay club.

One gay man who sparked a debate on an online chat forum

about Che T-shirts was especially irked by their presence in the clubs of Miami's South Beach. Here too, we encounter another ambiguity in Che's *meaning,* this time in terms of geography and the changing face of a vibrant, multicultural city. While Cuban exiles still have great clout in the city's politics, their demographic dominance has waned in Miami amid a steady influx of immigrants from other parts of Latin America. The Cubans—especially those of the dwindling island-born, older generation—are gradually being overshadowed by Colombians, Argentines, Venezuelans, Puerto Ricans, Dominicans, Haitians, and many other arrivals. Just as Miami has had its status as a warm retirement destination for white northerners diminished by the rising dominance of an Hispanic culture, so too have Cubans seen their control over that culture diminished by the input of other foreigners. Miami, in fact, looks neither east to Cuba nor north to Washington or New York. This city—which the fervently Latin Americanist Ernesto Guevara disliked so intently that he wrote nothing about the thirty days he spent there at the end of *The Motorcycle Diaries*— has become the financial, cultural, and entertainment capital of Spanish-speaking Latin America.

Here too it's the multiplicity of viewpoints that's striking, especially as it pertains to the Che icon. As we've seen, Che's meaning in the different countries of the region varies according to a wide range of historical circumstances. His presence in Miami can no longer be understood in the monolithic terms of the exiles of the generation of '59. As it does elsewhere in the world, the Che icon in Miami contains the contradictory, competing traces of these histories.

PART III

GLOBALIZING THE SPIRIT OF CHE

The Paradoxical Afterlife of a Post–Cold War, Post-Castro, Postmodern Cuban Icon

OMNIPRESENCE

Being an icon is overblown. Remember,
an icon is moved by a mouse.
 —William Shatner

THIS JOURNEY THROUGH Che's afterlife has centered on Latin
America. There are reasons for that: The region is Ernesto Gue-
vara's home turf and thus the natural home of his icon, and Latin
Americans have an especially complicated economic and cultural
relationship with the United States, the all-important foil in the
construction of the Che myth. (Also, I had a finite travel budget.)
But of course Che is a global phenomenon. I was reminded of
this one day when two of my friends, each unknown to the other,
independently e-mailed me photos from different parts of the
world. Pablo's was of a Japanese mountain climber wearing a Che
patch at the summit of Mount Fuji; Anton's, which landed in my
in-box just one hour later, was of a motorbike's fuel tank deco-
rated with the Korda image in Mauritius. Che's icon is everywhere,
just as the flesh-and-blood Ernesto Guevara often seemed to be.

"In a variety of ways Che presages globalization," says Eric Sel-
bin of Southwestern University. "He's in a leprosy colony in Peru
and then ends up in Guatemala and then he's in Cuba and then
on the Continent. He's in Algeria and then the Congo and then

there's rumors he's in Vietnam and then he's back to Cuba briefly and on to Bolivia. Here's a guy in the days before it was possible to do such things who manages to be everywhere. That carries with it a cachet."

These journeys make it possible for people from disparate ethnic, religious, and national backgrounds to identify with Che. In Ireland, for example, the stories of Che's high jinks during a March 1965 visit—which is retold in terms of an effort to retrace his Irish roots and is embellished with Arthur Quinlan's story of a boozy St. Patrick's Day celebration with the Cubans in Limerick— give Irish republicans a link to the historical legend. Such tales, whether true or not, help the storytellers legitimize their own place in a supposedly unbroken global narrative of revolution and rebellion.

Ideally, with more money and time, I would have kept traveling, since Che makes a symbolic appearance in many regional conflicts. Filmmakers Adriana Mariño and Douglas Duarte even caught neo-Nazis in Germany wearing Che T-shirts and explaining why they do so.

Another place high on my wish list was Lebanon. After the Israeli siege of 2006, images of Che and Nasrallah were plastered side by side in two-tone posters all over Beirut and other Lebanese cities, earning the Shiite mullah the title of the "Che Guevara of the Arab world." Then, a few weeks later, their faces were joined by that of another rising icon of rebellion, Hugo Chávez. Liberal critics of both socialism and Islamic fundamentalism sneered at the incongruity of linking a man who claims to represent God with a rational, atheistic, Marxist-like Che. Conservative supporters of Israel thought the connection perfectly natural, however: Both Che and Nasrallah were murderers, they said. Some amid the secular left, meanwhile, were upset over the misrepresentation of socialist principles and bemoaned how religious fanatics had sup-

planted Che's more worthy partners from past Arab liberation struggles, such as Algeria's FLN freedom fighters.

Che's sudden prominence in the Middle East has been helped by the evolution of an awkward new alliance between radical Islam and certain Latin American leftists, one that's fueled by Chávez's active insertion into the region. He has cultivated a relationship with Iran's Mahmoud Ahmadinejad, for example, and other leaders willing to bolster their rebel status by joining him in needling Washington. But as the critics of the Nasrallah-Che link point out, there are limits to the ideological consistency of this relationship. This was laid down pretty effectively by Aleida Guevara, during a visit to Tehran University around the time of the fortieth anniversary of her father's death, where she and her brother Camilo were invited to speak at a Venezuela-sponsored conference on the left and revolutionary Islam. When the coordinator of Iran's Association of Volunteers for Suicide-Martyrdom announced to the audience that Che was a "truly religious man who believed in God," Aleida—to her credit—set the record straight. "My father never mentioned God," she told the audience. "He never met God." After that, recounted *Times of London* reporter Sarah Baxter, the Guevara children were escorted out of the building and back to their hotel, where they spent the rest of the conference as "nonpersons."

Still, it's worth examining what icons like Nasrallah and Che have in common, to determine what compels propagandists to pair them. And when we do so, we discover that the current-day conflicts playing host to Che's icon are fueled by the same injustices and longings that defined the battles of his day, the same struggles for personal dignity that have always given meaning to our lives. Most of the world has moved beyond the ideological division of the Cold War—the global capitalist economic system is entrenched—but we haven't resolved the underlying human

tensions that fueled the battles of the pre–Berlin Wall era. Indeed, if we are to accept the gloomy arguments that war correspondent and philosopher Chris Hedges makes about human sin and the role that violent conflict plays in satisfying the deepest desires of the soul, perhaps we will never resolve these problems.

The conflict in the Middle East, the rise of global terrorism, and the emergence of rebel leaders like Chávez have done more than annihilate the capitalist West's hopes for an emerging political consensus; they have demonstrated that millions of people still feel a profound sense of injustice and are prepared to take extreme measures to confront it. Simply declaring the debate over was never going to suppress the internal spirit that can lead a person to pick up arms and fight to the death. These are the values with which the icon of Che is associated, not those of the religious or political creeds in whose name a battle is fought.

Che stands for the value of paying the ultimate sacrifice for your convictions. So when you're trying to find recruits who are willing to die for you, his symbol is pretty useful. It matters not whether we see Nasrallah as a fundamentalist and a terrorist or as a freedom fighter resisting an oppressor, or even whether his cause has anything to do with Ernesto Guevara's beliefs. What matters is that the Hezbollah guys who "sell" the mullah's image to disaffected Arab youths grasp the marketing value in linking it to the image of Che. It functions as the universal symbol for the act of following one's convictions. They might be devout Muslims, but they've learned how to play the branding game. They're plugged into a globalized economy, where the Che icon is immediately recognizable and readily available.

★

Another way to explain Che's prominence in the Middle East is to put it in the context of anti-Americanism, which is manifest in its most virulent form in that part of the world and with which Che,

as a die-hard foe of *yanqui* imperialism, is automatically associated. His image has been a mainstay at anti–Iraq War rallies, not for his association with the Middle East but for the opposition to U.S. policies that he represents. It's similar to the role he plays at the antiglobalization movement's actions against the World Bank or the IMF, which are viewed simplistically as agents of "Americanization." The widespread opposition to the dominance of the world's sole superpower has been a natural breeding ground for Che's icon.

This anti-Americanist label is not easily applied, however, to many other conflicts in which Che is prominent—such as among immigrant activists in the United States. Some anti-immigrant groups, such as the Minute Men, tried to claim that the Che T-shirts at the rallies that swept the nation in May 2006 were proof of the protesters' ill intent against the nation. In Miami, Cuban-American radio hosts cited the prevalence of Che in successfully appealing for a Cuban community boycott of these events in their city. In fact, the number of Che T-shirts was not overwhelming at any of the rallies. Far more common was the Stars and Stripes, which clearly outnumbered all other iconic symbols, even the Mexican, Dominican, and Salvadorian flags. Simply opposing a particular aspect of U.S. policy does not make people anti-American. Clearly, these immigrants want to be included in the United States, not at war with it.

So what were the fans of a *yanqui*-hating Argentine revolutionary saying at these protests? Clues might lie in the history of a fabled mural at the Estrada Courts Housing Project in East Los Angeles, an icon of the Chicano movement that arose in the 1970s among the city's millions of poor, marginalized Mexican-Americans. The mural, which was defaced on two occasions, showed Che with his finger pointing at the viewer à la Uncle Sam. It was accompanied by the words "We are not a minority." Here were two political messages intended for two separate audi-

ences. On the one hand, the mural was an appeal to the inhabitants of the housing project to stand up and demand a fairer piece of the economic pie. On the other, it was an assertion of political power targeted at the white establishment. In this role, Che was demanding the right to inclusion, to be considered part of the American dream. Here, as with at the 2006 rallies, he was a symbol for inclusion.

Even outside the United States, Che often comfortably sits on the side of groups aligned with U.S. interests. In Hong Kong, legislator and pro-democracy activist Leung Kwok-hung, known popularly as Long Hair, wears his trademark Che T-shirt everywhere. Leung's agenda is driven more by human rights and free speech concerns than by Marxism, and he directly opposes the Chinese communist political system for which Che held some admiration. His demands for democracy, meanwhile, are in line with America's repeated communiqués to China, and even more so that of influential U.S. lobby groups such as Human Rights Watch. Leung's Che T-shirt is a symbol of rebellion and resistance against authority and imperialistic power. But in this case, the empire is China, not the United States. He is adept at using Che for political marketing. With his T-shirt and long hair—which Leung has vowed not to cut until Beijing apologizes for Tiananmen Square—the high-profile legislator has branded himself superbly. He is better known than any other Hong Kong lawmaker, which assures popular support and offers him a certain amount of political protection.

It is a notable twist of history that the Chinese are now confronting Che in Hong Kong—not just because Guevara somewhat admired Mao, but also because for many years Hong Kong's colonial master confronted him closer to home. Korda image murals were common in Catholic parts of Belfast through the 1970s and 1980s, where they represented a powerful statement of rebellion against U.K. rule and an appeal to Irish nationalism. Now that

power-sharing accords between Catholics and Protestants are generally holding firm and the devolution of powers from London is helping defuse the long-running conflict in Northern Ireland, Che's status there is changing. Less overtly associated with the struggle against British rule, he's arising more as a generic symbol of teenage rebellion, mostly via fashion. Che T-shirts are back in vogue among an age group that has mostly known peace.

And yet while Catholics and Protestants are tentatively discovering the ballot box as an alternative to guns and bombs, it sometimes seems the British establishment is unaware that peace has broken out. The Victoria and Albert Museum's handling of Trisha Ziff's 2006 exhibition of Korda image–based art is a perfect example. Shortly before its launch, the curator of the Revolution and Commerce exhibition was informed by the London museum that her friend Gerry Adams was "not relevant or appropriate" as a name on her guest list for the opening. Adams, the Sinn Fein nationalist party leader, will always be a contested figure in British history due to his alleged associations to the Irish Republican Army. Still, more than any other person, it was he who facilitated the Northern Ireland peace process in convincing the IRA to lay down its weapons. That role makes Adams, who has been a sitting member of Parliament for a full decade, an important ally of the British government. The museum, however, in connecting the dots between Che and the IRA, seemed locked in an outdated narrative.

Meanwhile, the august Victorian institution had dived headlong into the crass world of Che commerce, offering Korda image–themed memorabilia as a supplement to the show. Among the items offered in its museum shop: Che lip balm. The angry curator eventually took a philosophical view of the affair. "I now think of the V&A episode as another [Che] T-shirt," Ziff says. "Each venue is its own T-shirt, each with its own form of censorship and its own interpretation of what Che represents."

★

This multiplicity of interpretations is another way to express the global nature of the Korda Che. Indeed, the phenomenon of varied, conflicted ideas has spawned its own internal industry of satirical and iconoclastic art. This genre does not so much use the image to make a statement as to make meta-commentary about the image and the conflicted meanings it evokes.

Since it is so entrenched in public consciousness and since it triggers certain preconceived ideas, the image is an easy vehicle for clever statements on all sorts of issues. Sometimes it is to take a shot at the phenomenon of Che commercialization. These include graphic art pieces like Patrick Thomas's reproduction of the Korda image via a montage of multinational corporate logos like Ford, Coca-Cola, and Disney. Apolitical statements and jokes about consumerism are sometimes made through the act of marketing in itself, by selling items whose appeal lies in their tongue-in-cheek irony more than it does in any straight-faced claim to

Che-branded condom.

Che chic. It's hard to imagine, for example, that a buyer of Che condoms would actually use them in the practical way for which the product is purportedly designed.

It's also common for Che-based satire to toy with the mercurial meaning of *revolution,* a word that has, like the image, become a floating signifier. From there we get GE's revolutionary CEO Jack Welch as Che on an *Economist* magazine cover, a Ronald Reagan Che with the slogan "Reagan Revolution," and a red-on-black revolutionary Christ portrayed as Che. The latter, a reversal of the "Chesucristo"—which depicts Che as Christ—tends to anger some Christians, as the British Church Advertising Network found when it was forced to explain that its Korda image–inspired "Jesus: No Wimp in a Nightie" posters were not an endorsement of communism.

Other times, the commentary is on Che the man. The Chesucristo is a positive version of this. But it can also take a more critical position: Che with a Hitler mustache or with a skull in place of the face, as with the images on che-mart.com, where Guevara is mocked as "the world's greatest T-shirt salesman." And then some manifestations will steer Che into a different political arena altogether. This was the case with the pink-hued "Che Gay" poster, which appeared in the U.K. in the 1970s, an idea that now has its real-life match in Victor Hugo Robles, a Chilean gay rights activist and Guevara admirer who dresses up as the Guerrillero Heroico and calls himself the Che of the Gays. Ultimately, many Che-spoofing graphics are ideologically neutral; they make fun of the icon itself, in isolation from the politics. There is the *New Yorker* cartoon of Che wearing a Bart Simpson T-shirt. Or there's the Che Ape, which morphs the revolutionary's face with that of Cornelius from *The Planet of the Apes,* a riff on *guerrilla* versus *gorilla* and a nod to the character's rebel role in the television series and movie. Meanwhile, a beret on a bleached-out photographic image turns Tony Blair's wife into *Che*-rie Blair; plays

Reagan Revolution.

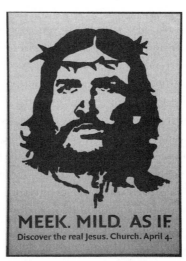

U.K. church advertising campaign poster.

Christopher Nash's *LiberaChe.*

with singer *Cher*'s name; and pokes fun at (Dick) *Che*-ney with
an oil well in place of El Comandante's star. My favorite is
Christopher Nash's Libera*Che:* Guevara's head atop a glittering
suit, complete with frilly cuffs and rings on his fingers under the
title "A Revolution in Rhinestones." The T-shirt was promoted on
Nash's San Francisco–based website, the Wrong Element, which
boasts that it has been "harassing sacred cows with the cattle
prod of parody since 2002."

Sergio Langer, an Argentine cartoonist who mixes offbeat
humor and ugly characters into a unique breed of satirical com-
mentary, explains why Che is so appealing as a subject in this
genre. "What works in humor is to take images that are already
[socially] installed and cross them with other installed images,"
he told me, pointing to one of his cartoons of Dirty War general
Jorge Rafael Videla's face in the style of Freddy Krueger, which he
had placed in a McDonald's Employee of the Month photo frame.
"It's fun to cross these things and come up with something origi-

Oleg Atbashian's *Che Is Dead, Get Over It*
graphic.

nal and strong." Langer's stock of Che pictures includes one of a
cigarette-smoking Guevara standing on a street corner in a Bob
Marley T-shirt. "I take symbols and mix them without devotion
and without respect," he says. "They are the repertoire that sur-
rounds me . . . I can't be solemn about any of this."

In taking this approach, he and other iconoclasts expose
painful, uncomfortable truths about our world. (The son of a
Holocaust survivor, Langer recently had an exhibition of some of
his Jewish-themed art that was both funny and agonizingly sad. It
was staged in the AMIA Jewish Center in Buenos Aires, a build-
ing built right on top of the site where, in 1994, a terrorist's bomb
destroyed the previous AMIA Center and took eighty-five inno-
cent lives.) People like Langer invariably run into trouble with
institutions that are heavily invested in the myths underlying the
icon under attack, as was his experience with the Cuban Com-

Cartoon by Sergio Langer similar to one he
produced for the Committees for the
Defense of the Revolution in Cuba. Caption
reads: "Not Evo, nor Chávez, nor Lula . . .
The tastiest form of socialism is Cuba's."

mittees for the Defense of the Revolution. Perhaps the CDR
organizers should have looked more closely at the cartoonist's
portfolio before they commissioned him to do some art; that way
they could have guessed that he'd expose the absurdities of Cuban
society, as he does with every society. Langer submitted a cartoon
of an overweight middle-aged European with a young dark-
skinned *jinetera* on either arm and a Che T-shirt with the words
EL CHE VIVE on his chest. The CDRs, an institution steeped in
revolutionary lore, responded in kind, by censoring it. There was
just way too much truth about the revolution's failures in that
cartoon.

IN SEARCH OF THE INNER CHE

Those who have never lied know little or nothing
of the inaccessibility of truth . . .
　　　　　　　　　　　—Omar Pérez López

OUR PURSUIT OF the globalized Che brings us full circle, back
to the country in which his iconic image was born. Although so
many other places have contributed to the construction of the
icon since then, Cuba continues to loom large in Che's afterlife.
The Cuba of the twenty-first century—a very different place from
the Cuba of 1960, especially now that it faces a future without
Fidel Castro—is the perfect place to comprehend the contradic-
tions that revolve around the icon in the age of globalization, as
well as the contemporary economic, political, and social factors
that shape its place in society. Contemporary Cuba is at once a
product of that age—dependent on tourists, foreign investment,
and overseas remittances—and a throwback to the insulated,
inefficient, restricted Cold War world.

Like Che, the Cuban revolution survives as an ideal and a mar-
ketable brand, one that is increasingly distant from the reality of
daily life on the island. While some of Cuba's heralded successes
have been maintained at great cost to the public purse—notably,
its universal health care system—its wider economy has collapsed

while its professed commitment to socialist principles has been challenged by the inequities of a dual-currency system that was erected in desperation in 1991. In this system, Cuba is not one country, but two—one geared toward a more open future and a place in the global economy and another clinging to a Cold War–era past and its noble but nonetheless failing principles of egalitarianism. It is in effect a country in denial. In one of those two Cubas, anyone possessing hard currency lives out his daily existence inside an exclusive economy reserved for this elite form of legal tender, bringing with it the material comforts of a more or less normal consumer existence. Millions of others, however, are trapped in the other Cuba, where the dilapidated economy of the revolution's worthless original currency offers little more than the dwindling pickings of the government's daily ration book.

Nothing defines twenty-first-century Cuba more than the contrast between these two economies and the daily battles its citizens wage to break from one into the other. And while the Cuban government, to its credit, does little to hide their economic hardships, displaying the country's collapsing infrastructure in all its glory (and blaming it, where possible, on the U.S. embargo), the regime is not being honest with its people, with the world, and with itself. There is a wide gap between the ideals of the Cuban revolution and the reality of life on the island, which means that its myths, including its most lasting and influential one—that of Che—are laid bare. And yet, despite all of this, somehow they survive, defying the comical incongruities that surround them.

The contradiction is embodied in a lanky-framed man who struts back and forth outside the Ambos Mundos Hotel in Old Havana each morning. The man's livelihood is simultaneously dependent on the strength of the old Cuba's revolutionary branding and the new Cuba's insertion into the modern global economy. With his

hands folded behind his stiffly upright back and his eyes locked in a serious expression, the gentleman projects an air of authority. Yet he is obviously not a policeman, nor indeed does he perform any other official function. He has a long, graying goatee of wispy, curly hair pulled into a triangular point at his chest. An unlit cigar protrudes from his left breast pocket and a plastic whistle dangles from the other. His shirt sports a Cuban flag pin and another that looks like a military medal but is in fact a commemorative badge for volunteer cane-cutting work. Two toy military radios are attached to his belt, one on either hip, and a fake plastic mobile phone is clipped to his right pants pocket. This uniformed sentry is on the lookout not for wrongdoers but for tourists. Through them he makes a living and through them his image, just like that of the man he imitates, travels the world.

"My name is"—he started to tell me—". . . actually, most people around here know me as El Che." And to prove this, he called out to a passerby. "Hey, excuse me, what's my name?" The answer was immediate: "You are El Che." He began to explain his "job" for the revolution, veering into a rambling speech about imperialism, love, war, peace, and the evils of El Presidente Doble Bush. (Literally, "President Double Bush"—he apparently dropped the second part of the Spanish word for W, doble ve.)

"Many tourists who come here to Cuba, which is blockaded by American imperialism, the American policy of President Double Bush, they come to see me and get to know me as a personality," said El Che, who later confided that his parents had given him the name Omar Sandovar Pose when he was born in 1946. "And, you know, I have been in Italy, in Austria also; I've been in France, in England, in Honduras . . . all the nations of the people who come to visit me here in Cuba. They come to take a photo and take it to their country . . . I've even been in America."

And what did this Che think of the real Che? He answered in the present tense: "He is a man of principle and ideals, a man of

well-formed morals, a man who always fights for the liberty of all people, and not only in Cuba, a man who is difficult to characterize, a personality of conscience. He is, as we say in Cuba, the patriotic conscience of our nation. You feel him always in your heart, but also in the hearts of the world." This feeling, Omar explained, is shared by "the American people, but not by the government." Americans, he said, "respect Che very much, they see him and they love him, because he is a man who fights to liberate people from this imperialist monster Double Bush . . . But there is a place in heaven where there will be a judgment and this President Double Bush will pay for all that he has done, in Cuba especially and in the world, everywhere . . . Viva Cuba! Viva all people of good moral conscience! Viva la revolución! Viva our comandante Fidel! May he have good health and may he recover rapidly according to the wishes of the Cuban people and the people of the world. And viva our comandante Che! Hasta la victoria siempre!"

With that he moved across the street and took up position against a painted brick wall. Stiffening, he adopted a fixed stare, looking in my general direction but focused above my right shoulder. And there it was, the look perfected over the years, the Korda look that had sent the image of this man and his wispy beard around the world.

I snapped some shots and it was time for payment. Never comfortable with the ugly business of haggling with a person whose income is pitifully smaller than mine, I'd neglected to set a price beforehand. "How much?" I asked.

"Two dollars."

"I'm just interested. What do you think Che would think of what you do?"

He seemed to take offense. "This is my work," he replied. "It is my job. I do it for the people."

We parted ways. Omar Sandover Pose returned to his patrol on

the other side of the street. Tourists approached and the look returned to his face. He was back on the job.

★

I paid my Che impersonator in convertible pesos, the special currency into which incoming foreign currencies must be converted for the bearer to gain access to a range of goods not available in *moneda nacional,* the old peso in which most Cubans are paid their government salary. In recent years, the value of the convertible peso has been at more than twenty times that of the old peso.

The trigger that brought this patently unfair two-currency system into being came with Mikhail Gorbachev's perestroika. When the Soviet premier halted sugar subsidies for Cuba in 1990, he plunged Castro's government into bankruptcy. With no inflows to fund them, Cuba began printing massive amounts of

"El Che" of Old Havana, November 2006.

moneda nacional simply to pay the eleven million Cubans on its payroll. It was a recipe for disaster.

With literally nothing to buy beyond the narrow list of fixed-price goods in their government-issued ration book, Cubans sent all these new, excess pesos in search of foreign currency. The value of the dollar against the peso soared in the black market, where it went from its one-to-one rate in the protected Soviet economy to 130, a clear sign of how things had become unhinged. Eventually, in a desperate and somewhat successful bid to save its finances, the government legalized the dollar in 1993 and shifted a host of "nonessential" products into high-priced, exclusively dollars-only stores. A year later it introduced the newly invented convertible peso as a vehicle for capturing the incoming dollars and other currencies. These days, the original peso is good for public transport—if and when the buses arrive—utilities, and an ever-shrinking and deteriorating selection of items on the monthly ration book. Anything imported, any electronic goods, any half-decent restaurant, anything of passable quality must be paid for in convertible pesos, for which a person essentially needs foreign currency. At $15 a month, the average *moneda nacional* government salary won't buy you very much of that.

In 2008, as Raúl Castro formally took power from his ailing brother and began gingerly pursuing a China-like moderation in policy, much attention was given to various "liberalizing" measures he introduced: He permitted the sale of computers, DVDs, cell phones, and other electronic goods to individual consumers and did away with an apartheid-like ban on Cuban citizens staying in hotels—which were previously reserved exclusively for foreign tourists. But along with some punitive measures taken against Havana-based bloggers, the perpetuation of the distorting dual-currency system was an indication that there were serious limits on this shift toward moderation. Making these "luxury"

items legal does not mean that the millions of Cubans who are stuck earning the worthless local currency can come anywhere close to buying them. If anything, the opening up of this market will only widen the wealth gap between the owners of foreign currency and those who earn local currency. It will also likely deepen a severe racial divide: The Cubans with the easiest access to dollars are the mostly white citizens with family members living abroad, while black Cubans tend to live in poor rural communities cut off from foreign income sources. Given these worsening divisions, it's hard to see how Raúl Castro can achieve his goal of "equal opportunity" without dismantling the deeply flawed dual-currency system.

But doing this is a daunting task. The 2,000 percent gap between the two currencies must be bridged without either creating rampant inflation or a devastating contraction in demand. It's tempting to speculate that some in Raúl Castro's administration now wish they'd found a different solution to the crisis provoked by the Soviet collapse. But the truth is, the roots of this monetary breakdown go much further back than 1989, to a man who thirty years earlier took a highly inappropriate posting as Cuba's top central banker. Che Guevara often joked that he mistakenly volunteered for that top finance job when Castro said he was looking for an economist to run the bank because he thought he'd said "communist." Once in office he signed the first new bank notes with a simple "Che," converting his nickname into something akin to a graffiti artist's tag. The country's banking community, or what was left of it, was aghast at the impropriety. They didn't know the half of it. In symbolically discrediting the revolution's first currency, this man who foresaw a socialist utopia dispensing with money altogether was willing its descent into worthlessness. And that's precisely where it ended up.

★

As if to commemorate Che's association with the valueless offi-
cial currency, his face is all over it. (Given all the notes in circula-
tion, it undoubtedly represents the largest single reproduction of
the Korda image in the world.) Most prominently, the Guerrillero
Heroico image appears on the three-peso bill. Yes, a *three*-peso
bill. Not being a factor of ten, bank notes denominated in threes
have a dubious reputation in many cultures—note the expression
"as phony as three-dollar bill"—which is perhaps why few coun-
tries print them. Ever willing to go against the international grain,
Cuba reintroduced the three-peso bill in 1995, when all other
ex–Soviet bloc countries were taking theirs out of circulation.
One reason to do so, apparently, was the bill's popularity with for-
eign collectors as a piece of Che memorabilia. In terms of its
ostensible purpose, however—as legal tender for commerce—the
moneda nacional three-peso bill doesn't command much respect
from the locals.

"You're interested in Che? Well, here, have this," a passerby
said to me in a back street of Havana's Cerro district. Then he
doubled back: "Oh, and have another one." The joke was clear:
This gift was not a gift at all, for he'd given me something that was
worthless to him. Yet we both valued the exchange. He'd earned a
laugh and I was given a priceless reminder of the harsh differ-
ences between Cuba's myths and its material existence. (The two
"worthless" bills now occupy pride of place on a bookshelf of
mine in Buenos Aires.)

I'd arrived in this gritty neighborhood via the services of a wiry-
bodied rickshaw driver, from whom I received another lesson
in the dynamics of Cuba's great currency game. I was looking
for homes with pictures of Che converted into mini-shrines.
Throughout a bumpy ride punctuated by potholes, I watched
Havana's dilapidated infrastructure get worse and worse as we
got away from the tourist center of Old Havana. Whole apart-
ment blocks defied gravity, some supported solely by rusted steel

girders exposed by the erosion of their concrete foundations. Against this material deprivation, the resourcefulness and spirit of Cuban society was on full display. From many higher apartments, people were pulling little packages up on a rope—a less tiring way to obtain groceries when the elevator doesn't work— and from virtually every open doorway, chatter, laughter, music, and people were spilling out into the street.

Suddenly my driver turned to me and said, "Quick! Police! Get out, get out!" He'd neglected to tell me he wasn't licensed to carry tourists. Only motorized taxis could do that, and with a tall blond guy in the backseat of a slow-moving, open-air vehicle, he was a sitting duck. It didn't mean the deal was off, though. I just had to slink away behind him as he went ahead solo for a block or two. Later I was to rejoin him. We repeated the same dismounting exercise six times before we got to our destination. Frequently someone would come over and warn us that the police were at an upcoming intersection. Thanking them, we'd take a detour, or I'd get out and walk a couple of blocks, trying to look like an innocent tourist in a neighborhood that was well off the tourist map.

Why this strange cat-and-mouse game with the police? And why were neighbors so willing to assist in our subterfuge? The answer is that although his official job is to carry Cubans around, my driver, like nearly everyone in Cuba, makes his living off people like me. His survival, or at least his chance to enjoy a small luxury every now and then, depends on finding a way around government restrictions on a most prized possession: foreign currency.

Thanks to this system, with stark distinctions between the haves and have-nots, all manner of illegalities have arisen. Prostitution has boomed, producing the common and unappealing sight of young Cuban *jinetera* girls on the arms of old foreign men. Meanwhile, workers paid in the worthless local currency steal their enterprise's output and sell it at a twenty times markup in

convertible pesos. Among countless other scams, I heard stories of employees in *moneda nacional* bakeries diverting the day's supply of bread rolls to hard-currency restaurants and cafés for a 2,000 percent profit. Of course this only means there are fewer products available for the wider, *moneda nacional*–carrying population.

Despite these inequalities, Cubans readily display their famous solidarity. Hitchhiking is commonplace. (Ride-sharing gets around the inefficiencies of public transport.) The barrios of Havana have their doors wide open. And there's a palpable euphoria at nightclubs, where gyrating youngsters seem to be celebrating their country's survival and independence. There is joy in Cuba, even if some Cubans (such as the country's political prisoners) are prohibited from sharing it. And this, it must be said, would not be possible if the government did not sustain some key elements of socialism—free medicine, education, housing (however substandard), and other basic necessities.

Where Cuban society breaks down is in its relationship with the state. Rates for crimes against individuals are low—although rising—but the state earns no respect. "They pretend to pay us; we pretend to work," goes a common expression. In fact, for countless pretend workers, stealing from their pretend paymaster is a daily undertaking. It's a matter of survival.

Even true believers in the revolution—remarkably, they still exist—accept that some corruption is unavoidable. For them, the question becomes: Where is the line between survival and capitalist greed? For a Cuban friend in whose tiny, dingy apartment I shared a late-night chat with some of her pals, a gathering interrupted by a neighbor eager to buy some of her contraband rum, "survival" meant the freedom to talk poetry and politics over coffee—to have what the Latin American left calls *una vida digna,* a dignified life. Defining the parameters of such a life is a personal matter. The problem is that the myth-laden language of the Cuban revolution allows no room for ambiguity or choice.

★

The national myth most damaged by this is that of Che. The revolution's morality standard-bearer since his death in 1967 is now caught up in a system that defies those standards. Schoolchildren still chant "Seremos como el Che" (We will be like Che) every morning, and his face still looks out across the Plaza de la Revolución and hangs in every office and peers out from billboards that dominate the island's landscape, most commonly in the form of the Korda image. In its anticorruption propaganda, the government evokes the New Man ideals of hard work and sacrifice, an ideology espoused by Che. But Che's icon is also a huge dollar-spinner in the very nonsocialist business of tourism, an industry that accounts for 40 percent of the foreign exchange inflows that Cuba needs to stay afloat.

Amid the shift from socialism to a hybrid form of masked capi-

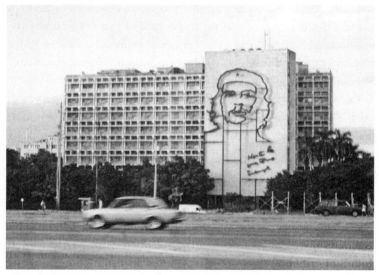

Plaza de la Revolución, Havana, November 2006.

talism, the *meaning* of Che is becoming unmoored in Cuba. Genuine reverence can still be found for Che, but it's not expressed homogeneously and it shifts across generations. Javier Castellanos, a Cerro resident of sixty-odd years who spoke to me from his doorway in a singlet, called Che "the man of the century . . . on par with Martí." He'd even named his son after him in 1969. But his son, Ernesto, was less effusive. "For me, Che was, let's say a good sort," said the thirty-seven-year-old, who was wearing a Florida Marlins baseball cap, T-shirt, khaki shorts, and sneakers. "I suppose I'm proud to have his name. But others feel differently. Some say he hated homosexuals or that he was a murderer."

One way to think about Che's place in post–Cold War Cuba is to speculate on what the real Ernesto Guevara might think of the daily battles Cubans wage with the state in their hunt for foreign currency. Roberto, with whom I shared a *mojito* in a downtown bar, was unequivocal. "He is with us, not Fidel," declared Roberto (not his real name) as he pointed to the Korda image on his olive green fake army cap. He explained how he and his friends buy smuggled cigars from workers in government factories and then sell them to tourists at prices below those charged in official Habano outlets. He argued that they were on the side of justice. "We are providing a product to people at the correct price, the market price, and we are stopping an avaricious government from charging an unfair markup," he said. "What's more, we're making sure the workers get a piece of the profits they deserve. That's why Che would approve."

If cigar hawkers like Roberto think they and Che are kindred souls, they are mistaken. It's fair to say, however, that Guevara, a firm believer in a pure, idealistic, and wholly equitable version of socialism, would not recognize the Cuban political-economic system that has developed under Castro. The growing disparities between rich and poor, the pervasive dishonesty, and the obsessive hunt for foreign currency are the antithesis of Che's utopian vision

for Cuba. It has always been hard to prove the commonly held theory among Castro critics that Che's 1965 departure and ultimately his death were the result of a rift with the Cuban leader. Yet it's easy to imagine that now, faced with this unjust, divided society, Guevara might roundly denounce his former boss.

Nonetheless, Che's own early contribution to these dysfunctional aspects of twenty-first-century Cuban society is clear. And it goes beyond his unorthodox ideas on money. For one, there is the damage done by his idea of moral incentives, which rejects the notion of material rewards for improved worker output. And then there's his zealous promotion of voluntary labor as a means of cultivating his ideal of the New Man, the self-sacrificing individual of the future.

Che, who formulated these hyperidealistic ideas after he moved from the central bank to the industry ministry, never acknowledged the damage they did to productivity and instead blamed production setbacks on human incompetence. He publicly derided factory managers for making a new line of toothpaste that "cleans just the same" as the previous one but "after a while turns to stone," and for producing cola that tasted "like cough medicine" and matches that broke when struck. To him, these did not prove the failure of moral incentives, but rather that the consciousness of the New Man was still a work in progress.

Most economists in our post–Berlin Wall era say such failures and those of the communist bloc in general prove the opposite: that society pays a high cost for suppressing the individual's drive for material betterment. Irrespective of the fall from grace that free market dogma has suffered in the recent global financial crisis, the accumulated evidence in favor of this argument is overwhelming. Yet Che's view has never failed to find a foothold among idealists who agitate for social change. Indeed, these people—newly emboldened by capitalism's funk—ask some legitimate questions: Why, exactly, must we succumb to the destruc-

tive power of greed? Why be so defeatist? Why can't we believe that human beings can change? If these are idealistic notions— generally dismissed by mainstream policy makers as naive at best and dangerously ignorant at worst—it's worth noting that they are also little different from the core beliefs at the foundation of most modern societies' value systems and religions. It matters not that Che's vision of a selfless society helped send Cuba's industrial base into ruin; the beliefs upon which he formulated it are very widely shared. In this sense, the Spirit of Che is universal, conceived as a perfect ideal of selflessness.

Omar Pérez López's adult life can be defined as a struggle to find this elusive moral standard, to discover the essential Spirit of Che. His has been a life of both pain and self-searching, shaped in a powerful way by Cuba's distorted mythologizing of Che. That struggle was made harder by the conflict he has had with the Castro regime and by his unique connection with Ernesto Guevara. In 1989, when the old Cuba was making way for the new, post-Soviet Cuba, the then-twenty-five-year-old Pérez learned for the first time that the larger-than-life Heroic Guerrilla, a billboard-dominating figure in whose presence he and all Cubans had constantly lived, was his father.

While it has never been proven, there is credible evidence to suggest that Omar Pérez López is Che's unacknowledged son. Yet for almost two decades afterward he studiously avoided the limelight, during which time he learned four languages, earned international recognition for his poetry, lived on and off as an expatriate in Europe, and became an ordained Buddhist monk.

Now, as Cubans confront a future without Fidel Castro and contend with the contradictions of a closed political system that presents a socialist face while engaging with foreign capitalists, Pérez emerges as a voice of conscience, a throwback to the lost

spirit of the revolution. Invoking the spiritual values of his father, he calls for a true return to Che's New Man project. Meanwhile, he condemns those who falsely use Che's image to burnish their revolutionary credentials while exploiting it for personal gain, explicitly naming his supposed half siblings as culprits.

With this stance, Pérez seems destined to make himself an unwelcome intruder in the affairs of the mainstream Guevara family, a quasi-official institution in Cuba. The children of Che's widow, Aleida March, are known for their angry attacks against those who crassly commercialize his image. And yet, justifying Pérez's charges of hypocrisy, they also oversee a vast international business operation selling books and other products tied to the rights that the family holds over Ernesto Guevara's name. Meanwhile, the five children of Alberto Korda are locked in their own bitter and highly politicized battle over the worldwide rights to Che's iconic image. Amid all this unseemly conflict, Omar Pérez, an antimaterialist, raises important and timely questions about the true Spirit of Che.

<div align="center">★</div>

His story begins further back than this, however, in 1963, on a day when Lilia Rosa López, a beautiful twenty-year-old journalism student in Havana, called on her friend Ida Pérez. When Lilia found Ida at the front desk of the oil institute at which she worked, she was reading *The Technique of Coup d'État* by Curzio Malaparte. In the hands of a receptionist, this weighty text also caught the attention of Che Guevara, who happened to be there on ministry of industries business. Apparently no fan of the Italian Malaparte, a onetime fascist who later converted to communism, Che told Ida he'd bring her a different book. "That's when I began to do what we Cubans call *satear* [local slang for flirt]," López told me during an interview in her home above Havana's Malecón seawall.

After that first meeting, López says, Che returned to Ida's office with the book he'd promised for her and a different one for López called *Corazon* (Heart), a nineteenth-century work by another Italian, Edmundo de Amicis. A short, "sporadic" relationship began. Then, before she even realized she was pregnant, their meetings stopped abruptly in mid-1963 as Che's travel commitments began to take him on lengthy world tours. Ernesto Guevara and Lilia Rosa López had no further contact.

Lilia Rosa says she planned to have an abortion but couldn't go through with it. Meanwhile, she separated from her heavy-drinking husband. Shortly after the birth, however, he returned to claim custody over the boy, delivering a completed birth certificate on which he'd inscribed his own first name for the child as a fait accompli. Worried about the shame to her family and terrified of the political fallout, she revealed her secret to no one but her closest confidantes—no doubt assuming it would stay there. Nonetheless, determined to associate the child in some way with his real father and blessed with a knack for making connections, she got an official to redoctor the birth certificate with a new first name for her son. For its inspiration she turned to a book Che had lent her: *Rubaiyat* by the Persian poet Omar Khayyam. Along with other memorabilia from the time she spent with the famous revolutionary, López showed me her copy of this book, which she says her lover never retrieved. A dedication in black pen inside the cover reads, "To Doctor Guevara, a poet of life and of the eternal dream." Signed "Cazeres, Mexico 1954," the book appears to have been a gift from a friend in Mexico City right before Che's historic meeting with Castro.

★

Until Omar was twenty-five, he always assumed his father was Benito Pérez, who died shortly after the startling alternative story emerged. But the truth is, the young man looked nothing like

Omar Pérez López, Havana, May 2007.

him and instead bore an uncanny resemblance to one of the best-known faces in the world. And when I met Omar, by now forty-two, in November 2006, the similarity still seemed present. It was impossible—certainly after so much research looking at one single face—not to find a striking familiarity in the dark, expressive eyes and shoulder-length wavy hair of the man who greeted me in the front bar of my Old Havana hotel. And as I was to discover, Omar Pérez's appearance was not his only Chelike attribute.

"Let's start at ground zero," he began. We were to start with the moment of reckoning, one that arose out of Pérez's relationship in 1989 with a group of poets, novelists, essayists, and artists who were exploring new political and cultural ideas for their country's uncertain future. Within this cross section of the Cuban intellectual scene, there were a few who had gotten wind of a titillating story concerning the young man—presumably through a network that incorporated his journalist mother. One thing led to another.

"They told me," Pérez said. "This was something quite known. It was no secret for anybody, except for me." It was not until some time later that his mother confirmed the account.

Some skeptics see the timing of the story as suspicious—as if it were planted to throw Pérez off. Either way, his first response was to forget about it. "Probably this was too much of a shock for me to have a conscious reaction," he said. Yet it was also because "at that time, I didn't have the patience to reflect on this."

Most of his energy was going into the new writers' organization, which bore the name Paideia, a Greek word meaning both education and culture. Its members had some edgy ideas on how to open the Cuban art and literary scene while protecting its left-wing roots. They discussed these ideas in a rarefied intellectual setting and eschewed the kind of urgent activism that young people elsewhere were embarking upon. While the Paideia members discussed European postmodernists and probed the theories of Italian Marxist Antonio Gramsci, Vaclav Havel's supporters were taking to the streets of Prague, Chinese students were occupying Tiananmen Square, and East Berliners were preparing to smash down the wall that divided their city. There was "a surrealism to this attitude," said French social commentator Jean François Fogel in a posting to his Spanish-language blog on Latin American literature. "In an island wounded by the collapse of the Soviet camp, amid a daily life of total scarcity, these young Cubans thought the most urgent thing to debate was philosophy and art."

Still, if anyone was going to develop a more confrontational posture as Paideia found its activities more restricted, Omar Pérez was. "In his ways of interaction, either with the authorities or with us, Omar was the most radical of all of us," recalls his friend and fellow poet Rolando Prats-Paez. "I remember his impatience at what he perceived as an excess of diplomacy and his patronizing disdain . . . for anything he might have thought was too compromising or purely tactical."

Readers will find similarities between this character description and the feisty demeanor of Pérez's putative father. But Prats-Paez cautions against an after-the-fact reading that attributes too much biological determination to the young poet's personality traits. He and others from the group were suspicious of the timing of the son-of-Che story, which disrupted their movement and put their charismatic colleague in a difficult position. Pérez would never be the same. "True or false, this story made Omar a hostage to a symbolic identity he had already carved for himself," Prats-Paez said. "Omar did not need to be the son of someone he already was in his own terms. Somebody else needed that. A castration took place: that of an individual and a whole generation who were embarked on writing their own history."

Whether genetically derived or otherwise, Pérez's defiance put him on a collision course with the Cuban state. In 1991, with Cuba's Soviet lifeline cut and its finances hitting rock bottom, he, Prats-Paez, and six others signed the Third Option manifesto—a title that seemed ahead of its time, as if borrowing from the future middle-ground terminology of Tony Blair and Bill Clinton. It offered a minimal program of political liberalization that respected the socialist foundations of the Cuban revolution, one described as a "democratic alternative" to U.S.-backed "neo-annexationist" free market solutions. This path, the authors argued, was the only guarantee of true "economic independence, political sovereignty, social justice, and human rights."

Even though it was packaged in this deliberately socialist framework, the Third Option manifesto prompted a swift backlash from the regime. At the Cuban Communist Party's national assembly three months after it was signed, a senior party member attacked the group's "petit bourgeois vision" and its "mediocre reading of history." A harsher crackdown was administered, causing some of its supporters to flee into foreign exile—they are spread around the world in places such as Mexico City, São Paulo,

Vancouver, Barcelona, and Miami—while a few of those who stayed ended up in jail.

The treatment meted out to Pérez, the most outspoken of the dissident group, seemed soft—at first. Whether his secret identity was a factor is not clear. Either way, his mother's lobbying paid off, as she obtained permission for her son to attend a studies program in Siena, Italy. (This was her last act of support. López had by then distanced herself from her son's controversial politics. They would not speak again for more than a decade.) Immediately upon return to Cuba, however, Omar Pérez was ordered to attend a labor camp in the province of Pinar del Río, where he spent a year picking tomatoes. The camp, nicknamed France, was modeled, as with others across the country, on one established on the Guanahacabibes Peninsula by industry minister Che Guevara in 1962. Founded on Che's plans to cultivate a revolutionary work ethic among ministry employees, that camp took in state functionaries and factory managers found "guilty of errors and transgressions committed in the performance of their duties."

Yes, Pérez acknowledges, it is ironic that Che's son spent time in a penal system he'd designed. But with characteristically philosophical insight, he adds, "What is irony in the end? Irony is a kind of sign which is hiding something. It is a kind of phony light which is telling you that behind this comicality of life, there is something to learn. It is not just mockery or ridiculousness. It is a sign."

For inmate Pérez, his detention was a sign to contemplate his parentage. And in that effort he found support from Hilda Guevara Gadea, the Mexican-born daughter from Che's first marriage, who was then working as a librarian at the Casa de Americas cultural center. Meeting Hilda "was the first time I had the opportunity to talk to somebody else who was also close to my father, and to talk about him as a person, not an icon," Pérez said.

Hildita, as she was sometimes known, was the black sheep of

what might be described as the Cuban revolution's first family. When Hilda Gadea brought Che's three-year-old daughter to Havana, she was warmly welcomed by her now-famous father, whose letters to his eldest daughter reveal a genuine fondness. But after he died, relations with the Cuban side of the family broke down—partly, it seems, because of her maverick ways. She'd married a Mexican left-wing revolutionary and had spent a stint in Italy in the 1970s, exposing herself and her children to a world outside the protective bubble erected around her Cuban half siblings. Her eldest son, Canek Sánchez, became a heavy-metal musician and is now active in Cuban exile politics in France.

The eldest of Che's children—she was eleven when he died—Hildita had a relatively well-formed memory of him, making her a valued source of information for Pérez. And as a kindred rebellious soul, she helped him struggle to find his place in the world. "She was a very unconventional person. She didn't want to be in any way whatsoever one of her father's representatives on earth . . . Of course, she cherished her father, but she was not very diplomatic about it," Pérez told me.

Hilda also had a dark, self-destructive side: She was prone to heavy drinking and bouts of depression. And she kept a huge secret from Pérez: She had cancer. Three years after they met, a brain tumor killed her. "It was another one of those shocks," he said. "You have time to rest for a while and ask yourself some questions before you rush off in a hurry on some kind of project or work or whatever. So she died, and I went on."

★

From there, Omar Pérez's personal journey would take him into Buddhism and eventually to what he now describes as a psychological kinship with his father. But he deliberately sought a low profile. Luckily, he lived in Cuba. Only in a place with a heavily

muzzled press would a juicy story like this one stay untouched by probing journalists. His name briefly appears in a couple of the more thorough Che Guevara biographies, but it is absent from most. He has a single-line reference in Wikipedia's online Che entry, and a few anti-Castro websites have talked up the story of Che's illegitimate son doing time in one of his father's prisons. Apart from these few references, though, Omar Pérez is off the Che radar screen.

Yet he has also lived a separate public life. Both his well-regarded poetry and his work as a translator have attained him a status in literary circles at home and abroad. Essays and articles by and about him have been published in different languages, along with interviews in which he talks about poetry and philosophy. Pérez, who is fluent in English, French, Dutch, and Italian, has spoken and read his Zen-inspired work at conferences, met foreign publishers, and has lived for some time in Italy and Holland. In all these settings, the question of his parentage rarely comes up.

Pérez's decision to isolate his Che connection from the rest of his life allowed him to create his own independent intellectual space in a way that Aleida March's children never could. "I had a chance to live a, so to speak, normal life. And I think this is ideally what my father wanted for his children," he told me during our first meeting.

Che's other offspring, those officially recognized as such, share the same intelligence and quick wit. But although they grew up with privileges and protection, their identities were subsumed in the Che myth. Forever associated with official representations of their father as a loving family man, the Guevara March children were roped into Cuba's public construction of the Che myth. And this continued into adulthood. The two eldest children, Aleida and Camilo, frequently attend official events around the world in their capacity as "Los hijos de Che." To some, they are noble

guardians of their father's legacy, spreading the word of his great deeds while taking on greedy capitalists who exploit his image. To others, they are opportunists living off his name. Neither label is fair. It's easy to forget that the Guevara March children are forced to share their father with millions of people.

When I met Aleida Guevara, a trained medical doctor and the family's de facto spokesperson, she shared intimate memories of her father and spoke thoughtfully about the challenges of living in his shadow. But when I asked whether the family would ever recognize Omar Pérez, her tone changed to one of contempt. "The first thing is that my father was totally respectful of all of his children, always. He never had relations with anybody else, ever," she said. "Second, he loved my mother so very much and did not even marry her until he had a legal divorce from his first wife, Hilda Gadea. So how could he have an adventure with another woman and have a child? It is the most enormous of stupidities!"

Then, shifting gears again, she adopted a more sympathetic, if still patronizing, tone toward Pérez. "Look, he had problems with the military service and his mother made up this issue to get him out of it, but they left it at that. They didn't say anything more about it and the poor man has had all those doubts in his head . . . We told him that if he wants, he could have a DNA study, and we would not have difficulty with this. [But] he did not respond."

When I relayed this to Pérez, he was shocked. He claimed he'd never before received a single communication from the Guevara family on any matter, let alone an invitation to have a DNA test. He had no idea what to make of this apparent highly belated offer directed through an unconnected third party—one that will of course have to be taken up eventually if this question is ever to be settled. But he had a sharp rejoinder to his supposed sister's claim about his motivation: "Does she think we could just make it up in front of the secret police and get away with it? Does she

think they would believe me? As if to say, I'm the son of Che Gue-
vara, and they would say, oh, really, okay, well, we'll let you go,
then." He laughed. "Why don't you try that sometime? Maybe you
could say you are the son of a Kennedy. Maybe that will get you
something. Give it a go."

★

Pérez has no desire to get into a public fight with his supposed sib-
lings. Rather, he'd prefer to be left in peace to explore his connec-
tions to Che as part of his religious pursuits. In the mid-1990s, in
the aftermath of his political problems and as he was still coming
to terms with his identity, Pérez met a Che Guevara–admiring
French monk who converted him to Zen Buddhism. (Monk Kosen
Thibaut, a.k.a. Stephane Thibaut, had just published a book,
Inner Revolution, whose cover superimposed the image of a medi-
tating monk with that of Korda's Che.) From there, aided by the
analytical and meditative tools afforded by this religion, he began
to develop a unique perspective on the legacy of the man he
believes to be his father. The value of the ideas he has since devel-
oped lies in the focus they give to the spiritual dimension of the
Che phenomenon and its interplay with the real flesh-and-blood
human being behind it. That in turn provides a framework for
understanding different aspects of that phenomenon, whether it
is the idealism conveyed by the Korda image's use as a political
banner or the force of collective human behavior that keeps the
icon in public view and turns it into a recurring fashion trend.
With Pérez's perspective on the icon, we find the *idea* and the
image of Che merged into a force that relates to a deep human
longing, a desire to be something that this man, this face, repre-
sents.
 Pérez believes Che was searching for a nirvana-like spiritual
essence during his final guerrilla campaigns, an idea he explained
by posing a question about human attachment to material exis-

tence. "What in fact is the ultimate point of attachment? It is not exactly difficult to shave your head and say good-bye to your family. But when you go through life and you've already shaved your head a few times, you have already said good-bye to your family a few times, like my father did—he also shaved his head, of course, not like a Buddhist, but he did shave his head [for disguise purposes]—maybe then, when you are in the middle of nowhere, like in the middle of the Congo, or Bolivia, maybe then you discover some other kind of attachment. And that attachment is far more resilient, far more resistant than love for women or for drink or success or whatever. What is this thing? This is what Buddhism has been studying for 2,500 years . . . It has to do with the real essence of ourselves, because what we are trying to attach to there is that which we think we really are. It's nothing less than that."

Before he could hope to understand what Che was looking for when he left Cuba, however, Pérez first had to reconcile himself with the personal anguish that the departure retroactively provoked in him. It was 1995, but emotionally he had regressed back to 1965, to a time when a one-year-old boy who was identified as the son of Benito Pérez was abandoned forever by a biological father who never knew him. Having overcome this "childlike resentment" at abandonment, he was then ready, he said, to apply his Buddhist perspective to the same question that Che aficionados and historians have pondered for forty years: Why did Guevara leave Cuba? Pérez's conclusion: His father was "running away." It was not flight from fear or from responsibility per se, but "from mediocrity," from a Cuban society that was losing the revolutionary drive that he'd hoped would lead to utopia and was falling under the dominance of an authoritarian, paternalistic state. Nonetheless, it was an act of flight and as such, Pérez contends, it reflected a universal human failing.

"Why do people always leave? We all leave at a certain time. We leave our wives; we leave our children; we leave our job for a better job or a worse job." The poet took a sip of his beer. "We abandon everything for something new. We trade religions, beliefs—political, ideological—so it is not something that you can say is a characteristic of a person or persons or a historical trait. This is a human trait, to abandon things for something else. It's not until I start looking at myself and I start saying, 'This is something that I have done also; it's not so famous, but it's the same,' that I start to understand things."

And so Che's forgotten son achieves something rare: He humanizes him. Finding a common weakness, he demystifies and unveils the man behind the icon. Not only does this defy Guevara's critics, who insist a monster lies under that veil, it also restores a dignity to Che that's absent from the official Cuban myth of the flawless revolutionary.

Pérez says he now wants to revive interest in Che's New Man ideal and sees it as a son's duty to try to do so. To explain, he quoted a line from Dylan Thomas's "Eulogy," the Welsh writer's ode to his deceased father: "Until I die, he will not leave my side." He said he thinks of this line in the context of a son assuming responsibility for a family enterprise. "You see, my father's enterprise, obviously, is not a material one. And this probably is the first virtue of his abandonment, because he had to make it very clear that this kind of enterprise is not connected at all to materialism, or even to matter. He had to go beyond matter."

MERCHANTS IN THE TEMPLE

So join the struggle while you may.
The revolution is just a T-shirt away.
—Billy Bragg

WITH THE FIRST decade of the new millennium almost over, political scientists and sociologists are having a hard time defining our current age. On the one hand, global capitalism is hegemonic. Those who find portents of its imminent demise in the recent financial meltdown pay too little attention to the mind-boggling complexity of the world market system we've created since the beginning of the nineties. Although global trade flow could diminish in coming years as a proportion of the global economy, the result of both a decline in rich-country demand for developing-country exports and a protectionist backlash, it is near impossible to imagine how we would dismantle the vast, interconnected matrix of private business relationships that now crisscrosses the world—much of it outside of the purview of governments—to make way for some kind of noncapitalist alternative. Equally hard to foresee is the notion that hundreds of millions of new middle-class consumers in rapidly growing economies like China, India, and Brazil will give up on a model that has given them a taste of

the material conveniences that were once the sole privileges of the industrialized West.

On the other hand, public discontent with the inequities of this system are higher than at any time during the Cold War: Predictions of environmental doom and food shortages abound. Rallies against U.S.-style employment laws keep getting bigger in Paris and other European cities. Chávez and his Latin American allies have built worldwide support for their anti-U.S. populist message, as have religious fundamentalists in the Middle East. The free market model has conquered the world, and yet the great uncertainty and volatility that have come with it have convinced many that the U.S. empire—the politico-economic entity most associated with globalization—has finally entered its decline.

Even more confusing, these new countercultures are being shaped by the modern information technology that's behind the latest phase of capitalist expansion. Without the computers, cell phones, cameras, servers, fiber-optic cables, transmitters, and satellites that form the infrastructure of the capitalist global economy, they would be unable to disseminate their messages widely and would pose less of a threat to the capitalist order. (The ill-defined Al Qaeda "network" is exemplary: It is truly a child of the information age.) An environmentalist group gets nowhere if it doesn't exploit advanced media tools to sell its ideas and outmarket its equally IT-dependent competitors—whether that is aimed at outbidding other organizations in search of charitable funds or at beating polluting corporations in a battle for public opinion. Political leaders from the right and the left are in the same boat: If they can't master the art of branding and image-making in the information capitalist economy, they don't attain power.

Perhaps because of our habit of classifying the world into neatly differentiated categories—such that we incorrectly conceive of marketing or technology as tools of capitalism and expect the left

to reject them—the integration of these varied interest groups into the information capitalist economy has given rise to a rich parade of seemingly contradictory signals. Quite likely, the contradictions always existed but were hidden beneath a deceptive veneer of order that has been stripped away by the end of the Cold War and the increased information flow of the digital age. Nonetheless, our world now seems filled with incongruous pairings of incompatible messages. Some take the form of an aesthetic clash: a mullah on a cell phone; an Amazonian Indian wearing Ralph Lauren; a bumper sticker that reads PROUD CONSERVATIVE on an SUV that's filling up on Venezuelan-owned Citgo gasoline; and of course Che Guevara as beer, as Major League Baseball icon, as condom, as coffee mug, etc. Yet our age contains more substantial contradictions than these, juxtapositions in which language and image are completely detached from the reality they purport to represent.

As should be evident from the previous chapter, Cuba today is a society profoundly afflicted by such contradictions. On one level, its government is as totalitarian and communist as ever. It is the official employer of the vast majority of the workforce, the arbiter of all media and political expression, the country's sole landowner and the exclusive provider of vital public services. Despite Raúl's reforms, Cuba continues to be, for all intents and purposes, a planned economy—this at a time when most former communist countries have already offloaded much of their industry onto the private sector. Yet on another level—primarily at the international level but also in the local convertible peso economy—the Cuban regime is an active, aggressive player in the global capitalist economy. A government that once outlawed virtually all private economic property now invites foreign investors into joint ventures and protects their right to profit with airtight contracts and laws. By exploiting the tools and norms of the international economic architecture, the Cuban regime bolsters its finances and protects

its political interests, so much so that global capitalism, ironically, is now the means by which it survives.

One fundamental feature of Cuba's interaction with the global economy lies in the ongoing management of its international image, its brand. Unlike other governments that have formally signed on to the capitalist system and have grasped that the consistent presentation of a particular positive image for their country can encourage tourism and foreign investment, Cuba's would not dream of making public something as crass as a plan to brand itself. No document showing as much is likely to come to light. But any examination of how the Cuban government has managed photographic images, artistic output, propaganda, and cultural exports over the past decade points to the existence of a deliberate branding strategy. And, as was the case in 1967 and afterward, when Che's image helped Cuba to present itself as an appealing idea to Western artists and radical students and to parlay their approval into a financial relationship with the Soviet Union, the Guerrillero Heroico remains a strong part of that strategy. Cuba's Che brand has changed—especially in terms of its purpose—but it is as prominent as ever and continues to be dominated by the lasting power of the Korda image.

The pivotal moment for this shift in strategy came in 1997, right when a new backlash against the smug capitalist establishment was coming to the fore among a highly motivated subculture of radicalized Western youth. Reminiscent of 1968, when would-be young revolutionaries carried the Guerrillero Heroico through the streets of Paris in demand of new social values, Cuba's new Che of 1997 arose out of the Castro government's capacity to exploit countercultural trends among Western youth.

The latest youth-led attack on the capitalist establishment was

focused on the institutions that were formulating the finance and trade rules of the post–Cold War world: the World Bank, the IMF, and the World Trade Organization. It was dubbed the antiglobalization movement, a major misnomer. Perhaps the only accurate description of this unwieldy, multifaceted coalition of interest groups was that it was fundamentally global in its all-encompassing nature. In 1999, this circus-like grouping of environmentalists, Marxists, indigenous peoples, trade unionists, farmers, graffiti artists, and anarchists exploded into public view with the riots at the WTO's Seattle summit. But it really had its birth two years earlier. Then the catalyst behind the quiet but rapid expansion of its e-mail–based network came not from the capitalist United States or from "communist" Cuba, but from Thailand, where Rambo and Che had once cohabited on a Tuk-Tuk. The worldwide financial turmoil that started there in 1997 provided the first reality check for the economists of those multilateral rule makers who had pried open developing countries' markets in the preceding years. Now, with the foreign capital they'd shepherded into these economies suddenly hightailing out of them, these technocrats were converted into demons in the eyes of radical youth everywhere.

Eight years earlier, it had been the opposite situation. The youngsters who razed the Berlin Wall had left the impression that capitalism had somehow, impossibly, become sexy. And as wide-eyed East Berliners began to drive their little Lada cars into the glittery, neon excess of the once-verboten western part of their city, the juxtaposition of failure and success fed the notion that the ideological debate was over. History, wrote political scientist Francis Fukuyama, had ended. But when Thailand devalued its currency, the baht, and set off the "contagion" that became known as the Asian financial crisis, history came roaring back with a vengeance. Here we saw an alternative juxtaposition, one that contrasted the image of mass bankruptcies, soaring poverty,

and the rioting that was shaking the developing world with that of brash Wall Street speculators, many of whom became obscenely rich on the back of this devastation. This is what energized the antiglobalization movement, especially those members who'd refused to believe that Marxism was dead. For them, the moment called for a symbolic gesture: the banner of Che. The flag of the man who'd called on people to "tremble with indignation at every injustice" would be unfurled anew.

The most recent global financial collapse, which saw markets undo a good chunk of their recovery from the mess of 1997, will likely dwarf those events in history textbooks. Still, in its own right, the Asia crisis was a major financial catastrophe that left hundreds of millions of victims in its wake and encouraged an image of post–Cold War global capitalism as an uncaring, destructive force. Inevitably, the youth-led movement that rose up in resistance to it offered fertile ground for a revival in the Korda image. And in this case, the Che icon's return to the world stage was made all the more explosive by its uncanny sense of timing and by the Castro government's willingness to exploit it. By now Che was already a global product, and the Cuban government, in recognition that it could not go against the grain of global capitalist expansion, was figuring out new ways to exploit it while maintaining the impression of a contrarian political position. It was no longer as important for Castro to prove his revolutionary credentials to radical leftists abroad as it was in the 1960s and '70s, but Che was still extremely valuable for generating badly needed foreign currency. This was the moment of Cuba's tourism boom, and Che was integral to that effort.

Fortuitously, 1997 was also the thirtieth anniversary of Che's death. Media and pop culture attention turned back to his icon. The success of the bestseller *The Motorcycle Diaries* had encouraged the Guevara family to participate in other projects reviving interest in Che. Three separate biographers gained access to the

family's archives to produce weighty works that same year. Immediately, actor Benicio Del Toro optioned one for a film, while Robert Redford and Mick Jagger showed similar interest in Che projects. (It would take Del Toro eleven more years and two more directors to fulfill his dream of playing Che, with Steven Soderbergh's delay-prone *The Argentine*. Redford eventually produced Walter Salles's interpretation of *The Motorcycle Diaries* in 2004, but Jagger had to shelve a movie about the life of "Tania," Che's East German comrade in Bolivia.) Meanwhile, the ambiguous narrator in Andrew Lloyd Webber's *Evita* was converted into a more faithful Guevara figure in Hollywood's version of the musical, in which the part went to Antonio Banderas. At the same time, many musical artists began revisiting the Guevara theme. They were led by Spanish heavy metal band Boikot, which launched a "Ruta del Che" (Che's Route) trilogy of albums.

The crowning moment for this revival was the announcement by a Cuban forensic team on June 28, 1997, that it had discovered Che's long-hidden bones, along with those of six of his dead comrades, in an unmarked grave in Vallegrande, Bolivia. With great fanfare, the remains were returned to Cuba on October 12. Five days later, on the thirtieth anniversary of the eulogy at the Plaza de la Revolución, Che's and his colleagues' bodies were laid to rest in a solemn ceremony at the Che Guevara memorial in Santa Clara. There, Castro declared that "Che is liberating and winning more battles than ever."

In 2007, the year of the next decennial anniversary of Che's death, Spanish journalist Maite Rico and a French colleague, Bertrand de la Grange, concluded in an article for *Letras Libre* magazine that the bones identified as Che's were not his. The 1997 discovery had been pure Castro theater, they claimed, a hoax aimed at reviving public fervor for his comatose revolution. They offered circumstantial evidence: witnesses who possessed the same belongings of Che that the diggers claimed to have

found in the common grave; soldiers' testimonies that the guer-
rilla leader was buried alone; the unexplained failure to conduct a
promised DNA test. Five months later, the Cuban government
formally rebutted the charges, rehashing the 1997 scientific
report's findings on the consistency of the skull's frontal lobe and
dental structure. Who is right? It remains to be seen.

★

Whatever the truth about Che's bones, it's less important than
the real hoax of 1997. Contrary to its government's claim, the
Cuba they were brought home to was nothing like the socialist
country he'd left three decades earlier. With the sweeping
changes of the Special Period and the advent of the dual-currency
system, the idea of social equity was now preposterous.

But any good marketer knows that the art of effective salesman-
ship is to sell an image, not the reality. That's where brands come
in. As part of the shift in its economic and political trajectory
brought on by the collapse of its Soviet benefactor, Cuba was now
actively selling itself as a product, a marketing drive that helped it
feed a hunger for foreign currency. What was on offer was the *idea*
of revolutionary nostalgia, not the *fact* of a socialist reality, an idea
that was to be consumed by tourists and other buyers of cultural
products such as music and art. Cuba was being sold as a pack-
aged concept, in this case as a romantic vision of a bygone revolu-
tionary era.

In reformulating a national brand to match the new global mar-
ketplace, the Castro regime was falling in lockstep with other
governments at that time. Around that same time, we found Tony
Blair promoting "Cool Britannia," India pitching itself as a soft-
ware factory, and other Asian countries talking up their past colo-
nial stereotypes. (Thailand was again the "Jewel of the Orient,"
while its capital, Bangkok, competed with Shanghai to be the
"Paris of the East.") This in turn reflected the exponential expan-

sion of private, brand-driven advertising at the end of the twentieth century. The world's public spaces are now awash with corporate logos and brands, a fact noted with concern by Naomi Klein in her bestseller *No Logo*. Nor is the trend confined to traditional for-profit enterprises. The same mania has invaded the realms of art, academic thought, and even the human soul, notes James Twitchell in *Brand Nation,* a study of how museums, universities, and churches are increasingly adopting commercial advertising strategies. In fact the practice goes both ways. In *The Culting of Brands,* Douglas Atkin advises businessmen to follow the examples set by churches and cults to turn their commercial brands into sources of community, belonging, and meaning.

Castro was ahead of his time. He'd long ago mastered the art of encouraging such phenomena, no more so than in his promotion of the Che icon. And in that case, not unlike some of the successful cult brands highlighted in Atkin's book—names such as Apple and Harley-Davidson—Castro relied on the fanaticism of consumers to give the brand a life of its own. Then, in the late 1990s, the Che resurgence overseas began to hint at new opportunities to exploit the brand. In 1995, the success of the *Motorcycle Diaries* book offered proof of Guevara's renewed selling power, as did the popularity of Swatch's Revolución line of watches, released that same year with René Burri's cigar-smoking Che image on its face. In response, the regime cranked up its Che marketing campaign again. Its first step was to buy 10,000 of those Swatch watches and sell them at the Havana airport.

"There was a conscious decision by the regime to exploit a certain perverse curiosity about Cuba as a museum, a country that resembles nothing else in the world," said Alcibiades Hidalgo, the former Cuban ambassador to the United Nations, in an interview with Dow Jones Newswires' Eduardo Kaplan after he'd defected to the United States in 2002. "The opening of Cuba to tourists

coincided with the sale of Che paraphernalia and it had nothing
to do with Che's ideals."

Che's ideals might have had nothing to do with the govern-
ment's strategy, but they were relevant to the tourism niche it
chose to target. Although many visitors to the Varadero resorts in
the north might see Cuba as merely one of a range of generic
Caribbean beach holiday options, most visitors to the island go
there with a clear political consciousness. This is not only the
case for Americans who defy the (easily thwarted) travel ban. For
Europeans and other visitors, going to Cuba is quite often a delib-
erate act of solidarity. This is especially so among backpackers,
part of a global phenomenon that surged in the 1990s and saw the
developing world swamped with young Europeans, Australians,
Israelis, and to a lesser degree, Americans. While hardly match-
ing the profile of hard-core Marxists, this group was openly sym-
pathetic to Cuban sovereignty demands, opposed to the U.S.
embargo, and interested in Cuban culture. Encouraged by the
rise of the antiglobalization movement, many of whose members
cloaked themselves in Che, these young travelers were drawn to
the image of the long-gone revolutionary and the spirit of adven-
ture and moral fortitude he embodied. They identified with his
values, and by consuming him they could vicariously assert them.

Still, it's also clear that Che's resurgence in Cuba was part of a
deliberate strategy to participate in a fundamentally market-
based global industry. In the 1990s, the country's revamped
Korda-image brand arose out of the interaction between a govern-
ment that still dominated its country's economy and the indepen-
dent tastes of a global tourism market. Inevitably, this altered the
nature and purpose of the brand. No longer was the Guerrillero
Heroico's face a mask to hide Cuba's Soviet sellout and keep the
faith with militant young leftists in Europe. The government now
needed the West's dollars as much as its moral support. For sure,

many who visited Cuba wore Che as an antiglobalization statement. But did they realize that this country, a symbol of their idealized alternative to global capitalism, was now actively endorsing that same system—and that their own euro-stuffed wallets were part of a plan to exploit it?

★

Cuba not only embraced globalization in the 1990s, it became an exemplary adherent to international trade and investment rules. It had little choice. Desperate for post-Soviet foreign investment, a government that had expropriated every privately owned asset in the country three decades earlier now needed to go the extra mile to prove its trustworthiness. So on April 20, 1995, it became one of the early members of the new World Trade Organization, the same body that would attract the ire of left-wing rioters at its Seattle summit four years later. And then in 1997, the Che anniversary year in which those young militants began organizing a network to challenge global capitalism, Havana took another decisive step in support of the new world order. In keeping with its commitments to the WTO, the Castro government signed the Berne Convention for the Protection of Literary and Artistic Works, the premier international copyright treaty.

After years of powerlessness, Cuba's artists, musicians, writers, and inventors were now permitted to claim royalties on the foreign use of their work. The country's culture producers thus became participants in the most important element of the current globalization trend: the increasing empowerment of the world's intellectual property owners. One telling indicator of this trend is found in the widening gap between stock prices and company book values. According to one study, in the United States in 1978 some 95 percent of the average public company's wealth-generating capacity lay in *tangibles* such as real estate, machinery, and bank accounts, whereas in 2004, 75 percent of

that power came from *intangible* assets, those not captured by cost-based accounting. Any company's engine of growth, in other words, is now almost overwhelmingly found in the goodwill derived from its name and brands, in its organization's inventive capacity, and in its human capital and ideas. The financial well-being of the world is now wrapped up in all this ephemera, which in turn keeps lawyers busy as they seek to give it definition and unlock its profit-making potential.

Cuba's leap into this world marked an about-face in socialist logic and a radical change in strategy. From the 1960s on, the revolution officially frowned upon copyright, viewing it as a capitalist tool that unfairly privileged one class of citizen over another. After 1997, however, Cuban artists, musicians, and writers were not only allowed to claim ownership and profits from their creations, they were encouraged to do so. As a result, "a highly visible elite [emerged] with transnational connections—their jet-setting lives contrasting with the bleakness of everyday food deprivation, electricity blackouts, and water shortages," notes cultural anthropologist Ariana Hernández-Reguant. But there was a price for this privilege: "lip service to government ideology and policies, an inconspicuous display of wealth, and financial contributions to the state welfare system," she adds, all while permitting the government free use of their works for propaganda purposes.

Indirectly, these artists also became agents of Cuba's new cultural image. And the most prominent in this capacity were not young, cutting-edge creators, but rather the old men of the early revolutionary and prerevolutionary eras. They helped generate the desired nostalgia imagery for the new Cuban brand, the notion of a culture frozen in time by decades of isolation, one that was now, for the first time, available as a consumable product to foreign customers. Its emblems were the music of the Buena Vista Social Club and the 1960s photos of the epic revolutionary photographers, among whom Alberto Korda was the undisputed superstar.

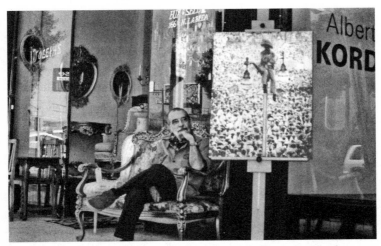

Alberto Korda at an exhibition of his work in Grand Forks, North Dakota, October 1998.

Korda was at that time sixty-eight. At an age when he'd expected to start taking it easy, he was as busy as he had ever been. He was taking fashion photos again, and that made him happy. But this new material was not what was occupying his time. The combination of the Che revival and Cuba's accession to the Berne Convention had overnight created a massive overseas market for his past work, and for one photo in particular. Korda set off on an endless world tour of exhibitions in cities such as Paris, London, Los Angeles, New York, Tokyo, and São Paulo. For photo fanatics in these places, a legend had walked out of the pages of history.

Korda's first U.S. exhibition in 1998 was "bedlam," says Darrel Couturier, who invited the photographer to exhibit at his Los Angeles gallery after meeting him in Havana. "People I didn't know were showing up at my house day and night," says Couturier, who became Korda's agent. "They caught wind that the maestro was here and the doorbell would ring and they'd say they wanted to see him." Part of Korda's appeal was his eternal charm.

The gallery owner was amazed. "He was like a magnet . . . particularly with women." But they were also drawn to *that* photo, a singular attraction that eventually became tiresome for the photographer. The endless traveling and the constant retelling of the story of that one millisecond of his life exhausted Korda, a homebody at heart. "He liked the idea and the honor of it all, but once he was out of his home, he wanted to go back," Couturier says. "To be constantly trotted around and asked the same question over and over and over again was exhausting. He was living off the fumes of what he'd done forty years ago."

As Korda's life changed, so too did that of the Guerrillero Heroico. During the preceding thirty-seven years of legal inaction, the image effectively roamed the world copyright free as producers of derivative art exploited it without paying fees. It functioned much like an open standard, to use a software industry term. Like the HTML web-building language and the PDF file format, it was a freely available template to which others could apply their inventive talents. This de facto public domain status facilitated an explosion of creative expression, as artists, satirists, and political commentators took to the image with glee. Some were faithful to the Cuban government's socialist representations of Che; others not. Neither group had to worry about lawsuits.

Korda did not find it easy to adjust to this new arrangement. He'd had no experience of how to be a capitalist, let alone contend with the complexity of the world's patchwork of copyright laws. So others stepped in to advise him. One in particular would carve out a central, if low-profile, role for himself in these affairs. His name was Patrick Magaud, a French photographer who'd built a career around doing soft pornography work for *Penthouse* and *Playboy* magazines. Magaud had spent a lot of time in Havana, where he was tapped to shoot an unprecedented pictorial of topless Cuban women for *Playboy*'s March 1991 edition. (The photo spread, which was approved by the government and which

accompanied an article entitled "Cuba Libre" about the country's tourism potential, prompted Castro's critics to accuse him of commodifying Cuban women and encouraging sex tourism. It coincided with the first surge in the *jinetera* prostitution problem.) Around the time of the shoot, Magaud befriended Havana's most famous "playboy," Korda, and from that relationship the Frenchman forged a potentially lucrative, influential position in the future management of the world's most reproduced photograph.

In 1995, after Magaud convinced his Cuban friend to take action against French activist folksinger Renaud for using the Che image in his performances, Korda transferred exclusive world rights to exploit the image to Magaud for a ten-year period. (Korda's eldest son, Fidel Alberto, claims the Frenchman duped his father into signing that agreement, which he says was written in French. I was never able to obtain a response to these charges from Magaud, who died in early 2008. A paraplegic, Magaud opted for a low-profile life after he began managing the rights to the Korda image, ceasing his work for *Playboy* around that time.) Although French law ensured that the moral rights were maintained by the

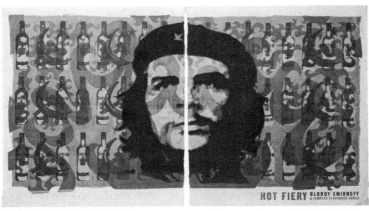

The Smirnoff vodka ad for which Alberto Korda sued ad agency Lowe Lintus in 2001.

Cuban photographer, the deal amounted to a sweeping transfer of economic power to the Frenchman. But it also gave Korda the advantage of a European beachhead from which to start legal action in foreign jurisdictions. The Euro Legal Group, a Paris-based law firm, was retained and began serving unauthorized users of the image with copyright infringement notices.

In September 2000, this behind-the-scenes effort was brought into the open in London when Korda extracted a $75,000 payment from ad agency Lowe Lintas and picture agency Rex Features, which had used the Che image in a publicity campaign for Smirnoff vodka. Although the parties settled before a formal judgment could be made, the agreement was ratified by the British High Court, which declared Korda to be the copyright owner. A precedent had been set, or so declared press accounts in a story just begging for clichés about Che's revenge on capitalism. Korda, who dutifully donated his $75,000 damages receipt to a Cuban health system—it would have been hard to keep it, with all the attention—was seen as a crusader for Che's integrity. Finally, declared admirers of the Guerrillero Heroico, the traffickers in their hero's image had been brought to justice. No mention was made of how the Cuban legal system's departure from socialism had made this possible. Che had not beaten capitalism; he had joined it.

When asked why he'd targeted Smirnoff over countless other abusers of his image, Korda answered that the ad was especially disrespectful because Che didn't drink liquor. In this way, the precedent-setting case left only narrow guidelines on where the owner of the copyright would draw the line in what was, after all, an impossibly large universe of potential violators. This Cuban lover of rum had made it clear: Che and booze were no-go. But was everything else fair game?

Time ran out for Korda to retest his copyright and answer some of the pending questions. He died on May 25, 2001. Friends and

associates who'd seen him weeks beforehand said the photographer had spiraled into decline. This once debonair, magnetic personality was losing his pizzazz. He even told some people he wanted to die, citing the idea that he was no longer attractive to young women. In the end, a heart attack killed him, during yet another exhausting world tour. Fittingly, perhaps, it happened in Paris, the city that had first turned the Korda image into a worldwide phenomenon and the home of a legal team now seeking to rein it in.

Korda's funeral was held in Havana's majestic Colón Cemetery, right near the place where he had frozen a history-changing moment on March 5, 1960. The tributes came in from around the world, most of which played on one or all of the themes summed up in a comment by the photographer's second wife, the model Natalia (Norka) Méndez: "He loved three things in this world—women, rum and the Cuban revolution." The ceremony was graced by the presence of Fidel Castro—unannounced, as is his style—and was attended by local and foreign press. It was in effect a state funeral. Still, as the mourners filed past the body, one burly-looking man served as a stand-in for millions of everyday people touched by Korda's most famous photo. The man rolled up his sleeve and leaned into the open casket to show a tattoo on his shoulder to the body. "We had no idea what he was doing," says Diana Díaz. "But it was really quite a moving gesture."

★

Behind the faces of mourning, a storm was brewing. The legendary womanizer was survived by five children from three separate relationships and left a twenty-one-year-old girlfriend who believed she was the de facto widow. When these various claimants were shown a will in which Korda had named Diana as the "sole and universal heiress" to his possessions, rights, and effects, they were livid. They'd been cut out of everything: his

apartment, his old cars, a significant stash of money, and the rights to the most reproduced photo in history.

There was another relevant complication. Like so many Cuban families—including Castro's—the Korda family is divided between those who stayed in Cuba and those who left, a geographical division that is inevitably, if oversimplistically, perceived in political terms. Fidel Alberto Díaz, the eldest of two children from Korda's marriage to Méndez, had settled in Norway, where he set up his own photography studio. His younger sister, Norka Jr., spent most of her time in Mexico City. Korda's youngest daughter, Alejandra, the second of two from his long-running relationship with actress Monica Guffanti, had left Cuba for Miami in 1997, shortly after ending a high school study program in Spain. "After that, I just couldn't live in Cuba anymore," she told me. The only other child besides Diana who hadn't made a home outside Cuba was Dante, Korda's fourth-born and the eldest of Guffanti's two children. In less than a year after the funeral, he joined his sister Alejandra in Miami.

Dante Díaz insists he had no intention of leaving Cuba. The problem, he believed, is that he challenged the will. After he did that, he was served with an eviction notice by Cuban authorities, who cited him for an unlicensed bungalow, which he had added to the top of Guffanti's apartment with his father's help. After barricading himself in his apartment and undergoing a traumatic standoff with the police, Dante eventually accepted his sister Alejandra's advice and joined her in Miami.

While all this was going on, Fidel Alberto was preparing a claim that he had an alternative will in his possession. And as if things weren't already complicated enough, Zaeli Miranda, Korda's young girlfriend, filed for posthumous recognition of a de facto marriage at the same time. Ultimately her case stalled in the courts and she made no further claims on the estate.

Alejandra Díaz, who briefly ran a gallery in Miami, where she

showed some of her father's early fashion photography, accepts that the will Diana showed her bears her father's signature. But she doesn't believe he signed it in full knowledge of what he was doing and instead accuses her sister and her Cuban lawyers of manipulating him. She claims that her father told family members during a visit to Miami shortly before he died that his plan was for Diana to manage the estate as a trustee on behalf of the five siblings. "But it was never meant for her to be the universal inheritor," she says. Her brother Dante confirms this version of events, but Norka says she was never in Miami, while Fidel Alberto, who says he is not on good terms with either Alejandra or Diana, dismisses this account as groundless. "That my sister never told me about that is a symptom of what's happened to our family," Fidel Alberto said of the deep fissures between the three maternal factions of the Korda clan.

Diana Díaz maintains that Korda left her everything because of an overriding concern that his work was to be used according to the principles of the Cuban revolution and that it be managed from within Cuba itself. "Despite the fact that they took his studio away and the problems he had with other photographers, despite the difficult moments, he never left Cuba and never once talked about doing so," she says. "And he made not a single word against the revolution. He was always in the struggle; his principles were reflected in the photos—like Guerrillero Heroico, which he defended right to the end of his life. Now, I was his daughter, the eldest child, and I lived in Cuba. So, when he died, he left the estate in my name. He knew that I would continue with this very big, very difficult responsibility."

To Fidel Alberto, Diana's version is a reconstructed history designed to keep Cuban authorities happy. "My father and Che Guevara weren't friends; they hated each other. So I suppose this is all karma. They both deserved it," he said in a phone interview. He believes Diana took up an offer from Cuban officials that he

claims to have received first and turned down, one that would have allowed him to manage the copyright for financial gain but in a manner consistent with Havana's political interests and with the proviso that he return to Cuba. They approached him, Fidel Alberto claims, because he was in possession of a letter assigning full and immediate rights to his father's photographic assets. That letter, he says, was signed on September 17, 2000, in London— the time and place of the Smirnoff case.

I could not verify the existence of this document, as the Oslo-based photographer said he would only show it to me if I flew to Norway, arguing that it might get into the hands of the Cuban authorities if he faxed it to me. Other people involved in the estate's legal affairs say they've never seen it either. Still, it is of note that just one week after the Smirnoff decision, Fidel Alberto personally filed a $500,000 suit against Bates Advertising in Norway over the use of his father's image to promote a local brand of flavored milk, which resulted in an out-of-court settlement. (This was confirmed by Fidel Alberto's former lawyer, Magnus Stray Vyrje, who declined to give more details for confidentiality reasons.) Shortly after the lawsuit was filed, one Norwegian press report quoted Bates creative director Bjørn Rybakken making the seemingly failed argument that the Korda image "has become such a symbol of freedom that it has moved on from its origins as a piece of intellectual property," comparing it to da Vinci's *Mona Lisa* and Munch's *Scream*.

Although they claim no knowledge of the Miami meeting cited by Alejandra, both Fidel Alberto and Norka believe their father made conflicting promises to various people toward the end of his life. This was partly due to stress, Fidel Alberto says, as friends, family, and government officials scrambled for a piece of the profits and power encased in Korda's most famous image. "He hated conflict. He kept on trying to keep everyone happy and created a mess in the process," the photographer's eldest son told me. "A lot

of people knew about this and they supplied him with everything he wanted—women and rum, especially—to get him on their side. I was very mad sometimes. I mean, look at what this friend in Europe [Magaud] did."

Norka takes a more sympathetic view, identifying both her father's innate romantic sensibility and the vast network of some-times powerful people that this gregarious man had gathered around him as reasons why such competing and contradictory claims seemed to arise out of his dealings with those he loved or admired. "My dad was a marvelous, vibrant man, who wanted to fulfill whatever wish was proposed to him, but without taking charge of the problems these would create," she said. "He was a person that any other person could use to get things done in Cuba. But that meant that he would end up saying one thing to one person and another thing to another." The second-eldest Korda daughter does not challenge the legitimacy of Diana's will, but she paints a complex picture of her father's wishes toward his life's work that is not easily distilled into a straight, legal interpre-tation of the various documents and accounts of his conversa-tions. "Like any human being, he had many faces, many facets, many versions," she said. "He believed in trying to help people improve their state of being, naturally, but was he a true revolu-tionary at heart, a Che Guevara, a Fidel Castro, one of those types who elevates this compassion to an ideology? No way. My father was a romantic. He sought out beauty and it was his talent to find it. With the beauty in his images, he did as much as any other person for the revolution and for the poor."

The ambiguity of Korda's legal intent is conveyed in a docu-ment he signed and dated March 6, 1999, granting Norka wide-ranging freedom to exploit as she saw fit a large collection of signed and unsigned prints and negatives he'd placed in her pos-session, seeking to exclude any third-party claims on those pho-tos. (The collection included both professional and personal

photos, including the early shot of her father and mother and his MG convertible that is included in this book.) In the typewriter-printed copy of the short letter that I saw, the photographer hints at the competing claims posed by his multiple promises and yet also cites Diana's special status. In reference to the exploitation rights that he signed over to Norka, Korda writes: "I want it to be left clear that this is something that I am doing of my own free will and that it does not form a part of the will I recently made with my first-born daughter on the 5th of February of the current year, nor of any other document I might have signed with any other of my children or other representatives."

Irrespective of the veracity or otherwise of their competing claims, Diana Díaz's siblings face a near impossible battle contesting her. The courts of Paris have repeatedly recognized her copyright claim. The jurisdictional reach spreads across Europe, courtesy of the EU-recognized trademark that her former French partner, Magaud, registered over the image.

To be sure, these rulings have generated controversy. In 2005, the Korda estate successfully blocked distribution of gay filmmaker Bruce LaBruce's German "agit-porn" film, *The Raspberry Reich*, which had shown footage of a character masturbating in front of a giant poster of Guevara. The original claim for damages of 700,000 euros (just short of $1 million at the time) was whittled down to 5,000 euros, but the director, whose low-budget film was intended as a countercultural statement, was bitter. "I was sued by communists for using the image in an anticapitalist movie that critiques the capitalist exploitation and commoditization of Che Guevara. You gotta love the chutzpah of the modern world," he said in an interview with a blogger by the name of Thomas Moronic. (Later, LaBruce released a revised, hard-core version of the film under the name *The Revolution Is My Boyfriend*, in which the Che image was replaced with slogans like "Intellectual Property Is Theft" and "Che Guevara is Counterrevolutionary.") Of

course Diana Díaz took the view that the original film's porno-graphic material was offensive to Che's memory and thus to her father's principles—by extension, so too did the former *Playboy* and *Penthouse* photographer listed as her French co-claimant in the lawsuit.

More important was the 2003 French ruling against Paris-based Reporters Sans Frontières, which had used the Korda Che in a campaign against the imprisonment of seventy-five dissident Cuban journalists that the Castro government accused of spying on behalf of the United States. The court ordered RSF to stop dis-playing a poster that superimposed Che's head onto the image of another well-known May 1968 poster, this one of a riot policeman wielding a truncheon. The press freedom group also had to pay 6,000 euros in damages—although this was a token of the estate's initial claim for 1.14 million euros. RSF secretary-general Robert Ménard slammed the decision, which he said permitted no dis-cussion of the "broader issue of the appalling state of press free-dom and human rights in Cuba." Díaz countered that RSF could not "plead press freedom to distort Korda's work for its political and advertising purposes." Her father's photo, she said, "repre-sented and still represents a symbol of struggle and the future of the Cuban people."

The RSF case left little doubt that the privately owned copy-right on the Che image would be exercised in accordance with the interests of the Cuban regime. But not every Che admirer was happy, including Jim Fitzpatrick, the Dublin-based creator of one of the most widely copied and best-known Che posters from the 1968 uprisings. "The Reporters Without Frontiers case was one that really stopped me to think, Hold on a second here. That's my image they're stopping them using, not the photograph. It's my graphic," says Fitzpatrick, who has repeatedly declared that his posters are copyright free.

The Irish artist's comments illuminate a legal minefield. Copy-

right is subject to a patchwork of differing laws around the world, the inconsistencies of which are increasingly complicated by the inherently global nature of Internet-based publication. Most countries' laws recognize that creators of derivative works such as Fitzpatrick's must obtain permission from the original artist, without which their own claims to copyright are void. But there are numerous exemptions and the standards differ greatly from country to country. In fact, the United States—often assumed to be a bastion of copyright protection—is starting to look relatively lenient, in part because of the primacy of the First Amendment. According to Stanford University copyright specialist Paul Goldstein, U.S. courts are increasingly allowing the fair use privilege—generally used to protect publication in the interests of making analysis or commentary—for transformative conduct, such as adapting a photo. This is occurring even in seemingly commercial contexts, he says. Then there's the question of copyright abandonment, a largely untested doctrine that Goldstein says might nonetheless offer the strongest defense against a Korda estate suit. And indeed, as Alejandra Díaz asserts, her "father took the photo but he never enforced his copyright." Korda "had never had an interest in the property," she told me. "He never wanted to be the owner of this image. He wanted it to be in all parts of the world."

The counterargument is that for most of his adult life Cuban rules on artists' rights meant that Korda could only exploit his by leaving his homeland for good. Certainly, French courts have repeatedly determined that Korda's rights survived—as recently as May 2007, a French appeals court upheld a 2005 lower court decision against T-shirt maker Planete Deco—while the British High Court and a Minnesota District Court judge have both spoken in Alberto Korda's and the estate's favor during out-of-court settlements. These rulings quite clearly recognize Diana Díaz as the rightful owner of the copyright to the image, a right that she is legally entitled to exercise how she pleases.

Still, it's not clear that this fight is over. No country's legal system other than that of copyright-friendly France has applied a full-trial test to the fundamental question in play: Can a universal cultural phenomenon, one that has thrived for four decades in the public domain, be belatedly removed from that domain?

In the meantime, the European decisions have allowed the Korda estate and its legal agents to deliver a fait accompli. Legende LLC and other license holders have bombed Che merchandisers with threatening letters that cite legal precedents and warn of severe penalties. Some have simply ignored orders that they appear in a French court, including Christopher Nash, the San Francisco–based designer of the LiberaChe T-shirt. But bigger sellers of regular Che T-shirts couldn't afford the risk. Scott Cramer, president of Products for Progressives, contemplated throwing his letter in the trash too, but eventually decided it was too dangerous. "We ended up settling so they'd fuck off and go away," said Cramer. A Minnesota judge endorsed the parties' agreement, delivering the prize of a U.S. precedent to the Korda estate.

This ruling provided a boost to a new breed of players in the commercialization of Che's image: licensed vendors. In 2002, the year after Korda's death, the estate had begun selling exclusive, geographically limited licenses to third-party merchandisers, who were then free to profit from the sale of Che products while actively enforcing the estate's copyright. The Minnesota ruling prompted one of these, a U.S. garment wholesaler called Fashion Victim, to contact retailers and sue them for selling illegal products while also offering deals on its licensed Che wear. It might not have been Fashion Victim's best PR move to put in a call to Products for Progressives immediately after the latter's settlement with Diana Díaz, however. A stunned Scott Cramer turned down Fashion Victim's offer and then exposed to the media the hypocrisy of selling a symbol of social conscience in this manner:

The company, Cramer divulged, was getting its shirts from Honduras, a notorious haven for sweatshops.

★

Some retailers were more compliant with Fashion Victim's demands, including TheCheStore.com, perhaps the best-known merchandiser of Che-themed material on the web. In an interview in 2006, the site's proprietor—who spoke on the condition that I refer to him by his trade name, Johnny Havana—told me that at that time he got his gear, which he sells under the slogan "For All Your Revolutionary Needs," from ten or so separate licensees. Fashion Victim supplied his Che T-shirts, while his Che belt buckles came from Mob Town Enterprises of Chicago. His other Korda-licensed offerings included baseball caps, key chains, track pants, lighters, and even hip flasks. (It's not clear what the Smirnoff precedent would lead one to surmise about this last item. Is the purchaser expected not to fill it with liquor?)

A year later, after Fashion Victim's license lapsed, Havana negotiated a blanket deal with the Korda estate. According to a statement on the website of his wholesaling company, All the Rage Inc., it became "the only company in North America officially licensed through a legal exclusivity agreement to use the iconic Guerrillero Heroico image of Ernesto 'Che' Guevara on shirts, hats, and various accessories and collectible items." Havana later told me that the license, which he assumed from Fashion Victim, applied only to garments. Nonetheless, it marked the consolidation of a mini Che empire. Havana was by then managing a string of differently themed Che-related websites, including an unofficial fan site for Soderbergh's movie *The Argentine*—all with prominent ads for and hypertext links to TheCheStore.com. In addition, he established an affiliate program with third-party sites, such as the Che-lives.com forum, which taps TheCheStore.com's back-office operation to sell Korda-licensed products to its vast

membership of typically leftist Che fans. With minimal overhead, Havana had in effect created a web-based clearinghouse to facilitate the expansion of commerce in Che's image.

In fact, TheCheStore.com is only part of what is fast becoming a global franchising operation—call it Che Inc. A Google search will bring up online offerings of officially licensed products bearing the Korda image from merchandisers in the U.K., Holland, Australia, and other places. How is this unfettered expansion consistent with promoting Che's values?

Diana Díaz says the ventures are not profit-making but rather are a way to finance the global legal battle she has undertaken against the misuse of her father's image. Citing a case against a big Mexican clothing company, she said, "You know, if we use lawyers in Cuba it's easy, but when we contract them in Mexico it's $450 an hour." In Norway, she said, her lawyer failed to win an injunction against a conservative outfit that had satirized Che but still demanded a $25,000 fee. "So what we do is we sell licenses, and with the licenses, we pay lawyers. That's how it works."

Still, the franchising and copyright enforcement strategy puts Díaz in an awkward position with respect to conservative critics of the Che phenomenon, who relish exposing any hint of hypocrisy. "She is as aggressive as Disney is about Mickey Mouse's image," says Brian McCarthy, owner of Che-critical spoof site Che-Mart .com. McCarthy's partner and graphic designer Oleg Atbashian was annoyed with online T-shirt distributor Cafepress.com for playing a de facto role as the Korda estate's agent. The company, which provides web-based logistics so that independent designers can market T-shirts, removed one of his Che-skull designs from its website and advised him that the image was protected by copyright. Atbashian sent a biting response back and published it on Che-Mart's sister site, The People's Cube, in a note accusing Cafepress.com of censorship. "A picture of a hairy skull

in a beret that I drew myself as an artist can not be an infringement of anyone's copyright," he wrote. "I assure you it isn't even Che Guevara's skull. It was a plastic skull purchased at a 99¢ store with a MADE IN CHINA tag." Taking a different tack, a blog called Killcastro.com, whose anti-Castro vitriol lives up to its alarming name, launched a campaign in 2007 to "blast the pricks" at web design company Web CEO for using the "infamous picture of the Butcher of La Cabaña to push their product." Providing assistance that Díaz would surely not welcome, the bloggers suggested that its readers e-mail the company to advise that they are infringing on her copyright.

No wonder Diana Díaz, who quit her job at the National Ballet to dedicate herself full-time to managing the copyright, describes it as an enormous headache. As a Cuban citizen who chose to stay in her country and fight for what she calls her father's principles, Díaz is caught in the middle of some powerful contradictory forces. In seeking to keep them at bay, she must distinguish between respectful and disrespectful treatments of Che's image—a line that's not always easy to draw.

The Guerrillero Heroico image is unlike any other Cuban artist's copyrighted asset and perhaps unlike any other such asset in the world. No other Cuban copyright holders, not even the other epic revolutionary photographers, are under anywhere near the same pressure. And the Cuban government is not the only party with the power to shape the Korda estate's copyright strategy. Díaz must also respect the interests of the Guevara family, which has no legal authority over the image or even official status within the Cuban government but which does have moral clout. When Aleida March and her daughter launched a campaign to stop the misuse of the Che image in 2005, it was not just a challenge to Che merchants; it was also a challenge to Diana Díaz. The Guevara family has twice tried unsuccessfully to have the

Cuban National Assembly transfer copyright on all photographic images of Che to its main institutional vehicle, the Che Guevara Studies Center, which nonetheless labels each photo on its site, including many by Korda and numerous other Cuban photographers, with "© Centro Che." The legislative failure can perhaps be read as a sign of Cuba's willingness to abide by international copyright norms.

Managing the Korda estate might be a headache, but it clearly generates a large money flow worldwide. Díaz claims that legal fees eat up most of the profits from these licenses and that she donates lawsuit proceeds to a children's hospital. (She does not like to disclose the amount donated, however.)

And yet there is little about Diana Díaz's material existence that suggests the money goes to her pocket. The two times we met in 2006 and 2007, she was living in a dilapidated part of Havana's Vedado district. (Some months later, after years of working through the labyrinthine Cuban housing system, she gained a permit to move to a somewhat larger but by no means luxurious dwelling a few miles away.) When I first visited her original home, the building's front door buzzer didn't work, so a neighbor threw me down some keys. On my second visit, the Díaz family had been cut off from the water main for two days. Outside, there were vacant lots strewn with rubble and many of the buildings bore the classic symptoms of disrepair seen elsewhere in Cuba: corroded concrete foundations, exposed rusted steel supports, and peeling, faded, or nonexistent paint jobs. Inside, the apartment was in much better shape than most in Cuba but still was modest by American standards. The pièce de résistance, however, was in the street: Diana Díaz was still driving her father's little white Lada, the car to which he downgraded from a Volkswagen years earlier. Many East Berliners are now driving latest-model BMWs, Mercedes, and Porsches. But in Cuba, the Soviet bloc's dubious contribution to world auto history is even more prevalent than its

fifties Chevy rust buckets—in part because the Lada's far less fetching boxy design has a modular shape that's comparatively easy to repair. Still, it's not easy to get anything in Cuba, which is why the passenger-side door on Díaz's hand-me-down car stayed broken. When she and her partner Rey took me out for lunch, he and I sat in the backseat while the sole owner of the most reproduced photograph in history chauffeured us in a Cold War relic.

And then there are the technology limitations that Díaz faces in managing her affairs. When I visited her in 2006 and again in 2007, she had a home Internet connection for e-mail purposes, a privilege that was at the time denied to most other Cubans. But it came via an agonizingly slow dial-up modem into an old, early edition Windows PC. Since it was difficult for her French lawyers to apply the arbitrary standards that only she could define, they were constantly sending her examples of potential infringement, filling up her in-box and testing her political finesse. It was a symbol of how her world—as defined by the politics and infrastructure limitations of Cuba—was not seamlessly merging with the world of global capitalism, its legal norms, or its modes of communication.

★

The uncertainty hanging over Cuba's political future adds another troubling dimension to Diana Díaz's management of the Korda estate. Because Alberto Korda donated his negatives to the government after the 1968 intervention into his studio, he and his heirs forfeited ownership of these physical assets. Setting aside the contentions of Diana's brother Fidel Alberto—who maintains that his father never actually made the donation—that means the estate's claim to Korda's work lies only in the intangible asset of copyright, which puts it at the mercy of judges. As of now, Korda's daughter enjoys unhindered, exclusive access to the negatives under a formal agreement with the Cuban government. But

there's no telling whether a post-Castro regime will extend the favor.

In the face of this uncertainty, it's easy to see how expanding the reach of a corporate-like Che franchise through legal action might give Diana Díaz a sense of security. This goes for the other family in this saga too: Ernesto Guevara's. Under the Castro regime, the Guevara family evolved into a quasi-official institution of the Cuban revolution, a status that afforded it privileges and a degree of indirect power. But that could all disappear in a post-Castro Cuba, which may explain why the family has lately been making its own grab at both power and money. Inside Cuba, it does this by exerting its moral weight on the political process, albeit with limited success. Outside the country, the Guevara children do so via the legal rights that accrue to them by the fact of their being Che's descendents.

In recent years, the Guevara March children have raised their profile in a campaign to boost awareness of Che's ideals and attack business interests that profit in what they say is a trade disrespectful of their father's image. Aleida Guevara put it well when, while explaining why Che marketing upsets her, she told me that if she ever met Gisele Bündchen, the Brazilian model who'd once displayed a Korda-image bikini, she'd ask her: "How would you like me to put the image of *your* father on *my* underwear?" Nonetheless, it's far from clear that the Guevara family wields their power in this struggle in a way that is fair or even constructive.

The artisans in Old Havana's flea market have certainly been hurt by the family's crackdown on merchants. The fair was once a haven for buyers of all sorts of Che knickknacks. But when I got there in November 2006, Che had all but disappeared from the offerings. All I found among the endless kitsch oil paintings of Havana street life were two boring "Hasta la victoria siempre" Che plaques. I was about to leave, disappointed, when I discov-

Alfredo Manzo Cedeño's *Cuba's Ideology Soup.*

ered some excellent Warhol-spoofing Che-themed pop art; they had been deliberately, though not perfectly, hidden from view. Why were they not on display? I asked the woman who was selling the paintings, which were the work of her husband, Alfredo Manzo Cedeño. "All the stalls received a recent directive from the authorities: 'No more Che,'" she replied.

Aleida March and her children have no such power over private merchants outside Cuba, since they do not own copyright over Che's image. Nor could they dream of telling the Cuban government to stop commercializing Che calendars, postcards, and T-shirts at official stalls around the island. In fact, the only players on whom they can bring pressure are local artists like Manzo and others, who hope that tourists will help them break the *moneda nacional* trap. If we add in the distortions resulting from the U.S. trade embargo, the unfairness of this situation is obvious. Consider the experience of TheCheStore.com's "Johnny Havana." He started out buying his Che-themed supplies from self-employed

merchants in Cuba and reselling them at huge markups on eBay. But then the U.S. auction site informed him he was in breach of the Trading with the Enemy Act. So he established his website, where as a merchant of exclusively licensed Che products he was again free to sell his offerings anywhere in the United States. That's because the Korda image is a "cultural product" and so is exempt from the embargo. But that was never going to help his Cuban suppliers. The U.S. law—still in effect at the time of this writing—disallowed the sale of physical products manufactured on the island. The physical products that are later stamped with the Korda image for sale on TheCheStore.com are made in Mexico and numerous developing countries other than Cuba. The winners in this absurd situation: the Korda estate, the Guevara family, U.S. retailers, the Cuban government. The losers: talented artists such as Alfredo Manzo, garment workers, and labor-rights-conscious U.S. consumers. (Before he took over the license, Havana said there was no way to know where the shirts were coming from—some may well have been from Honduras, he conceded. Once he began his own screen printing, however, he bought his blank shirts exclusively from large, verifiable sources such as the NAFTA-friendly Mexican vendor Alstyle. As of late 2008, TheCheStore.com was prominently declaring itself "sweatshop free" and that a few in the Eco line even came in chemical-free cotton with biodegradable dyes.)

Meanwhile, the Guevara family is growing its own global corporation—although they would not describe it as such. Their strategy is a thinly veiled exploitation of the prodigious selling power of Che's name. The family's Che Guevara Studies Center works with Melbourne-based Ocean Press, a publisher of left-wing books and documents that prints English-language versions of Che's ever-popular diaries and essays and aids in negotiations with third parties over rights deals. These parties include Holly-

wood filmmakers, who've used Che's writings as the material behind the latest wave of Che movies. Lately, as first seen in a Paris exhibition in March 2007, the family has branched out into the sale of photos—not *of* Che, but *by* Che. Camilo Guevara, who managed the Paris show, was offering collections of ten prints of his father's snapshots for 4,000 euros each. These were not even signed original prints, the standard by which photo collectors determine value. Rather, they were "authorized" by the Che Guevara Studies Center. Che was a good photographer, but he was famous for being a revolutionary. It's hard to see how this sales effort fulfills the center's mission to expand awareness of his ideas. It looks far more like cashing in on his cult.

Most of the proceeds of such sales, the family says, go to the Che center, which is directed by Aleida March and to which her children have transferred all rights to their father's intellectual output, according to Aleida Guevara. There is no public record of the finances of the center, however, which was conceived as a community center. The plan is to use it as a resource for researchers and educators, where various skills and ideas deemed valuable to children's development will be taught, all in keeping with Che's scientific and philosophical ideas. The hulking two-story structure, which is dominated by a flat stone facade that architect José Antonio Choy said was inspired by "the simplicity and austerity of Che," occupies an oversize lot directly opposite the long-held family home in the Havana suburb of New Vedado. Inside, fully equipped but unused, a conference room, a computer lab, art and photography studios, an exhibition hall, a research center, and an archival library await a postponed opening that was first scheduled for 2005. The explanation I was given then for the delay had something to do with the materials needed for the center's attached museum, but by late 2008 there was still no indication that an opening was planned anytime soon. What-

ever the reason, every day that the center stays closed is a day that the money from Che sales grows without being put to its stated purpose.

This wealth accumulation angers the Guevara children's putative sibling, Omar Pérez. He is especially upset over a Che center deal orchestrated by Ocean Press, in which Italy's Mondadori Publishing house paid a whopping $1.5 million for the Italian-language rights to Che Guevara's collected works. "You know, don't you, that Mondadori is owned by Berlusconi," he said, in reference to the right-wing Italian prime minister and media mogul. "A fascist!"

If the Guevaras are developing a financial nest egg as insurance against the political uncertainty hanging over Castro-era Cuba, then the last thing they need is someone like Pérez criticizing it. He'd be much less of a problem if he wanted money. But he doesn't. Instead, the risk they face is that this long-ignored half brother, a man with a religious code that evokes a compelling comparison with their father's antimaterialism, will gain enough legitimacy to make a moral challenge to their status as keepers of the Che myth. This is why the idea of a DNA test is so explosive. It has nothing to do with a potential inheritance claim.

★

This ugly situation—the family conflicts, the lies, the hypocrisy—is fueled by the inherent contradiction of a government that perpetrates a myth of socialist revolution while integrating its economy into a global market that doesn't give two hoots about such things. This is what breeds the stress bearing down on the descendants of Alberto Korda and Ernesto Guevara, the two men most involved in the construction of the most important revolutionary myth. In earning status within the Cuban revolution's social structure, they've also inherited an unenviable responsibility as protectors of the Che story. More recently, these two fami-

lies have also acquired a right, conferred upon them by the rules of the capitalist information economy, to exploit the intellectual output of those two men for personal gain. Unreasonably, they are now expected to exercise it in a way that promotes the nonexistent socialist ideal of a revolution.

This is an impossible demand to make of anyone, but it's even harder for these two families, split between children who favor the Cuban regime and those who oppose it. Worse, their divisions fall along maternal lines, a direct result of their respective fathers' willingness and capacity to have relationships with various women. In a very basic way, it is a result of the sex appeal that both Che and Korda exhibited.

Another factor fueling the conflict is the imprecision of the subject matter. It's one thing for the Guevara or Korda estate to vow to defend Che's integrity. It's another to define what that means in a world where there are countless competing ideas as to what Che represents. What plays out instead is a political and economic competition over how to represent the man and the image, a dispute over a nebulous concept that long ago ceased to belong to either Ernesto Guevara or the photographer who made his face famous. The repeated decisions of a Paris court notwithstanding, the concept of "Che" *is* part of the public domain. It is an idea, not a person, and it is ingrained in our global culture. It belongs to everyone and yet is inseparable from the Korda image.

Trying to get this global cultural phenomenon under control is a daunting task. The old weapons—security apparatus threats and propaganda—won't work off the island. The best chance the Cubans have now lies in new legal weapons, which may well become more lethal in the wake of the 2008 Wall Street collapse, amid talk of more internationally coordinated market regulation. For all the small-government, deregulation rhetoric of the neoliberal free market reformers, the post–Cold War global capitalist system has been built upon a multilateral effort to homogenize

and expand the reach of laws that define things like customs, corporate governance, investment contracts, and property rights. This regulatory expansion, coupled with the state's physical departure from the productive process, has enabled owners of private property to extend its profit-making potential ever more widely into foreign markets. And it has helped to create the semblance of a level playing field, a prerequisite for expanding competition and for attacking the monopolistic tendencies that constantly challenge the optimal functioning of the market.

These norms of the international capitalist system are now enabling Cuba's nominally anticapitalist institutions to demarcate the confines of their Che brand, narrowing its definition in strict legal terms and entrusting foreign courts to enforce it. The Korda estate's efforts to dictate the boundaries of acceptability for its copyrighted image and its growing number of licensee contracts increasingly resemble the practices of modern corporations. Large companies are sticklers for the integrity of their brands. They worry about the size, color, dimensions, and appropriate uses of their corporate logo, ensuring that detailed instructions are passed on to employees, clients, suppliers, and agents. No McDonald's franchisee would ever be allowed to put up a blue Golden Arches sign. Meanwhile, companies go to absurd lengths to defend their intellectual property. The Lyons Group threatens unlicensed Barney-the-dinosaur impersonators at kids' parties; Disney sues people for their playground murals of Donald Duck and friends; my employer, Dow Jones & Co., publisher of a certain business daily, makes a public relations blunder in ordering a children's newspaper in a town in Maine to stop calling itself *The Small Street Journal*. If these measures seem like overkill, it is because they are. But they also stem from the intrinsic logic of brand protection. Since a brand is not a tangible asset like a plot of land or a steel mill, brand owners worry about the

fragility of their vital piece of property. If someone deliberately or accidentally gives a brand a bad reputation, its value can vanish overnight. That's why the lawyers are dispatched as soon as a line is crossed.

The Korda estate's French lawyers are doing something similar, albeit with less consistency, efficiency, and transparency. They are drawing legal demarcation lines around the image to determine the boundaries of what's acceptable, constraining the Guerrillero Heroico's freewheeling open standard status to arrive at a narrower, legally defined and politically determined concept. In the process, they are also steering its money-earning power to a single legal entity. This is the new Che Inc. brand, one run by a global franchising corporation in partial service of the Cuban state.

Che has always been commercialized, but merchants did not previously expropriate the image as if they owned it. Rather, they leveraged its communal value; they rented its social power. T-shirt designers do the same, for example, with the universal peace symbol designed in 1958 by British activist Gerald Holtom for the Campaign for Nuclear Disarmament. Most of the power in Holtom's symbol does not lie in the intrinsic elegance of the forked lines he drew into a circle—though this was clearly its starting point. Rather, it comes from the human spirit of those who've carried it into rallies for nuclear disarmament or against the Vietnam War, or who've used it to promote everything from racial harmony to environmental conservation. Holtom and the CND deliberately renounced copyright on their symbol. So it's hard to imagine the designer's descendants convincing a court that his symbol should not belong to the public domain. And yet this is what is happening with the symbol of Che, an equally prevalent, socially constructed cultural asset. According to the current legal reading, Che is not a communal icon; he is a piece of identifiable private property. Legally, Diana Díaz is now the

only person in the world allowed to define what our global culture does with that image. It is no consolation to know that she must also in practice share that power with another party, the Cuban government.

This question of centralizing control over Che's image and ideas is off the radar screen for most Che fans. According to the conventional pro-Cuba view found at online Che forums, the Guevara and the Korda families are crusaders for Che's dignity. Still, a few see things differently. For Roberto Massari, Italian publisher, wine merchant, and head of his country's Che Guevara Foundation, hand-wringing over Che marketing is a red herring. The biggest harm done to Che's integrity, he says, comes from those, especially in the Guevara family, who've facilitated the Cuban state's monolithic control of what he stands for. "We never had this brand issue with Christ, with the Buddha. Why should we make a problem out of the image of Che?" he said. "There are probably forty million in the world who have that image. And if you ask them what it means to them, they'd all have a different answer. Those forty million people are not reducible to genotypes. What bothers me is that for forty-one years Cubans were not allowed to read the texts in which Che speaks very badly of the Soviet Union . . . This is the real problem, not the image of Che on sweaters."

★

The Che icon is a communal product of our culture. It is constructed upon millions of different, often competing personal stories. It would be convenient for Diana Díaz if it would be possible to separate this construct from the Guerrillero Heroico her father created. But it is not. The image is intertwined with the *idea* of Che. It feeds into the same stories and interacts with them in an ongoing dialogue—an exchange of tales that spans the breadth of human experience, as the sampling in this book hopefully demon-

strates. Che and his image are both produced by and reflective of our heterogeneous and contradictory global society.

If we recognize the existing public relationship with Che's face as a naturally free *idea* that belongs to and shapes our global culture, and thus as one that is deserving of special protection, then the legalese that's currently building new boundaries around it— the code, we might say, that gives Che his ©, his ®, or his ™— offers an alarming metaphor. In the threatening letters it sent to unlicensed merchandisers, Fashion Victim defined the Korda image specs as "U.S. GATT visual art copyright number VA-1-276-975." The face of Che Guevara, the icon that inspired socialist revolutionaries for two decades in the Cold War and drove his enemies into a fury, had been reduced to a nine-character alphanumeric code.

Human history is filled with disturbing examples of the system assigning numbers to people in place of names. We tend to see it as the ultimate denial of a person's humanity. We get this from the fictional stories of Orwell but also from real nonfictional places such as Auschwitz or South Africa's Robben Island, where Nelson Mandela spent twenty-seven years detained as Inmate No. 46664. Still, let's not forget that Mandela survived to lead his country out of its Orwellian past. And without diminishing that which cannot be diminished—the loss of six million—the Jews of Europe who told their stories and showed their numerical tattoos are rightfully called Holocaust *survivors.*

Can the conflicted Spirit of Che survive the dehumanizing effect of this process, that which reduces his iconic face to a set of numbers? Che's resilient afterlife puts the odds in his favor. And think about it: Did Sony Corp. and Michael Jackson's joint purchase of rights to the Beatles' songs make their music any less moving? Has Disney destroyed the magic of Cinderella? The company's distasteful princess-themed branding has not stopped little girls from falling for the rags-to-riches fantasy or from

inserting it into their childhood dreams. Similarly, the epic story of Che and the imagination it inspires shouldn't disappear as his face becomes a franchise. What's more, the regime that's currently setting the rules for that entity is going through a difficult transition. Who knows what the next owner of the brand will do with it?

EPILOGUE

To Be Immortal

Yes, in spite of all, some shape of beauty moves
away the pall from our dark spirits.
—John Keats, *Endymion*

IN MARCH 2008, after Fidel Castro announced his official depar-
ture from Cuba's political stage, I published an op-ed examining
his legacy in *The Wall Street Journal*. The response gave me a taste
of what I imagine is to come with the publication of this book.
The column, which drew upon my research into the Che icon to
argue that Castro owed much of his political longevity to the
Cuban revolution's success as a *brand,* provoked some strong
opinions in the blogosphere. And many of them were, in my mind,
way off base. The anti-Castro camp assumed that, in revealing
the revolution as a hollow facade, I was doing its bidding. Just as
predictably, the left saw the article as pure Cuba-bashing. "No
matter what Cuba does, it's always bad, according to the Wall
Steet [*sic*] Journal. Remember: bad, Bad, BAD, BBAADD!!"
wrote Cuba solidarity activist Walter Lippmann in a posting to his
CubaNews list.

This response was hardly surprising. According to the unwrit-
ten rules of American political discourse, a byline in *The Wall
Street Journal*'s editorial pages tends to automatically flag the

columnist as "conservative." Indeed, the *Journal's* on-staff editorial writers have dedicated tens of thousands of words over the years to discrediting Castro. Although they also criticize the U.S. embargo—with an intellectually consistent adherence to free trade principles—that history meant that the antagonists on either side of the Cuba divide, trapped in the ideological straitjackets of their respective narratives, pigeonholed my article. It was quickly slotted into the rigid dichotomy of their endless dispute.

While the language of branding is a product of modern U.S. capitalism, it is really just a commercially practical way to describe how symbols and images are used in many forms of communication. The stores of values that brands are said to represent had existed for centuries before U.S. business schools began offering classes in something called marketing. The nexus between image and message was at play in the evolution of religious symbols such as the Christian cross or the Islamic crescent, in the display of family crests by European nobles, in the prevalence of tribal markings, and in the development of cave painting. Humans have always used meaning-laden images to promote (sell) ideas, to build loyalty among followers (customers), to cultivate a sense of belonging within communities (markets), and to differentiate themselves from their enemies (competitors). In some cases, the icons that evolved did so organically (which was partly the case with the Korda Che); in others, they were overtly produced by and for political or economic interest groups (also present in the Korda Che).

What's key is that in our current era, as we are increasingly inundated with data, ideas, arguments, and sales pitches, this image-creating activity has become more and more important. The digital revolution is propelling us into a world of infinite resources for publication, throwing us all into greater competition for our prospective audience's finite capacity for attention and

retention. This imbalance between supply and demand is the defining feature of the giant global information economy. Technological advances simultaneously empower and challenge anyone seeking to get a message across—be they companies, politicians, churches, NGOs, ideologues, activists, countries, or just regular joes. The line between commercial branding techniques and traditional, noncommercial communication and image-building is increasingly blurred.

I can understand why this would present a depressing picture to anyone who has decided that revolutionary solutions are needed to fix the world's injustices. Such people would be offended when some financial journalist reduces the struggles in which they've shed blood, sweat, and tears to the seemingly soulless business of branding. After all, according to the stereotype, marketing is about deceit—it suggests a situation in which the marketer, or the brand manager, controls and manipulates his ignorant target. No one likes to be told they've been conned.

But this not what I'm saying. Acknowledging the role that branding and image-building play in politics does not mean, as Marxist sociologist Nelson Valdes sarcastically suggested in a critique of my article, that one believes "the entire globe is inhabited by dupes and idiots while the only people who comprehend the reality of the world are those who manipulate images." We owe it to ourselves to recognize human agency in the act of consumption and especially in forging brand loyalties. There's nothing to say that customers—or voters or activists or religious devotees—must be ill informed or disempowered when they make such choices.

The gap between Castro's socialism brand and its economic reality is too wide for me—especially since the country scores so poorly on freedom of expression, personal liberty, and other principles I regard as important. But a person who prioritizes social equality over individual freedom and property rights might see

Cuba's universal health care, the success of its free education sys-
tem, and its low crime rates as legitimate reasons to prefer it over
the alternative, Brand USA. What matters is that this package of
constructed image and real facts fits their personal value system.
Choosing a brand—much as choosing to display a loved one's
photo, to don a religious pendant or national flag pin, to wear a
favorite team's colors, or to declare our admiration for a political,
artistic, or sporting hero—is a personal act. Brands, symbols, and
images are incorporated into a person's identity. They form part of
the idealized self with which we define our place in the world.

This is why the Korda Che brand is so prevalent and so endur-
ing: It feeds the soul. Far from fitting Cuban-American writer
Humberto Fontova's description of them as "useful idiots," people
are drawn to the Che image for reasons that will defy outsiders'
political characterizations. Very often what matters is a personal
connection to the image itself, more so than the story of Ernesto
Guevara. In fact, the brand is powerful because, quite indepen-
dently of Che and his story, the icon that emerged from Alberto
Korda's photograph is independently capable of stirring the forces
of human imagination and of tapping into deep-seated longings
for a better world.

It took a trip to the Blue Mountains outside of Sydney—a most
unlikely place to encounter a conflict over Che—for me to com-
prehend this. Before the local council ordered a property owner
to remove a Che mural from his garage door, few people in this
sleepy tourist region had ever heard of the revolutionary. But
after the matter had produced six weeks of letters to the local
newspaper, more than any other in its history, just about everyone
had an opinion on it. Most people were angry at the perceived
violation of free speech and the fact that the now army green
garage door, newly defaced by graffitists' tags, had returned to its

ugly, pre–Guerrillero Heroico state. Yet pretty much everyone was ignorant of the reasons why the Uruguayan-born aerosol artist had painted the mural. Both the local Socialist Alliance political party, which had spearheaded the e-mail campaign against the council's order, and the conservatives who'd supported it assumed that Dan Lualdi's art was politically motivated. In fact, the way he told it to me, the mural was "more about the nostalgic connection" Lualdi retained to a childhood memory of being awed by a figure on a wall in the country of his birth. With his Latin American roots and his left-leaning worldview, the adult Lualdi is now acutely aware of Che's political significance. Nonetheless, he was adamant: "It was not statement art." The artist's work was all about what the Korda image meant to him personally.

This man's story speaks to the profound influence that a thing of beauty can have on the imagination, that all-important element in human endeavor. And although Lualdi acknowledges that his memory of being cowed by a mural in Uruguay may have been exaggerated by a consciousness of the concept "Che Guevara" acquired later, this merely confirms that an object of beauty can take on even greater emotional power when it is attached to a compelling story or myth.

Both Che's fans and enemies will cringe at the comparison, but there are similarities between the Korda image phenomenon and the adoration of Princess Diana. Much like the critics of the Che cult who express incredulity over the idolizing of a killing machine, the British royal family could not fathom why "that woman" prompted such an outpouring of public grief when she died. Tony Blair wasn't surprised, however. The prime minister and his spinmeisters were at home in the world of images, brands, and pop culture. They instantly recognized that the British people saw Diana, a beautiful woman linked to a story of charity, personality, and martyrdom, as the People's Princess.

So is Che merely a People's Prince, an entertainment magazine

celebrity with the perfect publicity photo? No, he is much more than that. In ways that Diana, Brad Pitt, or Marilyn Monroe could never do, he influences the political choices people make, he motivates the mind to action, encouraging it to dream, to redefine the impossible as possible. Meanwhile, as this book hopefully attests, people's responses to Che's image—beautiful to many, odious to others—differ greatly. In the end, Dan Lualdi's relationship with the image was separate from the political commentary that swirled around him. No one—no socialist, free speech activist, conservative blogger, politician, historian, or journalist—can tell another person what Che should mean to him or her. Adopting the brand is a very personal act.

Let us now return to Argentina, to a far less picture-perfect setting than the Blue Mountains National Park, to a community with more immediate concerns than skateboarders' graffiti. We'll head back to Villa de Arrojo la Pierda, the dirt-poor shantytown on the outskirts of Buenos Aires that I visited with the Jóvenes de Pie activists, a place in which an overflowing canal had weeks earlier drowned a young boy and a wheelchair-bound man.

There the women of the *villa* presented me, along with a film crew from the documentary *Chevolution,* with their Chica del Che, a girl who was never seen in public without her Che T-shirt. Thin, younger looking than her fourteen years, and wearing a black T-shirt with a faithful reproduction of Korda's photo, Jaquelin Cantero was placed in a chair in the dusty yard of her mother's lean-to. Before her stood Sylvia, the British director; Natalie, the film crew's administrative assistant; the soundman Gabriel, who was wearing headphones and holding a microphone on a boom; Jan, the Scottish cameraman, a $50,000 high-definition digital camera perched on his shoulder; four student activists; various *villa* women; and me. We were all eager to hear her answer the

question we'd been scouring the world to answer: Why Che? In this case, the answer would not come easily. Partly that was because Jaquelin was tongue-tied with terror. But it is also because we were all looking for different things. And as it turned out, we were looking for the wrong thing.

"What does Che mean to you?" I asked, once camera and audio were rolling. If that question made me sound like a detective, it became even more threatening after Jaquelin's mother, acting as an unsolicited "translator" of my sufficiently functional Spanish, rephrased it: "What do you know about Che?"

There was a long silence and then meekly, nervously, the girl began: "He was born in Rosario . . ."

Fear enveloped the rest of her answer. She stopped and looked around, seeking help that wouldn't come. Her mother urged her on: "He was born in Rosario. And then?"

"He went to Bolivia . . ."

A long pause. Again, her mother: "You are speaking well, sweetheart."

"And he fought with the Bolivians, who then . . ." Her voice stopped again, leaving us in another painful silence before it returned faintly. "He fell into a trap, and they took him to a little school. After that, they took photos of him, and then took him back in again, and they killed him."

As her daughter's eyes nervously darted back and forth, her mother sought to prompt her: "Where was he and who was he with?"

"In Bolivia . . ."

"And Fidel?"

"With Fidel."

What bothered me was not this error of fact. It was the excruciating sensation that we were putting this poor girl on trial. The terrified Jaquelin seemed to assume she was being subjected to a history exam. The members of the Jóvenes de Pie had been regu-

larly instructing the shantytown residents on Che and his message. Maybe she thought it had come to this: a test in front of a panel of foreign interrogators and an armory of intimidating equipment.

By now Jaquelin was frozen stiff. Still, the questions kept coming at her from all sides: "Why do you wear the Che T-shirt?" "What does Che mean to you?" "Why do you like this image and not some other Che image?" "What does it represent?"

Despite encouragement, our interviewee mostly remained in this trancelike state, offering very few responses other than to unconvincingly echo others' ideas. ("Proud," she said halfheartedly when we'd asked her to confirm her mother's pronouncement that "Jaquelin always tells me she is proud to wear Che.") Yet when I later read the transcript, I discovered some fleeting moments in which the Chica del Che seemed to speak independently about her attachment to the image, dropping clues that had failed to register at the time. "Because he is beautiful," Jaquelin offered at one point, conflating the persona of Che with the T-shirt she never removes. "I always sleep with him," she said at another. And in a final insight shortly before we cut the interview: "When I see someone with the T-shirt of Che, or on a big banner, I feel jealous, because, well, I dream of him always."

Jaquelin's Che was bound up in ideas of beauty, love, and dreams. It struck me that she didn't need to recall or even accept the stories about Guevara's valiant efforts to save the poor. What she sought in his image was beauty.

For all the young activists' worthy attempts to help the residents of this slum take control of their lives, Jaquelin Cantero's future is fairly bleak. She is a poor, undereducated adolescent living in an illegal settlement alongside a filthy waterway that's capable of transforming into a malevolent, life-stealing force. Faced with outsiders' repeated failures to fix such problems, Jaquelin may well have concluded that her escape from this depressing sit-

uation lay not in political mobilization but in the refuge of beauty. By making the exquisite Korda Che a part of herself, Jaquelin allows herself to dream, to imagine, to believe in magic, to do all those things that make her human and give her life purpose. For this she deserves not sympathy but something far more valuable: empathy.

Perhaps this, as much as anything, is why Alberto Korda's Che continues to tap a deep wellspring of emotion among millions of people and why it functions as a multipurpose brand. His image is beauty made manifest, in this case in photochemical form. And so long as it remains more or less copyright free, it is available for anyone to attach hopes and dreams to.

The randomness of the creation of the Korda image, the magic of a chance encounter, partly explains its power. In a perpetually dynamic, infinitely unpredictable universe, this moment of beauty was as fleeting as any. Yet in capturing it, the fashion photographer made it immortal. And immortality, we are told, is the stuff of art. Any great work's attraction, theorists say, lies in its power to subvert the ravages of time. Shakespeare's words are as beautiful now as they were four hundred years ago; the ancient Grecian urn so admired by Keats lives on, first in its physical form and later in his poetry. Art and beauty enrich and sustain the imaginative power that separates us from our earthly, mortal existence. With the Korda Che, this is taken to another level, since the very idea of immortality is contained in that image. What else is it that this man who stands before a funeral crowd is seeking to defy with his implacable expression if not death itself? When Ernesto Guevara was executed, it was natural that this image, one in which seems to be defying death, would end up on the r' Parisian students as they took to the streets and ch vive!" This image gave Che his afterlife.

Beauty is always in the eye of the beholder. And c people do not find it in the Korda Che. But *n the mi

do, it offers a taste of immortality. It is not only Guevara's high cheekbones, long eyelashes, and cool bomber jacket that make this photo desirable. Its appeal also lies in its spirituality, in its ability to feed people's longings for a better world and to encourage them to dream of defeating death. It helps them confront that sinister force, whatever shape it takes for them—a military dictatorship; a CEO slashing jobs; an offense against their religion, their sexuality, or their favorite TV channel; or a flooding drainage canal. Against these real and imagined threats, Korda's Che keeps hope alive.

NOTES

INTRODUCTION

5 *Death—and how to cheat death:* Summary of Che's life taken from vari-
ous biographies: Jon Lee Anderson, *Che Guevara: A Revolutionary Life*
(Grove Press, 1997); Paco Ignacio Taibo II, *Guevara, Also Known as
Che* (St. Martin's Press, 1997); Jorge Castañeda, *Compañero, Vida y
Muerte del Che Guevara* (Vintage Español, 1997).

5 *Officially Cuban history:* This version of the number of *Granma* sur-
vivors was sanctified in the journalist Carlos Franqui's official account
of the revolutionary war, appropriately entitled *Los Doce* (The Twelve).
Anderson, *Che Guevara,* p. 213.

7 *Ernesto ended the book:* Ernesto Guevara, *The Motorcycle Diaries: A
Journey Around South America* (Verso, 1995), p. 152.

8 New York Times *columnist:* Thomas Friedman, *The World Is Flat: A
Brief History of the Twenty-first Century* (Farrar, Straus, 2005).

18 *Ironically, Guevara saw:* Ernesto Guevara, *The African Dream: The
Diaries of the Revolutionary War in the Congo* (Grove Press, 2000), p. 15.

CHAPTER ONE: HAVANA, MAY 5, 1960

25 *Early on March 4, 1960:* Accounts of the *La Coubre* tragedy draw fro~
various sources, including numerous press interviews that Ko~ '
before he died, Hector Sandoval's documentary *Korda~'
and histories of Cuba as well as of Che's life. Also,
three comprehensive Che biographies cited above a~
cited elsewhere, I drew heavily on two books in particula~
of Cuban history such as this: Tad Szulc, *Fidel: A Critic~

(Perennial, 2002) and Hugh Thomas, *Cuba, or the Pursuit of Freedom* (Da Capo, 1998).

28 *Some say that:* The claim has been made, among many others, by the Maryland Institute (BBC News, May 26, 2001, "Che Guevara photographer dies") and by curator Trisha Ziff for her traveling exhibition of Korda Che–based artwork. The truth is, this claim is difficult to prove or disprove. In terms of straight reprints of the photograph itself, likely others exceed those of Korda's image. And in terms of graphic reproductions, it comes down to a question of quantity versus variety. Various photo-derived bank note images may have been so widely circulated in some countries that their quantity exceeds all reproductions of the Korda Che, including those on Cuban bank notes. But for pure variety—in terms of geographical location, interpretation, and social context—the Che image beats all others. It is by this standard that I stand by the claim that this is the most reproduced photo in the world.

29 *The image has been used:* The Peruvian air freshener was sighted by Andrew Benson, a colleague of the author at Dow Jones; the skis were produced by Austrian firm Fischer in 1997 under the Revolution label; the beer ads took the form of bill posters plastered around Seoul and sighted on the blog the Flying Yangaban: http://gopkorea.blogs.com/flyingyangban/2005/02/che_.html.

29 *It has appeared on advertisements:* While the Smirnoff ad is famous for the lawsuit the vodka maker attracted from—and lost to—Korda in 2001, the Converse ad never saw the light of day, most likely because of legal pressure. The prototype for the ad, which was produced by celebrated Polish graphic portrait artist Andrzej Dragan, morphed another man's face with that of Che in a way that gave it an uncanny resemblance to former Spanish prime minister José María Aznar. The combination of sneakers, a conservative Spanish politician, and Che angered many Che fans.

29 *Taking the form:* The bikini, which offended both Che's family in Havana and their enemies in Miami, who saw it as the insensitive celebration of a murderer's image, went public during the São Paulo fashion week on July 15, 2002: Mail & Guardian Online, http://photos.mg.co.za/tag.php?tag= che%20guevara.

29 *It subtly appeared: Rolling Stone,* February 2005.

29 *It was spotted on:* Brett Sokol, "Che Guevara—Still Cool as a Handy Symbol of Cool," *Miami New Times,* February 5, 2004.

30 *Meanwhile, Al Saadi Mootsam:* Karl Stagno-Navarra, "Maltese Flag for Gaddafi Jr.'s New Toy, the Che Guevara 2," *Malta Today,* August 20, 2006.

30 *But despite the conversion of Che:* Alvaro Vargas Llosa, *The Che Guevara Myth and the Future of Liberty* (Independent Institute, 2006), p. 7.

31 *Palestinian youths:* Details of appearances of the Che image in past Middle East conflicts found in Eric Selbin, "Zapata's White Horse and Che's Beret: Theses on the Future of Revolution," a 2001 working paper provided by the author.

31 *Go to genocide-racked:* I'm grateful to the globe-trotting Jim Della-Giacoma, who in his work for a democracy advocacy NGO encountered Che in places as far from each other as Darfur, Sudan, and East Timor.

32 *As Naomi Klein:* Naomi Klein, *No Logo* (Picador, 2002), p. 85.

34 *The man whose nose:* Telephone interview with Roberto Massari, June 22, 2007, referred by Trisha Ziff.

34 *The journalist had come:* See Anderson, *Che Guevara,* pp. 308–9, and Masetti's own autobiography: Jorge Ricardo Masetti, *Los Que Luchan y Los Que Lloran* (Nuestra America, 2006).

35 *Masetti's son:* As of mid-2008, their book—*Les Héritiers du Che* (Presses de la Cité, 2007)—had been released only in French.

36 *It contains what French philosopher:* Roland Barthes, *Camera Lucida* (Hill and Wang, 1981), p. 27.

37 *this kind of distant gaze:* Interview with David Perlmutter, July 25, 2006.

38 *Sebe claimed:* Christian Lupsa, "What If Your Laptop Knew How You Felt?" *Christian Science Monitor,* December 18, 2006.

38 *Sebe also analyzed:* I asked the researcher to run the same analysis of Korda's second photo. The results were cited in an e-mail he sent me on April 26, 2007.

38 *The photographer actually preferred:* Interview with Diana Díaz, Havana, November 7, 2006.

40 *UCLA art historian David Kunzle:* David Kunzle, *Che Guevara: Icon, Myth and Message* (UCLA Fowler Museum of Cultural History, 1997), p. 53.

41 *"Che's beard becomes":* Kunzle, *Che Guevara,* p. 49.

41 *There are paintings and posters:* Examples include those of Raúl Martínez and René Mederos, as displayed in Kunzle, pp. 48–53.

41 *Susan Smith Nash:* Susan Smith Nash, "Madonna in Che Guevara's Beret: Using Pop Culture Images to Teach Students to Track the Dislocated Referent," in *Integration: Xplana: Exploring How We Can ˈ ˈarn and Teach with Technology* (Xplana.com, 2003).

44 *Interviewed for:* Shown in *Un Imagen Recorre el Mundo,* dˈ Pedro Chaskel in 1981.

45 *He was thinking:* Also in *Un Imagen Recorre el Mundo.*

45 *That first full print:* Interview with José Figueroa, Havana, November 8, 2006.

46 *With Photoshop software:* Interview with Diana Díaz, Havana, November 7, 2006.

46 *In choosing to illustrate: Revolución,* March 6, 1960.

46 *Carlos Franqui, the newspaper's:* Interview with Franqui, Miami, November 19, 2006.

47 *In this way:* Barthes, *Camera Lucida,* p. 92.

48 *And in 1968:* Thomas, *Cub,* p. 1435.

49 *Writing in 1973:* Susan Sontag, *On Photography* (Farrar, Straus and Giroux, 1977), p. 180.

49 *An image's meaning:* David Perlmutter discovered, for example, that students in his communications studies class, unaware of the historical context of the 1970 photo of a woman kneeling by the body of a Kent State University student slain by campus police, a shot that at that time became an icon of outrage against the political establishment, interpreted it from a conservative perspective as a commentary on student-led gun violence on campuses.

CHAPTER TWO: ODYSSEUS

51 *"Revolution requires":* Quotes taken, respectively, from an e-mail received from Selbin on July 25, 2006, and in his paper "Zapata's White Horse."

52 *The myth of Che:* Selbin, "Zapata's White Horse."

52 *In the book's final section:* Guevara, *The Motorcycle Diaries,* pp. 150–152.

53 *In the published book:* Ernesto Guevara, *Pasajes de la Guerra Revolucionaria* (Editora Política, 2004), p. 54.

53 *There is no ambiguity:* Anderson, *Che Guevara,* p. 237.

54 *Che's stories "are":* Telephone interview with Anderson, January 3, 2007.

54 *His claim:* Ernesto Guevara, *Guerrilla Warfare* (University of Nebraska Press, 1998), p. 7.

54 *most scholars now:* Mark Becker, introduction to Guevara, *Guerrilla Warfare,* pp. v–xvii.

55 *John Daly:* Interview with John Daly, Miami, November 19, 2006.

55 *In 2005, Daly:* E-mail of November 13, 2005, to Rebecca Beach, reproduced on the website of the Young Americans Foundation on November 23, 2005, http://media.yaf.org/latest/11_17_05.cfm.

56 *In 1964, Che:* After the nonmilitary candidate Arturo Illia unexpectedly won elections in Argentina, Masetti wanted to call the operation off. He cited Che's own *Guerrilla Warfare* argument that a revolution was not possible in a country with elections. But his mentor persuaded him

to press on. Che also inserted a caveat on "false democracies" into his second *Guerrilla Warfare* essay. Overruled, Masetti took his People's Guerrilla Army off to the northern Argentine province of Salta, where it quickly self-destructed. Jon Lee Anderson's account of the campaign reads like a harrowing *Lord of the Flies* tale as Masetti becomes paranoid about deserters and turns on his own men. In combat, the guerrillas were quickly routed. Many were killed or taken prisoner. Masetti's body was never found. Anderson, *Che Guevara*, pp. 573–77.

57 *Different press accounts:* Taibo, *Guevara*, p. 433.

58 *The first accounts:* These included that of Captain Victor Dreke, given in 1990, as cited by R. Gott in the introduction to Ernesto Guevara, *The African Dream: The Diaries of the Revolutionary War in the Congo* (Grove Press, 2000).

58 *As a* Scotland on Sunday *reviewer:* Dust jacket of Guevara, *The African Dream*, ibid.

59 *By his own choice:* Guevara, *The African Dream*, p. 218.

59 *Thomas H. Lipscomb:* E-mail to the author, June 15, 2008.

59 *And yet as Ruben Mira:* Interview with Mira on set of *Chevolution* documentary, March 30, 2007. Mira's novel *Guerrilleros: Una Salida al Mar Para Bolivia* was published by Ediciones Tantalia in 1993.

60 *Regarded by many:* "Socialism and the New Man in Cuba," in Che Guevara, *Global Justice: Liberation and Socialism* (Ocean Press, 2002).

61 *Che's life story:* See Kunzel, *Che Guevara*, p. 85.

62 *"the true revolutionary":* Ernesto Guevara, "Socialism and the New Man in Cuba," in Che Guevara, *Global Justice,* p. 44.

62 *"intransigent hatred for the enemy":* Ernesto Guevara, "Message to the Tricontinental," in Guevara, *Global Justice,* p. 60.

66 *When his father, José Castaño Quevado:* This account is given circumstantial credence by ex-CIA spy Philip Agee, who later turned critic of the agency and, by default, supporter of Castro. In his 2004 article "Terrorism and Civil Society as Instruments of U.S. Policy in Cuba" (*Counterpunch,* August 9, 2003), Agee cites Guevara telling U.S. embassy officials in Havana that José Castaño Quevado "was going to die, if not because he was an executioner of Batista, then because he was an agent of the CIA."

67 *A writer using:* Pierre San Martin, "Como Asesinaba el Che," *El Nuevo Herald,* December 28, 1997.

68 *In a report for the human rights:* Armando Lago, "216 Documented Victims of Che Guevara in Cuba: 1957 to 1959" (Cuba Archive: http://www.thecubaarchive.com).

68 *Journalist Luis Ortega:* According to numerous blog accounts, the figure appears in Ortega's book *Yo Soy el Che.*

68 *Castro has acknowledged:* Tad Szulc, *Fidel: A Critical Portrait* (Perennial, 1987), pp. 482–83.

68 *exiles' estimates of total firing:* www.cubaarchive.com.

68 *Some anti-Castro writers:* See Humberto Fontova, *Fidel: Hollywood's Favorite Tyrant* (Regnery, 2005). Fontova's citation has been repeated on numerous occasions by posters to Cuban-American blogs such as Killcastro.com and Babalu Blog.

68 *The government vigorously:* See the comments of former ambassador Philip Bonsal in Szulc, *Fidel,* p. 483.

69 *José Vilasuso:* Interview shown in *Guevara: Anatomía de un mito,* directed by Pedro Corzo, 2005.

CHAPTER THREE: SEX, PHOTOS, REVOLUTION

70 *"Well-known performers":* From de Beauvoir's memoirs, quoted in Anderson, *Che Guevara,* 1997, p. 468.

71 *Celebrated Cuban novelist:* Guillermo Cabrera Infante, "La Verdad sobre el Póster del Che," *El País Internacional,* September 9, 2001.

72 Una cuenta cuentos: Figueroa's recollections come from our interview on November 8, 2006.

73 *In this sense:* The photographer's daughter, Diana Díaz, points out that both men did share one key personality trait: They were both true romantics. Interview, November 7, 2007.

73 *Korda was born:* The gap between Alberto Korda's and Ernesto Guevara's ages becomes four months if we accept the story of Julia Constenla de Giussani, who told Che biographer Jon Lee Anderson that her friend Celia de la Serna's son was born on May 14, a month earlier than the face-saving date his newlywed parents had fabricated on his birth certificate. Anderson, *Che Guevara,* pp. 3–4.

73 *He was consumed by:* Jaime Sarusky, "Korda," in *Alberto Korda: Diario de una Revolución* (Ediciones Aurelia, 2006).

74 *His photo file:* Recounted by Diana Díaz in interview, November 7, 2006.

74 *While his own portfolio:* Interview published after Korda's death in *Pagina/12,* June 3, 2001.

74 *Fittingly, the master storyteller:* Cited in the photo anthology of Korda's work, *Alberto Korda: Diario de una Revolución,* p. 14.

74 *Among the many interviews:* See James Leavy from 1997, "25 Seconds in the Life of Che Guevara," posted on Leavy's travel and cigars blog: http://www.forces.org/writers/james/files/che.htm.

75 *According to many accounts:* Interview with painter José Gómez Frezquet (Frémez) and photographer José Figueroa, Havana, both on November 8, 2006, for example.

76 *"Yes, Korda was a womanizer":* Interview, November 8, 2006.

77 *"Capitalism was Alberto's greatest foe":* Telephone interview with Darrel Couturier, May 30, 2006.

78 *The travel writer:* Tom Miller, "Myths of Cuba: The Image . . . And the Man Who Made It," *The Washington Post,* November 2, 1997.

78 *"I believe he had":* Norka Korda, interviewed by Enrique Villaseñor in *Korda: La parte mas bella de la vida* (November 2001) and shown at www.fotoperiodismo.org.

79 *Showing Castro:* In an interview with U.S. radio program *Democracy Now* played on May 29, 2001, after Korda's death, the photographer told interviewer Maria Carrin that the editors at the Castro-allied *Revolución* newspaper were so impressed with the photo that they invited him to join Castro on a visit to Venezuela, his first trip abroad.

79 *According to a Cuban press interview:* Ciro Bianchi Ross, "La fotografía está en el ojo del fotógrafo: Alberto Korda," *Prensa Latina,* May 2001, reproduced at http://www.fotografiasdepaisajes.com.

80 *This was the weapon of Huber Matos:* Acknowledged as such by Korda in an interview published by avisora.com, date unknown. Other photos taken that day also clearly show Matos's presence on the jeep.

82 *"Korda became very intimately involved":* Telephone interview with Lee Lockwood, March 3, 2007.

82 *"I censored many":* Pagina/12, June 3, 2001.

82 *"I was never interested":* Pagina/12, June 3, 2001.

83 *They include one:* Seen during interview with Diana Díaz, November 7, 2006.

85 *Shortly after his 1959 triumph:* Interview reproduced at the Murrow Blog, http://murrow.wordpress.com/category/video/.

85 *Familiar with the teachings:* Szulc, *Fidel,* p. 564.

85 *Some have described:* Graphic artist Tony Evora, for example, in a telephone interview with the author on June 3, 2006.

85 *"The history of the revolution":* Sarusky, "Korda," in *Korda: Diario de una Revolución.*

86 *"The public identified* Revolución": Carlos Franqui, *Cuba, La Revolución: Mito o Realidad* (Península, 2006), p. 232.

86 *"I embraced the revolution":* Telephone interview with Evora, June 3, 2006.

87 *In one fell swoop:* Franqui, *Cuba,* pp. 235–36.

87 *"Right from the beginning":* Interview with Salas, Havana, November 12, 2006.

89 *It showed how two:* The *Revolución* appearances were cited and shown in the companion book to the exhibition. Trisha Ziff, ed., *Che Guevara: Revolutionary and Icon* (V&A Publications, 2006), p. 15.

89 *More recently:* Cited in an Italian-language update of Ziff's exhibition companion book.

89 *Separately, Tony Evora:* Telephone interview with Evora, June 3, 2006.

89 *"He was a guy who":* Interview with Salas, Havana, November 12, 2006.

90 *Taking a dig at Castro's:* Cabrera Infante, *El País,* September 9, 2001.

CHAPTER FOUR: BANISHED, CRUCIFIED, RESURRECTED

92 *In the months and years:* Various Castro speeches played up the Che standard. See, for example, Castro's January 15, 1966, speech at the inaugural conference of the Organization for Solidarity with the Peoples of Asia, Africa, and Latin America ("Message to the Tricontinental"), in which he ridiculed foreign press reports on Che's whereabouts, or his speech that same year on the anniversary of the Monaca assault of July 26, 1953, in which the Cuban leader spoke to rousing applause of Che's moving example for volunteer revolutionaries to follow.

92 *in the audience:* A tearful Aleida March wore a black outfit as she watched from a viewing box in the hall in which Castro read out the letter. He did so during a speech to mark the opening of the newly established Communist Party central committee, the moment at which multiparty politics in Cuba was formally disposed of. Archive footage available at http://www.youtube.com/watch?v= IOspUjwgEIA.

93 *Then midway through 1967:* See Alain Jouffroy, "Che, Sí," *Opus International,* October 1967, pp. 21–31.

93 *One sign at the salon:* Alain Jouffroy, "Che, Sí," p. 19, and Laura Bergquist, "Cuba," *Look,* December 12, 1967, p. 32.

94 *Che's Bolivian diary:* Ernesto "Che" Guevara, *The Bolivian Diary* (Ocean Press, 2006), p. 154.

94 *Meanwhile, the artists:* Gerald Gassiot-Talabot, "La Havana: Peinture et Revolution," *Opus International,* October 1967, p. 14.

94 *A ten-minute documentary:* I am indebted to Sara Vega, researcher at the Cuban film institute, ICAIC, who helped me deal with the bureaucratic obstacles I faced to receive a showing of this archived documentary.

94 *When this planeload:* Jouffroy, "Che, Sí," p. 26.

95 *Carlos Franqui:* See Franqui, *Cuba, La Revolución,* pp. 323–39.

96 *The mural's most striking:* Martínez's Che is singled out, for example, by Gassiot-Talabot in "La Havana."

96 *Art historian:* Kunzle, p. 4.

96 *In his* Lápiz y nube *blog:* "Dos bromas de Raúl Martínez," April 18, 2008, http://lapizynube.blogspot.com/2008_04_01_archive.html.

97 *Although the painting:* The work appears in the background of a photo of Martínez in *Opus International's* October 1967 coverage of the Salon de Mayo.

97 *One French painter:* E-mail correspondence with Rancillac in May of 2007. Rancillac said *phoenix* was also being used by the government daily *Granma* in reference to Guevara at that time.

99 *Foreign magazines' pictorial:* See *Paris Match,* August 19, 1967, *Opus International,* October 1967, and *Look,* December 12, 1967.

99 *Highlighting "fiestas":* Bergquist, *Look,* December 12, 1967, p. 32.

99 *"Down had come the old posters":* Lee Lockwood's photos accompanying Bergquist's article show a giant Korda image billboard at an open-door event in Santiago de Cuba. Bergquist, *Look,* December 12, 1967, pp. 32–35.

100 *The presence of markers of Che:* Resistance came from, among others, Chile's Salvador Allende, who was engineering a democratic path to the presidency in his country.

100 *The mural certainly impressed:* John Gerassi, "Havana: A New International Is Born," *Ramparts,* August 22, 1967.

100 *Just nine days later:* Estimations from *Granma,* October 19, 1967.

101 *As Castro rose to the podium:* See *Granma,* October 19, 1967.

101 *Che was a "person of total":* Accounts of Castro's speech available at Cuban government archive of Castro speeches (http://www.cuba.cu/gobierno/discursos/1967/esp/f181067e.html) and according to declassified CIA memo "Fidel Castro Delivers Eulogy on Che Guevara," October 19, 1967, published by the National Security Archive at George Washington University.

102 *In a declassified memo:* "Fidel Castro Delivers . . . ," October 19, 1967, National Security Archive at George Washington University.

102 *By running a simple screen print:* Interview with Frémez, November 8, 2006.

102 *For this reason:* Kunzle, p. 59.

102 *it appears that neither:* See *Paris Match,* August 19, 1967, p. 18.

103 *Cuba's production:* Hugh Thomas, *Cuba,* pp. 1574–78.

104 *"The process over those years":* Mike Gonzalez, "The Resurrection of Che Guevara," *International Socialism,* Issue 77, December 1997.

104 *Figueroa remembers the day:* Interview with Figueroa, Havana, November 8, 2006.

105 *Security issues, argues photojournalist:* Interview with Lee Lockwood, March 15, 2007.

105 *Korda officially "donated":* Interview with Diana Díaz on November 7, 2006.

106 *"In essence, they took away his women"*: Telephone interview with Sandoval on July 3, 2006.

106 *Korda's daughter Norka*: In *Korda: La parte mas bella de la vida.*

106 *"There were a lot of photos"*: Telephone interview on May 30, 2006.

106 *Korda got rid of the sports car*: Interview with Figueroa, Havana, November 8, 2006.

107 *a sweep that Castro biographer*: Szulc, p. 608.

107 *Figueroa recalls*: Interview, Havana, November 8, 2006.

107 *In September of that year*: Various accounts of the backlash against Western fashions and behaviors in Hugh Thomas, *Cuba,* p. 1435.

107 *One commentator*: Guido García Inclan, quoted in Thomas, p. 1435.

108 *Sounding a bit like Che*: Cited in Thomas, p. 1465.

108 *Korda loved scuba diving*: Telephone interview with Lockwood, March 15, 2007.

108 *And yet, according to Diana Díaz*: Interview, Havana, November 7, 2006.

108 *Lockwood says it was*: Telephone interview, March 15, 2006.

109 *This was possible, Figueroa explained*: Interview, Havana, November 8, 2007.

CHAPTER FIVE: MILAN, PARIS, BERKELEY

110 *there's the Korda Che*: The designer of the *Opus International* cover, Polish-born graphic artist Roman Cieslewicz, was incapacitated at the time of my research. Gassiot-Talabot had died and Jouffroy, by then eighty years old, could not be contacted. Still, much can be deduced from a brief stop-press note signed by Jouffroy and Gassiot-Talabot about Che's death days before publication in which the editors state that the typesetting had been completed before the news broke. It suggests Cieslewicz must have obtained a print of the photo quite some time before then—perhaps as a souvenir from Jouffroy's and Gassiot-Talabot's May visit to Havana.

111 *At least until*: Photographer Roberto Salas, intimately familiar with his colleague Korda's photo, recalls seeing it during international assignments in the 1960s; interview with Salas in Havana, November 12, 2006.

112 *The intersecting stories*: Malcolm Gladwell, *The Tipping Point: How Little Things Can Make a Big Difference* (Back Bay Books, 2002).

113 *Carlo Feltrinelli, who today*: Telephone interview with Feltrinelli, July 5, 2006. The younger Feltrinelli is the source for the bulk of my material on his father's life, courtesy of a detailed biography he authored, *Feltrinelli: A Story of Riches, Revolution and Violent Death* (Harcourt, 2001). The book, however, is surprisingly short on information about

the Korda meeting, the photo, and the poster. More details were forthcoming in my interview with the younger Feltrinelli.

113 *Forty years later:* Telephone interview with Kunzle, July 26, 2006.

114 *As for profits:* Telephone interview with Feltrinelli, July 5, 2006.

114 *It has also come to light:* This is addressed in *The Laundered Novel,* a full account of the affair by Ivan Tolstoy (a grandson of the acclaimed Russian novelist Alexei Tolstoy). See Peter Finn, "The Plot Thickens: A New Book Promises an Intriguing Twist to the Epic Tale of 'Doctor Zhivago,' " *Washington Post,* January 27, 2007.

114 *According to his biographer son:* Carlo Feltrinelli, *Feltrinelli,* pp. 247–48.

115 *"In 1964, when I became":* Ibid., p. 253.

115 *So, kissing good-bye:* In his recent memoir, Franqui has an amusing account of how he traversed Europe with the money in a suitcase to get it into a Swiss bank account: Franqui, *Cuba, La Revolución,* pp. 283–84.

116 *the idea of attending Debray's trial:* Carlo Feltrinelli, *Feltrinelli,* p. 254.

116 *according to former interior minister Antonio Arguedas:* Carlo Feltrinelli also cites Arguedas making a claim that Feltrinelli offered $50 million to the Bolivians if they kept Che alive. The account is not confirmed by any of the other documents that Carlo uncovered in his research. Ibid., pp. 257–58.

116 *That's why he dusted off:* Telephone interview with Carlo Feltrinelli, July 5, 2006.

117 *"A Revolutionary Has Fallen":* From *Potere Operaio,* March 26, 1972, cited in Feltrinelli, p. 332.

117 *One of his travels:* Ibid., p. 220.

118 *In late 1967:* Most of the information on Malanga's experiences in Italy comes from documents supporting the 2006 exhibition at the Andy Warhol Museum, supplied by the Pittsburgh museum's archivist and curator, Matt Wrbican.

118 *As Malanga puts it:* E-mail correspondence with Malanga, September 18, 2006.

119 *After David Bourdon:* David Bourdon, *Warhol* (Harry N. Abrams, 1995).

119 *not the lawyer:* Telephone conversation with Spencer, September 21, 2006.

119 *not any of the subscribers:* A September 29, 2006, posting to a Warhol interest group on Yahoo! inquiring about the "Warhol Che" authorship drew not one response.

121 *Fitzpatrick says:* Telephone interview with the artist, July 11, 2006.

123 *"Pop's depersonalization":* Cited in Trisha Ziff, *Che Guevara: Revolutionary and Icon,* p. 81.

124 *In equipment-starved Cuba:* The work of the OSPAAAL pop artists, who included Raúl Martínez, Ñiko, and Frémez, went far and wide, ending up on the walls of dorm rooms and apartments around the world and influencing iconography elsewhere. Graphic artist, archivist, and researcher Lincoln Cushing has noted, for example, how classic Cuban art forms found their way into graffiti and other propaganda art in San Francisco and other U.S. cities. See Lincoln Cushing, "Red All Over: The Visual Language of Dissent," published by the American Institute of Graphic Art, January 9, 2007.

124 *These various techniques:* Telephone interview with Beegan, February 23, 2007.

125 *"In a way, 1968 began in 1967":* Quoted in Sean O'Hagan, "Just a Pretty Face?" *Observer,* July 11, 2004.

126 *There's no record:* Telephone interview, May 16, 2007, with archivist Lincoln Cushing, who cited an extensive review of the workshop's output by University of California Berkeley, colleague Gene Marie Tempest.

127 *He was still in his Bolivian jail:* "Régis Debray: The Writer and Philosopher on Religion and Revolution," Gerry Freehily, *Independent,* April 13, 2007.

128 *In February of 1968:* E-mail from the artist, July 2, 2008.

128 *The offices of the magazine were firebombed:* See Ziff, *Che Guevara,* p. 22.

129 *And nothing, certainly not the peaceniks':* Stokely Carmichael, who at one stage sought asylum in Cuba, had a special affinity with Che. His Student Nonviolent Coordinating Committee (SNCC) group's magazine, *The Movement,* even offered Che posters to its readers—though not those based on the Korda image—in an October 1966 edition.

129 *In its May 17, 1968, edition:* "The Cult of Che," *Time,* May 17, 1968.

130 *In his iconoclastic study:* Thomas Frank, *The Conquest of Cool* (University of Chicago Press, 1997), pp. 1–9.

CHAPTER SIX: ARGENTINA

137 *In an essay entitled:* Published in Ariel Dorfman, *Other Septembers, Many Americas: Selected Provocations, 1980–2004* (Seven Stories Press, 2004).

138 *Guevara "represents the heroism":* Castañeda's extensive research provided much of the material here for Latin American revolutionary movements in the 1960s and 70s: Jorge Castañeda, *Utopia Unarmed: The Latin American Left After the Cold War* (Vintage, 1994), p. 80.

143 *After the September 11 attacks:* Hebe Bonafini, "El 11 de septiembre

sentí que la sangre de tantos caídos era vengada" Rebelion.org, October 7, 2001.

143 *And when Pope John Paul II died:* "Bonafini cargó duro contra las Abuelas, Juan Pablo II y Blumberg," *Clarín,* April 13, 2005.

143 *It's hard to see Che:* Telephone interview with Dorfman, April 11, 2007.

147 *After visiting the Che museum:* Cited in a posting by "Morrisey" on the Squidoo travel blog: http://www.squidoo.com/argentina/.

149 *Che was seen as the antithesis:* Interview with Peralta, Córdoba, August 8, 2006.

150 *Che was always associated:* Interview with Marinozzi, Rosario, August 7, 2006.

150 *According to Poots:* E-mail received June 30, 2007.

150 *Even members of Guevara's:* Alberto Benegas Lynch, "Mi Primo, El Che," *El Instituto Independent,* October 18, 2007.

152 *The building in question:* "La placa de la polémica," *El Ciudadano,* Rosario, October 6, 2006.

157 *Zerneri says his project:* Interview with Zerneri, Buenos Aires, March 30, 2007.

158 *There it revolves around:* Comments from Brizuela and accounts of his tour come from two separate visits to the Solar del Che. One I made alone on August 11, 2006, the other with the *Chevolution* documentary team in March 2007.

160 *In the online pitch:* Cited at the website for Loporto's book, *The DaVinci Method:* www.davincimethod.com.

160 *Carlos Heller:* For the January 25, 2007, edition of Argentine newsweekly *Veinti-tres,* the photo accompanying a cover story titled "La paradoja del banquero guevarista" showed Heller sitting on a park bench with an image of the Korda Che on its concrete base.

168 *Noting an association:* Interview on set of *Chevolution,* March 30, 2007.

168 *The link between Che:* Luciana Vainer, *Mira que linda se viene: La murga porteño* (Papel Picado, 2005).

CHAPTER SEVEN: BOLIVIA

176 *The events described:* The diary accounts cited in this chapter are taken from the most recent English translation of Che's diary published by Ocean Press, the left-wing, pro-Cuba Australian publisher contracted exclusively to the Guevara family's Che Guevara Studies Center: Ernesto Che Guevara, *The Bolivian Diary, Authorized Edition* (Ocean Press, 2006).

178 *aided by an "affable nun":* Christopher Roper, Reuters, as per Argentina's *Clarín* newspaper, October 11, 1967.

179 *"His clear gaze"*: Christopher Roper, *Departures,* November 2006, p. 200.

180 *It could have been worse:* Information on what happened to Che's possessions taken from Taibo II's biography, *Guevara, Also Known as Che,* pp. 571–78.

182 *In his reporting:* Jean Lartéguy, *The Guerrillas: New Patterns in Revolution in Latin America* (Signet Classics, 1970).

183 *Two weeks after Alborta's photo:* Berger's essay cited in Kunzle, p. 90.

185 *The theme was revived again:* See Robert Faires's review in *The Austin Chronicle,* September 5, 2003.

185 *As Jorge Castañeda has argued:* Castañeda, *Compañero* (Spanish version), pp. 19–21.

186 *In an explanation:* Extract taken from Roberto Cuevas Ramírez, *Arguedas* (Artes Gráficas Latinas, 2000).

186 *Before his government and CIA jobs:* Details of Arguedas's life before 1997 taken from Taibo II, *Guevara,* pp. 574–82.

187 *In February 2000:* "Muere en La Paz el ministro que entregó las manos del 'Che,'" *El Mundo,* February 24, 2000.

187 *"We worked for a whole week"*: Telephone interview with Evora, June 3, 2006.

187 *According to the Italian publisher's son:* Carlo Feltrinelli, p. 261.

189 *The marketing pitch:* The branding was also aided by a report in *Granma* that Cuban doctors had restored the sight of Sergeant Mario Terán, the soldier who executed Che, in 2006. Cuba's official newspaper sat on this great story for a whole year, holding off publication until the fortieth anniversary of Che's death. "Four decades after Mario Terán attempted to destroy a dream and an idea, Che returns to win yet another battle," the paper declared in an article picked up by the BBC, the *Los Angeles Times,* and other foreign news outlets.

190 *I later found Tapia Aruni:* Eusebio Tapia Aruni, *Piedras y espinas en las arenas de Ñancaguazú,* 3rd ed., 2001.

190 *In March 1967:* Ernesto Che Guevara, *The Bolivia Diary,* pp. 96–119.

190 *A founder of Bolivia's:* In a second interview he gave me a year later, Tapia Aruni was equally determined to pin blame for his unfair treatment throughout the years on the current leaders of the Che Guevara foundation, including Chato Peredo, the brother of Che's fallen comrades in arms Inti and Coco, as well as on Cuban officials. He is one of many followers of Che who, despite being subjected to hardship by others nominally on the same side, remains devoted to the ideals of the revolutionary if bitterly opposed to the powers that be who claim to represent them.

197 *In 2006 a Cuban film:* The documentary, which was directed by acclaimed Cuban actress Isabel Santos, had its premiere at one of the open-air official events in Vallegrande before the ceremony in La Higuera that year.

198 *Antonio Peredo:* Personal interview during a visit to Buenos Aires, June 14, 2008.

202 *In 2008, a Fulbright:* Dan Keane, "US Official Will Not Return to Bolivia," Associated Press, February 13, 2008.

202 *But the gap has simply:* S. Romero, *New York Times,* February 23, 2007, "Venezuelan Aid to Bolivia May Surpass $120 Million from US."

202 *But after Morales:* Interview in La Paz with CARE Bolivia country director Barbara Jackson, October 4, 2006.

203 *Santa Cruz–based agent:* Personal interview, Santa Cruz, October 5, 2006.

203 *One case is the Mambo Tango Cultural Center:* Reporting based on visit to the center, October 5, 2006; interviews with staff; and e-mail correspondence with Nadine Crausaz.

CHAPTER EIGHT: VENEZUELA

224 *According to the World Bank:* David De Ferranti et al., *Inequality in Latin America & the Caribbean: Breaking with History* (World Bank, 2003).

225 *By the end of it:* "Socio-economic Database for Latin America and the Caribbean" (SEDLAC), Universidad de la Plata, 2007.

225 *In 1999, real per capita GDP:* United Nations Human Development Report, 2000.

226 *"Resource-rich countries' failures":* Personal interview with Stiglitz in Buenos Aires, June 5, 2007.

226 *When Chávez assumed:* Data series from economagic.com.

226 *As a function of this, the Venezuelan government:* In May 2008, the government announced that its *proven* reserves had reached 130 billion and that it hoped to have the Organization of Petroleum-Exporting Countries (OPEC) certify a figure of 235 billion in 2009: "Venezuelan oil reserves swell to 130 billion barrels," Agence France Presse, May 8, 2008.

227 *Despite the global oil boom:* "Energy Economist Newsletter" (WRTG Economics, May 2007).

227 *Venezuela quickly replaced the United States:* S. Romero, *New York Times,* February 23, 2007.

227 *one University of Miami report:* Duncan Currie, "Cuba after Fidel," *Weekly Standard,* March 3, 2008.

228 *Embellished by talented:* Eduardo Galeano, *The Open Veins of Latin America* (Monthly Review Press, 1973).

229 *If we follow* Foreign Policy: Moises Naim, "The Washington Consensus: A Damaged Brand," *Financial Times,* October 28, 2002.

CHAPTER NINE: MIAMI

233 *"a psychotic Marxist thug"*: M. Bramanti, "Obama Office Adores Psychotic Marxist Thug," lonestartimes.com, February 11, 2008; "Che Guevara Flags in Obama's Houston Office," littlegreenfootballs.com, February 11, 2008; "Obama Campaign Workers Display Che Guevara Flag," moonbattery.com, February 11, 2008.

235 *As can be gleaned from:* See an excellent compilation of Bardach's reporting in *Cuba Confidential: Love and Vengeance in Miami and Havana* (Vintage, 2002).

237 *he published a tell-all book:* Most of the details of Rodríguez's life here are taken from his autobiography *Shadow Warrior* (Simon and Schuster, 1989).

238 *Rodríguez says he lobbied:* Interview with Rodríguez, Miami, November 20, 2006.

238 *a recently declassified CIA briefing:* Available through the George Washington University National Security Archive's "Death of Che Guevara" file: www.gwu.edu/~nsarchiv/NSAEBB/NSAEBB5/index.html.

238 *"Look at what people write"*: Interview with Rodríguez, Miami, November 20, 2006.

242 *There, Gonzalez helped:* See Tristan Korten and Kirk Nielsen, "The Coddled Terrorists of South Florida," *Slate,* January 14, 2008.

243 *Posada-Carriles, a man whose extensive FBI dossier:* See chapter 7 from Bardach's *Cuba Confidential* (pp. 171–223), in which she relates Posada-Carriles's confessions of his actions during an interview in a secret Caribbean location she conducted for two front-page stories in *The New York Times,* July 12 and 13, 1998.

244 *In fact, Paz Romero:* "INS Releases Cuban Car-Bomber," *Tampa Tribune,* August 11, 2001.

247 *It arises in the opening interview:* Pedro Corzo (director), *Guevara: Anatomía de un mito* (2005).

249 *New Orleans–based:* Humberto Fontova, *Exposing Che Guevara and the Useful Idiots Who Idolize Him* (Sentinel HC, 2007).

249 *Writing for the online conservative zine:* Humberto Fontova, "Che Guevara: Assassin and Bumbler," *Capitalism Magazine,* October 25, 2005.

250 *The line comes from:* It was reportedly first heard by Sergeant Bernardino Huanca and then twenty years later became the title of a book by a former Bolivian officer involved in the hunt for Che but who

was not present at his capture, General Arnaldo Saucedo Parada. *No disparen . . . Soy el Che* (Editorial Santa Cruz, 1987).

251 *The actors' restrained performances:* Cited in Christina P. Sellin, "Demythification: The Twentieth Century Fox Che!" in Kunzle, *Che,* p. 99.

252 *Back in January 2006:* "Soderbergh Admits *Che* Is Complicated," Paul Davidson, ign.com, January 12, 2006.

253 *A case in point:* Paul Berman, "The Cult of Che: Don't Applaud the Motorcycle Diaries," *Slate* magazine, September 24, 2004.

CHAPTER TEN: OMNIPRESENCE

259 *"In a variety of ways":* Telephone interview with Selbin, August 1, 2006.

260 *the stories of Che's high jinks:* Arthur Quinlan, *The Limerick Leader,* March 15, 1965, cited in "The Night Che Guevara Came to Limerick," December 28, 2003.

260 *Filmmakers Adriana Mariño:* As seen in their documentary *Personal Che* (2006).

260 *"Che Guevara of the Arab world":* The term was coined by Michel Awad from the Institute of Social Sciences at the University of Lebanon; "Nasrallah es el Che del mundo árabe," *La Nación,* July 30, 2006.

260 *Then, a few weeks later:* Andrew Higgins, "Anti-Americans on the March: Inside the Unlikely Coalition of the U.S.'s Sworn Enemies, Where Communists Link Up with Islamic Radicals, Hezbollah, Chávez and London's 'Red Ken,' " *Wall Street Journal,* December 9, 2006.

260 *Liberal critics of both socialism:* See August 25, 2006, article and follow-up reader commentary at *The Arabist;* http://arabist.net/archives/2006/08/25/the-arab-che/#comments.

261 *This was laid down:* Sarah Baxter, "Where Do You Stand in the New Culture Wars?" *Sunday Times,* October 21, 2007.

262 *Indeed, if we are to accept:* See Chris Hedges, *War Is a Force That Gives Us Meaning* (Anchor, 2003) and *I Don't Believe in Atheists* (Free Press, 2008).

263 *Some anti-immigrant groups:* See, for example, the coverage and photos at limitstogrowth.org of the "May Day Illegal Alien Rally in San Francisco, May 1, 2006." One contributor wrote, "There were plenty of Che Guevara posters and red flags, signifying the clear revolutionary intent of the marchers" (www.limitstogrowth.org/WEB-text/maydaysanfranciscophotos.html).

263 *In Miami:* In his coverage of the Miami rally at his *Miami Herald* blog, Oscar Corral argued that the radio hosts' bluster about Che T-shirts and Castroists proved unfounded. "Pro-Fidel Literature Ignored at Orange Bowl Rally," May 2, 2006, http://blogs.herald.com/cuban_connection/2006/05/profidel_litera.html.

263 *Clues might lie:* Shifra Goldman, "Che, Chicanos, and Cubans: The Struggle over a Symbol," in Kunzle, pp. 74–75.

264 *In Hong Kong:* Leung was also featured in Mariño and Duarte's documentary, which tracked people from varying backgrounds and political causes around the world who've made Che their personal icon: *Personal Che* (2006).

265 *The Victoria and Albert Museum's:* Telephone conversation with Trisha Ziff, July 12, 2006.

267 *This was the case:* See Trisha Ziff, *Che Guevara,* p. 83.

CHAPTER ELEVEN: IN SEARCH OF THE INNER CHE

272 *"Those who have never lied":* From the poem "Evangelicas" (Gospels), *Algo de lo salgrado* (Ediciones Union, Havana, 1995).

276 *With no inflows to fund them:* Archibald Ritter, an economist and Cuba specialist from Carleton University in Ottawa, helped me grasp the distortions of the dual-currency system. "There was then a huge surplus of these things, which without price controls would have been a major source of inflation," he said of the impact of the initial devaluation in 1991. "But we're talking about rationed products . . . so you essentially had all these additional pesos chasing other things." Telephone interview with Ritter, July 5, 2007.

277 *A year later it introduced:* For many years, the greenback ruled as the dominant currency. But in 2004, Cuba moved to reduce its influence, slapping a 10 percent punitive tax on dollar conversions, partly in retaliation against new anti-Castro sanctions from the Bush administration.

277 *But along with some punitive:* In May that year, after the reforms had been announced, Yoanni Sanchez was banned from traveling to Madrid to receive the Ortega y Gasset prize for digital journalism that she had won for her site, Generación Y. "Cuban Blogger Given Press Award," BBC, May 7, 2008.

279 *One reason to do so:* In 2004, when the government printed a new three-peso "convertible peso" for foreign currency–based transactions, it made sure to put Che on both sides of it because, as reported by the expat-targeted *Havana Journal,* the old one's Che image had proven "a hit with collectors"; October 15, 2004.

284 *He publicly derided:* See Taibo II, *Guevara* (1997), pp. 312–17.

289 *Most of his energy:* For a comprehensive archive of documents arising from the Paideia and related projects, along with a series of long-overdue retrospective essays and interviews dealing with this little-covered

period in Cuba's dissident movement, see the summer 2006 online edition of *Cubista* magazine (http://cubistamagazine.com/intro.html).

289 *There was "a surrealism"*: http://blogs.elboomeran.com/fogel/2006/10/paideia.html, October 2, 2006.

289 *"In his ways of interaction"*: E-mail from Prats-Paez, August 28, 2008.

290 *It offered a minimal program*: Rolando Prats-Paez et al., "Nota de prensa y declaración de tercera opción," available at *Cubista* magazine, summer 2006 (http://cubistamagazine.com/050012.html).

291 *Founded on Che's plans*: "The Situation of Human Rights in Cuba Seventh Report," 1983, Chapter X, Inter-American Commission on Human Rights of the Organization of American States.

293 *His name briefly appears*: Among them, Jorge Castañeda's *Compañero*, pp. 327–29.

293 *Yet he has also lived a separate*: The rumors surrounding Pérez's parentage are mentioned in the biographical material attached to a recent collection of contemporary Cuban poetry published in the United States, but only in passing; *Origin*, sixth series, issue 4, spring 2007 (Longhouse Poetry), pp. 123–49.

CHAPTER TWELVE: MERCHANTS IN THE TEMPLE

298 *So join the struggle*: From the song "Waiting for the Great Leap Forwards," from Bragg's album *Workers Playtime*, 1998.

302 *political scientist Francis Fukuyama*: Francis Fukuyama, *The End of History and the Last Man* (Avon, 1992).

304 *Immediately, actor Benicio Del Toro optioned*: C. Petrikin, "Gerolmo Plans 'Che' Biopic," *Variety*, April 21, 1997.

304 *Five days later*: Archive of Castro's speeches: http://www.cuba.cu/gobierno/discursos/.

304 *Spanish journalist Maite Rico*: Bertrand de la Grange and Maite Rico, "Operación Che: Historia de una mentira de Estado," *Letras Libres*, February 2007.

306 *a fact noted with concern*: Naomi Klein, *No Logo* (Picador, 2002).

306 James Twitchell: *Brand Nation* (Simon & Schuster, 2004).

306 The Culting of Brands: Douglas Atkin, (Portfolio, 2004).

306 *"There was a conscious decision"*: Eduardo Kaplan, "Che's Marketing Revolution," Dow Jones Newswires, September 27, 2004.

308 *So on April 20, 1995*: World Trade Organization membership list: http://www.wto.org/english/thewto_e/whatis_e/tif_e/org6_e.htm.

308 *In keeping with its commitments*: Press release: Berne Notification No. 176, November 20, 1996.

308 *According to one study:* Based on various studies by Baruch Lev, an economist at New York University's Stern business school. Partly cited in Ben McLure, "The Hidden Value of Intangibles," http://www.investopedia.com/articles/03/010603.asp.

309 *As a result:* Ariana Hernández-Reguant, "Copyrighting Che: Art and Authorship Under Cuban Late Socialism," *Public Culture,* volume 16, number 1, winter 2004, pp. 1–29.

310 *Korda's first U.S. exhibition:* Telephone interview with Couturier.

311 *The photo spread:* In approving the *Playboy* pictorial, "the government was complicit in the commodification of Cuban women's bodies," wrote Florence E. Babb of the University of Florida in "Che, Chevys, and Hemingway's Daiquiris: Cuban Tourism as Development Strategy in a Time of Globalization," a paper dated August 3, 2005.

312 *after Magaud convinced:* Interview with Diana Díaz, Havana, November 6, 2006.

312 *Korda transferred:* In 2002, this right was extended for another three years to May 2008. See the ruling of the Cour d'Appel de Paris, RG no. 2005/16337, May 9, 2007. http://uami.eu.int/pdf/natcourt/che_guevara.pdf. Magaud died before the extension expired.

312 *Korda's eldest son:* This and subsequent citations taken from a telephone interview with Fidel Alberto Korda, October 14, 2008.

313 *In September 2000:* Matt Wells, "Big Payout over Guevara Photo," *Guardian,* September 15, 2000.

314 *the model Natalia (Norka) Méndez:* Mary Murray, "Cuba Buries Famed Photographer," NBC News, May 29, 2001.

314 *as the mourners filed past the body:* Interview with Diana Díaz, Havana, November 6, 2006.

314 *Behind the faces of mourning:* The battle over the will got surprisingly little coverage either on or off the island. Nonetheless, Kirk Nielsen offered a fine, detailed account in "Blowup: You've Seen the Revolutionary Photo, Now Here's the Soap Opera," *Miami New Times,* April 4, 2004.

315 *"After that, I just couldn't":* Telephone interview, July 16, 2007.

315 *Alejandra Díaz:* Telephone interview, July 16, 2007.

316 *Her brother Dante:* Telephone interview, November 4, 2008.

316 *Diana Díaz maintains:* Interview, Havana, November 6, 2006.

317 *This was confirmed by:* E-mail from Vyrje, October 14, 2008.

317 *Shortly after the lawsuit:* Lena Lindgren, "Havner i retten" (Ending Up in Court), *Dagens Naeringsliv,* October 27, 2000.

319 *the director, whose low-budget film:* "Thomas Moronic Talks to Bruce LaBruce," January 28, 2007, http://thomasmoronic.blogspot.com/2007/01/thomas-moronic-talks-to-bruce-labruce.html.

319 *Later, LaBruce:* LaBruce interview with another blog-based critic under the name espanz, http://espanz.noblogs.org/post/2007/04/16/i.i-bruce -la-bruce.

320 *by extension, so too:* As holder of exclusive exploitation rights in Europe, Magaud is commonly an accompanying party to the Korda estate lawsuits there. For an account in this case, see the German news website taz.de: http://www.taz.de/index.php?id=archivesite&dig=2006/06/08/a0218.

320 *RSF secretary-general Robert Ménard:* Account of both arguments at RSF website, www.rsf.org, July 9, 2003.

320 *including Jim Fitzpatrick:* Telephone interview with Fitzpatrick, July 11, 2006.

321 *Stanford University copyright specialist:* Interview with Goldstein, July 10, 2007.

321 *as Alejandra Díaz asserts:* Telephone interview with Alejandra Díaz, July 16, 2007.

321 *as recently as:* Cour d'Appel de Paris, 4ème Chambre—Section A, May 9, 2007, in reference to a June 29, 2005, decision by the Tribunal de Grande Instance de Paris—RG no. 05/216. http://uami.eu.int/pdf/natcourt/che_guevara.pdf.

322 *including Christopher Nash:* Telephone interview with Nash, July 27, 2007.

322 *Scott Cramer, president of:* Telephone interview with Cramer, July 2007.

322 *A Minnesota judge:* According to a letter citing copyright infringement that was sent to Bellingham, WA–based clothing retailer Merch-Bot by U.S. Korda license-holder Fashion Victim, the decision is filed as number 04-CV-04696 MJD/JGL at the United States Minnesota District Court. Merch-Bot posted the letter on its website: http://www.merch-bot.com/index.php?main_page=page&id=3&chapter=0.

323 *In an interview in 2006:* Telephone interview with Havana, November 23, 2006.

323 *Havana later told me:* E-mail from Havana, October 29, 2008.

324 *Diana Díaz says:* Interview with Díaz, November 7, 2006.

324 *"She is as aggressive as Disney":* Telephone interview with McCarthy, November 23, 2006.

324 *Atbashian sent a biting:* http://www.thepeoplescube.com/red/viewtopic .php?+=309.

328 *Aleida Guevara put it:* Interview with Guevara, Havana, May 24, 2007.

329 *TheCheStore.com's "Johnny Havana":* Telephone interview, November 23, 2006.

330 *Before he took over:* Telephone interview, November 23, 2006, and e-mail received October 29, 2008.

331 *Paris exhibition in March 2007*: http://gpzphoto.over-blog.com/article -6158422.html.

331 *José Antonio Choy*: Pérez Guillén, July 9, 2004, cited on the Che Center's website http://cheguevara.cubasi.cu.

334 *The Lyons Group*: Lyons and Disney cases cited in Klein, *No Logo*, p. 177.

334 *Dow Jones & Co.*: See Douglas Cruickshank, "Steppin' in It. Woof! Who Breaks a Chihuahua on the Wheel? Wall Street Journal Gets Medieval." *Salon*, November 6, 1999.

335 *Holtom and the CND*: A recent book explores the history of Holtom's peace symbol: Ken Kolsbun, *Peace: The Biography of a Symbol* (National Geographic, 2008).

336 *For Roberto Massari*: Telephone interview with Massari, June 22, 2007.

337 *If we recognize*: See in *Free Culture* (Penguin Press, 2004), Stanford University law professor Lawrence Lessig's persuasive case for limiting the reach of copyright laws in the name of protecting the building blocks of culture.

337 *In the threatening letters*: Merch-bot.com posted Fashion Victim's letter on its website under the title "Why We Don't Sell Che Guevara Shirts Any More."

EPILOGUE

339 *"No matter what Cuba does"*: At the Lippmann-moderated CubaNews site; http://groups.yahoo.com/group/CubaNews/message/81542.

341 *Marxist sociologist Nelson Valdes*: "Caveat Venditor: The Imperial Branding of Simon Bolivar and the Cuban Revolution," Counterpunch, March 17, 2008; http://www.counterpunch.org/valdes03172008.html.

342 *writer Humberto Fontova's*: Fontova, *Exposing the Real Che Guevara* (Sentinel, 2007).

ACKNOWLEDGMENTS

As I STARTED OUT on this book project, one friend advised me to approach it like a marathon runner: to just keep going without thinking about the ever distant finish line. Now, almost three years later and finally catching my breath, I look back and realize that without a huge team of people helping me and cheering me along, some of them virtually running the entire race themselves, my legs would have given out long ago. My comarathon runners are too numerous to all be named here. But I hope those unmentioned know that I am deeply grateful for their help and well aware of the debt I owe them.

My agent, Gillian MacKenzie, must be singled out for her boundless enthusiasm, energy, and creativity, without which this book would never have been conceived, let alone finished. Thanks must also go to my friend Melissa de la Cruz for introducing me to Gillian.

Lexy Bloom proved a patient, exacting, and thoughtful editor as she shaped my disjointed mesh of ideas into a coherent product. She and others at Vintage took an open-minded approach to an unorthodox project. In that vein, I'd like to highlight Danny Yanez for his dogged work in tracking down photographers and artists so that we could publish the dozens of fabulous images displayed in this book.

Many people at Dow Jones Newswires deserve thanks, but especially my editors Eduardo Kaplan and Charlie Roth, who showed great flexibility toward an endeavor far removed from my daily journalistic output. Both also generously provided their own unique insights into Latin America. Meanwhile, my colleagues in Buenos Aires—Taos Turner, Shane Romig, and Drew Benson—kept the bureau running while I lost

myself in revolutionary texts or in remote parts of the continent and yet were still willing to offer their valuable advice. I also appreciate the input and support of various editors and reporters at *The Wall Street Journal*, including David Luhnow, Bob Davis, and Mary O'Grady.

Since a book is inevitably viewed as a milestone in a journalist's career, I'll make a very long overdue expression of gratitude here to those who helped me find my way on this path. These include a trio of mentors at *The West Australian* in the early nineties—André Malan, Norm Aisbett, and Mark Thornton—and, going even further back, a man who encouraged a skinny kid with more interest in surfing than books to have a go at writing: my year-nine English teacher Shane Negus.

We journalists don't thank our sources enough, believing perhaps that the publicity we give to their causes compensates for their time and information. We take for granted the leaps of trust they make in talking to us. There is often much at stake, especially so when the topic inflames passions as the story of Che Guevara does. So the credits listed here are indeed warranted, even if they will read to some like a grouping of odd bedfellows. Whatever differences exist among them, each is owed a debt of gratitude. They helped me strive toward what I hope most readers will perceive as an accurate, fair, and balanced book. Yet I know that some of those listed here won't agree with everything I've written. It is therefore important to state that I am solely responsible for this book's content, including whatever errors it may or may not contain.

I must first thank members of the two families at the center of this story, many of whom voluntarily shared their memories, both joyful and painful, with me. From the Korda family, I wish especially to cite Diana Díaz López and Reinaldo Almira, who placed enormous trust in me, shared considerable information, and opened up their home with generosity and warmth. But I was also blessed with similarly open and cooperative responses to my requests from Diana's four siblings, Norka, Alejandra, Fidel Alberto, and Dante. From the Guevara family, Che's daughter, Aleida, graciously received me at the home her father established in Havana five decades ago, and María del Carmen Ariet, a longtime associate of the family and an eminent Che historian, gave me a tour of the Che Guevara Studies Center across the road. Meanwhile, I received useful input from other, lower-profile members of the far-flung Guevara clan, including Che's brother, Juan Martín, in Buenos Aires, and his grandson, Canek, in France. It is also appropriate that I make

special mention here of Omar Pérez López and his mother, Lilia Rosa López, who bravely shared with me a story that had been under wraps for decades.

I am enormously indebted to Trisha Ziff and the team who transformed her Korda Che art exhibition into the cutting-edge documentary *Chevolution*, including her codirectors Sylvia Stevens and Luis López. They stand out for the spirit of collaboration with which they involved me in their project and helped me with mine. Another who went above and beyond was Rolando Prats-Paez, who stuck his neck out to open doors and then, with his intellect and integrity, offered invaluable guidance on some of the more sensitive parts of the manuscript. For his part, Tom Miller kept me plied with sources, ideas, and advice on Cuba while keeping his eye out for all things weird, wonderful, and newsworthy on Che. His frequent e-mails almost always contained something of value and, if not, would at least make me laugh.

For their knowledge on the history of the Korda image, I'm extremely grateful to Darrel Couturier, David Kunzle, Gerry Beegan, Jim Fitzpatrick, Tony Evora, Roberto Massari of the Che Guevara Foundation in Italy, Carlo Feltrinelli, and Matt Wrbican of the Warhol Museum. For their expertise on Che's life and writings, I owe much to Jon Lee Anderson, Jorge Castañeda, and Eric Selbin. And for insights into photography, Korda Che art and copyright issues, I thank David Perlmutter, Paul Goldstein, Ariana Hernández-Reguant, Johnny Havana, Brian McCarthy, Oleg Atbashian, and Christopher Nash.

For my research in Cuba, I was helped by José Figueroa, Roberto Salas, Sara Vega of the Cinemateca de Cuba, Reina María Rodríguez, Pedro González Reynoso, José Llufrio in New York, Sandra Levinson of the Center for Cuban Studies in New York, and Sergio Codino in Buenos Aires. In Argentina, I must cite Daniel Menéndez and Orlando Cisterna of the Jóvenes de Pie, Ricardo Brizuela in Iguazú, Julia Perié of the Misiones Department of Museums, and Brenda Pereyra and others at the IDES institute. For my trip to Miami, I received advice and contacts from Ann Louise Bardach, Maria Werlau of the Cuba Archive, Enrique Encinosa, Humberto Fontova, Pedro Corzo, and Kirk Nielsen.

In Australia, Terry Townsend, Lisa Macdonald, and John Tognolini introduced me to participants in the Blue Mountains Che mural dispute, and in Venezuela, Vinod Sreeharsha shared his contact list while Ricardo and Estela Castillo shared their memories and knowledge of

their country's history. In Bolivia, my dear friends Marcelo Alvarez and Consuelo Tapia Morales arranged meetings and offered valuable advice. Also deserving mention in Bolivia are Nadine Crausaz and Manuela Prax-Meyer Tusco of the Mambo Tango Cultural Center, who among other things let me travel in a truck full of kids to Vallegrande for the 2006 Che anniversary, as well as Fernando Porras, who enabled my return trip the following year in a very different truck.

Many friends and family around the world saved me from dropping out of the race prematurely. I'm especially grateful to Rubén Mira, Josefina Tommasi, and Sergio Langer in Buenos Aires for their generous artistic and intellectual contributions to this project, and for their enthusiasm, and companionship. Jim Della-Giacoma, a world traveler to rival Che, provided early advice on the manuscript and demonstrated a special knack for spotting the Korda image in all corners of the globe. In Australia, my mother and father, Sally and Kevin Casey, slogged through an early, clunky version of the text. Meanwhile, back in Buenos Aires, the suggestions and encouragement I received from Michael Poots, Jane McGrath, Pablo Bertorello, and Liz Stangle meant that they were very much cotravelers in this journey.

Among the many others who shared their thoughts, offers of accommodation, Che paraphernalia and sightings of the image were: Hector Tobar, Jennifer Carmona; Elizabeth Carmona; Tom Barkley; Dan Grech; Kimberley Fyffe; Jamie and Catherine Mackenzie; Anton Bowker-Douglass; David Rigg; Anya Reading; Peter Roebig; Emmanuel Bidegain; and Renee Rankine, who is here recalled in loving memory.

To my darling daughters, Zoe and Analia, I say thanks for the joy you would bring to a sometimes bleary-eyed father and for tugging at his arm from time to time to say, "Look, Daddy, there's your friend, Che!" Finally, to their mother and the love of my life I owe a debt of inconceivable proportions—for her patience, encouragement, wisdom, and enthusiasm, for being an indispensable copy editor of last resort, and for a wellspring of love that never dries up. Alicia didn't ask to share her home with a second man for three years. But even as it filled up with his images and books, she stuck by me and carried me and the rest of us over the finish line. Oh, and in the meantime she earned herself a PhD. This book is for her.

INDEX

ILLUSTRATION CREDITS

Black-and-white Images

27, 35, 80, 81, 83, 84—Photos © 2008 Artists Rights Society (ARS), New York/ADAGP, Paris. Courtesy of Banque d'Images, ADAGP/Art Resource, New York.

30—Product designs © Jimena Chague and Soledad Calvano of Stickme.com.ar, Argentina. Photo © Michael Casey.

40—Image © Hernán Berdichevsky, Gustavo Stecher, imagenHB.com.

42 (left), 62, 312—Images courtesy of David Kunzle.

42 (right)—Image © Rubén Alpizar and Reinerio Tamayo, reproduced with kind permission. Photo © Michael Casey.

43, 142, 144, 169, 219, 243, 276, 282, 288, 329—Photos © Michael Casey.

44—Image © Maverick Records/Warner, 2003. Cover design by M/M Paris.

75—Photo courtesy of Norka Korda.

90, 112, 266—Courtesy of the exhibition, Revolution and Commerce: Portrait of Che Guevara by Alberto Korda, curated by Trisha Ziff.

98—Image courtesy of the Center for Cuban Studies, New York.

121—Image © Jim Fitzpatrick 1968. Courtesy of the artist.

173—Photo © Natalie Brady/Faction Films.

182—Photo © The Estate of Freddy Alborta Trigo. Courtesy of Jorge Alborta Auza.

184—Photos © Erich Lessing/Art Resource, New York.

185—Photo courtesy of Félix Rodríguez.

212—Photo © Josefina Tommasi.

250—Photo © Taos Turner.

268 (top)—Image © J. J. Jackson, Land of the Free Studios, Inc. and www .therightthings.com.

268 (bottom)—Image © The Churches Advertising Network.

269—Image © Christopher Nash.

270—Image courtesy of ThePeoplesCube.com and Che-Mart.com.

271—Cartoon © Sergio Langer.

310—Photo courtesy of Darrel Couturier.

Color Insert

1—Photo © 2008 Artists Rights Society (ARS), New York/ADAGP, Paris. Courtesy of Banque d'Images, ADAGP/Art Resource, New York.

2, 9, 10, 11, 12—Photo © Josefina Tommasi.

3—Photo © Catherine Mackenzie.

4—Courtesy of the exhibition, Revolution and Commerce: Portrait of Che Guevara by Alberto Korda, curated by Trisha Ziff.

5—Image © Jim Fitzpatrick 1968. Courtesy of the artist.

6—Image © Paul Davis. Courtesy of the artist.

7, 8, 15—Photos © Michael Casey.

13—Image © Patrick Thomas. Courtesy of the artist.

14—Photo © Natalie Brady/Faction Films.